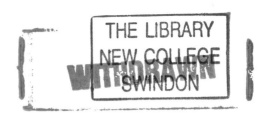
PHOTO
BOX

20090002189

PHOTO BOX

Bringing the Great Photographers into Focus

Foreword by Roberto Koch

Thames & Hudson

On the cover, from top to bottom: Eadweard Muybridge,
Martin Parr, Martin Munkacsi, Alessandra Sanguinetti,
Robert Capa, Alex Webb

Every effort has been made to trace the copyright holders
of the images contained in this book and we apologize
in advance for any unintentional omissions. We would
be pleased to insert the appropriate acknowledgment
in any subsequent edition of this publication.

Translated from the Italian *Foto:Box* by Jimena Bargados,
Catriona Cappleman, Clare Costa, Grace Crerar-Bromelow
and Luisa Nitrato Izzo

First published in the United Kingdom in 2009
by Thames & Hudson Ltd, 181A High Holborn,
London WC1V 7QX

Reprinted 2010, 2011

Original edition © 2009 Contrasto due srl, Rome
Italian texts © 2009 Alessia Tagliaventi, Laura Leonelli,
Alessandra Mauro, Francesco Zanot, Denis Curti
Foto:Box was produced collaboratively by Contrasto
and *Corriere della Sera*
Edited by Roberto Koch
Graphic design: A+G AchilliGhizzardiAssociati
Layout design: Tania Russo
This edition © 2009 Thames & Hudson Ltd, London

British Library Cataloguing-in-Publication Data
A catalogue record for this book is available from
the British Library

ISBN 978-0-500-54384-9

Printed and bound in Hong Kong

To find out about all our publications, please visit
www.thamesandhudson.com. There you can subscribe
to our e-newsletter, browse or download our current
catalogue, and buy any titles that are in print.

Producing a varied and complex book such as this requires teamwork, and this is essential to its success. First and foremost I would like to thank the photographers and copyright holders who kindly gave us permission to reproduce their photographs. The text was written with great verve and clarity by several contributors: Alessia Tagliaventi and Laura Leonelli, who supplied the bulk of the material, as well as Alessandra Mauro, Francesco Zanot and Denis Curti. My heartfelt thanks go to all of them. I would also like to thank the staff at Contrasto: in particular, Barbara Barattolo (quality control and production), Tania Russo (design), Alessia Tagliaventi (editorial), Roberta De Fabritiis, Alice Tudino and Franca de Bartolomeis (copyright), and Alessandra Mauro for overseeing the project. Thank you also to Franco Achilli and his studio, A+G Design. Thanks go to Luisa Sacchi and the staff at RCS who, together with Corriere della Sera, were instrumental in bringing about the book in the early stages and believed in it right from the start. Finally, I offer my warmest thanks to Michael Jacobs, Eric Himmel, Thomas Neurath and Juan Carlos Luna Briñardelli for their valuable advice and their confidence in this project.

Roberto Koch

FOREWORD

A 'curious, sublime discovery': this was how photography was described in 1825 by Claude Niépce, the brother of the celebrated Nicéphore Niépce who invented the process itself. The experiments of those early years had already begun to demonstrate the amazing new visual possibilities of the medium, this product of technology and ingenuity which would go on to expand in unexpected and unprecedented ways. In comparison with other innovations of its day, photography seemed to possess unique advantages in terms of its ease of use and its relatively modest costs. Its ability to adapt quickly to the demands of a broad public soon led to its recognition as a very democratic way of representing the world and assured its widespread and longlasting success.

Between those early experiments and the present day, photography has changed in almost every aspect – technique, equipment, materials and more – but over its more than 170 years of existence it has continued to draw on a fascinating ambivalence that is inherent in its very essence; on the one hand, it is able to bear witness and act as a faithful record, and on the other, it has great potential as a means of self-expression, capturing different states of mind, needs and drives, both personal and collective.

To celebrate these many decades of experimentation and innovation, we now present a single collection that attempts the almost impossible task of encapsulating the history of photography. This is a visual bazaar, a multifaceted assortment of events, objects, landscapes and faces both famous and unknown, all connected to each other by a single, subtle thread, that of the ambiguity of images, the fact that they are what the American photographer Diane Arbus called 'a secret about a secret', capable of holding so many possible meanings to those who chance across them.

This book brings together two hundred and fifty great photographs, a representative selection of work from some of the greatest photographers of all time. Every one is reproduced as faithfully as possible, and accompanied by an explanatory text and a brief biography of its creator. Many are renowned images that have become true icons of our time, their shapes and colours already imprinted on our collective memories. Their reproduction here is a

confirmation of their status, allowing their innate truth to be appreciated once again. Others are lesser known, but worthy of discovery and containing unexpected pleasures and insights for those who seek them.

To give an overarching structure to the collection, the photographs have been divided into twelve categories, which intertwine and overlap to a certain extent. The chosen themes are portraits, reportage, still life, war, art photography, fashion, nudes, women, nature, travel, sport, and cities, which studies and explores the urban habitat in which we live.

All these photographs – from the earliest days of the medium to the work of the most innovative contemporary photographers – deserve their place in this anthology, and piece by piece, they make up the fascinating and enigmatic jigsaw that is the history of photography.

Roberto Koch

ERNESTO BAZAN

'In Cuba I rediscovered my lost childhood, fell in love, became a father and developed as a photographer... I spent fourteen intense years of my life there, as a "Cuban", with my family and friends, simple, wise people who worked on the land.' For the Sicilian photographer Ernesto Bazan, Cuba was much more than a photography project. It was a life-changing place with which he shared a close bond. Bazan first set foot in Cuba in 1992 during the most difficult era in the island's history, dubbed 'el periodo especial', 'the Special Period': an era ushered in by Fidel Castro in a 1989 speech when he famously called on his people to 'tighten their belts'. This was a time of severe economic crisis brought on by the collapse of the Soviet Union and exacerbated by the US embargo. Bazan wandered through the streets of Havana documenting the empty stores, the endless queues of people, and the desperate struggle to survive in the face of an uncertain future. Yet the indomitable spirit of the people shone through the hardship, and they never lost their ability to smile or to enjoy life. 'I tried to capture their dignity, their joyfulness, their love of life and of their children, their passion for music and dance, their strong sense of patriotism, their commitment to a public health care and education system, their religious fervour,' says Bazan. In 1992 he decided to move to Cuba, and would share the next fourteen years with a people who, while 'tightening their belts', managed to find an inner strength that was infectious. Bazan's photographs are the diary of those years. Like the pieces of a monumental mosaic, they portray a country undergoing profound change, and tell the story of an island's fight to maintain its social-ist identity in a post-Communist world. Bazan wanted to present a candid, 'unsanitized' view of the Cuban people, without imposing a particular ide-ology: 'Cuba's reality is made up of extremes. The quality of life is raw from all points of view, both positive and negative.'

'El periodo especial'
('The Special Period'),
Cuba

© *Ernesto Bazan*

BORN IN PALERMO in 1959, Ernesto Bazan moved to New York in 1979 to study photography. In 1982 he won first prize in the young photographers' category at the Rencontres d'Arles International Photography Festival and was invited to join Magnum. In 1983 he travelled to Asia on a study grant awarded by *Paris Match*. He worked as a freelancer for American and European titles, and in 1982 published *Il passato perpetuo*, a project on New York's Italian-American community. In 1993 he brought out *Passing Through*. In 1992 he joined Contrasto and began a project on Cuba, which won first prize in the Daily Life category of the 1996 World Press Photo contest, the Mother Jones Award, and (in 1998) the prestigious W. Eugene Smith Award. He divides his time between Mexico and New York.

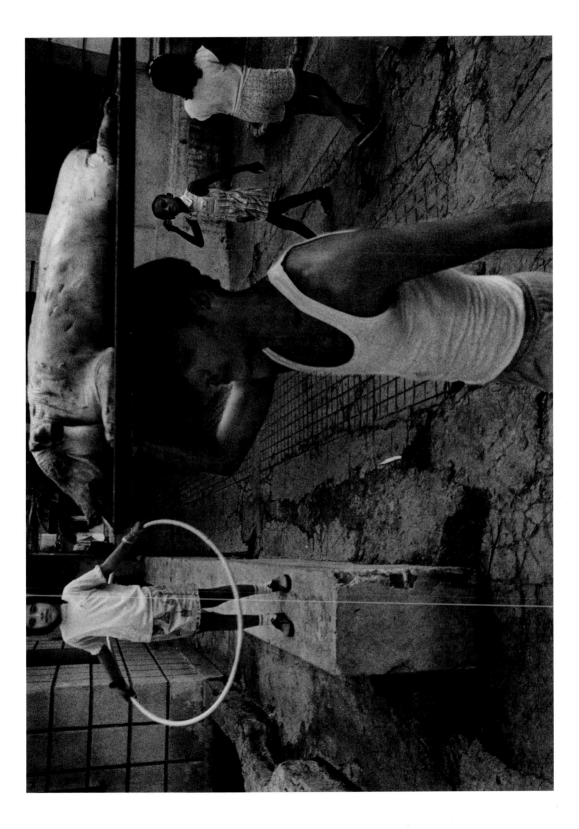

JONAS BENDIKSEN

'I love working on stories that get left behind in the race for the daily head-lines – journalistic orphans. Often, the most worthwhile and convincing images tend to lurk within the hidden, oblique stories that fly just below the radar.' The twenty-six-year-old Norwegian photographer Jonas Bendiksen, a member of Magnum, spent four years travelling through the fringe countries of the former Soviet Union, tracing its lost borders. In a journey that covered Eastern Europe, Central Asia, the Caucasus and Siberia, he visited little-known areas such as Transnistria, Abkhazia, Nagorno-Karabakh, the Fergana Valley and the Jewish Autonomous Oblast. His photographs explore scenes of everyday human life, scattered across now-deserted geographical zones just like the carcasses of crashed spaceships lie scattered across the land. One of the busiest launch facilities in the world is located in Kazakhstan, writes Bendiksen in the text accompanying the images in his book *Satellites*, and it is cheaper to launch satellites from there than from anywhere else: 'More than four decades of space exploration, encompassing hundreds of rocket launches, have turned the area between the Baikonur Cosmodrome and southeastern Siberia into one big junkyard for thousands of tons of space debris.' The government has done little to clean up the zone, and the remains – including those of Sputnik – have been lying there for years in the exact spot where they fell. Bendiksen spent many nights with the space junk collectors who try to eke out a living by recovering and selling the fragments of titanium- and aluminium-rich metal alloy. His lens captures the confusion, desolation, nostalgia and beauty of those places. In his photographs, these futuristic ruins – remnants of a twisted dream – reveal themselves in all their surreal uselessness, evoking scenes straight out of a sci-fi novel, both alluring and menacing.

Villagers collecting scrap from a crashed spacecraft, surrounded by thousands of white butterflies, Altai Territory, Russia, 2000

© Jonas Bendiksen/ Magnum Photos

JONAS BENDIKSEN was born in Norway in 1977. At the age of nineteen he interned at the Magnum London office and subsequently joined the prestigious agency in 2004. For a number of years he worked as a freelance photojournalist in the former Soviet Union, winning a World Press Photo Award in 2005. The following year he published a book, *Satellites*, which has been translated into several languages. Over the past few years Bendiksen has been shooting a project on urban slums around the world, with the help of a grant from the Alicia Patterson Foundation.

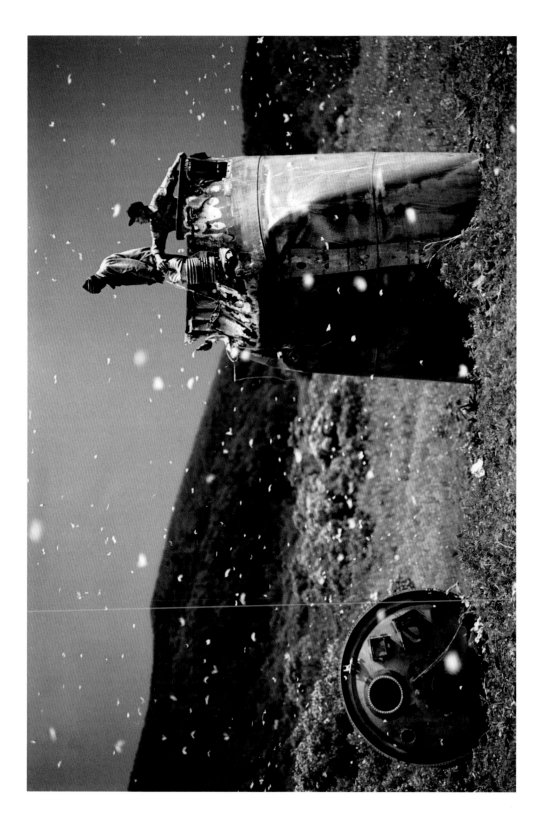

PIERGIORGIO BRANZI

In 1953 Piergiorgio Branzi attended an Henri Cartier-Bresson exhibition in Florence. Awestruck, he immediately rushed out and bought himself a camera. Branzi's work was a reflection of his times: this was the era of neorealist film and literature, an era of far-reaching political and social change which compelled him to hold a magnifying glass to his country, to tell its story as a means of 'contributing a body of evidence to the collective memory'. In 1955 he set off on a Moto Guzzi motorbike with a friend to discover the South: a mysterious, pagan, archaic land which the cinema had only just begun to explore. He continued to travel, first to the depressed areas of Italy's Veneto region, and then on to Andalusia in Spain, and Greece. During his journeys he focused on humans and their environment in an attempt to understand 'their problems, their struggle to survive, capturing their everyday lives before they become so overwhelmed by desperation and the need to cry out in agony that all truth is lost'. Branzi's calm, contemplative style is very different from traditional news photojournalism or indeed formalist photography. He does not shoot reportage stories, rather collections of single images: fragments or snapshots which have a timeless quality because they focus on the misery and enigma of raw human existence rather than the news of the day. Branzi's photography is dominated by the human form, set within rigorously executed compositions which might feature a door or window frame, a perspective grid, or simply a puddle reflecting the strange, motionless silhouette of a little boy carrying a clock on his shoulders. The time told by the clock is arbitrary, suspended; and time becomes indefinable, creating an atmosphere verging on the surreal, where confusion and alienation reign.

Boy with a clock, Comacchio, 1956

© Piergiorgio Branzi

BORN IN FLORENCE in 1928, Piergiorgio Branzi started reading law at university but interrupted his studies to concentrate on photography and journalism. He went on to work on Italy's first illustrated weekly reviews, including the cultural and political publication *Il Mondo* (founded and edited by Mario Pannunzio). In 1962 he joined the Italian national broadcasting company RAI and two years later he was sent to Moscow by Enzo Biagi, the head of television news programming. During his years as a broadcast journalist Branzi continued to take photographs, and in 1995 he picked up his Leica once more when he was invited to participate in Italo Zannier's group photographic project 'Itinerari Pasoliniani'. In 1997 he published a book in collaboration with FIAF and Alinari, followed by a monograph in 2003 edited by Paolo Morello and Sandra Phillips. His work was exhibited in the 2006 show 'Incanti e altri ritratti', held at the FORMA International Centre for Photography in Milan.

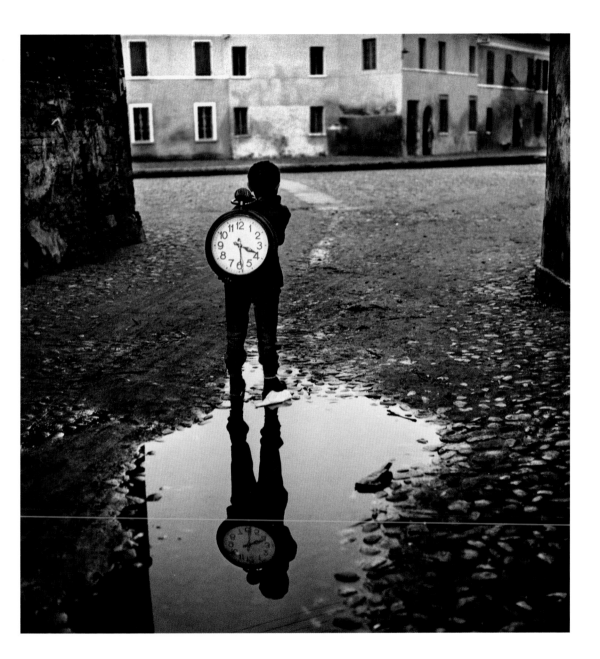

BRASSAÏ

'The night suggests, it does not show. The night disquiets and surprises us with its otherness; it releases forces within us which by day are dominated by reason.' Brassaï arrived in Paris from Hungary in 1924 and immersed himself in the life of the city. Like an embodiment of the *flâneur*, the urban wanderer described by Baudelaire and discussed by Walter Benjamin, who follows the flow of the crowds and lets himself be carried along, he found his way into the veins of the city, armed only with his camera. He was not trying to create a single vision to explain all aspects of life, nor to reveal a guiding thread that would lead through the labyrinth of the modern world, nor to predict the future; he sought only fragments of human experience, modernity and the fleeting nature of the present. He loved Paris by night, its rainsoaked pavements, its imposing doorways, its bridges, the timeless streets of the old quarters. It was there that he documented the secret lives of prostitutes and homosexuals, opium addicts and tramps. The city that Benjamin called the 'capital of the 19th century' gave up all its mysteries to this *flâneur*. Brassaï wandered with no specific aim but the search itself. What he loved was reality. The night became his accomplice and he experimented with different ways of capturing it in his photographs. He didn't shoot secretly from the shadows, since he needed to set up a tripod and use a flash, but he nonetheless managed to capture all the atmosphere of the evening light. His framing and compositions were precise. Light outlines the subject, which is often located at the edge of the image to accentuate the dynamics of the lines. A man and a woman kiss at a table in a small café: a large portion of the scene is dominated by deep black shadows, from which emerge a few objects and the couple themselves, pressed into a corner where the lines of the image meet, surrounded by their own reflections in the mirrors on the wall. As Henry Miller wrote in his essay 'The Eye of Paris', the photographer's way of living became in the end a way of being: 'For Brassaï is an eye, a living eye.'

Lovers in a café, Place d'Italie, Paris, 1932

GYULA HALÁSZ, known as Brassaï, was born in Brasov in Hungary (now Romania) in 1899. He studied art in Budapest and went to Berlin in the early 1920s. In 1924 he moved to Paris, where he met Atget and Kertész and became interested in photography. He took his first photos in 1929, and in 1933 he published *Paris de nuit* (later English edition: *Paris After Dark*). In 1937 he began working for *Harper's Bazaar*, taking portraits of great artists. This collaboration came to an end in the early 1960s when Brassaï gave up photography. In 1956 his film *Tant qu'il y aura des bêtes* won an award at the Cannes Film Festival. In 1978 he was awarded the Grand Prix National de la Photographie in Paris. He died in Beaulieu-sur-Mer in 1984. In 2000 the Centre Georges Pompidou in Paris held a major retrospective of his work.

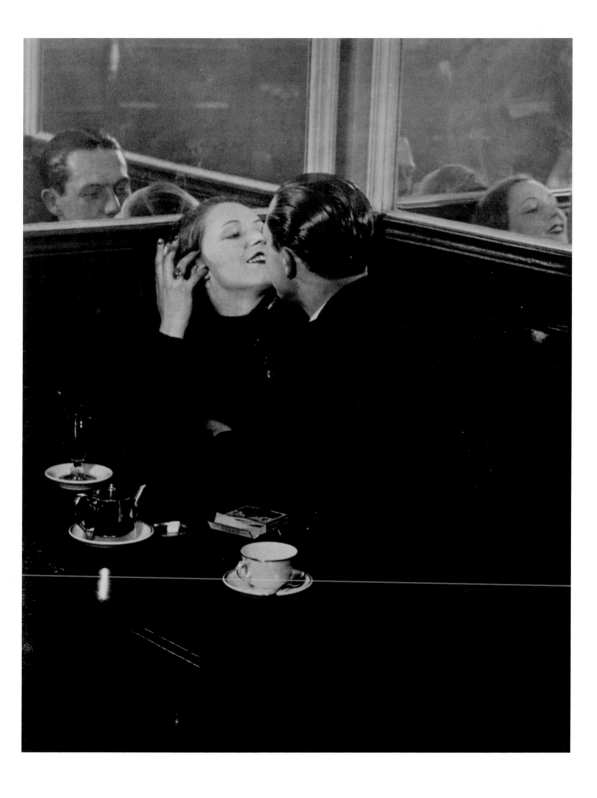

ROBERT CAPA

This is one of the most controversial photographs in the history of photography; it is also one of the most important images of the twentieth century. In August 1936 the twenty-two-year-old Robert Capa set off for Spain to report on the Spanish Civil War, the bloody conflict described by Hemingway as passionate and passion-inspiring for the fervour with which the people fought to defend their freedom and gain independence from the totalitarian regime. Capa, ever passionate, inevitably followed suit: he took a militant stance and engaged in the war, joining ranks with the Republican soldiers to document, more eloquently than anyone else, the bravery of the fighters and the hardships endured by the civilian population. It was during a Loyalist offensive at Cerro Muriano on the Cordoba front that he took his most famous photograph, capturing the precise moment in which a militiaman was fatally wounded by a bullet. The image, first published on 23 September 1936 by the French weekly *VU* and subsequently reproduced in *Life* magazine, caused a huge stir and became one of the most iconic pictures of the twentieth century. At the same time controversy raged over the photo's authenticity, and Capa was accused of setting up the shot. The question was eventually resolved when a succession of in-depth investigations, conducted primarily by Capa's biographer Richard Whelan, finally identified the name of the dead militiaman. The photograph instantly entered the collective consciousness, fusing documentary evidence with universal metaphor by transforming a historic moment into a tragic symbol of the battle for democracy. John Steinbeck wrote of Robert Capa: 'He knew … that you cannot photograph war because it is largely an emotion. But he did photograph that emotion by shooting beside it. He could show the horror of a whole people in the face of a child. His camera caught and held emotion… His pictures are not accidents.'

Death of a Loyalist militiaman (Federico Borrell García), or 'The Falling Soldier', Cerro Muriano, Cordoba front, 5 September 1936

© Robert Capa/ Magnum Photos

BORN ANDRE ERNO FRIEDMANN in Hungary in 1913, Robert Capa later became a US citizen. He shot to international fame with his photographs of the Spanish Civil War, and went on to report on the Second World War for *Collier's* and *Life* magazines. In 1947 he founded Magnum Photos with Henri Cartier-Bresson, David 'Chim' Seymour and George Rodger. A photojournalist, war correspondent, celebrity portraitist and Magnum leading light, Robert Capa lived fast and took some of the seminal images of the twentieth century. He was accidentally killed by a landmine in Vietnam in 1954.

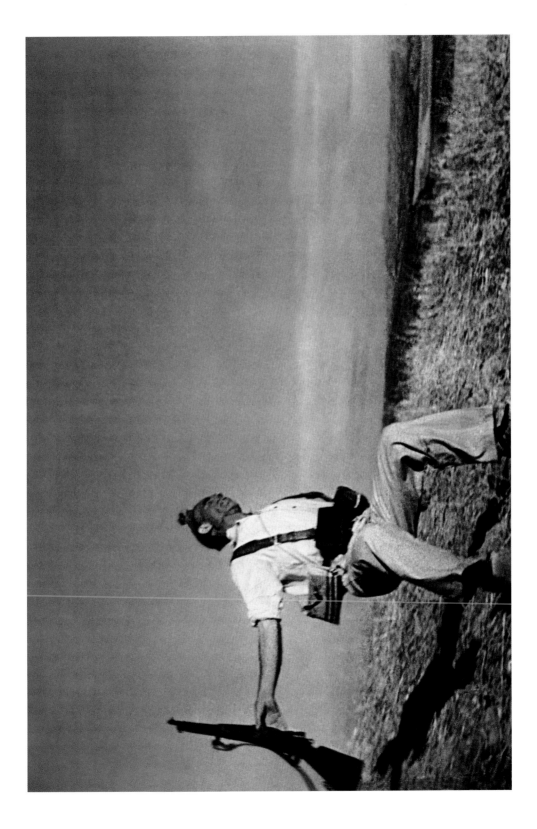

GILLES CARON

'He loved life and lived at a hundred miles per hour, almost as if he knew that he did not have much time. He was the best reportage photographer of that period, 1967–70: he was quick, and always in the best position. He always knew what he was photographing and that's the best thing you can say about a photojournalist.' This is how photographer Raymond Depardon eulogized Gilles Caron, a unique figure in contemporary photography. He burned briefly but brightly, and lived through years so intense that they seemed to last a whole century. Although Caron was not yet thirty-one when he died in Cambodia in 1970, he had already experienced and reported on the conflicts in Chad, Ireland, Biafra and Vietnam, and had produced a series of iconic images that would be forever seared into the collective memory. On 6 May 1968 Caron was in Paris, having just returned from Biafra. In Place de la Sorbonne, a line of riot police in helmets was facing a line of students. All it took was a sudden look, a quick glance, and Caron had his shot: he had captured the wry smile of Daniel Cohn-Bendit, one of the leaders of the student movement. It's the smile – the image, even – of a whole generation, a generation of confident young people who were happy to be alive, who challenged authority in their joyfully irreverent way, playful more than violent; the same generation who went down into the streets of Paris and scrawled 'Il est interdit d'interdire' – 'Forbidding is forbidden' – on the city walls, asserting their right to freedom of expression and questioning the mentality of an entire society. Caron's images became a part of the 1968 student uprising. He was everywhere and shot everything: the first stone to be hurled, the nights of barricades, the flying truncheons, the burning cars, the peaceful protests. The photograph of Daniel Cohn-Bendit became a symbol of defiance in the face of authority.

Daniel Cohn-Bendit in front of the Sorbonne, Paris, May 1968

© Gilles Caron/Contact Press Images/Grazia Neri

GILLES CARON was born in 1939 in Neuilly, near Paris. He spent his military service in Algeria in the parachute regiment, serving two months of detention for his opposition to the war. When he returned to Paris he became interested in photography and started working for the APIS agency. In 1967 he was one of the founding members of the Gamma agency. He covered the Six-Day War in Israel, the Vietnam War, the Biafran conflict, the May 1968 student uprisings in Paris, the troubles in Northern Ireland, the anti-Soviet demonstrations in Prague and the 1970 insurrection in Chad. That same year he left for Cambodia, and on 5 April, just a few months before his thirty-first birthday, he disappeared on the road from Phnom Penh to Saigon, a zone controlled by the Khmer Rouge. He was never seen again.

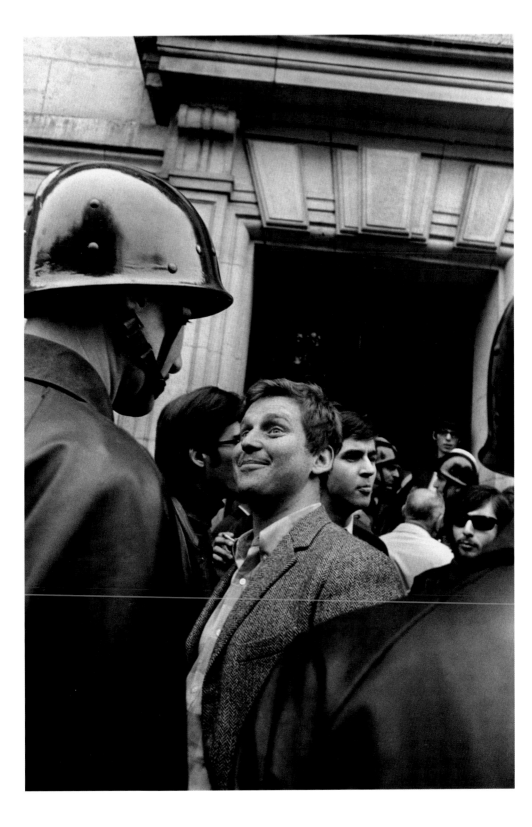

HENRI CARTIER-BRESSON

Collectively, Henri Cartier-Bresson's images form a picture album of his own life and of the twentieth century. More than any other photographer, he was the 'eye of the century', and his unique vision changed the way we view reality and the photographic medium. Intelligent and instinctive, throughout his life Cartier-Bresson had a knack of being in the right place at the right time, enabling him to record some of history's most pivotal moments, including the death of Gandhi in India, the triumph of Mao in China, and the era of Khrushchev in Russia. But Cartier-Bresson had an even more remarkable talent for recording the everyday lives of ordinary people. His photograph of overweight, round-shouldered French Popular Front workers quietly contemplating the water's edge during a trip to the countryside calls to mind their battle to obtain paid holidays, a huge leap forward in human rights, and evokes the changing habits and attitudes of Western society. The image, shot in 1938 on a Leica, is also a visual homage to Renoir, and says much about the artistic journey of Cartier-Bresson, a photographer-artist with a passion for painting and a Surrealist sensibility who chose to document the lives of his contemporaries with photographic realism. It is a great example of Cartier-Bresson's 'decisive moment', a belief that photographers should catch life by surprise, and that their images should reflect this sense of the world being 'caught in the act' through the composition of forms loaded with meaning: 'To me, photography is the simultaneous recognition, in a fraction of a second, of the significance of an event as well as of a precise organization of forms which give that event its proper expression... For me photography is to place head, heart and eye along the same line of sight.'

Sunday on the banks of the River Marne, France, 1938

© Henri Cartier-Bresson/ Magnum Photos

HENRI CARTIER-BRESSON was born in 1908 in France. After high school he developed an interest in Surrealism and studied painting under André Lhote. In 1930 he travelled to the Ivory Coast, and started taking photographs on his return. In 1934 he spent a year in Mexico, and the following year went to the USA, where he learned about motion picture photography from Paul Strand. From 1936 to 1939 he was back in France, working as an assistant to Jean Renoir. In 1940 he was captured as a prisoner of war by the Germans, but escaped in 1943 to join the Resistance. In 1947 he returned to the USA for the 'posthumous' exhibition that MoMA had dedicated to him, believing him to be dead. He was one of the founders of Magnum in 1947, and subsequently journeyed to India, China and Indonesia. In 1954 he became the first photographer to be admitted to the USSR, and continued to travel, taking in China, Cuba, Mexico, Canada and Japan. From 1974 onwards he devoted himself to drawing. In 2003 he set up the Fondation Henri Cartier-Bresson with his wife and daughter. He died in 2004.

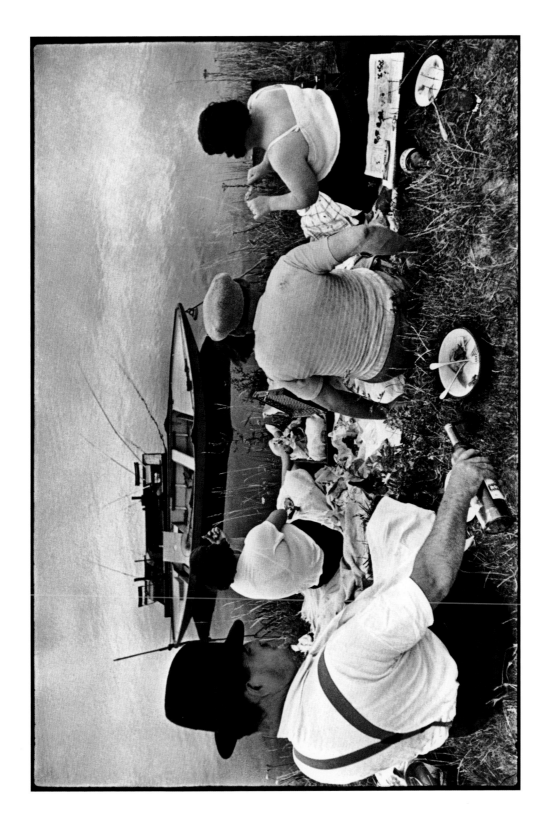

LORENZO CICCONI MASSI

A journey around your own homeland can take a very long time and, more importantly, be very surprising. You might stop to look at a landscape that you thought you knew well only to be astonished at how different it appears, to see it in a blinding new light, perhaps make out a contour outlined against the sunlight that you had never noticed before. You might get lost while chasing after the dreams and images of a childhood you've left behind, while trying to retrace your steps or simply attempting to tell the never-ending story of those dear to you, glimpsed in the lines of a hand or the wrinkles of a face that you love. Lorenzo Cicconi Massi has made this long journey. For him, home is a stretch of the Italian Adriatic coastline that is not quite northern and not quite southern Italy: a town called Senigallia which looks out over the sea and is itself overlooked by the unique mountainous landscape of the Marche region, rising up on the horizon like a theatrical backdrop. While wandering through this all too familiar land, Cicconi Massi often stopped to observe young people and their adolescent rites of passage, captured at an age when they have yet to become cynical, but when they are no longer entirely carefree. The photographer managed to record the fleeting anxieties which cast faint shadows across their faces, shadows set to darken in time. He followed their gazes and lingered delicately over their immature, beautiful bodies, intertwined yet ready to separate in an instant and float away from each other forever. Cicconi Massi's work on young people was recently exhibited in the group show 'Eurogeneration' alongside a poem by the young British poet Alice Oswald which sums it up perfectly: 'into the five-inch space between heaven and heaven / he's skimming a stone it's just the smack of it / contacting water, the amazing length / of light keeps lifting up his slid-down strength.'

Eighteen-year-old students, Senigallia, Italy, 2003

© Lorenzo Cicconi Massi/Contrasto

BORN IN SENIGALLIA, Italy, in 1966, Lorenzo Cicconi Massi graduated in sociology with a thesis on the photographer Mario Giacomelli and started working in black-and-white photography. His pictures have won numerous awards, including first prize in the 1999 Canon Photography Competition, and have also appeared in a number of leading Italian publications. Cicconi Massi has been the subject of two solo exhibitions in Germany, at the Treffpunkt Galerie in Stuttgart and at the Stadthaus in Ulm. In 2006 several of his prints were acquired by the FORMA Collection in Milan. In 2007 he won a World Press Photo Award in the Sports Features Singles category, and the G.R.I.N. prize. That same year he mounted the exhibition 'Viaggio intorno a casa', which premiered in Senigallia and was subsequently shown at FORMA in Milan; he also made his directorial debut with the film *Prova a volare*.

ANTOINE D'AGATA

The border in question is not a geographical entity. It is merely hypothetical, a line on a map separating two countries from each other, both physically and spiritually: Mexico from America, poverty from wealth. The border envisioned by the intense and instinctive photographer Antoine D'Agata, one of Magnum's most exciting new talents, is painfully 'interior'. The work was inspired by the tragic mugshots which for years have been a regular feature in the news. The figures lined up in this compendium of despair and hopelessness are symbols of all the men and women who have tried, and keep trying, to enter the United States clandestinely from the Mexican border every single day. Some make it, but many fall foul of the police nets and the merciless lenses of surveillance cameras. By reproducing the images in this way, D'Agata transforms them into a kind of ex-voto on a wall, votive offerings to a divinity for miracles as yet not worked. Nobody knows what happened to these bodies with no name. They are probably living on the borders of 'no man's land', a place the photographer himself, who has no fixed address, holds especially dear. D'Agata is interested in producing work that is unfettered and that flouts middle-class mores and conventions; he forces himself to look at intimate, even erotic images, when others might prefer to shut their eyes. But this does not make him a voyeur: it is almost as if he were somehow using his work to come to terms with his own vagabond existence. The borders of his images are therefore vague, blurred and out of focus, and it is unclear whether this is an aesthetic choice, an emotive choice, a concession to modesty, or all three. These imprecise, dimly lit images conceal and reveal Antoine D'Agata's sublimated anger. The cruel act by which the figures are immortalized with harsh flash photography is another story; the atrocious reality of those who cannot cross any borders.

La frontera/the border, mugshots, Mexico, 1999

© *Antoine D'Agata/ Magnum Photos*

ANTOINE D'AGATA was born in Marseilles in 1961. In 1983 he left France and remained abroad for the next ten years. In 1990, while living in New York, he became interested in photography and took courses at the International Center of Photography, where his teachers included Larry Clark and Nan Goldin. From 1991 to 1992 he worked in the editorial department at Magnum. After returning to France in 1993 he took a four-year break from photography. In 1998 he published two books, *De mala muerte* and *Mala noche*, and the following year he joined the VU agency. In 2001 he published *Hometown* and won the Niépce Prize for young photographers. More books followed: *Vortex* (2003), *Insomnia* (2003), *Stigma* (2004) and *Manifeste* (2005). In 2004 D'Agata shot his first short film, *Le Ventre du monde*, which he followed up in 2006 with a feature film, *Aka Ana*, shot in Tokyo. He became a full member of Magnum in 2008.

BRUCE DAVIDSON

It was the summer of 1959, and Bruce Davidson was a young twenty-five-year-old photographer looking for a story to tell. But it couldn't be just any story. He needed to find a subject that he could immerse himself in completely, something that not only fascinated him, but struck a deep personal chord. 'At the time there were an estimated thousand gang members in New York City,' Davidson recounted. Tensions were rising and a committee was formed to stop the violence. One gang in Brooklyn, 'The Jokers', made the front page of the newspapers and Davidson contacted them via the committee. They let him go with them to Coney Island, where they usually spent the night drinking beer under the boardwalks. In the morning they all started dancing on the wooden boards. Before catching the bus back home, one girl stopped to fix her hair in the mirror of a cigarette machine. It was a moment of calm after the rowdy night outdoors. Davidson, who was little older than the teenagers in the group, held his Leica steady and captured the instant. He carried on following them for months, documenting their world of drunken nights, days in the street, love, friendship, violence and tenderness. There was a powerful, vital energy about them that bordered on self-destruction. Years later, Davidson went back to Brooklyn and found the girl in the photo. She had married the leader of the gang and had a fifteen-year-old daughter, the same age she had been when Davidson photographed her.

Brooklyn gang, Coney Island, New York City, 1959

© Bruce Davidson/ Magnum Photos

BORN IN 1933, Bruce Davidson started taking pictures at an early age. In 1957 he began working as a freelance photographer for *Life* magazine, and two years later he became a full member of Magnum. He has reported on the Civil Rights Movement in America and documented daily life in a housing block in New York's East Harlem – the famous series 'East 100th Street' which was exhibited at MoMA in 1970. Other projects have focused on the New York subway (1980) and New York's Central Park (1991–95). His book *Brooklyn Gang* features the work he shot in 1959 on young members of the Brooklyn gang called 'The Jokers'. He currently lives in New York.

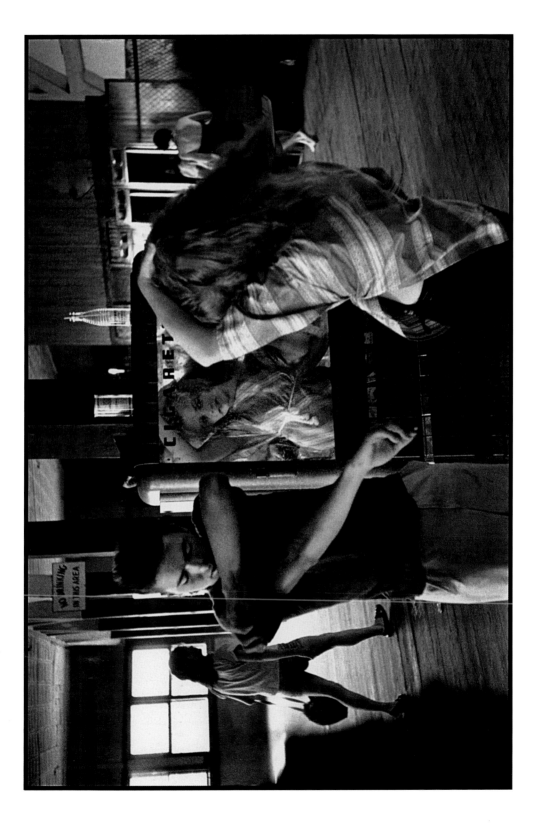

JESSICA DIMMOCK

The place: No. 4 West 22nd Street, an elegant apartment block facing the Flatiron building in Manhattan, New York. The date: some time in autumn 2004. The lift opens on to the ninth floor and a large three-bedroom apartment which was once valued at millions of dollars. But inside it's dark and it smells disgusting. In one of the bedrooms, four or five people are sitting around on piles of dirty clothes and broken furniture. The floor is covered with rubbish. This is where the story of these photographs began, says Jessica Dimmock. Three days earlier she had met an oddball cocaine dealer called Jim Diamond on the streets of Manhattan who asked her to photograph him. Intrigued, Dimmock followed him on a frenetic night's journey into Manhattan's seamy underworld. On their third meeting Diamond let her into the apartment and opened her eyes to a whole new universe, which would become an all-consuming obsession, day and night, for the next eight months. The apartment was being rented by Joe Smith, a sixty-eight-year-old who had once been a player on the New York art scene before becoming a junkie. To pay the bills he had sub-let one of his rooms to a young hustler, and from then on the apartment had been filled with addicts – at least thirty during the eight months that Dimmock spent photographing her story. Joe would get the others to help him shoot up in exchange for staying there, since he had become too weak to do it himself. The place was permeated by a sickly silence, interrupted from time to time by the odd angry outburst. Its inhabitants would stare vacantly into space, plunged in a perpetual night-time darkness that the light of day could not penetrate. In Dimmock's pictures, nothing is out of bounds: sex, violence, alienation and desperation, self-disgust and powerlessness are all captured on her Leica. She would continue to follow them after their eviction from the apartment, until she realized that she had become too intimately involved. You have to maintain a certain distance from your subjects to photograph them, something that's difficult to do if you care about them.

Jesse and Mike in the room of a rent-controlled apartment building, New York, 2006

© Jessica Dimmock/VII

JESSICA DIMMOCK was born in New York in 1978, and graduated from the International Center of Photography in documentary photography and photojournalism. Her visceral final year project documented the lives of a group of drug addicts living in a New York apartment, for which she won the F Prize for social documentary photography and the Inge Morath Award from Magnum. In 2007 the series of photographs was published as a book, *The Ninth Floor*. Dimmock's images have appeared in numerous publications, including *Aperture*, the *New York Times Magazine*, *Fortune*, *Newsweek* and *Time*.

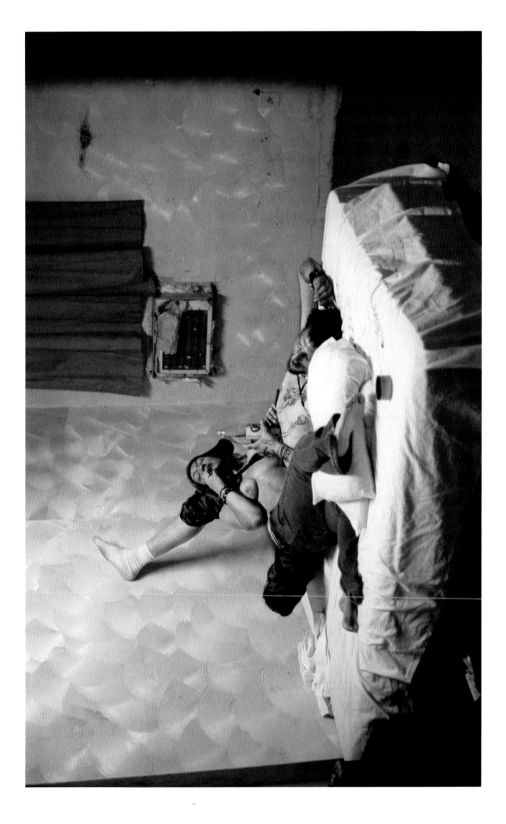

ROBERT DOISNEAU

Robert Doisneau never photographed 'big' events. He photographed the simple ebb and flow of the city, its squares and street life. He was born in Gentilly, in the southern Parisian suburbs, and it was back to the suburbs that he would continually direct his Rolleiflex camera and mildly ironic gaze, because (as he explained), 'what I was trying to show was a world in which I would have been happy, where people would have been kind to each other, where I would have found the tenderness I longed to be shown. My photos were proof that this world could exist.' And so the protagonists of his pictures are children, lovers, labourers wearing dirty, torn clothes and proud expressions. Doisneau the photographer was a 'free' agent: free to move around his city and evoke the romance of the streets, free to record the daily life of a society on the margins, free from the constraints of working for the press, free to shun sensationalism in favour of simplicity: 'sensational-ism is often an admission of one's inability to see'. Doisneau's friend Jacques Prévert told an interesting anecdote about the photographer: one day he was following a flock of sheep when a truck suddenly ran over some of the sheep and dogs. Rather than start taking pictures, Doisneau went to comfort the shepherd. 'In a world where the mass media has so much power and control,' he commented, 'I think photography could prove to be the medium through which we can rediscover simple emotions, in much the same way that horse riding or sailing helps us to rediscover the primitive sensations which have long since been buried.' Doisneau reflected ordinary life and its ups and downs, a life that was largely carefree, curious, sometimes bizarre, but often quite boring. Yet every so often he would find something unexpected around the corner, something to prick our emotions and remind us of the wonder of everyday life.

Children in Place Hébert, Paris, 1957

© *Robert Doisneau/ RAPHO/EYEDEA*

BORN IN PARIS in 1912, Robert Doisneau studied lithography and from 1929 dedicated himself to photography. His first job was as an advertising and industrial photographer at the Boulogne-Billancourt Renault factory. He left in 1939 to go freelance, working for the RAPHO agency until war broke out. He fought in the French army until 1940, when he joined the Resistance. From 1949 to 1951 he photographed for *Vogue* magazine. In 1951 his work was exhibited in a group show held at MoMA in New York. His favourite subject was the city of Paris, and some of his most famous shots include the series on the city's suburbs (published in the book *La Banlieue de Paris*, 1948) and the iconic photograph *Kiss*. He died in 1994.

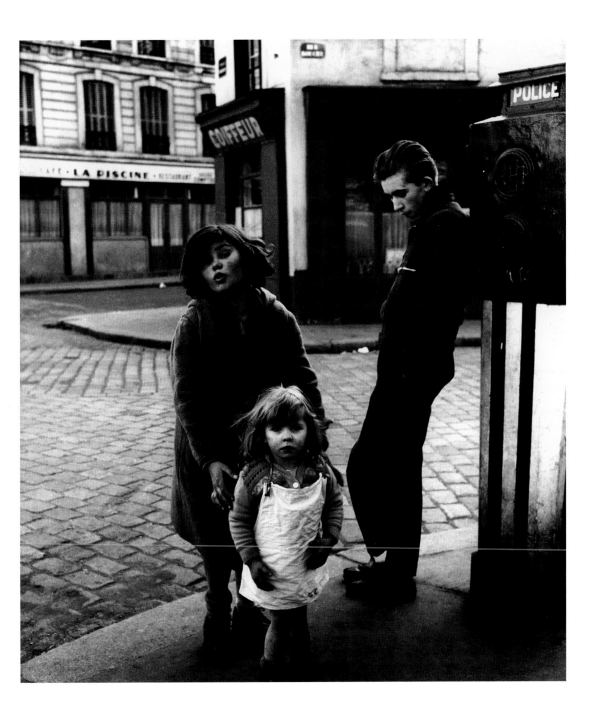

ELLIOTT ERWITT

'Elliott Erwitt writes about photography with a knowing sense of humour and a profundity that avoids pedantry,' said Henri Cartier-Bresson. Erwitt's photographs have the rare and precious quality of managing to be simple without ever being simplistic. His inimitable style is born out of an innate capacity for finding the unusual in the everyday and for translating his personal, subtle sense of irony, his wit, and his attraction to paradox, into images. For Erwitt, being a photographer means travelling the world, observing it and getting to know it, and being constantly surprised by the thousands of strange, tragic or tender ways in which life reveals itself to him and his camera lens. History for him is all about freeze-framing an instant in what he likes to call a 'snap', a quick click of the shutter. According to his philosophy, photographs 'happen', but your mind and eye must still be capable of seeing them. He is never without his camera, so when, for example, he came across this car parked by the ocean with its two smiling lovers reflected in the wing mirror, he was ready to accept this 'gift' of a shot. He took the snap and immortalized the scene, perfect for its internal dynamic and double-framed composition which gives it added meaning. As Erwitt commented, 'When photography is good, it's pretty interesting, and when it is very good, it is irrational and even magical … nothing to do with the photographer's conscious will or desire. When the photograph *happens*, it comes easily, as a gift that should not be questioned or analyzed.'

California, USA, 1955

© *Elliott Erwitt/*
Magnum Photos

ELLIOTT ERWITT was born in 1928 in Paris to Russian émigré parents. He attended primary school in Italy but in 1939 his family moved to the United States to escape Fascism. He studied film in New York, and spent his military service in Europe as an assistant photographer with the US Army Signal Corps. In 1953 he was invited to join Magnum by one of its founders, Robert Capa. Erwitt began working for some of the world's most prestigious magazines, and a year later became a full member of the agency (he would later be elected as its president twice). In 1970 he also started making films. His work has been exhibited in major museums and galleries around the world, and his photography books have become bestsellers.

ROBERT FRANK

'That crazy feeling in America when the sun is hot on the streets and music comes out of the jukebox or from a nearby funeral, that is what Robert Frank has captured in tremendous photographs taken as he traveled on the road around practically forty-eight states in an old used car.' This is how Jack Kerouac, the godfather of American 'Beat' culture, described Robert Frank's photographs in his introduction to Frank's cult book *The Americans* (1958). Born in Zurich, Switzerland, Frank had been living in the United States for just a few short years when, in 1955, he decided to change tack, take a different path, and get a breath of fresh air. With a grant from the Guggenheim Foundation he embarked on an epic two-year trip across America, passing through big cities and small communities, watching crowds and solitary passers-by, recording the statues in town squares and the wagon-loads of travellers standing motionless as if to pose, looking at him looking at them. He admired the long, straight road that dissected the continent and shone majestically in the light of the moon. Frank's photographs are achingly beautiful and so intensely poetic as to take your breath away. *The Americans* is the ultimate celebration of subjective reportage photography, presented as a series rather than as individual shots. It is also a celebration of 'everything-ness', as Kerouac put it: everything about the photographs is American and everything is equally meaningful because the photographs are a testament to the very heart of the continent, which reveals itself only through fragments and only through the wonderstruck, sensitive gaze of a foreigner. Kerouac again: 'Robert Frank, Swiss, unobtrusive, nice, with that little camera that he raises and snaps with one hand he sucked a sad poem right out of America onto film, taking rank among the tragic poets of the world. To Robert Frank I now give this message: You got eyes.'

Parade, Hoboken, New Jersey

© Robert Frank

ROBERT LOUIS FRANK was born in 1924 in Zurich, Switzerland, to a wealthy Jewish family. From 1941 to 1944 he trained as an assistant photographer to Hermann Segesser and Michael Wolgensinger. In 1947 he moved to the USA and began to shoot fashion stories for *Harper's Bazaar*. The following year he travelled to Peru, Bolivia and on to Europe as a freelance reporter. He participated in two landmark photography exhibitions, '51 American Photographers' and 'The Family of Man'. In 1955 he set off on a long journey across the USA, shooting photographs which were later published in his book *The Americans* (1958). He moved away from photography in the 1960s to concentrate on film, picking up his camera again in the mid-1970s. In 1994 he donated the majority of his work to the National Gallery of Art in Washington, DC. The gallery created the Robert Frank Collection in his honour, the first such collection to be dedicated to a living artist.

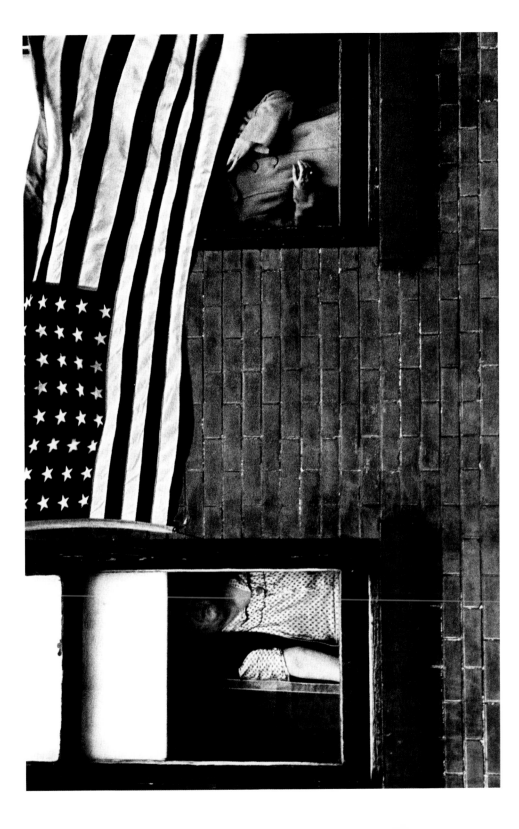

LEONARD FREED

If it is true that we photograph our own obsessions above all else (perhaps in order to understand them and exorcize them), then Leonard Freed was a master at giving a face and form, light and shade, to his personal obsessions: the childhood he spent in New York's Jewish community and his difficult relationships with family tradition and religion. In 1954 he shot a powerful series of images on Brooklyn's community of Hasidic Jews. The work was instantly recognized as special: after showing it to *Life* magazine, Freed was awarded his first contract with Magnum Photos by Cornell Capa. This image from the series depicts a group of men dancing at a Jewish wedding, while the women dance with the bride in a different room. Silent and quick, the photographer's presence goes almost unnoticed as he records an ancient tradition that is alive and well. He explores the roots of his own identity and at the same time investigates the structure and dynamics of an entire community, and the sense of belonging on which it is founded. There are twelve figures outlined against the neutral backdrop of the wall, but they appear as one continuous whole. The image relies on the repetition of an aesthetic model translated as evidence of a complex ritualism. All of the men are shot in profile except for one, who is caught facing the camera, creating a striking sense of immediacy that demands our attention.

Jewish wedding, New York, 1954

© Leonard Freed/ Magnum Photos

LEONARD FREED was born in Brooklyn in 1929 to parents of Jewish descent. At an early age he developed an interest in painting and the arts, and started taking photographs while on a trip to the Netherlands. After travelling to Europe and Africa he returned to the United States, and in 1954 studied at Alexey Brodovitch's Design Laboratory. A tough, incisive commentator on contemporary society, Freed shot important reportage stories documenting Jewish life, the post-war reconstruction of Germany, New York's African-American community and the New York Police Department. He became a member of Magnum in 1972. He died in 2006, and the following year the Musée de l'Elysée in Lausanne dedicated a major retrospective exhibition to him, which was accompanied by a comprehensive catalogue of his work.

MAURO GALLIGANI

This photograph was taken when St Petersburg was still called Leningrad, two years before the fall of the Berlin Wall and the collapse of Communism. The Soviet Union was stagnating, but all this was about to end: just a few months later the state's big 'thaw' would commence, unleashing a powerful tidal wave that would overwhelm every institution and every level of society. Some could see it coming. But others were in denial, preferring to look away or bury their heads in the sand. Nothing epitomizes the atmosphere of that critical period leading up to the collapse – petrified, yet soon to turn incandescent; frozen, yet soon to reach boiling point – better than this image of a young girl and an elderly lady, captured in one of the rooms of the Hermitage beneath Canaletto's famous painting of *The Arrival of the French Ambassador in Venice*. The girl is the picture of sweetness in her smart lavender outfit and with her flower hair decoration, while the elderly lady sitting next to her is severe and imposing, like the sacred symbol of Mother Russia. Mauro Galligani has always followed the seismic shifts in Eastern Europe with fascination and sensitivity. In this image of contrasting female figures, he manages to evoke both Russia's past and its future, telling the tale of an entire century. On the left is a woman who, as a child, lived through war, the siege of Leningrad, hunger and poverty, and perhaps would have drawn strength and courage from the music of Shostakovich which was played through loudspeakers in the streets of the city. On the right, hovering uncertainly between a little girl's closed eyelids, is the Russia of Perestroika. And in the middle, as if ready and waiting to spring to the defence of the past and ensure its survival, is one of the artworks belonging to the largest painting collection in the world. And maybe, as an adult, the little girl on the red couch has already brought her own daughter to look at these masterpieces and has taken comfort in the fact that amid the violent upheaval of the 'thaw', something beautiful remained intact.

Leningrad, 1987

© *Mauro Galligani/ Contrasto*

MAURO GALLIGANI was born in Farnetella, Siena. He studied at the School of Cinematography in Rome – an experience that informed his reportage photography, which has a cinematic quality. He joined the Agenzia Italia press agency and in 1964 started working on the daily newspaper *Il Giorno*. In 1971 he moved to the Mondadori publishing house, then from 1975 to 1997 he was the picture editor at the newspaper *Epoca*. He has also worked for *Life* magazine and is now a freelancer. Throughout his career he has covered major national and international news stories. His books include *Uno sguardo discreto*, *Tempi dell'Est* and *San Patrignano. Gente per male*.

CRISTINA GARCÍA RODERO

Spirits: you cannot see them, but they are there. The sacred, its tangible presence on Earth, and its spectacular eruption into the daily lives of human beings, has always been at the core of Cristina García Rodero's superb body of work. In the 1970s she began to document traditional Spanish festivals and baroque Catholic celebrations, which had their roots both in a recent sacred past and in a deeper, more distant pagan history. For years she followed the strange processions of self-flagellating men, masked people, miniature brides, worshippers bearing crosses on their shoulders pointed to the sky, and those terrifying little white biers carrying living children lying in state in order to cheat death. Her research on syncretic religious practices then began to take her further afield. Haiti was an obvious choice, with its voodoo traditions which open the doors on to realities, images and rituals with enormous emotional impact. Voodoo means 'spirit', but its origins are founded on a deep divide, not only between life and death, but between two identities, two different worlds and two different human fates: freedom and enslavement. In the eighteenth century merchants transported thousands of African slaves to the French island colony to work on the plantations, forcing them to convert to Christianity. But their own traditions survived and fused with the new religion, hiding within its rites and rituals. In the picture, a man carries a sacrificial animal in a river of mud. It might be a lamb, a traditional Christian symbol. But it is to another deity, not the Christian God, that the sacrifice is being offered. The muddy water does not represent the biblical River Jordan, but the ocean separating him from his homeland; and the salvation he invokes is altogether different from the salvation promised by the Christian heaven and its angels.

Plaine du Nord, Haiti, 2001

© Cristina García Rodero/ Magnum Photos

CRISTINA GARCÍA RODERO was born in 1949 in Puertollano, Spain, and started taking photographs at the age of twelve. She read history of art at university and went on to become a teacher. For several years she documented popular traditional festivals – religious and pagan – in Spain and Mediterranean Europe. The project culminated in her book, *España oculta*, which won the Book of the Year Award at the 1989 Rencontres d'Arles International Photography Festival. That same year, García Rodero also won the W. Eugene Smith Award. More recently she has broadened her area of research to other cultures and traditions, travelling across Haiti for four years to photograph voodoo rituals. These images, published in the book *Rituales en Haiti*, were exhibited at the 2001 Venice Biennale. In 2005 García Rodero joined Magnum. **44**

ANDRÉ KERTÉSZ

The caption is precise, indicating the place, year and even the day: the first day of January. Not just any day, but a new beginning, the spark igniting the engine of 1972. And this precision finds its graphic equivalents in Kertész's photograph, in the horizon of the sea vertically dissected by a pane of glass and in the sloping line of the balcony which subtly sets the scene off balance, reminding us that life cannot always be in perfect equilibrium. Perhaps it can be for a few moments, even for a few days, but not forever. The figure in the picture, leaning on the other side of the balcony of this hotel in Martinique like a cloud of vapour, a faint echo of some distant memory, must have been well aware of this existential truth. The identity of the figure remains a mystery. But our eyes are still drawn in and our emotions stirred. This is the magic and romance of the photographs of André Kertész, a Hungarian who emigrated first to France and then to America, and who embodies three different identities, three lines of thought which together combine to form a geometric figure, a place, a primordial area of research. Andor became André and, like everyone who has changed their name and country, he had to reinvent himself in other cities; cities that he loved more, and felt more comfortable in, but that would always be foreign. Kertész was constantly examining the arcane, fragile amalgam of urban signs that make up a city for proof of balance and harmony within human existence: first in Paris, as he walked through the city streets from Montmartre (where he instantly found a home) to the Eiffel Tower, and later in New York, as he contemplated the metropolis from his twelfth-floor apartment at No. 2, 5th Street. An eternal optimist, Kertész had an unswerving faith in the indefatigable spirit of human beings, be they artists, circus acrobats, passers-by in the street, children or flower sellers; and he captured them all in his lyrical geometries, experiencing their special moment, their special day, a new beginning. And not necessarily on 1 January.

BORN IN BUDAPEST, Hungary, in 1894, André Kertész bought his first camera in 1912 and began taking photographs of acquaintances and street scenes. In 1925 he emigrated to Paris, where he became involved in the avant-garde art movement. He also worked as a freelance photographer for several magazines, including *VU*. In 1933 he shot the famous series 'Distortions'. In 1936 he and his wife moved to New York, where he worked for *Harper's Bazaar*, *Vogue* and *Look*, all the while pursuing his personal photography projects. In 1984 he donated all his negatives and personal documents to the French state archives. He died in 1985.

JOSEF KOUDELKA

'It's common to call a photographer a *predator*... One could say that Josef's eye is *savage*, it's true, but the word is still not strong enough,' wrote Robert Delpire in the retrospective book *Koudelka* (2006). Certain images by Koudelka are unforgettable, and haunt our mind's eye almost obsessively. They affect us because of their mysteriousness, because of their unorthodox point of view, which vigorously constructs reality rather than representing it: Koudelka does not describe the world as it is, but as he imagines it and feels it. The precise framing and exceptional quality of his images are what imbue the subjects with meaning and value. A self-imposed exile and nomad, Koudelka never anchored himself to one particular 'home' and was prepared to sleep anywhere and in any conditions in order to keep travelling. He learned his craft in Prague while working as a stage photographer; the theatre taught him about lighting, and how to recognize the 'right' moment. In the early 1970s he started a photographic project on gypsies, later published in the book *Gypsies* (1975), which made him famous. Perhaps it was his interest in folk music that pushed him in this direction, or perhaps, as Michel Frizot said, gypsies for him were 'like a recurring musical motif that was touched upon year after year', which would gradually become 'a personal commitment, a pursuit that was both geographical and anthropological'. To follow gypsies, you need to move around and walk at a different pace. Koudelka's style avoided ethno-anthropological analysis or classic reportage to concentrate simply on collecting evidence of an enigmatic culture, clues to a timeless world. The photographer travelled with the community, blended in with it, and was recognized and accepted. His images portray a tragic, magical world in which living things – human or animal – retain an air of mystery. It is a world taken from a frontal perspective, in which the silent dialogue between a crouching man and his statuesque white horse can appear real to us.

Romania, 1968

© *Josef Koudelka/ Magnum Photos*

JOSEF KOUDELKA was born in 1938 in the former Czechoslovakia and studied engineering in Prague, where he took photographs for the theatre. While he was working as an aeronautical engineer, he started shooting a project on gypsies. In 1967 he became a full-time photographer, and in the summer of 1968 documented the Soviet invasion of Prague. The photographs were smuggled across the border and published anonymously by Magnum. In 1970 Koudelka sought asylum in the UK. In 1971 he joined Magnum as an associate photographer, becoming a full member in 1974. In 1980 he moved to France, and the following year took part in the landscape project organized by French DATAR (Delegation for Regional Planning and Action), for which he used a panoramic camera. His large retrospective book *Koudelka* was published in 2006 in ten countries.

JACQUES HENRI LARTIGUE

In 1912, the eighteen-year-old Lartigue stood at the edge of the ACF Grand Prix track, armed with his camera and the spontaneous, wondering eyes of a boy. He had been taking photographs since the age of six, fuelled by a driving obsession with freezing the passage of time and excited by the idea of capturing the most transient moments. He had never received any formal lessons, and so there was no technical rule that he could not break. On that day, when car number 6 rushed towards him, Lartigue framed the shot and, as the car raced to the finishing line, he turned his body to follow it and took the photograph. Capturing this moment may have been unlikely, but his agile mental reflexes made this visual miracle possible. The focal-plane shutter of his Ica Reflex camera allowed for a long exposure with a slight distortion. As the automobile flashed past, the photographer twisted his body and the outlines of the objects were skilfully distorted. The spectators on the edge of the track are leaning as if pushed by the blast of the racing car, which hurtles in the opposite direction and breaks out of the rectangular frame so quickly that its oval-shaped bending wheels also seem to lean from the sheer force of the acceleration. No Futurist painter managed to represent speed and dynamism in such a startling manner. The Futurists would certainly have loved this image and its photographer if they had known him. Lartigue took photographs throughout his life but his reputation was not truly established until 1963, when MoMA mounted a retrospective exhibition of his work. He did not see himself as a photographer: taking pictures was simply a part of his daily routine, stemming from a personal interest. Pleasure and passion drove him to show the fast-changing world at the start of the twentieth century: speed, optimism and joie de vivre in an age of technological revolution. As the photographer and curator John Szarkowski remarked: 'When his work came to light, it seemed to confirm the inevitability of what had happened in photography much later, when more mature and sophisticated photographers came to understand what the child had found by intuition.'

Delage racing car, ACF Grand Prix at the Dieppe circuit, 26 June 1912

© Ministry of Culture – France/AAJHL

JACQUES HENRI LARTIGUE was born in Courbevoie in 1894 to a wealthy family. At the age of six he received his first camera as a gift from his father and from that moment photographed his world, creating thousands of images preserved in large photo albums. In 1915 he entered the Académie Julian and eventually began a career as a painter. The turning point came in 1963 when MoMA, New York, dedicated a show to him and he became celebrated for his photographs. In 1975 the Musée des Arts Décoratifs in Paris showcased the first retrospective exhibition in France. Lartigue died in Nice in 1986.

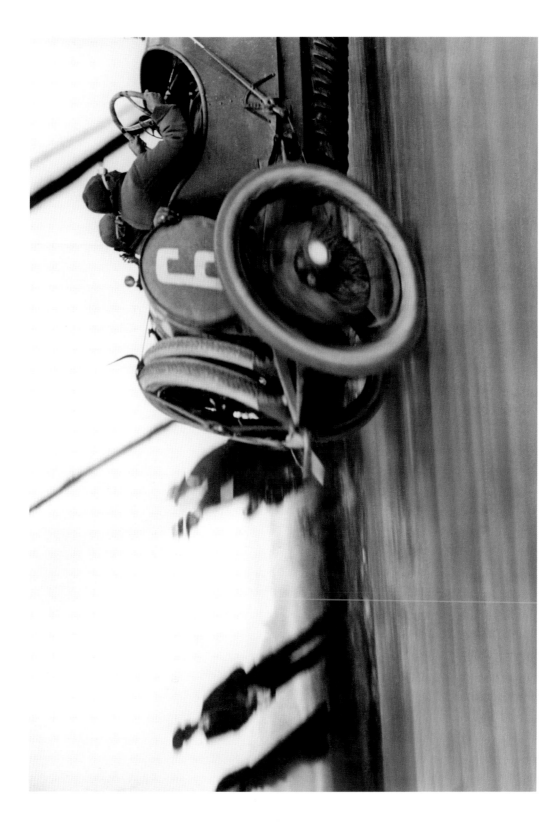

GUY LE QUERREC

It must have been a meteorological sense of harmony, an intimate conso-nance of greys – grey skies, grey sands – that pushed the Breton Guy Le Querrec, a man of the sea and its powerful tides, towards the world of jazz music. He developed his passion for music as a child, and it has become the leitmotif of his career, wherever he has found himself; no more so than in Finistère in northern Brittany, a magnificent stretch of coastline which is perhaps the most romantic in France. Every year in August, the beach at Plouescat in Kernic Bay becomes a racecourse for one of Europe's most important – and most scenic – harness horse races, attracting hundreds of jockeys and magnificent thoroughbreds. But Le Querrec is not interested in the crowds, nor in the speed of the animals, nor in the feather-light sulky-carts which seem almost to fly across the sand without leaving a track. What catches the eye of this photographer and jazz enthusiast is rather the quietly composed 'quartet' of men standing on a raft like shipwreck survivors waiting for the start of the concert, as if they were approaching a beauti-ful, welcoming piece of *terra firma*. The sky is heavy with rain clouds, the beach is a mirror, it has just rained. But if you switch off the daylight, which is already dim, the scene is transformed into that of a smoky New York club, strangely solitary despite the audience at the tables. Cigarette smoke spirals into the air, a spotlight hits the stage, the first notes are played, the first solo, the first response, jostling voices. They continue deep into the night until the early morning hours. Then the tide comes in and the last solo players in Kernic Bay finally go home.

Brittany, France, 1973

© *Guy Le Querrec/*
Magnum Photos

GUY LE QUERREC was born in Brittany, France, in 1941. He had an enduring passion for photography and jazz, and in the 1950s he photographed musicians on the London jazz scene. He became a professional photographer in 1967. In 1969 he started working for the weekly magazine *Jeune Afrique*, travelling to Chad, Cameroon and Niger. He joined Magnum in 1976. He has made two films, and on a memorable evening in 1983 at the Rencontres d'Arles International Photography Festival he projected his jazz images to a live musical accompaniment. There were other trips to China and Africa, and he has followed the Romano-Sclavis-Texier trio on their world tour across twenty-five countries. His books include *Jazz de J à ZZ* (1996), *Suites africaines. Carnet de routes* (1999), and *Jazz Light and Day* (2001).

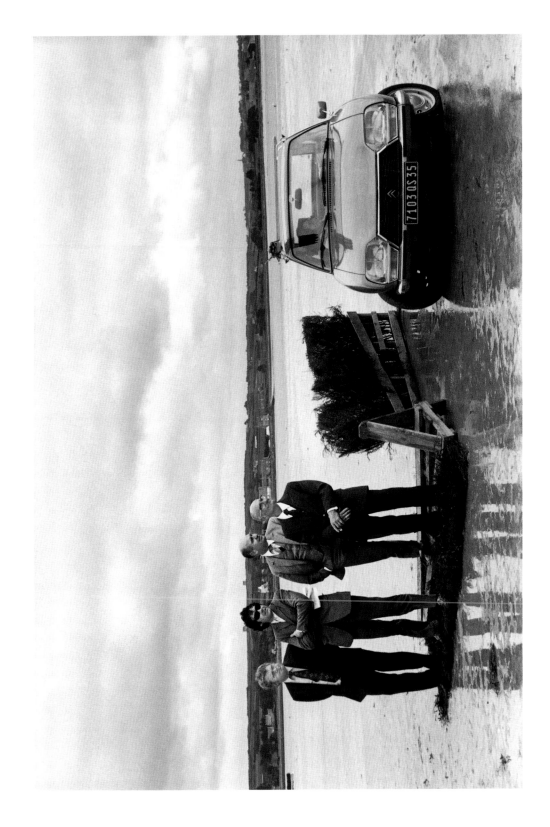

STEVE MCCURRY

Steve McCurry became an international household name when his haunting photograph of a young, green-eyed Afghan girl in a refugee camp in Pakistan made the front cover of *National Geographic* magazine. The image was shot in 1984 at the start of the American photojournalist's career. Disguised in indigenous clothing, he had crossed the Pakistani border into Afghanistan just before the Russian invasion. From then on he has always been on the frontline. McCurry is particularly drawn – both personally and professionally – to South East Asia, repeatedly returning there to cover everything from conflicts to daily life. The colour and light of these countries, he says, along with their intense relationship with the past and their ancient traditions, are unique in the world. His work is fuelled by a deep curiosity in people and their human experience: 'I spend a lot of time looking at faces, and the faces seem to tell a story. When something about the life experience is etched on the face, I know the picture I'm taking is going to represent more than just that moment. I know there's a history here.' When shooting his subjects, McCurry tries to record the exact instant in which their 'essential soul' shines through. The brilliant colours and intense light which characterize his lyrical images often carry a powerful symbolism: 'As I reflect back on it, I see it was the vibrant colour of Asia that taught me to see and write in light… Wait for the light at its deepest and most intense like a farmer's rain.'

Mother and child at a car window, Bombay, 1996

© Steve McCurry/ Magnum Photos

BORN IN PHILADELPHIA in 1950, Steve McCurry read film studies and history at Pennsylvania State University. After graduating he left for India, where he lived for two years. Following the publication of his first book on Afghanistan, he shot for a number of prestigious magazines. Over the course of his career he has covered the Iran–Iraq War, the war in the former Yugoslavia, and the Gulf War. As a *National Geographic* photographer he has travelled extensively, particularly in South East Asia. A full member of Magnum since 1986, McCurry is the recipient of numerous major awards, and his work is owned by several public collections and has been widely exhibited around the world.

PETER MENZEL

It was a normal morning in Peter Menzel's home in the Napa Valley, California. He had just completed a long, exhausting reportage assignment in Kuwait in the aftermath of the first Gulf War and was sitting at his table downloading his work when Madonna came on the radio to publicize her latest book, *Sex*, singing her hit song 'Material Girl'. Menzel stopped to listen to the words for a few minutes – 'You know that we are living in a material world/And I am a material girl' – and thought hard about what they really represented: the chasm between the West and its unbridled consumerism, and countries so poor that their people were starving to death. Feeling ashamed and appalled, he asked himself a question: if we are all living in a material world, then what kinds of material goods and possessions do poor people have? It was the departure point for his first book project, *Material World: A Global Family Portrait*, which made a direct comparison between the haves and have-nots, sending out a clear message. The book was a kind of atlas of excess and poverty, a dramatic, brutally honest, round-the-world trip tracing the economic and social inequalities of thirty different countries. Menzel launched a global appeal for photographers to take part in the project, to which sixteen replied. Their brief was to photograph a family standing outside their home, with all of their possessions – symbols of their wealth or poverty – laid out in front of them. For some families, such as those in Japan and America, it was an incredibly lengthy process. For others, such as the one in Mongolia, it took just a few minutes: the time needed to carry a television outside. It was the same story in Mali, Sarajevo, and in the village of Shingkhey in Bhutan, home to the family of Nalim and Namgay, whose worldly goods comprised a rug, a table, two stools, a few bowls, a wooden statue of the Buddha, two candlesticks, some work tools, clothes and blankets. Not quite the 'material world' that Madonna was singing about.

Nalim and Namgay with their family, Bhutan, 1994

© Peter Menzel/Grazia Neri, from the book Material World: A Global Family Portrait *www.menzelphoto.com*

THE AMERICAN PHOTOJOURNALIST Peter Menzel has a career spanning thirty-five years and is internationally renowned for his scientific reportage stories covering subjects from DNA to robots and solar energy. He has shot for *National Geographic*, *Life*, *Time*, the *New York Times Magazine*, *Geo*, *Stern* and *Paris Match*. He has regularly made the headlines with his ambitious book projects, starting with *Material World: A Global Family Portrait* published in 1994, followed by *Women in the Material World* (1996), co-produced with his wife Faith D'Aluisio, *Man Eating Bugs: The Art and Science of Eating Insects* (1998), and his latest book, *Hungry Planet: What the World Eats* (2005), an enquiry into food and society across twenty-four different countries.

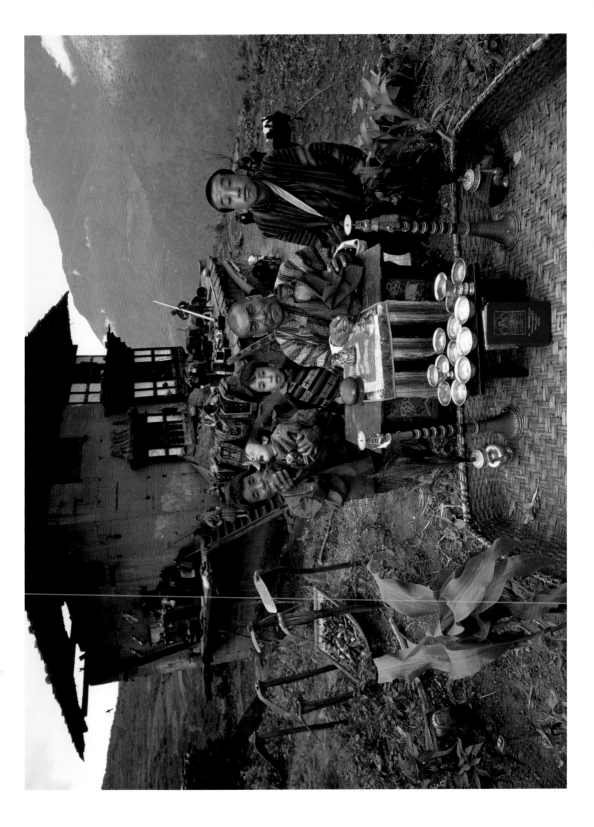

TINA MODOTTI

'I cannot accept life as it is – it is too chaotic – too unconscious – therefore my resistance to it – my combat with it – I am forever struggling to mould life according to my temperament and needs – in other words, *I put too much art in my life.*' Tina Modotti's life was, indeed, like a work of art, and the stuff of legend. A strong, independent woman, a committed artist and revolutionary, a striking beauty with a huge personality, and a passionate companion of great artists and political thinkers, she was undoubtedly one of the most captivating women of her era. Originally from Italy's Friuli region, she emigrated to San Francisco and took on a dazzling string of roles: textile machinist, Hollywood silent film actress, photographer, political militant, Comintern official in Moscow, and aid worker in the Spanish Civil War. At the age of twenty-six she discovered Mexico, and was instantly smitten by its vitality and by the collective desire of the people to build themselves a utopian society. Up to that point her photographic style had been influenced by Edward Weston, but Modotti now changed tack, using her camera as an instrument of social enquiry. In 1927 she joined the Mexican Communist Party, and the relationship between her creative and political activities became indissoluble. Her work took on a new intensity as she photographed peasants on the march, labourers' hands at rest, women breastfeeding their babies, work tools and weapons. 'Photography', she wrote, 'takes its place as the most satisfactory medium of registering life in all its aspects, and from this comes its documentary value. If to this is added sensibility and understanding and, above all, a clear orientation as to the place it should have in the field of historical development, I believe that the result is something worthy of a place in social production, to which we should all contribute.'

Marching peasants, Mexico, 1926

© *Archivio Fotografico di Cinemazero – Pordenone 'Fondo Modotti'* www.cinemazero.it

TINA MODOTTI was born in Udine in 1896. In 1913 she emigrated to San Francisco. Her love of the arts initially led her to become involved in amateur dramatics, and by the early 1920s she was being offered Hollywood roles. In 1922 she met Edward Weston, and became his assistant and companion. The following year she moved to Mexico City, where in 1929 she held her first exhibition. She fell in love with Julio Antonio Mella, who was assassinated while at her side, apparently by agents of the Cuban government. In 1930 she was expelled from Mexico. She gave up photography to take part in political missions for the International Red Aid organization. In 1939 she returned to Mexico City, where she died in 1942 under suspicious circumstances. The official cause of death was heart failure.

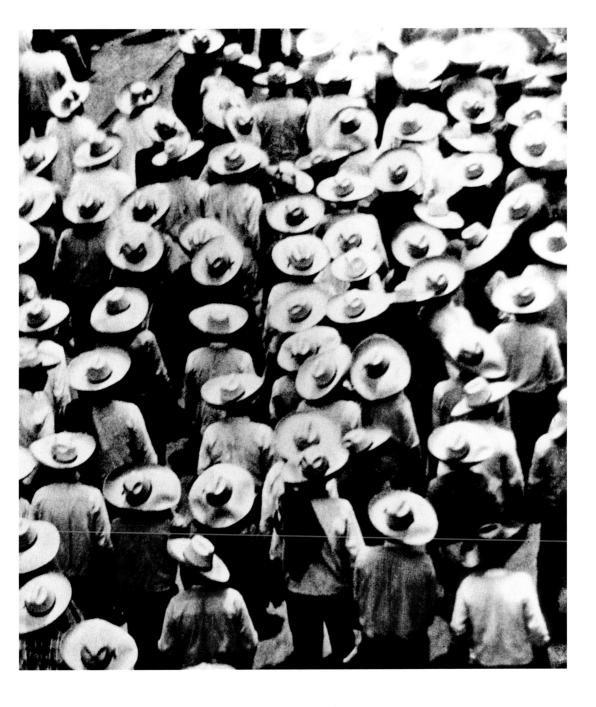

MARTIN MUNKACSI

'Think while you shoot!' was the credo of the Hungarian photographer Martin Munkacsi. While his name has now been largely forgotten by the general public, in his heyday he enjoyed worldwide fame and the respect of some of the greatest photographers of the twentieth century, who considered him a master. He was also the highest-paid photographer on the planet. His career path took him from Budapest to Berlin and finally to New York. In Hungary he specialized in sports and dance photography, but the dynamism and energy of his shots soon attracted the attention of major magazine and newspaper editors. In 1928 he moved to Berlin, where his compositional style became *the* model to be imitated. He travelled widely on assignment for the *Berliner Illustrierte Zeitung*, notably to Liberia, where he took one of his most iconic photographs: three naked young boys playing in the waves at Lake Tanganyika, their black silhouettes contrasting against the white sunlit surf to create a perfectly balanced composition. The photograph struck a deep chord with Henri Cartier-Bresson: 'For me this photograph was the spark that ignited my enthusiasm. I suddenly realized that, by capturing the moment, photography was able to achieve eternity. It is the only photograph to have influenced me. This picture has such intensity, such joie de vivre, such a sense of wonder, that it continues to fascinate me to this day.' The image inspired Cartier-Bresson to put down his paintbrush and pick up his camera. Munkacsi reached the pinnacle of his success in New York, revolutionizing fashion photography. Richard Avedon would later say of him: 'He brought a taste for happiness and honesty and a love of women to what was, before him, a joyless, loveless, lying art. Today the world of what is called fashion is peopled with Munkacsi's babies, his heirs.'

Boys playing in the surf at Lake Tanganyika, Liberia, 1931

© *Munkacsi/Ullsteinbild www.ullsteinbild.de*

MARTIN MUNKACSI was born in Kolozsvár in Hungary (now Cluj-Napoca, Romania) in 1896. He specialized in sports photography in Budapest before transferring to Berlin in 1928, where he worked for the *Berliner Illustrierte Zeitung*. In 1934 he moved to New York to escape the Nazi regime, and started shooting for the top fashion magazine *Harper's Bazaar*, where he was a runaway success. He took his models out of the studio and was responsible for one of the first nude shoots to be published in a popular magazine. Munkacsi also worked as a portrait photographer to Hollywood film stars. However, he died in poverty in 1963, having been largely forgotten. In 2007 F. C. Gundlach dedicated a major exhibition to him.

JAMES NACHTWEY

'The events I have recorded should not be forgotten and must not be repeated.' For over twenty years James Nachtwey has been leading us into the 'inferno' to show us the darkest, most evil recesses of our world and the horror and pain of human existence. He has been first in line to bear witness to the most critical events of our times. By humanizing war, he says, photography shows ordinary people what happens in the field. Every one of his images jumps out from the sea of photographs of human suffering that we have become used to seeing every day; every one is a news flash and often also an antidote to our apathy. This photograph of a young Hutu man who had been repeatedly attacked with a machete thus becomes an accusation towards the West for having closed its eyes to the humanitarian catastrophe that was happening in Rwanda. From 6 April to mid-July 1994, in just one hundred days, more than 800,000 people – the majority of them Tutsis – were systematically slaughtered. Following the genocide, over a million people fled from Rwanda to Zaire, creating one of the largest refugee camps in history. Nachtwey was there, and shot a chilling series of images. The man in the photograph managed to survive after being freed and treated by the Red Cross. Nachtwey closes in tightly on his violated face, which has been reduced to matter, flesh and scars. That face is a denunciation: 'What allows me to overcome the emotional obstacles inherent in my work is the belief that when people are confronted by images that evoke compassion, they will continue to respond, no matter how exhausted, angry or frustrated they may be.'

Survivor of a Hutu death camp, Rwanda, 1994

© *James Nachtwey/VII*

JAMES NACHTWEY was born in Syracuse, New York, in 1948 and taught himself photography. In 1980 he moved to New York to begin a career as a freelance photographer, and since 1984 he has been contracted to *Time* magazine. He was a member of Magnum from 1986 to 2001, when he became one of the founding members of the VII agency. In 2003 he was seriously wounded by a grenade attack in Baghdad while travelling in a jeep with US Army personnel. His reportage stories on Afghanistan, Rwanda, Eastern Europe and Romania after the fall of Ceausescu are particularly memorable. He has won the Robert Capa Gold Medal five times, the Magazine Photographer of the Year Award six times, and is also the recipient of the W. Eugene Smith Memorial Grant in Humanistic Photography.

MARTIN PARR

According to Martin Parr, the brilliant chronicler of everyday life, good photography needs to reflect a certain vulnerability. Parr does not report from war zones or distant locations, but from the very heart of the so-called 'developed' world and its over-privileged, over-indulged society. A collector of faces, gestures, social gaffes and group rituals, over the years he has constructed his own original and alarming 'theatre of the ordinary'. The questions he asks are those of a sociologist armed with a camera. He is acutely aware of how quickly the banal can become absurd, grotesque and therefore worthy of representation. Using a documentary approach, he focuses his eye – honed by a typically British sense of irony – on the surface of everyday life, investigating how the working classes express their 'common sense', and uncovering the social norms, the conformism and the imaginary stereotypes they are imprisoned by. The blatantly obvious is transformed into something meaningful, capable of raising a laugh but also of stirring up a disquieting sense of the ridiculous, and provoking a reflection on the potency of our needs and desires. Parr's universe is made up of 'last resorts', bored couples, anaemic postcards, gigantic greasy burgers dripping with mustard, and crowded shopping centres. The angles are unusual and the colours often bright and garish, an effect achieved by using forced flash in daylight conditions. The world Parr depicts is saturated, not just by colour, but by consumerism, tacky souvenirs and stacks of fancy-dress hats. He homes in on details and shoots unforgiving close-ups of lobster-red sunburned skin. Val Williams wrote that Parr's photographs make us feel uncomfortable because they bring out the worst in us, making us look proud or foolish, snobbish or cynical; in a certain sense his photos are like jokes – apparently innocuous, but designed to make us look like idiots.

Dorchester, Weymouth, 1998

© Martin Parr/ Magnum Photos

BORN IN 1952 in Epsom, Surrey, Martin Parr studied photography at Manchester Polytechnic. In the late 1970s he won the Arts Council of Great Britain prize three times in a row. From 1975 to the early 1990s he taught a series of courses. In 1994 he became a full member of Magnum. Parr's controversial style of photography has been the subject of fierce debate throughout his career. His work has been exhibited in Europe and the United States in major museums and galleries, and is held by a number of important public and private collections. Parr has also shot documentary films and a television series, 'Think of England'.

GEORGE RODGER

During the Second World War George Rodger was a war correspondent for *Life* magazine. On 20 April 1945 his life and career reached a painful turning point when he became the first photographer to enter the Bergen-Belsen concentration camp. As a photojournalist, he experienced the trauma and shame of having to see and report on scenes that no one should have to witness. 'I swore I would never take another war picture, and I didn't. That was the end,' he later said. In order to restore his belief in humanity, he went in search of an unsullied utopia: 'I just had to get rid of the filth of war, the screams of the wounded, the groans of the dying. I sought some spot in the world that was clean and untrammelled.' He uses the simple adjective 'clean' to express a spiritual, mental, ethical and moral imperative. But in a Europe reeling from the violence of a devastating conflict, it was impossible to find 'cleanliness' or innocence. He needed to go far away to try to purge his mind of the memory of that brutal inhumanity. In 1947 he co-founded Magnum and subsequently left on a long trip across Africa. In Sudan he shot a reportage story on the Nuba people for *National Geographic*, which to this day remains one of the most outstanding works of documentary photography. Rodger would later say that he found salvation in this encounter with a culture that seemed pure, profoundly religious and in harmony with nature. He was struck by the physical presence of the men and women, their dignified nudity and their ancient rituals. The victor of the traditional wrestling bout, carried in triumph on the shoulders of his adversary, fixes his ancient warrior's eyes on the photographer and shows him his proud face. His strength is naked, loyal, honest, unarmed, of muscles and veins, of unwritten laws which determine life and combat. It is a scene far removed from the deadly bombs, poisonous gas and invisible enemy of the Second World War. This is an age-old humanity, simple, natural and 'clean'.

The Nuba, Kordofan Province, Sudan, 1949

© George Rodger/ Magnum Photos

GEORGE RODGER was born in 1908 in Hale in the UK. After school he joined the British Merchant Navy and subsequently worked as a photographer for the BBC and the Black Star agency. During the Second World War he was a war correspondent for *Life* magazine, winning eighteen medals for bravery. In 1945 he became the first photographer to enter the Bergen-Belsen concentration camp. The experience traumatized him and he gave up war photography. In 1947 he became one of the founding members of Magnum. His next major trip took him across Africa, during which he shot his reportage story on the Nuba people in Sudan (the photographs first appeared in *National Geographic*). He continued to travel around Africa, and also photographed the Masai people's circumcision ceremonies. He died in 1995 in the UK.

FULVIO ROITER

The image was taken fifty years ago, but the scene looks centuries old. Fifty years ago Italy was a different country, archaic, enclosed between its mountains and valleys. It was a slow, silent land with no motorways or traffic, and it was in little or no hurry to emerge from the political and cultural isolation imposed on it during the years of dictatorship and war; a land, in short, that seemed near and familiar, but that was in reality far and exotic. The first wave of neorealism and its innovative, reactionary cinema had exhausted itself; and it was on the second wave, dominated by literature and painting, that the young Fulvio Roiter arrived with his fresh approach and technical mastery. Roiter was from Italy's Veneto region, in those days before the Venice Carnival had been reinstated. In 1954, the year in which the Italian national broadcasting company RAI first went on air, the photographer went on a long trip to Sicily, the extreme symbol of the nation's 'otherness'. His next journey, to Umbria, was closer to home, and a whole other project in itself. It was here that Roiter took one of his most iconic photographs. The image echoes the *Subjektive Fotografie* ('Subjective Photography') of Otto Steinert, a concept developed by the German photographer in the 1950s which emphasized personal vision and experimental photography over documentary realism. Here, the image's subjectivity – and what makes it authentically 'photographic' – is achieved through Roiter's expert handling of technique to create a highly personal, extremely modern effect which transforms a simple scene into a true work of art. The contrasting black-and-white tones are maximized to create an internal dialogue about life in a country with one foot in the past and one foot in the future. In the middle, as if blazing the trail from past to future, is the shepherd with his cargo of firewood. It was winter, and it had never been so long, cold and exhausting.

Umbria, 1954

© *Fulvio Roiter*

FULVIO ROITER was born in Meolo, near Venice, Italy, in 1926. He started taking photographs while studying at the Technical Institute, where he graduated with a diploma in chemistry. In 1948 he became associated with the Venetian photographic group 'La Gondola' and made friends with one of its founders, Paolo Monti. He turned professional in 1953 and took his first photography trip to Sicily. The following year a portfolio of his Sicilian images appeared in the prestigious magazine *Camera*. His book *Venise à fleur d'eau*, published in 1954, launched him internationally. *Ombrie, terre de Saint François* (1955) won the Prix Nadar. In 1957 Roiter travelled to Brazil to document the birth of Brasília. Twenty years later he published *Essere Venezia*, one of a long series of books dedicated to the city.

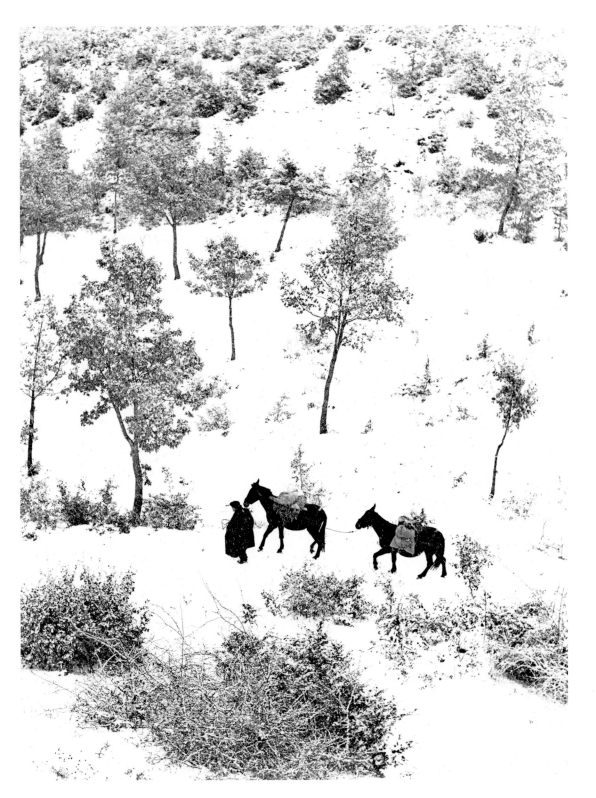

SEBASTIÃO SALGADO

Eighteen years is a long time in news terms. But yesterday's tragic events have a way of repeating themselves, like the air bubbles rising up and popping on the surface of this oozing black swamp of crude oil, a small fraction of the 70,000 tons that spewed out of the Kuwaiti oil fields sabotaged by the retreating Iraqi army during the first Gulf War. Baghdad, Saddam, the invasion of Kuwait, Bush, the UN, the ultimatum, clinical bombardments, lines of desperate refugees, followed by another Bush, more bombardments, the death of Saddam, and an ongoing conflict. It is as if the two workers photographed by Salgado, and included as a symbolic image in his book *Workers: An Archaeology of the Industrial Age* (1993), had already foreseen everything: the first man stands with his arms open, empty, in a gesture that is half-imploration, half-surrender, while the other appears to be slowly sinking, exhausted, into that physical and metaphorical morass of oil and violence. It took eleven months for the clean-up workers to extinguish the 650 burning oil wells in Burgan, a few kilometres south of Kuwait City – and 7,000 shots for Salgado to produce an extraordinary photo story which transformed a slice of contemporary history into a page of epic poetry that was, in its own way, universal. The protagonists of the image are no longer two engineers sent by the White House, but two heroes whose oil-soaked skin has become a bronze surface that reflects the light like antique statues. Salgado's painterly compositions ennoble suffering, firmly and authoritatively denouncing the miserable, desperate conditions humans are forced to live and work in, conditions we thought belonged to bygone eras. The economist-turned-photographer shows us that, for many, this is a present-day reality.

Kuwait, 1991

*© Sebastião Salgado/
Amazonas Images*

SEBASTIÃO RIBEIRO SALGADO was born in Brazil in 1944, and is a leading social documentary photographer. After graduating in economics and sociology he moved to London, where he worked for the International Coffee Organization. In 1973, while living in Paris, he began his career in photography. His published work includes his sweeping visual panorama over the world of manual labour at the dawn of the new millennium (*Workers: An Archaeology of the Industrial Age*, 1993) and his project on global migration (*Migrations: Humanity in Transition*, 2000). Many of his books and exhibitions have been conceived by his wife, Lélia Deluiz Wanick Salgado, with whom Salgado founded Amazonas Images in 1994. Salgado is a UNICEF Special Representative and an honorary member of the American Academy of Arts and Sciences.

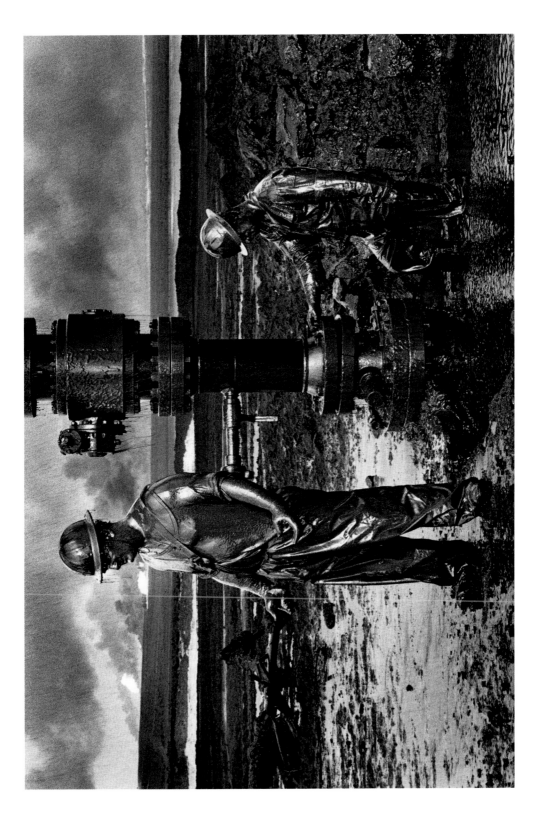

ENZO SELLERIO

Sicily is at the centre of Enzo Sellerio's photographic universe, his preferred setting and object of enquiry. His work is critical and challenging, often referring to Sicily's dark history, but just as often it tells a passionate, involving, intelligent and even amusing tale of everyday life there, with all its verve and vitality. He captures grace and irony with a magical depth, and this image of a street scene in Palermo is the result of a deeply felt empathy with his surroundings, a perpetual sense of wonder, and a sharp eye for graphic composition. Nothing seems left to chance, even if it was chance that arranged all of the elements of the scene in such an orderly fashion. The image's structure resides in a rigid geometric scheme established by the sides of the chairs perched on the children's heads, which are perfectly centred within the frame yet at the same time create a sense of dynamism, with their broken line suggesting a climb or descent. The compositional balance is further offset by the position of the children's legs, along with the silhouette of a man to the side of the frame. Perhaps this dark, hunched figure, wrapped up in a coat that's too long for him, embodies the true mystery of the photograph.

Children carrying chairs, Palermo, 1960

© *Enzo Sellerio*

ENZO SELLERIO was born in Palermo in 1924. A law graduate, he left his career as a university lecturer to devote himself to photography. In 1952 he had his first images published in *Sicilia* magazine and in 1955 shot the photo story 'Borgo di Dio', an undisputed masterpiece of neorealist photography. He subsequently worked for a number of famous publications, including *Il Mondo* (edited by Mario Pannunzio), *Du*, and (in the 1960s) *Vogue* and *Fortune*. In 1969, after having approached the writers Leonardo Sciascia and Antonino Buttitta, he and his wife founded the Sellerio Editore publishing house. In 2007 the Museo Nazionale Alinari della Fotografia celebrated his career as a photographer with a retrospective exhibition of 150 works, held at the Museo Alinari in Florence and the Metropol in Milan.

DAVID SEYMOUR

When the alluring nude statue of Pauline Borghese was first unveiled at the Borghese Gallery in around 1808, it drew enormous crowds and caused a stir. Antonio Canova had depicted the princess as the *Venus Victrix* of classical mythology, judged by Paris to be the most beautiful of the goddesses, for which she received an apple as her prize. Pauline was one of the most popular and talked-about women of her era, renowned both for her beauty and open-mindedness. According to one story, when asked by a lady at court if she had really posed naked for Canova, she candidly replied: 'Yes, but the room was heated!' By the time this picture was taken, the sensation surrounding the statue had abated, and the marble's carnal beauty could be contemplated and appreciated in silence. The man looking intently and admiringly at the statue is the collector and art critic Bernard Berenson (by then ninety years old), who was passionate about Italy and its culture. Standing behind the lens is David Seymour, the mercurial 'Chim', a founding member of Magnum and a legendary photojournalist. Famous for documenting the pain of war and the desolate emptiness of its aftermath, Seymour here demonstrates his love of capturing life's simple, ordinary moments in which all the delicacy of humanity is revealed. He proposed an idea to *Newsweek* for a series of photographs that would 'dramatize the human qualities of modern missionaries (teachers, technicians, scientists, officials, experts, etc.). The conception of good-doers is lately ill considered. I feel it would be important to glamorize them.' A cultured man who had been deeply affected by the trauma of the war in Europe, Chim understood the need to value these 'modern missionaries' who had done so much to raise human spirits through their work. And no one appears more profoundly human than this celebrated elderly art critic caught with his eyebrows raised in admiration, in time-honoured fashion, at the sight of something beautiful.

Bernard Berenson standing in front of a statue of Pauline Borghese by Antonio Canova, Borghese Gallery, Rome, 1955

© David Seymour/ Magnum Photos

BORN IN WARSAW in 1911, David Szymin studied graphic arts in Leipzig and continued his education at the Sorbonne in Paris, where he discovered photography. He was working as a freelancer when he met Robert Capa and Henri Cartier-Bresson. In 1934 his photographs started appearing in *Paris Soir* and *Regards*. From 1936 to 1938 he documented life in Spain during the Civil War. When the Second World War broke out, he moved to New York and changed his surname to Seymour. In 1942 he joined the US Army intelligence unit as an interpreter. He was a co-founder of Magnum in 1947 and continued to photograph major reportage stories, including one on the new State of Israel. He was killed by Egyptian machine-gun fire during the Suez Crisis of 1956.

W. EUGENE SMITH

In 1955 'The Family of Man' exhibition opened in MoMA in New York, a seminal moment in the history of photography. The show, which featured 503 pictures taken by 273 photographers from around the world, was conceived and created by Edward Steichen, whose intention was to reveal 'the essential oneness of mankind' and to promote photography as 'a tool for penetrating beneath the surface of things'. The exhibition took viewers on a moving photographic journey through modern times, but the closing shot by W. Eugene Smith, 'The Walk to Paradise Garden', also offered an expressive vision for the future and was rich in symbolic meaning. Smith had been a correspondent in the Pacific Islands during the Second World War until he was injured by a grenade in Okinawa in 1945. The consequences were serious: he had to spend two painful years in hospital and underwent thirty-two operations, plunging his career as a photojournalist into crisis. He had to dig deep to reignite his creative spark. While convalescing, he picked up his camera again for the first time to take this photograph of his two children walking through the woods. He felt the urgent need to create an image which recorded a delicate, graceful instant in direct contrast to the depraved bestiality of war, his most recent – and detested – subject. The result is one of the most famous photographs of all time: the vision of the two children walking hand in hand encapsulates humanity's passionate desire to be reborn, to turn its back on the darkness and move towards the light. Smith eloquently evokes the journey from paradise lost to paradise found: it is a picture of hope for himself and for his times. Cartier-Bresson would write: 'In Gene's photographs there is something which throbs, something always tremulous. They are taken between the shirt and the skin. Anchored between the shirt and the skin – at the heart – his camera moves even by its passionate integrity.'

The Walk to Paradise Garden, USA, 1946

© *W. Eugene Smith/ Magnum Photos*

W. EUGENE SMITH was born in 1918 in Wichita, Kansas, and started taking photographs for local newspapers when he was still at high school. In 1937 he moved to New York where he began working for *Newsweek* and, two years later, for *Life* magazine. From 1942 he followed the Pacific island-hopping American offensive against Japan until he was injured by a grenade in 1945 in Okinawa. Between 1947 and 1954 he produced a series of photo essays which revolutionized photojournalism, including 'Country Doctor', 'Spanish Village' and 'A Man of Mercy'. In 1956 he worked on a project about Pittsburgh. In 1972 he relocated to Japan and reported on the ecological disaster of Minamata, for which he suffered a beating. In 1975 he returned to the United States and was awarded the Robert Capa Gold Medal. He taught at the University of Arizona until 1978, the year of his death.

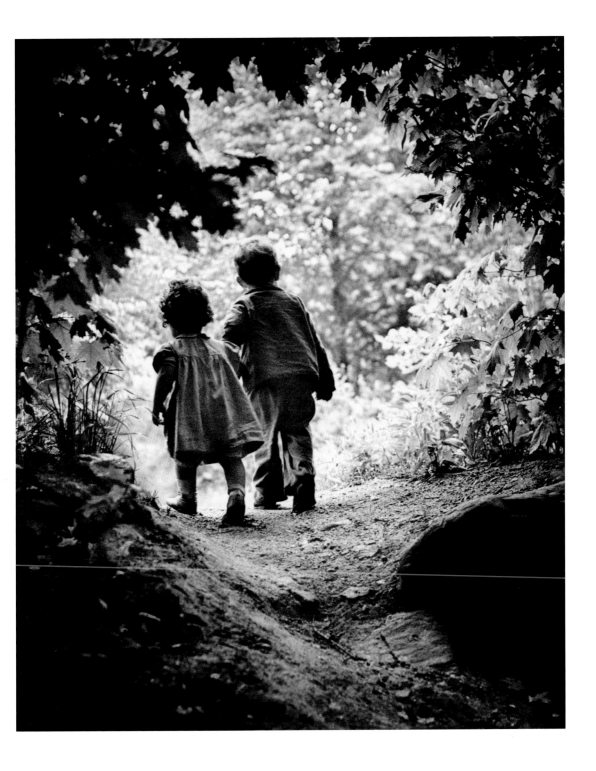

DENNIS STOCK

Concerts invariably start like this, with an arm raised in the air, releasing dreams and energy at the sound of the first chord. This image of a young woman dancing, her hair swinging in the breeze, her braless back free to the elements, is one of the most iconic photographs in American history. The time and place of the picture are already the stuff of legend: Venice Beach, Santa Monica, 1968, one of the epicentres of the counterculture and flower power. It was here that Jim Morrison and The Doors took their first musical steps, and it was here, during one of the 'hottest' summers of the century, that Dennis Stock shot the new pioneers of American culture, who had started their very own Gold Rush. The thousands of young people gathered at this rock concert all shared a common hope, to change the world and affirm their right to live out an alternative, peace-loving, tolerant and sexually liberated version of the American Dream. There is room for everyone on this beach, which seems to herald the start of something new. For Stock, who had always flown the flag for individualism, it was a defining moment. After years of photographing jazz musicians and Hollywood stars, including Marilyn Monroe, Audrey Hepburn and his friend James Dean (whom he followed from the streets of New York to his childhood home in the country), the photographer felt something in the air – the same air that was blowing through the young woman's hair. It was the beginning of a new age, an age of emancipation, freedom, change. And he made it his own. 'My subjects – the bikers, hippies, road people, artists – are simply people who have sought a less conforming way to explore this conforming life that we all lead. It was my fascination with their ability to survive as individuals that kept my camera busy.'

Venice Beach, Santa Monica, 1968

© Dennis Stock/ Magnum Photos

DENNIS STOCK was born in New York in 1928 and joined the US Navy at the age of seventeen before turning to photography. In 1947 he became the assistant to *Life* magazine photographer Gjon Mili, winning first prize in the '*Life*'s Young Photographers' contest. Four years later he joined Magnum and went on to make a series of portraits of Hollywood stars, most notably James Dean, who was the subject of an exceptional reportage story. From 1957 to 1960 he photographed leading jazz artists, including Louis Armstrong and Billie Holiday. In the late 1960s he was drawn to California's hippie youth culture. In 1968 he set up his own film production company, Visual Objectives, and shot a series of documentary films. Throughout the 1970s and 1980s he explored colour and the beauty of natural landscapes, and his later work was focused on the abstraction of flowers. He died in January 2010.

LARRY TOWELL

It takes a special talent to record the tiny gestures of everyday life, those little moments of tenderness and silence, of glances exchanged within the intimate surroundings of the home. It takes a special talent, and the realization that those (apparently) insignificant little moments are loaded with significance, that they are, in fact, everything. According to Larry Towell, photography ultimately means photographing families: war and famine are about families in dire conditions. So by setting his camera on a dining table or between the folds of a pillow, he is recording human life while remaining anchored in reality. It is this same reality that led him to leave his 'front porch' and travel to Nicaragua, El Salvador and Palestine to understand and document oppressed peoples and the battle to reclaim their land: 'If there's one theme that connects all my work, I think it's that of land-lessness; how land makes people into who they are and what happens to them when they lose it and thus lose their identities.' This is the theme closest to Towell's heart, as simple and complex as the job title on his business card which reads 'Human Being'. Back in Ontario the photographer came across a group of Mennonites living close to his rural home. The Mennonites are members of a Protestant sect originating in Germany who refute modern technology and live entirely off the land. One of the largest colonies is in Mexico, but many are forced to migrate to Canada for the harvest. Feeling a kinship with them and their traditional way of life, Towell decided to follow them on their return to Mexico. It was a journey back in time, where the pace of life was dictated by the hardships and poverty of rural existence, the rules and contradictions of their religion, the continual fight for work and for the land, and a strong sense of community. In the picture, a group of women are walking together across an arid stretch of land. There is no promise of a welcoming final destination on the flat horizon, but perhaps the purpose of their walk lies in the very fact that they are walking together. And as they walk, their heavy Prussian dresses billow proudly in the face of the corrupt modern world.

Mennonites, Chihuahua, Mexico, 1996

© Larry Towell/ Magnum Photos

BORN IN 1953 in rural Canada, Larry Towell studied visual arts at Toronto's York University. In 1976 he left to volunteer in Calcutta, where he began to write and take photographs. After returning to Canada he taught folk music and in 1984 became a freelance photographer, shooting assignments on Nicaragua, on the relatives of the 'disappeared' in Guatemala, on El Salvador and on the Mennonite communities in Canada and Mexico. In 1988 he joined Magnum, and was made a full member in 1993. In 1997 he photographed a reportage story on Palestine. He is currently working on a project about his family in Ontario. He is the recipient of numerous awards and has published several books, including *El Salvador* (1997), *The Mennonites* (2000) and *No Man's Land* (2005).

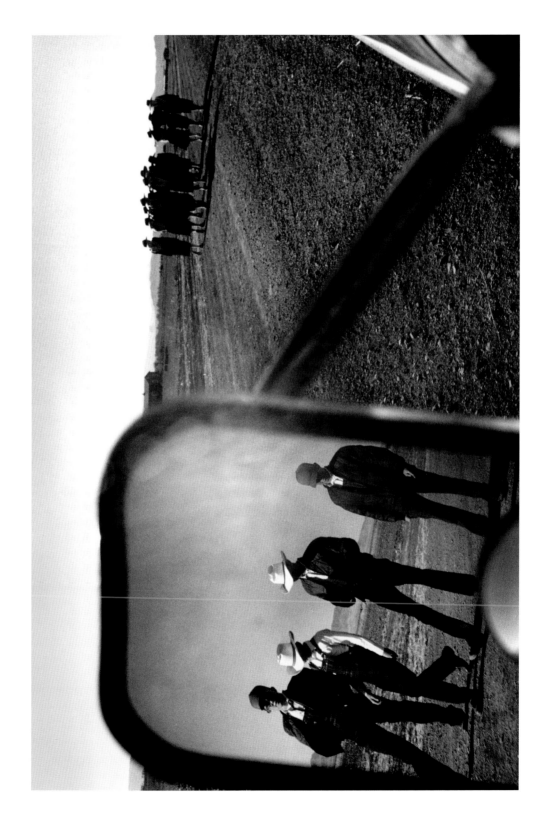

GARRY WINOGRAND

In New York's Central Park Zoo, Garry Winogrand's provocative eye is caught by an unconventional family: a white woman and black man carry a pair of chimpanzees, which are dressed in much the same way as the child standing beside them. The photograph was taken in 1967, at a time of political and civil unrest. The term 'Black Power' had first been taken up by the activist Stokely Carmichael just a year earlier, while in Virginia the Supreme Court overturned state laws prohibiting interracial marriages. One of the major interpreters of the reality of American life, Winogrand confronted tough issues with a sense of humour and an element of the grotesque. His work is often loaded with irony, accompanied by an obvious sense of unease generated by his reflections on social issues, nuclear risks and the destruction of the environment. But that unsettling quality also came from deep inner turmoil. John Szarkowski, the former director of the photography department at MoMA in New York, would later write that Winogrand's work reflected the 'manic sense of a life balanced somewhere between animal high spirits and an apprehension of moral disaster'. The quick-fire gestures and expressions in this photograph give rise to a complex image full of points of interest: the chimps' arms clinging onto the collars of the couple, the perpendicular play of eyes, the hand squeezing the child's hand, and the shadow cast by the photographer himself. Yet at the same time everything seems perfectly ordered in this exercise in virtuosity.

*Central Park Zoo,
New York City, 1967*

© *Estate of Garry
Winogrand*

GARRY WINOGRAND was born in New York in 1928 and started taking pictures in the US Army Air Force at the end of the Second World War. After studying painting he attended Alexey Brodovitch's Design Laboratory. Inspired by the work of Walker Evans and Robert Frank, he developed his own distinctive style during the 1960s and became one of the leading exponents of American 'street photography'. His work was exhibited for the first time in 1963 by MoMA in New York. He subsequently exhibited in a number of other major museums and published a large number of books. He died in 1984, leaving an archive of hundreds of thousands of images which have yet to be catalogued. In 1988 John Szarkowski organized the retrospective show 'Winogrand: Figments from the Real World' at MoMA, New York.

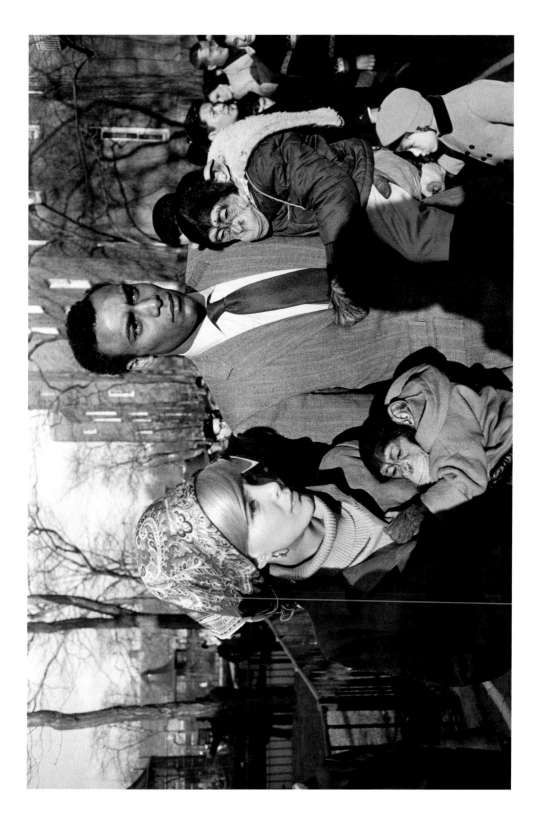

EDDIE ADAMS

When Eddie Adams took this photograph on 1 February 1968, he was already an established photojournalist with an extensive body of work on widely differing subjects, including the Korean War and the funeral of John F. Kennedy. But this photograph, taken during the early days of the fierce Tet Offensive in Saigon, at the height of the Vietnam War, was the one for which he would always be remembered. On a city street General Nguyen Ngoc Loan is seen executing the Vietcong prisoner Nguyen Van Lem in cold blood, with a single shot to the head. The image was published around the world and raised public awareness of the events that were unfolding in Vietnam, and it won Adams both the Pulitzer Prize and the World Press Photo Award. In this depiction of a brutal execution and the senseless violence of war, the dark side of photography is revealed. Compelled to document the horrors of which the human race is capable, the photographer must distil in a single shot the victor and the vanquished, the executioner and the victim, conveying judgments that are not necessarily his own, and portraying a black-and-white reality when perhaps he would prefer it to be grey. Adams never liked this photograph, and particularly disliked being famed for it; he preferred 'Boat of No Smiles' (1977), a poignant and intimate series of photographs of a group of Vietnamese refugees. This image of execution came to epitomize the brutality of war and the complex role played by the eye-witness. Adams referred to this, when talking about his famous picture, in an interview with *Time* magazine: 'The general killed the Viet Cong; I killed the general with my camera. Still photographs are the most powerful weapon in the world. People believe them, but photographs do lie, even without manipulation. They are only half-truths.'

General Nguyen Ngoc Loan executing a Vietcong prisoner, Saigon, 1968

© Eddie Adams/AP

EDDIE ADAMS was born in the USA in 1933. During the Korean War he was a combat photographer with the Marines. He took his most famous photograph, the execution of a Vietcong during the Vietnam War, while working for AP (Associated Press), which won him the Pulitzer Prize and the World Press Photo Award in 1969. In 1977 he published 'Boat of No Smiles', a series of photographs of Vietnamese refugees. During his long career he was awarded over 500 prizes, and documented numerous wars. He photographed Malcolm X, Louis Armstrong, the Dalai Lama and Fidel Castro. He died in New York in 2004.

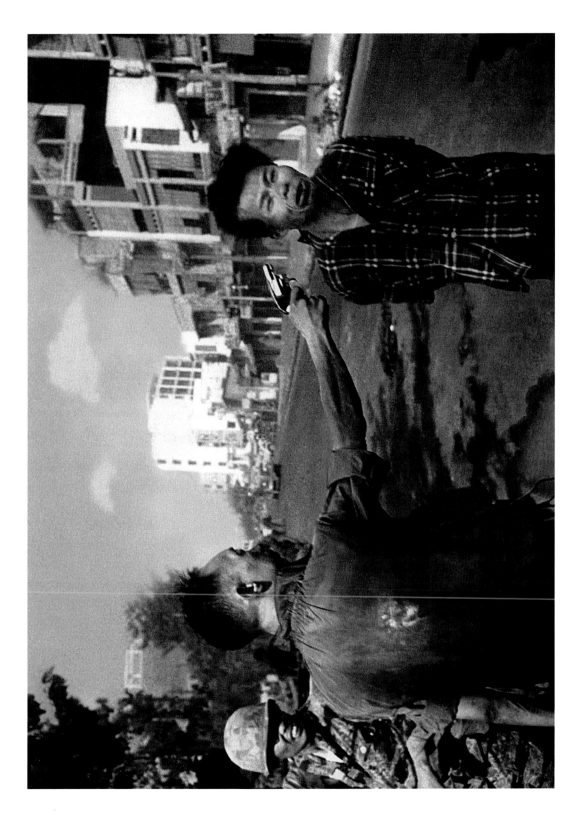

BRUNO BARBEY

It was the first war to be televised, but paradoxically it was a war without photographs. The world watched the progress of the Gulf War on the television screen, but there isn't a single image of destruction that remains etched on the collective memory. The night sky above Baghdad – speckled with bright green flashes, the macabre fireworks of exploding bombs – was viewed through an indifferent lens, but beneath it people were dying. As far as the news was concerned, nothing was left to chance, and American propaganda generated the image of a technological war that was brief and painless. It was only shortly before the end of the war that journalists and photographers managed to gain access to the country to record the destruction caused by the shelling, and the apocalyptic scene of environmental destruction as a result of the burning of the oil fields in Kuwait. It had been almost impossible to record the conflict in action, so most of the photographs show the aftermath – the state of the country after the Iraqi withdrawal. Bruno Barbey has never regarded himself as a war photographer, although he has documented several world conflicts, conscious of the fact that – in the photographer's words – there are certain dates with history that you just cannot miss. He has been to Biafra, Nigeria, Palestine, Vietnam and Cambodia, as well as documenting the Gulf War. On 26 February the Iraqi troops began to withdraw from Kuwait, and as they went they set fire to all the oil wells they encountered en route. Barbey captured an emblematic image. The earth is black, as in a lost world. An American tank advances through an empty space devoid of human life. Behind the soldiers, the flames heralding environmental and economic disaster are burning fiercely. In front of the eyes stretches a deserted, apocalyptic landscape. Over it all hangs a thin and asphyxiating haze of oil.

The Burgan oil fields burning during the Gulf War, Kuwait, 1991

© *Bruno Barbey/ Magnum Photos*

BRUNO BARBEY was born in Morocco in 1941, and studied at the École des Arts et Métiers in Switzerland. In the early 1960s he travelled around Italy and produced a black-and-white photo essay on the Italians, and also worked in Africa. He has covered many different conflicts around the world, including those in Biafra, Vietnam, the Middle East, Northern Ireland, Kurdistan and Cambodia. In 1968 he became a full member of Magnum, and documented the Paris uprising during May of that year. He worked in Poland from 1976 to 1981, then witnessed the fall of the Berlin Wall in 1989 and events in the Persian Gulf in 1991. Over the course of several decades he has frequently worked in Morocco whenever possible. He has received numerous prizes, including the Overseas Press Club Award. His photographs have been exhibited all over the world, and feature in many museum collections.

ERIC BAUDELAIRE

Imagine seeing an image of violence for the first time, if you had never been exposed to such scenes. If only our eyes could be opened to the violence all around us, in which we are all too often the protagonists. But the flood of pictorial and photographic images of human suffering has been so great that our minds have become numbed; images of war have become so familiar to us that, beyond their initial impact, they have little effect. In the diptych 'The Dreadful Details', Eric Baudelaire addresses the form of the war image in this age of saturation. He sets it against the backdrop of the Iraq War, with the fundamental ethical issues that the protracted conflict has raised. There are many moral diptychs, but Baudelaire has pushed the boundaries of the genre, determined to open our eyes more fully. The location is Hollywood, city of dreams. In a television production studio the set is prepared. Costume designers, set designers, extras: everyone sets to work. In a matter of days, a neighbourhood has been created out of nothing. It could have been in Baghdad, Kirkuk, Samarra or Nasiriya. Enter the actors, and there you have it, the first two frames of the film. A bomb has just exploded, and six bodies are lying on the ground. A woman bends over a body. Perhaps it is her son, or maybe her husband. A soldier points a gun at a man; another one points his gun at us; an old man puts his hand to his brow, and a camera-man films the scene. It seems to be real enough. It looks like one of those pictures that once upon a time we would have pored over, but now merely glance at distractedly, never bothering to question it. Baudelaire's diptych, with all its 'dreadful details', teaches us that we must learn to question what we see, and to look at it with new eyes, with genuine revulsion, as if we were seeing it for the first time.

The Dreadful Details, diptych, C-print, diasec and oak frame, 2006

© E. Baudelaire. Courtesy of the Elizabeth Dee Gallery, and the Juana de Aizpuru Gallery. Commissioned by the CNAP

BORN IN SALT LAKE CITY in 1973, Eric Baudelaire now lives and works in Paris. He uses photography, video and installations to explore the problems of perception, and the relationship between the media, politics and current affairs. His work is represented in personal collections at the Elizabeth Dee Gallery (New York), the Juana de Aizpuru Gallery (Madrid), the Musée de la Photographie (Charleroi) and Phillips de Pury (New York), and works by him are also housed in the Centre Pompidou, the Fonds National d'Art Contemporain and the FRAC Auvergne. In 2002 he received a fellowship from the New York Foundation for the Arts, and in 2005 he won the Fondation HSBC pour la Photographie Prize. His books include *Imagined States* (2005) and *Site Displacement/Déplacement de site* (2007). In 2008 he was artist in residence at Villa Kujoyama in Kyoto.

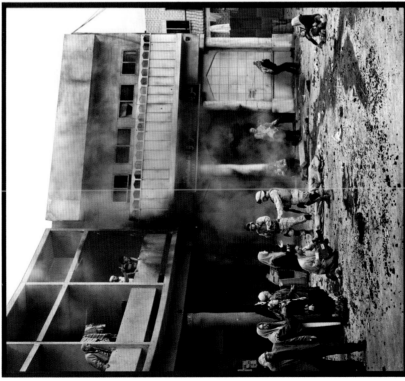

LARRY BURROWS

Americans at home were confronted with the true horrors of the Vietnam War when they flicked through the pages of *Life* magazine and saw photographs of the conflict in colour. Never before had a war been portrayed in such a graphic way. This iconic photograph, taken by Larry Burrows on 5 October 1966 after Marines had been caught in an ambush on Mutter Ridge, was the first image to capture the apocalyptic devastation, the desperation, the loneliness, the cruelty, of being first at the mercy of one's own country and then of the enemy, but it was also the first image to capture the compassion. On the hillside, a makeshift first aid base, one wounded soldier in the centre, bandaged, bloodied and in shock, is seen reaching out to a stricken comrade in the mud; the photograph is known as 'Reaching Out', in reference to this gesture. Burrows's response is that of a journalist, a photographer, an artist and a human being, and demonstrates his balanced approach, sensitivity and sense of justice in documenting the conflict. The emotive scene is emphasized by the use of colour – the single red bloodstain on the bandage, which becomes the focal point of the whole picture, the scorched earth, the muted cyan. The two soldiers look at each other, with the diagonal position of the bandaged man's arms and the limbs of the men on the left-hand side of the image directing attention to the man on the ground. There are other figures in the foreground and in the background, framing the central scene, against a distant landscape that is reminiscent of a fifteenth-century painting. The art of photography explores the art of war.

South of the DMZ, Vietnam, 1966

© *Larry Burrows*

LARRY BURROWS was born in London in 1926. When he was sixteen he went to work for *Life* as a darkroom assistant, and then as a laboratory technician. During the war he was sent to work in a coalmine. Between 1945 and 1961 he worked on over 700 assignments in Europe, the Middle East, Africa and Pakistan. In 1961 he was taken on by *Life* and sent to Hong Kong, transferring to Vietnam in 1962. It was to be his war, as evidenced by the posthumous book *Vietnam* (2002). His first photo essay in colour was published in 1963, and 'Vietnam: A Degree of Disillusion' came out in 1969. In 1971 the helicopter in which he was travelling was shot down over Laos.

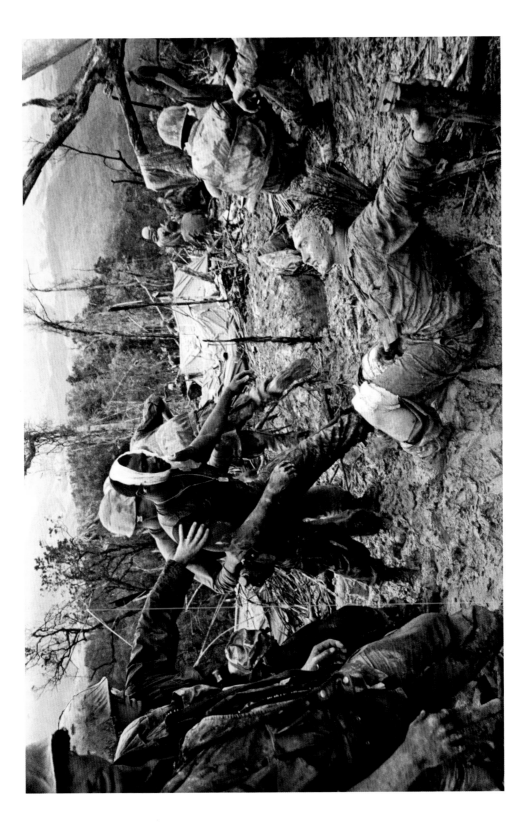

ROBERT CAPA

As dawn broke on 6 June 1944, American troops disembarked at Omaha Beach, the code name for one of the landing points along a stretch of the Normandy coast. The famous photojournalist and war correspondent for *Life*, Robert Capa, was among them, arriving with the first wave of Allied soldiers shortly after dawn. In what was to become one of his most famous assignments, he courageously followed American soldiers as they forged a way ashore, trying to protect themselves from the enemy fire that was tearing holes in the water. 'It was still very early and very gray for good pictures,' he wrote in his autobiography, 'but the gray water and the gray sky made the little men, dodging under the surrealistic designs of Hitler's anti-invasion brain trust, very effective.' The next day he sent the negatives to the London offices of *Life*. A darkroom technician, in his haste and excitement, dried the film too quickly and melted the emulsion, causing the photographs to be blurred and grainy. Out of 106 frames, only eleven could be salvaged. *Life* published ten of these, describing them as 'slightly out of focus', due to the photographer's hands shaking with fear as he held the camera. Something that started out as a technical error thus acquired a semantic value, effectively conveying the chaos of that day and Capa's active participation in the recording of history. The irony was not lost on him; indeed Capa decided to use the phrase 'slightly out of focus' as the title for his memoirs.

American troops disembarking on Omaha Beach, Normandy, 6 June 1944

© Robert Capa/ Magnum Photos

BORN ANDRE ERNO FRIEDMANN in Hungary in 1913, Robert Capa later became a US citizen. He shot to international fame with his photographs of the Spanish Civil War, in particular the celebrated image of the 'Falling Soldier' – a militiaman killed by a shot to the chest – and went on to report on the Second World War for *Collier's* and *Life* magazines. In 1947 he founded Magnum Photos with Henri Cartier-Bresson, David 'Chim' Seymour and George Rodger. In his career as a photojournalist, courageous war correspondent, celebrity portraitist and Magnum leading light, Robert Capa created many of the iconic images that have shaped the collective memory of the twentieth century. In 1954 he was killed after stepping on a landmine while covering the war in Indochina.

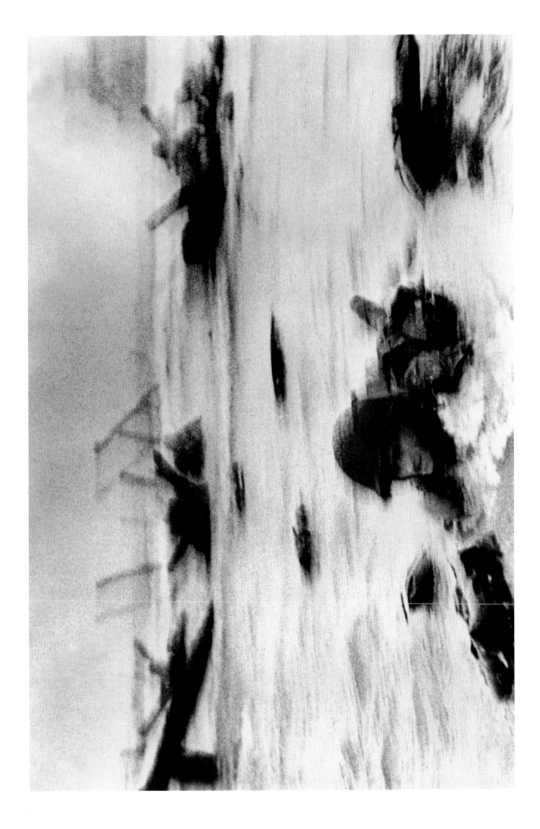

STUART FRANKLIN

On 13 May 1989 students thronged Tiananmen Square and began a hunger strike, demanding two things of the Chinese government: dialogue and democratic reform. Instead, they were subjected to martial law. The demonstrations started off peacefully: participants sang the 'Internationale' and on 30 May erected an enormous statue of polystyrene and papier-mâché, the Goddess of Democracy, in the middle of the square. However, during the night of 3 June, the army began to close in on the occupied square and opened fire wherever it encountered resistance. It was a bloodbath. Stuart Franklin was in Beijing covering the protest for Magnum, and along with many other journalists he was staying in a hotel that looked onto the square. On the morning of 5 June he went out onto his balcony and saw the tanks coming up Chang An Avenue. Lines of students confronted them. The army fired shots to disperse them. 'I saw this student emerge and stand in front of a tank,' Franklin explained. 'The tank stopped. He climbed up on the tank and talked to the driver in the turret. Then he stood in front of the tank again until three civilians dragged him away, and the tanks carried on.' There were other photographers in the same hotel, and at least three of them captured the same moment. The photograph taken by Stuart Franklin appeared in newspapers around the world and won him the World Press Photo Award. In 2003 *Life* included it among the 100 photographs that changed the world. The incredible simplicity of the single, anonymous figure confronting the vast array of military power, clutching nothing but a couple of shopping bags, spoke a thousand words and symbolized a ray of hope for humanity. In 1998 *Time* magazine included 'The Unknown Rebel' in its list of the most important people of the twentieth century.

Tiananmen Square, Beijing, 1989

© Stuart Franklin/ Magnum Photos

BORN IN LONDON in 1956, Stuart Franklin studied photography at the West Surrey College of Art and Design, and geography at Oxford University. In the early 1980s he worked as a correspondent for the agency Sygma in Paris. He was invited to join Magnum in 1985 and has been a full member since 1990. His photograph of Tiananmen Square won the World Press Photo Award, and he also won the Tom Hopkinson Award for photojournalism, and the Christian Aid Award for humanitarian photography, acknowledging his work during the famine in the Sahel (1984–85). Since the 1990s he has photographed many stories for *National Geographic* magazine, travelling widely in his role as a photojournalist to cover issues connected with the changing landscape. His published works include the photo essay *The Time of Trees* (1999) and *Footprint: Our Landscape in Flux* (2008).

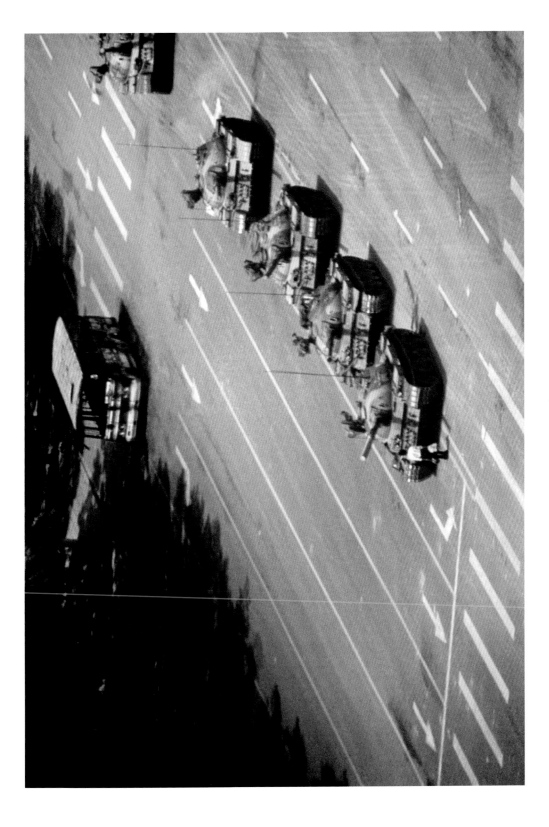

PHILIP JONES GRIFFITHS

Philip Jones Griffiths once said that truth emerges in times of war: trapped precariously between life and death, people reveal their true selves, drop their masks, and display a unique honesty. In this photograph, which was taken in Northern Ireland in 1973 during the period of conflict known as 'the troubles', we see a man's face behind a scratched surface. He is wearing a helmet, and his eyes are like two dark shadows. The image is disconcerting because it is not immediately comprehensible; it is a visual enigma. The subject, a British soldier, stands behind an anti-riot shield of Plexiglas which has been scarred by the marks of direct hits. There seems to be a visual stand-off between the observer and the subject; the kind of detachment that war imposes on the humanity of the individual. Philip Jones Griffiths was one of the most perceptive and sensitive commentators on the devastating absurdity of war, describing it as 'the worst thing people do to each other'. He experienced the conflict in Vietnam, bringing to the West images not only of the daily skirmishes, but also of the many different aspects of a country torn apart by violence. His book *Vietnam Inc.*, published in 1971, is a work of unsurpassed visual potency which testifies to an epoch in history. Griffiths developed a new style of photography, which became a reference point for all photographers who believe reportage to be not just a job, but a mission. This photograph, which appears on the front cover of his book *Dark Odyssey* (1996), a retrospective of forty years of documenting the chaos of the world, has the power to transcend its original context, and it has become a metaphor for the absurd condition of humanity during war.

Soldier behind an anti-riot shield, Northern Ireland, 1973

© *Philip Jones Griffiths/ Magnum Photos*

PHILIP JONES GRIFFITHS was born in Wales in 1936. He studied pharmacy in Liverpool, and worked for three years as a pharmacist in London, spending his days in the pursuit of photography, and working for the *Manchester Guardian*. In 1961 he became a full-time photographer for the *Observer* in London, and the following year he reported on the war in Algeria, travelling with the FLN (National Liberation Front). He joined Magnum in 1966 (he became a full member in 1971) and was sent to Vietnam, where he remained until 1968, making several further trips thereafter. In 1971 he published *Vietnam Inc.* In 1973 he covered the Yom Kippur War, and worked in Cambodia until 1975. He moved to New York in 1980. In his final years he made many documentaries for the BBC and for the Office of the United Nations High Commissioner for Refugees. He died at his home in London in March 2008.

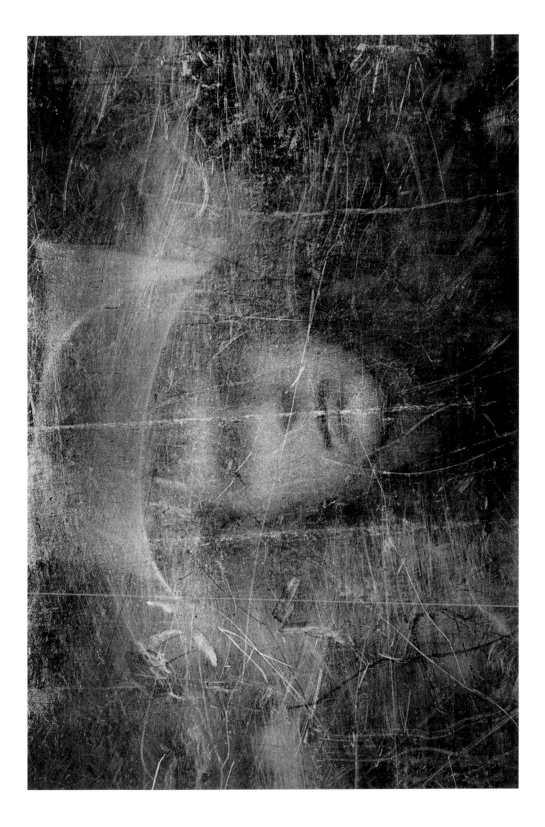

RON HAVIV

During the violent ethnic conflicts of the Yugoslav Wars, it was difficult to identify the combatants and distinguish the professional soldiers from the militiamen in uniform. There were attacks on armed men and on innocent civilians, targeting anyone who was deemed 'different'. Ron Haviv was one of the first photojournalists to follow this civil war. On 31 March 1992 he was in Bijeljina, a city in the north-east of Bosnia. The infamous Serbian paramilitary leader known as Arkan was patrolling the deserted streets of the city with his death-squads, the 'Tigers'. Haviv had permission to follow the group, and was sheltering behind an abandoned truck. Suddenly, as he watched, the gunmen dragged a family of Bosnian Muslims out of their house and shot them dead on the street. Haviv knew that in order to prove that this unspeakable crime had taken place, he needed to capture the Tigers and their victims in the same frame. This picture shows the moment when a young Serbian soldier, with his sunglasses tilted back on his head and a cigarette in his left hand, walked over to the lifeless bodies of the family and raised his black boot to kick one of the female victims in the head. Haviv clicked the shutter and caught this shocking act on film. His pictures appeared in magazines and newspapers all over the world and provided the first incontrovertible evidence of the atrocities taking place at the heart of Europe. Arkan was incensed by the photographs. Haviv was kidnapped, accused of being a spy, interrogated and beaten for three days, but was released after diplomatic intervention from the West. However, he continued to work in the former Yugoslavia until 2001, documenting the genocide, and his book *Blood and Honey: A Balkan War Journal* (2000) serves as a constant reminder of those times, and as a warning. The photographs he took on that day in Bijeljina were used as evidence for the prosecution during the trial of Slobodan Milosevic and his troops at The Hague.

Arkan's troops attacking Muslim civilians, Bijeljina, Bosnia, 31 March 1992

© Ron Haviv/VII

RON HAVIV was born in 1965 and studied journalism at the University of New York, initially taking photographs as a hobby. In 1989 he had the opportunity to go to Panama for the re-election of Noriega; his photograph of the beaten and bloodied vice president was published on the front page of the newspapers. He then went on to cover the drug wars in Cambodia, the release of Nelson Mandela, the Gulf War, the exodus of the Kurdish people from Iraq, and most notably the war in the former Yugoslavia. He worked as a photographer for *Newsweek*, and was one of the founders of the VII photo agency. His work has earned him numerous World Press Photo awards, an Overseas Press Club Award, and the Leica Medal of Excellence. In 2000 he published *Blood and Honey: A Balkan War Journal*, which accompanied the exhibition of the same name.

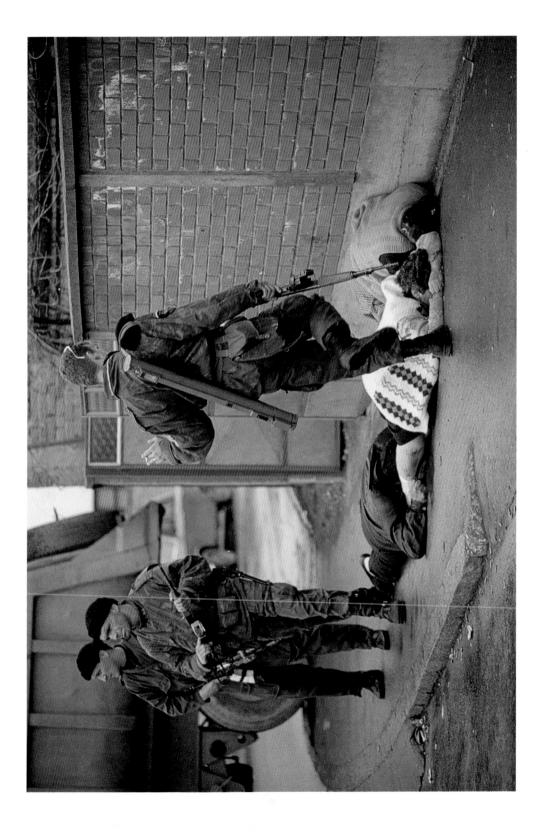

GARY KNIGHT

Since the Second World War a new visual language has come into being, a rhetoric of war that makes use of classical forms of expression. Images of saints, their hands clasped in prayer or raised heavenwards, or great divas in languid poses, bathed in the softest of lights, have been replaced with photographs of war: soldiers running, or on the ground, or taking cover behind a wall, assisting wounded comrades or urging on the attack. This photograph was taken by Gary Knight on 7 April 2003, on the bridge at Diwaniya, which was a vital access point for the Americans in the invasion and occupation of Baghdad. The siege, conducted by the 3rd battalion of the 4th Marines, lasted for three days. Knight took fifty-seven shots in total. The line of soldiers snakes down the middle of the photograph, between the geometric shapes of the iron structure. An image takes shape in the confusion: there is a sculptural plasticity in the composition, which focuses on the open mouth and on the arm raised in the foreground. In an iconographic parallel, the statue of Saddam Hussein was to be toppled in the centre of Baghdad only two days later, his arm raised in leadership, as if greeting his people; a powerful gesture – both heroic and paternal – that has endured through the ages and been seized upon by totalitarian regimes throughout history.

Baghdad, 2003

© *Gary Knight/VII*

GARY KNIGHT was born in 1964 in Oakham, England. He moved to Bangkok, and began working as a photographer in the late 1980s, primarily in the countries of South East Asia and Indochina. In 1993 he moved to the former Yugoslavia, where he documented each successive phase of the war. He is a member of the Crimes of War Foundation. He was co-founder of the VII photo agency (2001), the current affairs quarterly *Dispatches* (2008) and the Angkor Photography Festival. He covered the invasion of Iraq, the occupation of Afghanistan, the civil war in Kashmir and the tsunami in Asia. In 2002 he published *Evidence: War Crimes in Kosovo*. He works as a freelance photographer for *Newsweek*, and his images have been published in all the major international newspapers.

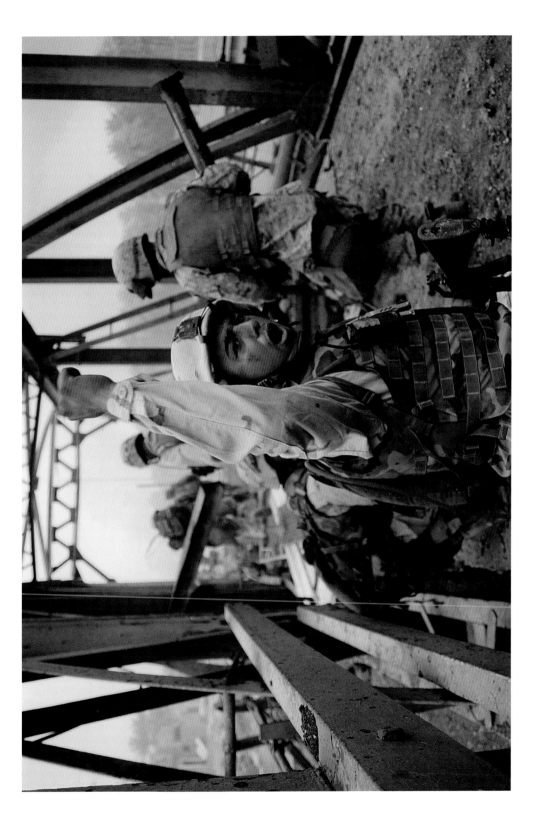

JOSEF KOUDELKA

In the early hours of 21 August 1968, troops of the Soviet-led Warsaw Pact invaded the Czechoslovak Socialist Republic with a contingent of 600,000 soldiers and more than 5,000 armoured vehicles. It was a bold and unexpectedly aggressive move. The 'socialism with a human face' advocated by the reformist Slovak Alexander Dubcek appeared too great a threat to the Soviets, who responded by sending tanks to occupy the streets of Prague. Koudelka was there: it was his own country, his own city. He was thirty years old and had recently decided to become a full-time photographer. Enraged by what he was seeing on the streets, he began to take pictures, acting not as a photojournalist but as a citizen, a protester and an active participant. He documented the soldiers on the streets, and the courage of those brave enough to run among the caterpillar tanks in an attempt to stop the violence, using all manner of means to express their outrage, including graffiti. During those days, Prague came to represent the struggles of a small country against the oppression of a great power. The photographs taken by Koudelka were to change his life. They were smuggled out of the city and into the hands of the Magnum office in New York, and on the first anniversary of the invasion, the agency decided to circulate them to the newspapers, but anonymously, so as to protect the photographer and his family. It was quite by chance, while travelling around England, that Koudelka saw his photographs in the *Sunday Times*. He sought asylum in Great Britain, began a new life as a stateless person, and turned to photojournalism – documenting the lives of gypsies in Western Europe. In 1980 he settled in France. It was only in 1984, after the death of his father, that Koudelka felt he could finally admit to authorship of the photographs, but he did not return to his country until after the fall of the Berlin Wall. The photographs were not published in Czechoslovakia until 1990.

The invasion of Warsaw Pact troops, Prague, 1968

© Josef Koudelka/ Magnum Photos

BORN IN CZECHOSLOVAKIA in 1938, Josef Koudelka studied engineering in Prague and began photographing theatre. During his career as an aeronautical engineer, he took many photographs of gypsies. From 1967 onwards he devoted himself solely to photography. In the summer of 1968 he documented the Soviet invasion of Prague. His photographs were smuggled across the border and published anonymously by Magnum. He was awarded the Robert Capa Gold Medal for them. In 1971 he joined Magnum, becoming a full member in 1974. He settled in France in 1980. In 1986 he took part in the DATAR project, photographing the French countryside, and started to use a panoramic camera. His books include *Gitans, la fin du voyage/Gypsies* (1975), *Exils/Exiles* (1988), *Chaos* (1999), the retrospective *Koudelka* (2006), and *Invasion Prague 68* (2008).

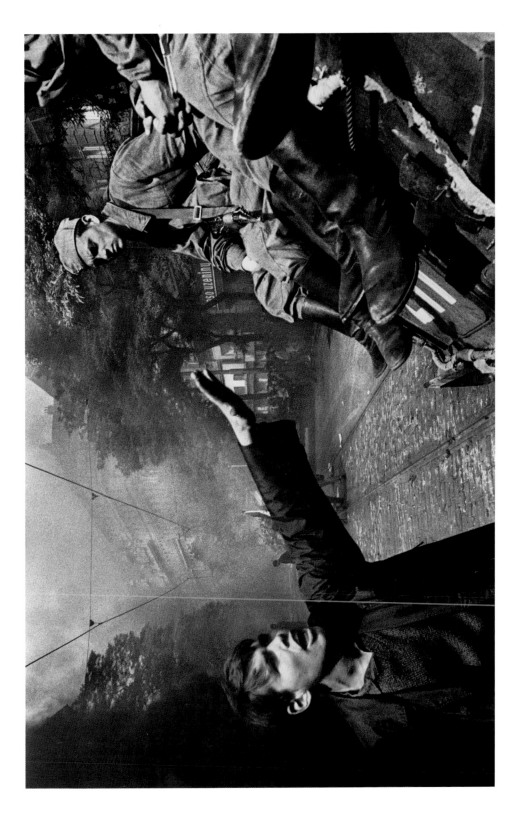

DON MCCULLIN

During the fierce Tet Offensive at Hue in 1968, Don McCullin approached an American Marine and took one of the most extraordinary portraits of contemporary photography. It is the universal image of the soldier, with the stunned and vacant expression of one who can no longer endure the horrors of war, an image that is etched on the memory like a photograph that will never fade. As with the nineteenth-century photographer George Barnard, who decided to re-enact scenes from the American Civil War and photograph them days and even months after the end of the conflict, McCullin focused on the aftermath of the fighting, on the cruelty and unbearable suffering inflicted. According to Susan Sontag, there was no mistaking the intention behind this impassioned portrayal of hell: McCullin wanted to create portraits that would move the heart. Indeed, the image of the Marine at Hue is striking in its neutrality: the immobility of the subject transcends its medium. There is no consolation to be found, and the soldier, compressed within the confines of the picture, clutches his rifle like an old man clutching his walking stick.

An American Marine suffering from shell-shock, Hue, 1968

© Don McCullin/Contact Press Images/Grazia Neri

DON MCCULLIN was born in London in 1935. He did his national service in the RAF, where he became an assistant photographer, taking aerial shots during reconnaissance missions. His first professional photographs, of a London gang, appeared in the *Observer* in 1959. In 1961 he photographed the building of the Berlin Wall, and in 1964 he did his first piece of war reportage from Cyprus, winning the World Press Photo Award for the best picture of the year. He travelled to Vietnam in 1965, and since then he has covered most major international conflicts. In 1980 he received the ultimate accolade: his first major retrospective, at the Victoria and Albert Museum in London. In recent years his career as a photojournalist has taken him to Africa and Oceania.

GEORGES MÉRILLON

Some photographs remain etched on the memory. They stand out from the rest, from the avalanche of images with which the media bombards us every day and turns us into indifferent observers. Some pictures have both a political and an aesthetic dimension, contributing to the fabric of history and memory. In late January 1990, Georges Mérillon, then working for the Gamma agency, decided to travel to Kosovo without an interpreter and without an escort. Apart from some stone-throwing at the police in Pristina, he had witnessed very little violence, but then he came across this scene. He had followed a French television crew to a village where there had been a protest and the police had killed four Kosovan soldiers. The journalists were led into a house where the body of a twenty-eight-year-old man was covered with a sheet, surrounded by female mourners. Mérillon waited until the television crew had taken their footage, turned off their strong lighting, and left the house. The result was an image of iconographic status, and it won the World Press Photo Award for the picture of the year in 1990. Dim, natural light is filtered through the window into the room, sculpting the faces of the women and highlighting shapes and shadows, in the manner of Mantegna or Caravaggio. The scene shows a Muslim funeral rite and yet it is reminiscent of the iconography of the Deposition of Christ: two cultures, in a time of fierce ethnic fighting, discover in a moment of extreme grief and loss, a communality of gesture and custom. The marvellously classical composition of the image makes its impact on Western eyes all the more powerful, touching something profoundly intimate and familiar in our own culture, and bringing the suffering of this remote village in Kosovo closer to home.

A funeral shroud covers the body of Nasimi Elshani, a Kosovan soldier killed by troops loyal to the government of Milosevic, Nogovac village, 1990

© Georges Mérillon/ Gamma/EYEDEA

GEORGES MÉRILLON was born in France in 1957. In 1981 he co-founded the agency Collectif Presse and in 1987 joined the agency Gamma. He went on to cover the fall of the Berlin Wall, the Gulf War and numerous other events of international importance. From 1990 he documented the war in the former Yugoslavia. He became chief editor of Gamma in 2001 and editorial director in 2004 but left the agency in 2005 to pursue new projects. He has received numerous prizes for his work, which has appeared in all the major international publications.

JAMES NACHTWEY

James Nachtwey lives in New York and on 11 September found himself only metres away from the Twin Towers. Used to reporting on world events, he made his way through the fleeing crowds towards the scene, taking photographs of casualties as they were being helped by doctors and paramedics or lying by the side of the road waiting for help. He was shooting the South Tower, with the cross of a church in the foreground, when the skyscraper collapsed. It was only at the very last minute that he realized that he was about to be hit. As he ran to seek cover on the opposite side of the street, the ruins crashed down and the street quickly became engulfed in smoke. Nachtwey is one of the most famous photojournalists of our time, and his life has been devoted to visual testimony. He has documented the major disasters that have afflicted the planet, brought events into the public eye, and shown the newspaper-reading public the true nature of war and its aftermath. On that particular afternoon he was on the frontline again, but in his own city this time, demonstrating his innate drive to document atrocities despite the risks: 'My instinct was to go to the place where the [first] tower had fallen… As I was photographing the destruction of the first tower, the second tower fell and I was standing right under it, literally right under it.' He dashed into the lobby of a hotel and through the open doors of a lift as the debris crashed to the ground around him: 'The debris swept through the lobby and it instantly became pitch black, as if you were in a closet with the light out and a blindfold on. You could not see anything. It was very difficult to breathe. My mouth, my nose, my eyes were filled with ashes.' On that day, he conquered any fear for the sake of documenting events as they unfolded and took many colour photographs spontaneously, because his main aim was to get them published as quickly as possible, and into the hands of the public. It was his way of finding meaning as he stumbled over the ruins of that never-ending day.

New York, 11 September 2001

© James Nachtwey/VII

JAMES NACHTWEY was born in Syracuse, New York, in 1948. Self-taught, he began his career working as a freelance photographer in New York in 1980. He worked for *Time* magazine from 1984, and was a member of Magnum from 1986 to 2001. He was one of the founders of the agency VII. In 2003 he was seriously injured by a grenade attack on a jeep in which he was travelling with some American soldiers. He is particularly well known for his work on Afghanistan, Rwanda, post-Ceausescu Romania, and Eastern Europe. He has won the Robert Capa Gold Medal five times, the Magazine Photographer of the Year Award six times, and has been a recipient of the W. Eugene Smith Grant in Humanistic Photography.

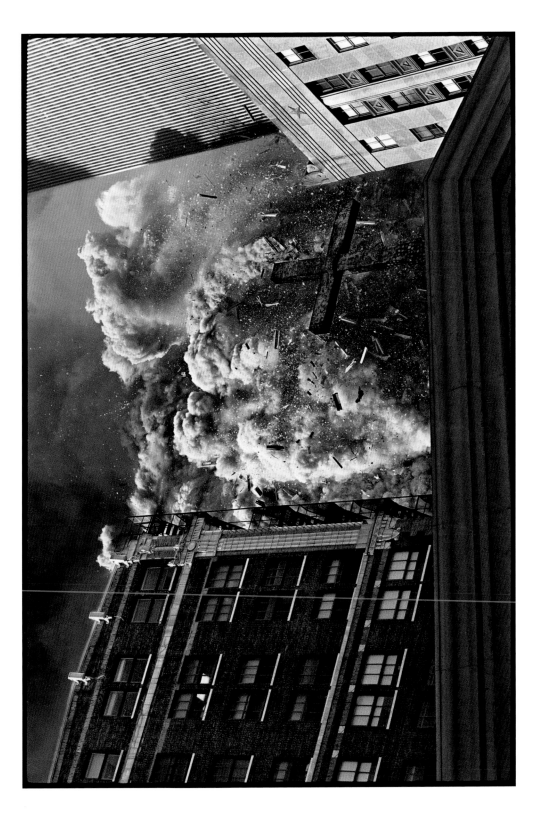

PAOLO PELLEGRIN

The smoke in the background, like a cinematic special effect, obscures the extent of the disaster. The bent heads of the men in the foreground act as a barrier, blocking the view of the onlooker, who has become immune to such scenes of violence. Yet the raised arm is summoning help and commands attention. In Pellegrin's words: 'I'm more interested in a photography that is "unfinished" – a photography that is suggestive and can trigger a conversation or dialogue. There are pictures that are closed, finished, to which there is no way in, no invitation to the spectator to engage in a dialogue. They may be extremely beautiful or complex, but I find them less interesting. I prefer photographs that beg questions.' The raised arm of the man acts as our invitation to ask questions about the world. In a short while the smoke will have dispersed, the people will have moved on, and all that will remain will be the lifeless backdrop of a war-torn world. It was August 2006, and Beirut was under aerial attack from Israel, in a thirty-four-day war that left most of southern Lebanon in ruins. Paolo Pellegrin was there to record in black and white the life and suffering of a people under continuous enemy fire. He was wounded himself, but for him there was no turning back. For this assignment he was to receive the most prestigious award of all, one that acts as an incentive to risk life or death: the Robert Capa Award for bravery. 'Each time you click the shutter, you are revealing your thoughts about the world; you are taking a certain stance, and your composition will reflect that stance: photography does not merely involve the documentation of facts, but also the filtering of them through the light of your own experiences.'

After an Israeli air-raid, Beirut, Lebanon, August 2006

© Paolo Pellegrin/ Magnum Photos

BORN IN ROME in 1964, Paolo Pellegrin began to take photographs in the eighties, in collaboration with the agency VU, and then Grazia Neri. He joined Magnum Photos in 2001 and has been a full member since 2005. He has produced a wide-ranging body of work which has been published in all the major newspapers, and since 2000 he has been working extensively for *Newsweek*. He has received numerous awards over the years, including the Robert Capa Gold Medal (2007), the W. Eugene Smith Grant in Humanistic Photography (2006), the Leica Medal of Excellence (2001), and eight World Press Photo awards between 1995 and 2007. Together with other Magnum photographers, he created the touring exhibition and installation 'Off Broadway'. In 2007 he won the Leica European Publishers Award for Photography, and his book *As I was Dying* (2007) has been published in seven European countries.

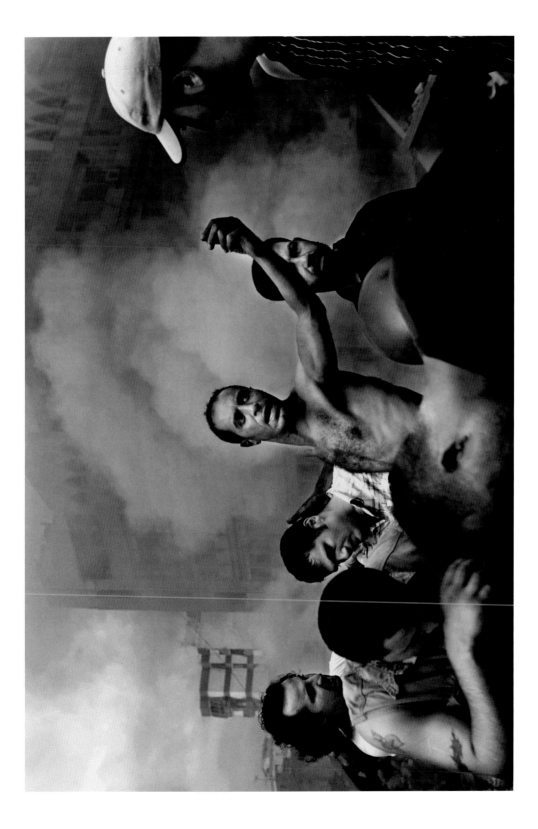

GILLES PERESS

What can the man in the foreground be hearing as he lies stretched out on the ground, weak from exhaustion and terror? Are there any words left after a massacre, after death has impregnated every fibre of your being and become the only certainty in your life? There is nothing, just silence. *The Silence* is the title chosen by Peress for his book on the genocide in Rwanda, with the article used to stress its ugly reality. In 1994, in the space of just over three months between the beginning of April and mid-July, an estimated 800,000 to a million people were brutally slaughtered. Most of the victims were Tutsis, the minority ethnic group, but economically stronger than the Hutus. The catalyst for the massacre occurred on 6 April, when the aeroplane carrying the president of Rwanda, Juvénal Habyarimana, was shot down by a missile attack. Those responsible were never found, but the massacre began the following day. Romeo Dallaire, commander of the UN peace-keeping forces, issued a grave warning that there was a risk of genocide, but the warning fell on deaf ears. The slaughter continued – in Gikongoro, for example, at the headquarters of the technical institute, where over 27,000 people were killed. But the West remained silent. When Peress arrived on the scene, having already experienced the fratricide in Bosnia, he saw before him the corpses of thousands of Tutsis and Hutus. He photographed them like a forensic detective, and the results are gruesome. In Peress' view the enormity of this crime, which was beyond the realms of the imagination, was surpassed only by the indifference shown by the West, which seemed incapable of intervening to prevent these atrocities: 'The passivity was as painful to witness as the horror itself.' The silence pervading the refugee camp in Goma, where 10,000 Rwandans sought refuge on 13 and 14 July 1994, lays bare the silence of the Western response.

Refugee camp in Goma, Zaire, 1994

© Gilles Peress/ Magnum Photos

GILLES PERESS was born in France in 1946. He studied at the Institut d'Études Politiques at the University of Vincennes and began to take photographs in the early seventies, producing an intimate portrayal of life in a French coal-mining village. He joined Magnum in 1971. In 1972 he went to Northern Ireland and covered the civil rights struggle. He continued to explore this theme in his book *Power in the Blood* (1996), the first part of his research into intolerance, and the re-emergence of nationalism in the post-war era. The subsequent volumes were entitled *Farewell to Bosnia* (1994) and *The Silence: Rwanda* (1995). During the 1979 hostage crisis at the American Embassy in Iran, Peress spent five weeks in the country, later publishing the book *Telex Iran: In the Name of Revolution* (1983).

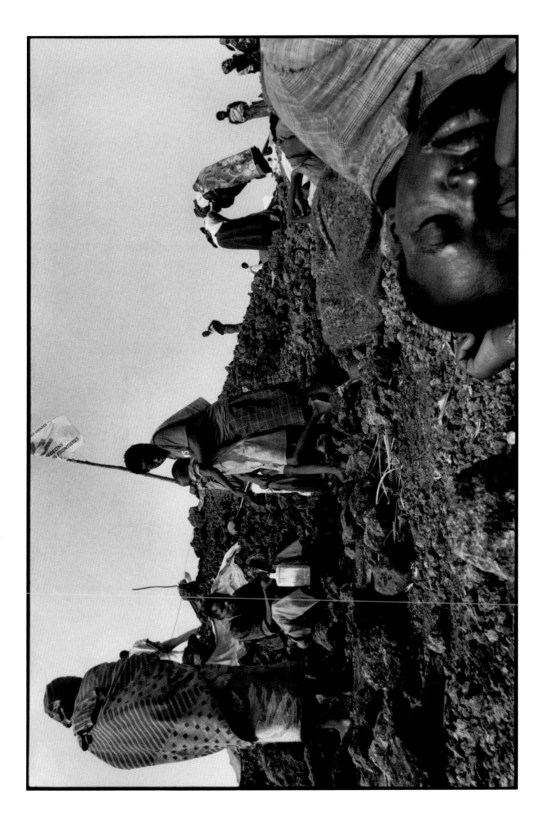

JOE ROSENTHAL

On 23 February 1945, when he was thirty-four, Joe Rosenthal picked up his Speed Graphic, set the shutter speed at 1/400th second and the aperture at between f/8 and f/11, and took one of the most famous war photographs of all time. For America and its army, 'Raising the Flag on Iwo Jima' – as the photograph is known – came to symbolize eternal victory. This powerful image inspired a sculpture at Arlington National Cemetery, just outside Washington, DC, a postage stamp, and a string of Hollywood movies, from *Sands of Iwo Jima* (1949) with John Wayne, to *Flags of our Fathers* (2006), directed by Clint Eastwood. On 19 February 1945, Marines disembarked on the island of Iwo Jima in the Pacific Ocean. It was a Japanese outpost, and the fighting was heavy. Four days later, during his daily reconnoitre, Rosenthal discovered that a group of soldiers had gone to hoist the American flag on the summit of Mount Suribachi, an extinct volcano. He quickly ascended the mountain, but arrived too late – the flag was already flying. A few metres further down, another group of Marines were about to hoist a second, larger flag on top of an iron pipe. His first idea was to photograph both flags, but then he decided to capture just one. He chose his position. Not being a tall man, he needed a more elevated view-point. He piled up some sandbags, climbed on top, and then realized that he had almost missed it. He grabbed his Speed Graphic and snapped, with scarcely a moment to frame the photograph. He took two other pictures, one of a few Marines having finished the job, and another of the whole group. A few hours later, the image had been printed and wired to the New York offices of AP. Seventeen hours later – a record for those days – it was on the front page of the newspapers. Decades later, the iconic image was to be re-echoed in Thomas Franklin's photograph of the three firemen hoisting the flag in the ruins of the World Trade Center following the attacks of 11 September 2001.

Marines hoisting the American flag on Mount Suribachi, Iwo Jima, 1945

© Joe Rosenthal/AP

JOE ROSENTHAL was born in Washington in 1911 to Russian parents. During the Great Depression, he moved to San Francisco with his brother, and began to take an interest in photography. In 1932 he became a reporter for the *San Francisco News*. At the outbreak of the Second World War, he applied to join the army as a military photographer, but was rejected because of his poor eyesight. Instead he joined AP, and was sent to cover the operations of the Marines in the Pacific. On 23 February 1945 he took his most famous photograph: 'Raising the Flag on Iwo Jima'. The image became iconic, and won the Pulitzer Prize. It was the first photograph to have won an award the same year it was taken. At the end of the war, and for the next thirty-five years, he worked for the *San Francisco Chronicle*. In 1996 he was named an honorary Marine. He died in 2006.

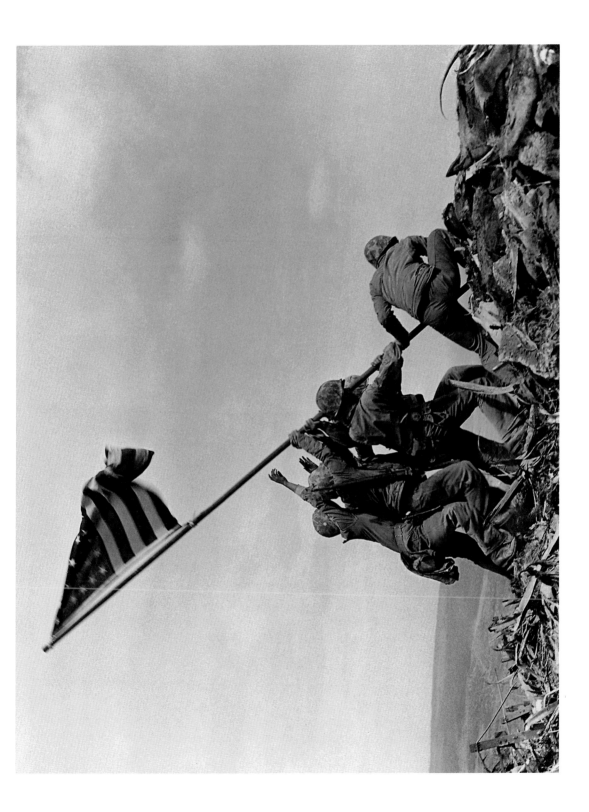

W. EUGENE SMITH

A soldier takes a sip of water before facing death again. In a rare moment of peace, he stares into the distance knowing that he must soon return to the killing and the destruction of everything, internal and external. That was the nature of war, as documented by W. Eugene Smith, the legendary American photojournalist and icon of humanist photography, who in 1942 was sent to the Pacific Front, initially by *Flying* and then by *Life* magazine. He covered over thirty missions, including the capture of Saipan and Guam, and was seriously injured at Okinawa, where 12,500 American and 66,000 Japanese soldiers died. But the statistics were of secondary importance to this photographer; what really struck him was the tragedy of man, the eternal victim, caught up in an endless struggle between light and darkness, in which darkness almost always seemed to have the upper hand. Smith was weighed down by the suicide of his father, and by a sense of impending existential doom, and so he knew instinctively how to portray in simple gestures man's desperate and heroic struggle to overcome tragedy. In this case the subject of the tragedy was the carnage of war, and many of his pictures, particularly those showing the violence of the American army, were deemed too brutal to be published. On other occasions it might be sickness, as in his renowned photo essay 'A Man of Mercy' about Albert Schweitzer, doctor and winner of the Nobel Prize, who worked in the leper colony at Lambaréné in Gabon. Or the tragedy might be the agony of a mother holding the deformed body of her son, the subject of a photograph taken during his coverage of the pollution disaster which decimated the Japanese fishing village of Minamata, when the waters became contaminated with mercury. The sip of water that the soldier takes in this photograph is also tainted: his fixed gaze tells of a universal living death, whether then, later in Vietnam, in our so-called peace operations or beyond the realms of war.

Second World War, Battle of Saipan Island, 27 June 1944

© *W. Eugene Smith/ Magnum Photos*

W. EUGENE SMITH was born in 1918 in Wichita, Kansas. In 1937 he enrolled at the New York Institute of Photography. In 1939 he was employed by *Life*, but later left the magazine. He rejoined *Life* in 1947 and worked there until 1954, producing photo essays such as 'Country Doctor' and 'Spanish Village'. In 1955 he joined Magnum, and began an ambitious project about Pittsburgh (a series that was finally published in 2001), but resigned in 1959. In 1971 the Jewish Museum in New York mounted his retrospective 'Let Truth Be The Prejudice', curated by Cornell Capa. From 1971 to 1975 Smith was in Japan producing his photo essay on the Minamata tragedy. In 1977 he began teaching at the Center for Creative Photography in Tucson. He died in 1978. The W. Eugene Smith Grant was created in his honour and gives annual awards to the best photojournalists in the world.

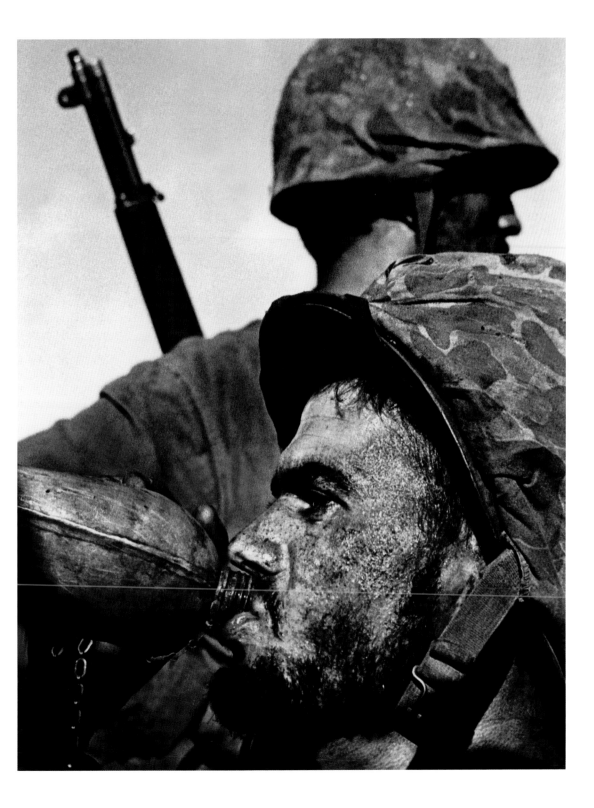

NICK UT

It is a picture that has left its mark on an entire generation. A naked and desperate young girl runs screaming towards the camera, breaks down the wall of indifference, and demands a response. Nick Ut immortalized a moment that has a timeless quality, and the image has come to symbolize the atrocity of all conflicts. Ut was covering the Vietnam War for AP at the time. On that day in June, he heard that the North Vietnamese army was heading down Route 1 and set off in that direction in a jeep. For three days there was fighting between the North Vietnamese and South Vietnamese armies on the outskirts of the village of Trang Bang, resulting in the displacement of thousands of people. Towards midday journalists were informed that aerial reinforcement was on its way. The objective was to flush out the Vietcong who were allegedly hiding in the village. The bombing started: first explosive bombs, then napalm incendiary bombs. The sky was completely obscured by smoke. After twenty minutes or so the first few silhouettes of people came into view, emerging from the darkness. They looked like ghosts. There were no Vietcong, only civilians: women and children, seared with burns, carrying dead or badly burned babies in their arms. Nick Ut's hands shook as he took the iconic photograph. Nine-year-old Phan Thi Kim Phuc was running towards him, screaming with fear and in agony from her terrible injuries. Her clothes had been burned off her back and she was in desperate need of water. Her brothers ran screaming alongside her. Their parents were trapped underneath the rubble. Water was not enough to relieve the girl's tiny frame. Ut put down his camera, carried her into the jeep, and rushed her to the nearest hospital. He stayed by her side until the nurses took her into the operating theatre, and then returned to Saigon to show the world the true horrors of the war. Twenty-eight years later, in London, in the presence of Queen Elizabeth, Phan Thi Kim Phuc was able to thank the photographer publically for saving her life.

Phan Thi Kim Phuc fleeing her village after a napalm attack, Vietnam, 8 June 1972

© Nick Ut/AP

NICK UT was born in Long An, Vietnam, in 1951. When he was sixteen, after the death of his older brother in the war, he began to work for AP, and travelled to South Korea, Japan and the Vietnamese city of Hanoi. His most famous photograph, for which he won the Pulitzer Prize, shows a young Vietnamese girl, Kim Phuc, fleeing the village of Trang Bang after a napalm attack during the Vietnam War. He became an American citizen and now works for AP from Los Angeles.

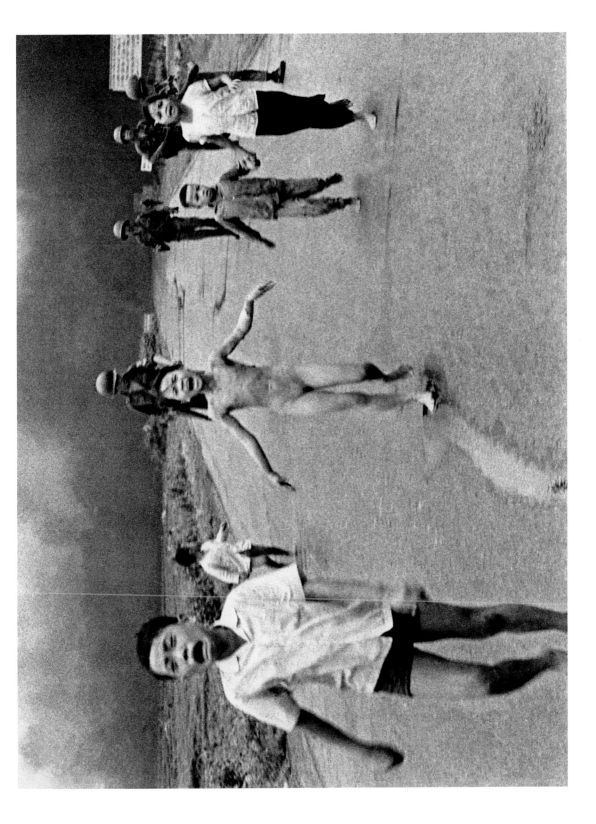

FRATELLI ALINARI

There must have been a sense of fun that day, when the staff of the Alinari firm posed together for a group photograph. It is one of those images that evokes a certain nostalgia for times past. It is unlikely that these amusing gentlemen, pointedly avoiding looking at the camera, could have guessed that the enterprise they worked for would come to play such an important role in the cultural history of Italy, and that this staff photograph would become famous. The firm has continued to flourish from those early beginnings right up until the present day, using the same premises seen in the photograph, the same photographic workshops, and the same artisan technique of collotype printing. It all began in 1852 when, together with the copperplate engraver Luigi Bardi, the photographer Leopoldo Alinari opened a small studio in grand ducal Florence. Two years later, with the help of his brothers Romualdo and Giuseppe, he founded the Fratelli Alinari company, the oldest photographic firm in the world. The three brothers had in mind an ambitious and wide-ranging cultural project, that of reproducing the most famous works of art and monuments in Italy. Over the years, the style and subject matter diversified to include scenes from daily life. The company acquired important photo archives, and now possesses a collection of three and a half million images, which constitutes a historical portrait of Italy and the Italian people, their customs, their art and their society. Today, the Fratelli Alinari Museum of Photographic History plays an important role in research and in the conservation and dissemination of its collection of photographs from around the world, which date from the nineteenth century to the present day.

Portrait of the employees of the photographic firm Fratelli Alinari (Alinari Brothers), Florence, 1899

© Archivi Alinari, Florence www.alinariarchives.it

LEOPOLDO ALINARI (1832–65) first started work in Florence, alongside the copperplate engraver Luigi Bardi. In 1854 he founded a company with his brothers Romualdo (1830–99) and Giuseppe (1836–90). Their main subjects were landscapes, townscapes and monuments. In 1861 they took part in the Florence Exhibition, and launched the Fratelli Alinari firm. In 1890 Leopoldo's son Vittorio (1859–1932) took over the management of the company. Since 1893 the company has been producing limited-edition art reproductions, using the sophisticated technique of printing known as collotype. In 1921 Vittorio produced a work comprising all the landscapes in the *Divine Comedy*. This was his magnum opus, and the jewel in the crown of the Alinari family's work.

EVE ARNOLD

A Magnum Photos anecdote recounts Robert Capa's comment on Eve Arnold's photography. He is said to have described her work as 'falling between Marlene Dietrich's legs and the bitter lives of migratory potato pickers'. Eve Arnold was the first woman to be employed by the famous photographic agency, and her strong, determined personality enabled her to move between the extremes of social documentary and the glittering world of Hollywood stars. She spent many hours on set with the sirens of the silver screen, getting to know them and trying to discover the human being beneath each façade. She first met Marilyn Monroe at a party in the early fifties. Arnold had just published some photographs of Marlene Dietrich, and Marilyn asked her if she thought she might be able to do as good a job on her as she had on Marlene. The two women worked together several times over the years, culminating in Arnold's reportage on the set of John Huston's *The Misfits* in 1961. 'She adored the camera, and loved to pose in the studio,' Arnold remembers. 'I didn't like that type of photograph particularly, but I wanted to indulge her. I was curious to know what fantasies she had about herself, and how she would like to appear. I asked her who she would like to be, and she replied: Botticelli's Venus.' Both women used to play a game with each other, pitting the art of seduction against the art of portraiture. Arnold was able to get beneath the luminous and frivolous exterior of the legendary diva, and portray her as a real and fragile woman.

Marilyn Monroe, Hollywood, 1960

© Eve Arnold/ Magnum Photos

EVE ARNOLD was born in Philadelphia, USA, in 1913, the daughter of Russian immigrants. Her only formal training was a six-week course with Alexey Brodovitch at the New School for Social Research in New York. She joined Magnum Photos in 1951. Her works have been exhibited in numerous private and public collections, and have received many accolades. In 1995 she was awarded one of the highest honours in her field, that of Master Photographer, by the International Center of Photography in New York.

RICHARD AVEDON

'I have always given myself a framework of negatives to work within: no conspicuous lighting, no obvious composition, no seductive poses or narrative.' Comic and philosophical, elegant and minimalist, eccentric and strict, Richard Avedon was one of the most influential, charismatic and perceptive photographers of his generation. He said on many occasions that 'there has always been a distinction between the world of fashion and what I would call my more profound work. Fashion photography is my bread and butter, and I wouldn't criticize it, but I derive much more pleasure from portraits: I regard myself as a portrait photographer.' His style, which is as precise and recognizable as a signature, has evolved through the elimination of the superfluous. He reinforces the impact of the subject by removing anything extraneous from the photograph. By using a white backdrop for his portraits, he allows the figure, or sometimes just the face, to dominate the space. His portraits, whether of a street artist, Marilyn Monroe, the Dalai Lama, Björk, or himself, are closely observed; they are crystallized moments of encounter and interpretation. Avedon puts great emphasis on the complexity of the human face; in the words of Truman Capote, he was interested in 'the basic state of the face'. He only took a few self-portraits, half a dozen or so at the most. Simultaneously, in front of and behind the lens, Avedon has complete control over these photographs. In this one, taken when he was fifty-seven, he has chosen to photograph himself as if caught by chance, taken slightly by surprise. His hands are moving, and he looks serious; there is an aspect of sadness in the face. But nothing is left to chance in his photographs; he is conscious that 'a photographic portrait is a picture of someone who knows he is being photographed', and that 'all photographs are accurate, but none of them constitute the truth'.

Richard Avedon, self-portrait, Provo, Utah, 1980

Richard Avedon © The Richard Avedon Foundation

BORN IN NEW YORK in 1923, Richard Avedon was one of the most prominent photographers of his generation. In 1944 he joined the fashion magazine *Harper's Bazaar*, becoming artistic director in 1961 and revolutionizing fashion photography. He worked for all the leading magazines, and never ceased taking portraits, with groundbreaking results. He died of a brain haemorrhage in 2004. His work was celebrated by a retrospective in 2008 at the International Centre for Photography in Milan.

CECIL BEATON

It is said that as a boy Cecil Beaton tried to persuade his parents to change the area code of their telephone number from Paddington to the far more aristocratic Mayfair. It would have been like casually wearing the family coat of arms on one's little finger. Born in 1904, Cecil Beaton was to become the dandy par excellence. He cultivated the blasé manner of one who moves in the beau monde, and is au fait with its merits and defects. From London he moved to New York, where he worked for *Vogue* and *Vanity Fair*, and frequented the artistic and theatrical worlds. His talents were manifold: photographer, set designer, costume designer, production designer, actor, author, filmmaker, painter, caricaturist, interior designer, and style guru second to none. Erwin Blumenfeld described him, albeit with heavy sarcasm, as 'Prince of the Kingdom of Brillantia'. His creations were popular and trend-setting. In 1958 he won his first Oscar for his sumptuous costumes for the film *Gigi*, and in 1964 he won his second for the elegant and graceful costumes he designed for the radiant Audrey Hepburn in *My Fair Lady*. The film is memorable for its music and its clever screenplay, but above all for its fabulous costumes, the like of which had never been seen – even at Ascot. Beaton was well aware that beauty is ephemeral and must be cultivated with all due diligence. As a result, he makes everyone appear beautiful in his photographs, although it would of course have been an easy task with Audrey Hepburn. The light is flattering and the setting perfect, transforming actors, Hollywood divas, monarchs and English aristocrats into graceful Greek statues. When Queen Elizabeth II was under his floodlights – a stage that marked the pinnacle of his career and the ultimate recognition of a lifetime's work – all her regal attributes were there, the crown, sceptre and throne, and Her Majesty appeared beautiful. Beaton often liked to say that 'beauty is the most important word in the dictionary'.

Audrey Hepburn in costume for My Fair Lady, *designed by Cecil Beaton*, Vogue, *1963*

© *Condé Nast Archive/ Corbis*

CECIL BEATON was born in London in 1904. He was a man of prodigious talents: illustrator, painter, writer, set and costume designer, but above all, photographer. After studying at Cambridge, he dedicated himself to professional photography. He showed a predilection for artistic portraits with lavish sets, revealing his other vocation as set and costume designer, which he developed to the full between 1940 and 1970 (winning Oscars for *Gigi* and *My Fair Lady*). From the 1930s onwards he worked as a fashion photographer, and from 1939 to 1945 he was official photographer for the royal family and for the Ministry of Information. He took portrait photographs of numerous famous people. He died in 1980 at Broadchalke in Wiltshire.

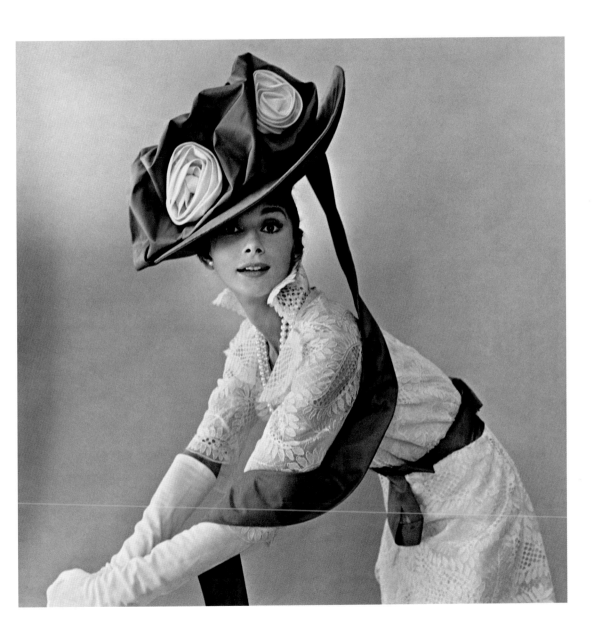

ÉDOUARD BOUBAT

'If our eyes were to see things as intensely as the lens of Boubat's camera does, would they be able to bear it?' Marguerite Duras asked herself, musing on the silent and profound mystery contained in Édouard Boubat's photographs. Children were some of the favourite subjects of this great French photographer, whose first image in 1946, which soon became a classic, was of a little girl wearing an outfit of fallen leaves in the Jardin du Luxembourg in Paris. In 1995 it was the turn of young Rémi, listening with enchantment to the sound of the sea in a shell too big for his small hands to hold. The image is poetic, accessible, affectionate, moving and intimate. Boubat was above all a humanist photographer, who was passionate about the faces and stories of those who stood for a moment in front of his lens. His style is characterized by an apparent simplicity, and this image celebrates the beauty and poetry of a timeless and universal gesture. The little boy's closed eyes prevent direct contact, but the observer can imagine his actions: pausing, listening, and dreaming. Bernard George wrote of Boubat: 'He always looked for gestures familiar to mankind… Everyday gestures, but illuminated by a transforming grace. They are moments belonging to a thousand-year-old ritual.'

Rémi listening to the sea, Paris, 1995

© Édouard Boubat/ RAPHO/EYEDEA

ÉDOUARD BOUBAT was born in Paris in 1923. At the age of twenty he began work in a photo-engraver's workshop. He took his first photographs in 1946. In 1950 he published a series of photographs of daily life in Paris in *Camera*. In 1951 his photographs were exhibited at Galerie La Hune in Paris, along with those of Brassaï, Doisneau, Facchetti and Izis, and he worked for *Réalités*. Two years later he spent four months travelling around the United States, and then travelled extensively throughout the world. He joined the agency RAPHO in 1970. In 1973 he was awarded the Octavius Hill Prize, and in 1988 the Hasselblad Prize. He died in 1999. His collected photographs were published in *Édouard Boubat: A Gentle Eye* (2004), edited by his son Bernard Boubat and Geneviève Anhoury.

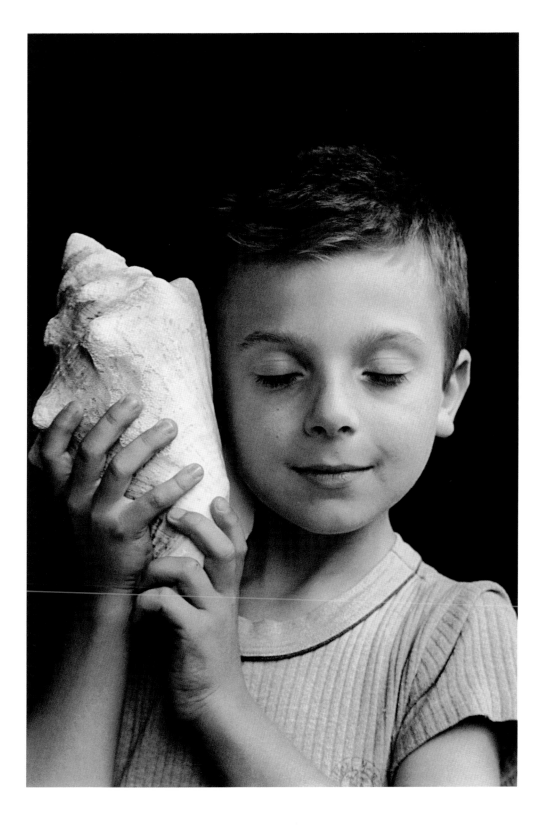

RENÉ BURRI

PORTRAITS

René Burri, born in Zurich, Switzerland, recounts how on expeditions into the Alps as a boy, he would experience a menacing sensation of claustrophobia. 'Often on trips, as we started the final ascent I would free myself from the climbing rope and rush up to the summit. It wasn't in order to be the first; it was so that I could enjoy the panoramic view. I wanted to see the whole world. But instead I could only see other mountains. I thought that having a camera might help me to get away from the Swiss mountains.' Burri is a photojournalist who is happiest 'out in the field'. His collection of works, spanning over forty years, represents all the different genres of photography and documentary. He is the quintessential itinerant photographer, Swiss-born but seemingly rootless, full of insatiable curiosity, eager both to hear and to tell stories of interest and relevance, full of humanity, and utterly genuine in his work. His trademark style is an elegant and harmonious composition, and he has the rare ability to balance geometry, space and meaning. He ventures beneath the surface of the captured moment and reveals a personal standpoint. He has been present in all the major troublespots of the world: the Six-Day War, the Suez Crisis, Lebanon, Vietnam, Egypt under Nasser, Iran under the Shah, China under Mao. He has photographed the principal protagonists of the cultural and political life of our times, and several of these shots have become icons of the twentieth century, images etched into the collective memory. One such image is this photograph of Che Guevara, smoking a cigar and looking into the distance, taken in Cuba in 1963. It was published the same year by *Look*, one of the leading magazines of its day, and the image then appeared everywhere, on postcards, special-edition stamps and posters, until all traces of its original author were lost. 'I don't think many people realize that I took that photograph. It has become a part of collective history. The photograph of Che no longer belongs only to me, and that's a big compliment for a photographer.'

Ernesto Guevara (Che), Havana, 1963

© René Burri/Magnum Photos

RENÉ BURRI was born in Zurich in 1933, and studied at the School of Applied Arts in his native city. He began to use a Leica during military service. In 1955 he was introduced to Magnum by Werner Bischof, and his first photo story on deaf and hard-of-hearing children was published by *Life* and other European magazines. Magnum sent him on many assignments in Europe and the Middle East, and he worked as a reporter in war zones. During these years he produced renowned reportage stories, and also photographed creative artists such as Picasso, Giacometti and Le Corbusier. He became president of Magnum Photos in 1982. In 1991 he was made Chevalier of the Order of Arts and Letters in France.

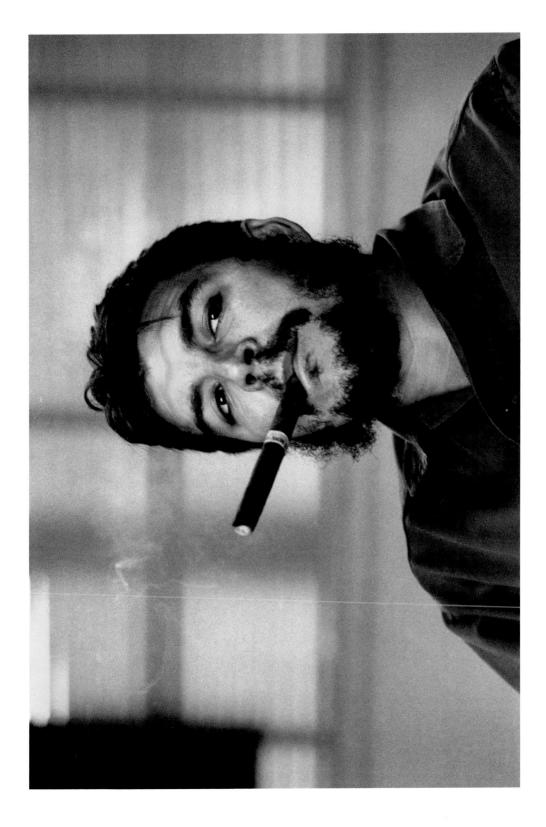

ROBERT CAPA

Robert Capa and Pablo Picasso. Two of the most important figures of the twentieth century on either side of the lens. They were friends, both artists and fascinating men. Both of them had spoken out, visually at least, against the inhumanity, brutality and devastation of war, one with the camera, the other with the paint brush. Both of them had produced emblematic works showing both the nobility and the degradation of mankind. Picasso's *Guernica* and Capa's 'The Falling Soldier' (see pages 20–21) have endured in the heart and memory of Europe. But the war was now over, and the joy of peace had returned. Robert Capa, with his journalistic spirit and his artistic eye, his insatiable curiosity and his desire to travel, continued to visit battle zones and document the conflicts he witnessed, with a mixture of human generosity, political passion and adventurousness. On that sunny summer's day in 1951, however, any thought of war was far away from Golfe Juan, and the nature of the photograph he took was intimate and animated, a snap for the family photo album. Capa had always maintained that he was at heart a photographer of peace – as evidenced by his striking and unusual portraits – who had been forced into the role of war photographer. He was an engaging personality, an exuberant character, with a carefree vivacity. His family consisted of the Magnum photographers and a wide circle of friends. One of them, Henri Cartier-Bresson, remembered him like this: 'For me, Capa was magnificent, like a great toreador, only he didn't kill; he was a tremendous player, who fought generously for himself and for all those caught up in the whirlwind that surrounded him. The type of person who would want to die whilst in their absolute prime.'

Pablo Picasso and his son Claude, Golfe Juan, 1951

© *Robert Capa/Magnum Photos*

BORN ANDRE ERNO FRIEDMANN in Hungary in 1913, Robert Capa later became a naturalized American. He achieved international recognition through his photographs taken during the Spanish Civil War, in particular the celebrated image of 'The Falling Soldier' – a militiaman killed by a shot to the chest. Capa followed the Second World War as correspondent for *Collier's* and *Life* magazines. In 1947 he founded Magnum Photos with Cartier-Bresson, Seymour and Rodger. In his career as photojournalist, courageous war correspondent, avid portraitist of screen idols and common people, and as the inspiration behind the founding of Magnum, Robert Capa created many of the iconic images that have shaped the collective memory of the twentieth century. He died in 1954, stepping on a landmine while covering the war in Indochina.

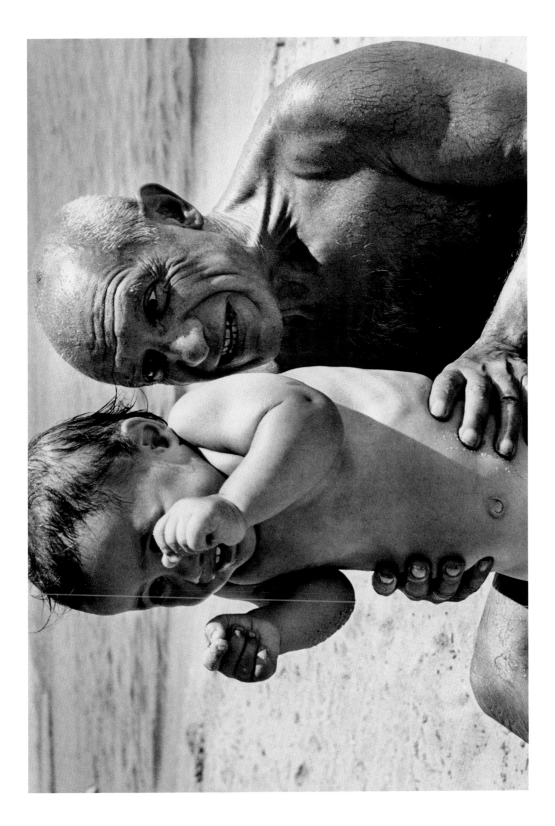

ANTON CORBIJN

December 1986. Although still in their early twenties, U2 had already been making music together for ten years, and had released four successful albums. They were on the verge of a big break into the American market, and their new release had a serendipitous title. 'The Joshua Tree' refers to the giant cactus that grows in Death Valley, which was christened 'Joshua' by the first Mormons to arrive in America, likening the place to the Promised Land given to Joshua in the Bible. *Rolling Stone* magazine had already named U2 the 'Band of the Eighties', but now they needed an international image which would take them to the top of the charts. Along the way they met Anton Corbijn, and the result was an artistic association that has lasted until the present day. The result was also an album cover that has become one of the most famous photographs taken by the Dutch photographer. It is December, and cold in Death Valley, despite it being a desert. Corbijn used a panoramic camera so as to include as much landscape as possible in the shot. His intention was to show the men against the backdrop; the young Irish musicians in an enormous expanse of unknown territory. He positioned the figures to the side of the frame, with silent, sombre expressions, leaving most of the frame occupied by the vast American landscape. Their jackets and hair, even Bono's eyes, are jet black; there is hardly any visible detail. What matters is the impression of a remote and almost imaginary space. The album cover was printed, and the record reached the top of the charts in the United States and Great Britain. Anton Corbijn continued to work with the band for the next twenty years, producing album covers and videos, and in 2005 he published the book *U2 and I*, which tells the story of a long and successful collaboration. Throughout the book, the story that unfolds is not just the story of the evolution of a successful rock band, but also the evolution of the style of a photographer who created a new visual language for rock.

U2, Death Valley, USA, 1986

© *Anton Corbijn*

ANTON CORBIJN was born in the Netherlands in 1955. His career was launched in 1972, when a magazine published some photographs he had taken using his father's camera at a concert given by a local band. In 1979 he moved to London, driven by his passion for music, where he worked for the *New Musical Express*. He specialized in portraits of musicians, actors and other celebrities, and in the early 1980s he began working for *Vogue, Rolling Stone, Spin* and *Details*, among others. During that period he directed his first music videos. In 1993 he won the MTV Music Award for best video of the year, for 'Heart Shaped Box' by Nirvana. In 2007 his first feature film, *Control*, about the life of Ian Curtis, lead singer with Joy Division, won the Best European Film award at the Cannes Film Festival. In 2010 he directed the movie *The American*.

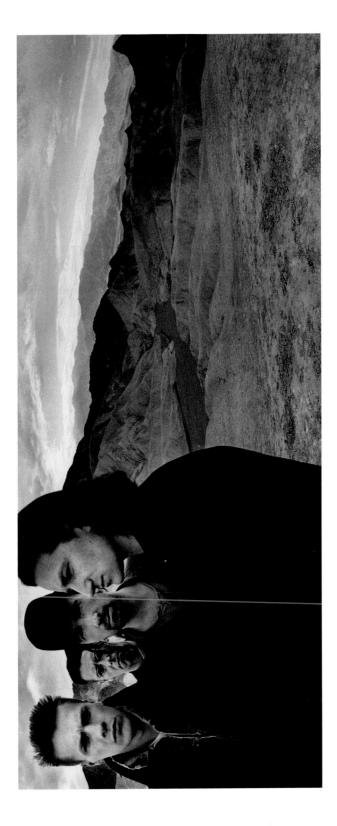

BRUCE DAVIDSON

In 1963 Martin Luther King made his famous speech: 'I have a dream that one day this nation will rise up and live out the true meaning of its creed: "We hold these truths to be self-evident, that all men are created equal."' In 1966 Bruce Davidson began work on a project that has gone down in the history of photojournalism, not just for the beauty and intensity of its images, but also for the respectful way in which he approached his work. Every day for two years, he walked the streets of a neighbourhood in East Harlem. He knocked on doors and courteously asked permission to take photographs, treating people as equals. He photographed their everyday lives and their celebrations, their threadbare clothes and their Sunday best, work and rest, church services and barbecues. He also tried to represent human emotions: couples, families, children, alone or in their mother's arms, old people. He photographed the squalor of their homes: a room totally occupied by a bed, photographs on the walls, a kitchen, remnants of a meal. East Harlem, a neighbourhood and a microcosm, an area in which hundreds of people were segregated, for this was America in the 1960s, an America where there were different seats for blacks and whites, different toilets for blacks and whites, and different schools for blacks and whites. An America best forgotten. But Bruce Davidson would not remain silent, declaring that 'the only true difference is that they are poor, and sometimes the colour of their skin is different'. Those were radical words for the time. Equally radical was the respect demonstrated by the photographer, and the dignity of his portraits. In 1968 Martin Luther King was assassinated. Two years later Bruce Davidson's book, *East 100th Street*, was published, in which the fight for equality continued.

East 100th Street, Spanish Harlem, New York, 1966

© *Bruce Davidson/ Magnum Photos*

BRUCE DAVIDSON was born in 1933 in Oak Park, Illinois. At sixteen, he won the Kodak National High School Competition. He studied at the Rochester Institute of Technology, and at Yale University. During military service in Paris he met Henri Cartier-Bresson. In 1957 he worked freelance for *Life*, and joined Magnum in 1959. In 1962 he followed the Civil Rights Movement in America, and the following year his work was exhibited at the Museum of Modern Art in New York. In 1966 he began work on his project on East 100th Street, documenting life in the Spanish quarter of Harlem. His publications include *Subway* (1986), *Central Park* (1995), *Brooklyn Gang* (1998), *Time of Change: Civil Rights Photographs 1961–1965* (2002), and *Circus* (2007).

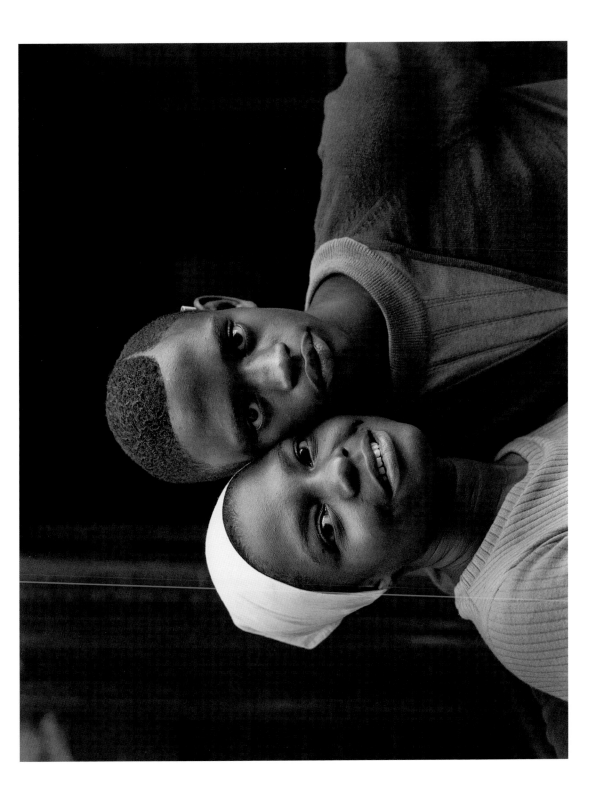

FABRIZIO FERRI

'Beauty is intelligence; it is the intensity of an alluring and enigmatic expression,' according to Fabrizio Ferri. 'A photograph is only successful when it arouses an emotion in the spectator.' In the centre of this picture there is an expression laden with erotic tension. The mouth is the primary source of nourishment for all human beings; it is also the primary source of sensuality and pleasure. The photographer plays with erotic gestures, symbols and suggestions in a supremely elegant manner. Honey, an ancient food, and naturally perfect, is smeared over the sensual Mediterranean face of Monica Bellucci, which occupies the entire foreground of the picture, to the exclusion of all else. Her eyes are closed as she savours the forbidden pleasures of eating messily. The close understanding between the model and the photographer was to deepen over the years, culminating in the photograph Bellucci asked Ferri to take of her for *Vanity Fair*, pregnant and nude, to demonstrate her support of the right to motherhood, at a time of controversy about fertility treatment. Full of intense beauty and femininity, the photographs of Ferri, one of the most renowned photographers in Italy, speak a language of sensual energy and seduction. Whether a posed fashion shot, or an enchanting image of a body dancing in harmony with nature, his photographs are always a tribute to beauty and eroticism as fundamental life forces.

Monica Bellucci, 2000
*(*Esquire *magazine)*

© *Fabrizio Ferri*

BORN IN ROME in 1952, Fabrizio Ferri began to take photographs as a reporter. In 1973 he turned to fashion photography, rapidly becoming one of the most sought-after photographers. He worked for all the leading international and national magazines. In 1983 he founded the Milan-based Industria Superstudio, a complex of photographic studios, opening a similar complex in New York in 1991. Between 1997 and 2000 he worked on a project called *Aria* with his wife, the ballerina Alessandra Ferri, producing a book, the first to be realized using digital techniques alone, and a short film. He was awarded the RAISAT Digital Show prize for the direction and cinematography of *Aria*, *Prélude* and *Carmen*; this last film also won the Best Live Performance in 'Dance Screen' at the 2002 Monaco Dance Forum.

BURT GLINN

'One of the things I learned from Henri Cartier-Bresson,' recounted Burt Glinn, 'was the important distinction between invention and discovery. A lamp is an invention, a very good one, but the discovery was electricity. Your job is to discover, not to invent, and you must not have any preconceived ideas about what there might be to discover. I think that what you've got to do is to discover the essential truth of the situation, and have a point of view about it.' As in all his encounters with prominent figures, Burt Glinn accepted the advice offered and took it to heart. Over the years, he developed an acute sense of intuition, an essential element in all inventions, and the technical skill which enabled him to transform his intuition into something tangible: a photograph. When as a recent graduate of Harvard he came to the attention of the editorial staff of *Life*, and made a great impression on them, he confessed that he would far rather take photographs than pursue written journalism. His Harvard degree may have got him through the doors of the magazine, but it was his contact with great photographers such as Robert and Cornell Capa, Gjon Mili and Philippe Halsman that enabled him to cultivate the sensibilities required of a photographer. The crucial thing was to seize the right moment. On New Year's Eve 1959, he was at a black-tie dinner party in New York when he heard the news on the radio that Batista had just fled Cuba. His instinct told him he should leave immediately. Still in his dinner jacket, he hurried to the airport. Soon he had produced the first dramatic reportage story to be received from Cuba. He always composed a portrait instinctively, finding a visual solution for each subject – in this case a tired and pensive Sammy Davis, Jr. – which was authentic to their character, and also capable of expressing the all-important point of view of the photographer.

Sammy Davis, Jr. looking out of the window in Manhattan, New York City, 1959

© *Burt Glinn/Magnum Photos*

BURT GLINN was born in 1925 in the United States. He studied literature at Harvard College (1946–49), and then worked for *Life*, before becoming an independent photographer in 1950. He joined Magnum in 1954. In 1959 he photographed the Cuban Revolution, and notably Fidel Castro's arrival in Havana. He also covered Russia and Japan, publishing a volume on each country. He worked for numerous magazines (*Holiday*, *Life*, *Paris Match* and *Geo*), and worked on the annual reports of many American corporations. He has been the recipient of several awards, including the Mathew Brady Award for Magazine Photographer of the Year from the University of Missouri. He died in 2008.

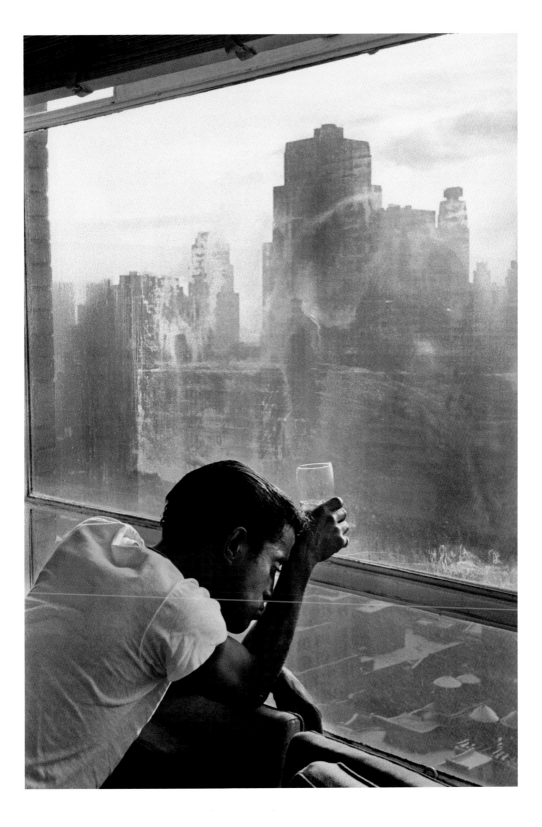

PHILIPPE HALSMAN

'Every face I see seems to hide – and sometimes, fleetingly, to reveal – the mystery of a human being. Capturing that fleeting revelation has become the purpose and passion of my life.' With his charm and ingenuity, sense of humour and intense, introspective gaze, Philippe Halsman is one of the greatest photographic portraitists of all time. 'Sitting for a portrait is an extremely artificial situation. Not many people are able to drop their guard and behave as if the camera was not there, so in most cases the photographer must help the subject to reveal their true selves. I have realized that in many sessions what I said to the client was far more important than what I did with my lighting and equipment.' For Halsman, photography has always meant portraits, and each portrait involves the challenge of capturing the true essence of a face in its rapid movements, in its sudden alterations in gesture and expression. He produced numerous memorable magazine covers, a record 101 just for *Life*, featuring many famous people from the political world, the cultural scene and the theatre, who believed in his methods and trusted his judgment. For example, in his series 'Jumpology', politicians, scientists, actors, writers, even royalty, agreed to jump for him, as if celebrating a moment of personal victory for the photographer and his insightful methods, to which his 'victims' submit willingly, as if spending the shortest of sessions on the psychiatrist's couch. In 1951 in Rome he met Anna Magnani, the actress who brought an unprecedented humanity and reality to the roles she played on screen. Halsman's portrait is a tribute to her compassion and unnerving intensity. Her dark eyes are closed, her hair is ruffled, and her hand half-covers a face which is beautiful because it is truthful and enigmatic.

Anna Magnani, Rome, 1951

© Philippe Halsman/ Magnum Photos

PHILIPPE HALSMAN was born in Latvia in 1906, and began his career in Paris. In 1934 he opened a portrait studio in Montparnasse, where he photographed many of the prominent artists and writers who were part of Parisian life. During the Nazi occupation he managed to escape from France with the help of Albert Einstein. After an initial period of uncertainty, his career took off in New York, and he consolidated his unique style. His pictures appeared on 101 covers of *Life*, a record unsurpassed by any other photographer. In 1979 he mounted an anthological exhibition of his work for the International Center of Photography in New York. He died later that same year.

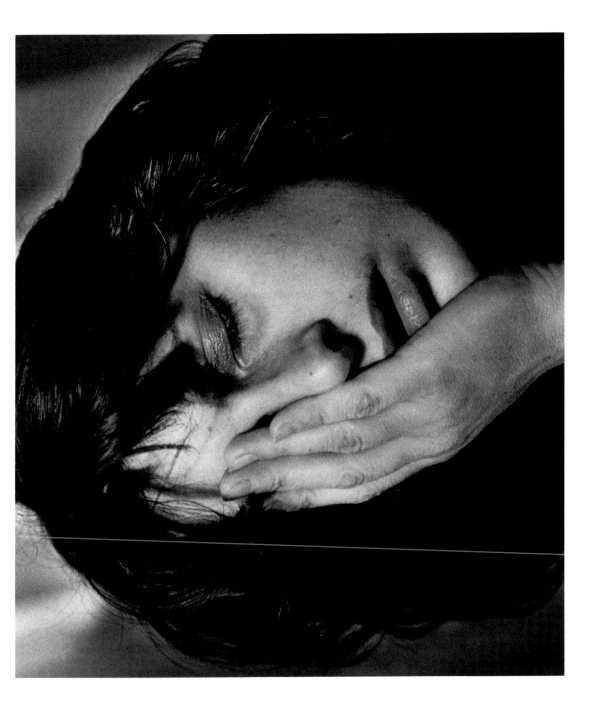

GUIDO HARARI

They are tunes in different keys, one major, one minor. Each harmonizes the other's melody. His melody is played on a distorted guitar, hers on a soaring violin. His voice is rough and harsh, hers is sophisticated and intense. He prefers poetry, she prefers fiction. He quotes Edgar Allan Poe, she quotes Walter Benjamin. But neither of them would have been anything without the Beat generation. Two exceptional artists and human beings in an intimate embrace. Their expressions are peaceful, their smiles natural, and the deep lines on Lou Reed's face betray the life of a rock star. In front of the lens there is no posing to convey the image of an eccentric or intellectual artist, there is no attempt to impress, only two heads resting delicately and intimately on each other. On the other side of the lens stands Guido Harari, one of the best-loved photographers in the music world, with whom Laurie Anderson and Lou Reed have developed a close artistic partnership over the years. As well as being a photographer, Harari works as a music critic, and in the 1970s he set himself up as a specialist freelance professional in both fields, which was unprecedented in Italy. He was twelve years old when he heard the Beatles in concert in Milan and, from that moment on, music became the driving force of his life. He was selective when photographing musicians, only working with those with whom he felt a musical and emotional affinity. And how could he fail to feel an affinity with these two artists who represent different but complementary facets of the New York Underground? Lou Reed: poet, rock musician, agitator, homosexual, bisexual, heroin addict, health fanatic. Laurie Anderson: composer, writer, photographer, director, ventriloquist, inventor of electronic sounds, instrumentalist, performer. But what is seen here is, quite simply, a middle-aged man and woman embracing.

Laurie Anderson and Lou Reed, Turin, 2002

© Guido Harari/ Contrasto

GUIDO HARARI was born in Cairo in 1952. In the early 1970s he worked as a photographer and music critic. He toured with Emerson Lake & Palmer, Genesis, Santana, Zappa and PFM. From 1979 to 1981 he followed Lindsay Kemp on tour, in 1982 publishing a volume about him. In 1983 he organized his first show, 'Rockshots', with ambient music by Peter Gabriel and David Sylvian. He co-published two books with Claudio Baglioni: *Notti di note* and *Assolto. Non solo*. He produced album covers and tour photography for Fabrizio De André, Pino Daniele, Ligabue, Mia Martini, Gianni Nannini, Vasco Rossi, Lou Reed, Bob Dylan, Ute Lemper, Paul McCartney and Simple Minds, among others. In 2004 he co-published *The Beat Goes On* with Fernanda Pivano. In 2007 he edited De André's autobiography, *Fabrizio De André. Una goccia di splendore.*

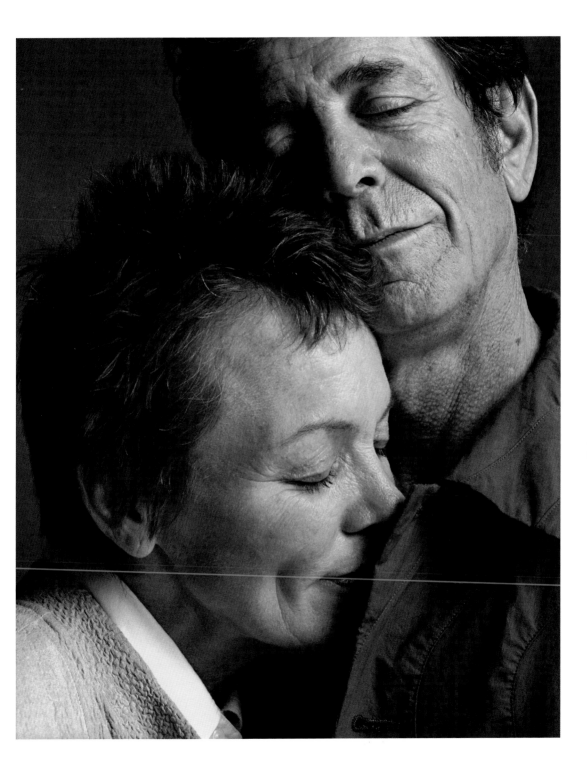

ANTONIN KRATOCHVIL

'I believe I take portraits in the tradition of the great journalists like Cartier-Bresson and Kertész. I am only continuing the tradition of these great photographers, who photographed artists, writers and actors. Today they are called "celebrities"; before they were just actors. I am inspired by the humanity of those I photograph.' Born in Czechoslovakia, photojournalist Antonin Kratochvil has spent most of his life in exile. A refugee himself, he spent a long time working in a refugee camp, documenting the sufferings of people forced to live in unbearable conditions. His own experiences have shaped his distinctive approach to photography, an approach which is dedicated and compassionate. The focal point of his interest and his pictures is always the human being, whether he is covering the wars in Afghanistan and Iraq, producing reportage on street children in Mongolia, photographing famous people, exploring the situation in Eastern Europe or the issue of civil rights in America post-9/11. His photographs serve as much more than documentary: they speak of the emotions of the photographer as well as of his subject. In the tradition of the great photographers, he also did portraits, but only of men and women whose personalities interested him. Every portrait involves a meeting, and a challenge to uncover the real personality of the subject. In this portrait of David Bowie, Kratochvil has magnificently captured the charisma, ambiguity and intensity of one of the most fascinating personalities in the history of music – the Thin White Duke, tall and glacial, the androgynous alien, with a disconcertingly insane look in his eyes.

David Bowie, New York, 1997

© *Antonin Kratochvil/VII*

BORN IN CZECHOSLOVAKIA in 1947, Antonin Kratochvil was forced to leave his country in 1967, a year before the Soviet invasion. He escaped across the border illegally, and lived in refugee camps in Western Europe. He later studied at the Art Academy in Amsterdam, and then moved to the United States, where he started to work for the *Los Angeles Times*. His photographs have been published by the international press, and have won many prizes, including the 2002 World Press Photo, in the General News category. He lives in New York, and in 2001 co-founded the photographic agency VII together with six colleagues.

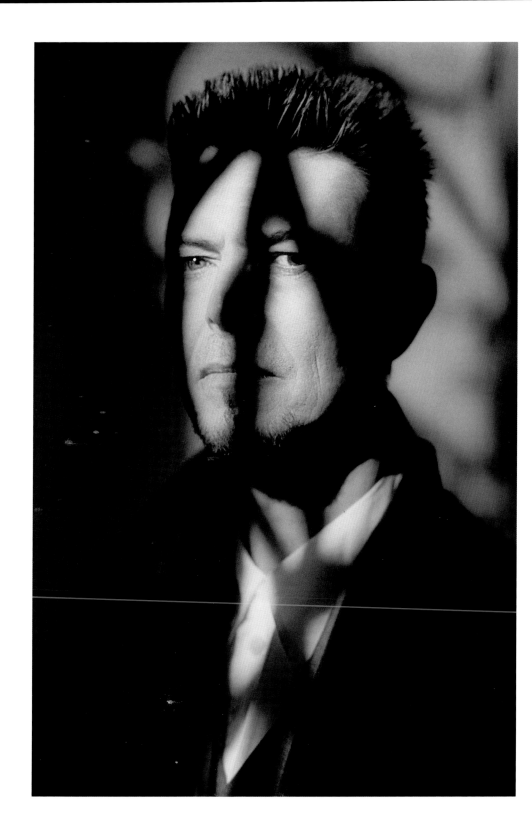

MARY ELLEN MARK

The Damms have nothing, except the desperation in their eyes, and a car to drive along the roads of California in a hopeless existence. Nothing but poverty, drugs and violence. No job, no four walls to call home – other than the four sides of the photo frame – and not even a table to sit at. Those few moments of respite within the viewfinder were provided by Mary Ellen Mark, who had been commissioned by *Life* to produce reportage on homeless Americans. The encounter with Dean and Linda, and Linda's children Crissy and Jesse, happened by accident. The family had been thrown out of a refuge, and started a life on the road. The itinerant poor have always been a popular topic in American literature and photography, and for Mary Ellen Mark it took her on a journey through some of the most deprived and hopeless areas of the United States, places where all traces of beauty and wellbeing have evaporated. Since beginning her career in the 1960s, Mark's work has always concentrated on society's outcasts, such as the poor of Calcutta in the care of Mother Teresa, the mentally ill in Oregon State Hospital, the child gangs in Seattle, and the child prostitutes in Bombay. Children are another favourite subject, as shown by this photograph. In contrast to the masculine arms which seize and take possession with some force, the young girl Crissy places a gentle, feminine hand on her brother's cheek, caressing him in a mature gesture. Eight years later, Mark went in search of the family once again. She found them with two more children, still trapped in drugs and violence. It was Crissy who caught her attention. She was beautiful, more beautiful than before, and more alone. There was no way out, and her life on the road was already a dead-end.

The Damm family,
Los Angeles, 1987

© Mary Ellen Mark/
Grazia Neri

MARY ELLEN MARK is one of America's best-known photographers. She began to take pictures in 1962, and was awarded a grant to travel to Turkey, Asia, Europe and then back to the States. The photographs were published in the volume *Passport* in 1974. From the late 1960s she worked as stills photographer on the sets of *Alice's Restaurant*, *Satyricon*, *Apocalypse Now* and *One Flew Over the Cuckoo's Nest*, this last film providing her with the opportunity for a project on the mentally ill. She then did a photo story on the work of Mother Teresa, and returned to India a few years later to produce *Indian Circus* and then *Falkland Road*, about prostitution in Bombay. In 1995 *Portraits* was published, and the monograph *Exposure* followed in 2005.

UGO MULAS

'I was a friend of Lucio Fontana, one of his many friends. Everyone in Milan was his friend.' So began one of the most important 'visual' relationships in the history of Italian culture and photography, with Mulas's innate sense of elegant simplicity, and his ability to reduce form and emotion to the bare essentials. It was these qualities which enabled this highly cultured and contemporary man to mix with the protagonists of the international art scene. There was no one who understood the mystery, intellectual fulfilment and physical beauty of creating art better than he did, and throughout his career he documented the creative process in the exhibition hall and the atelier. He also understood the important concept of waiting, and indeed 'L'Attesa' ('The Wait') was the title he gave to his series of photographs of Fontana. This one is the last of the four photographs, and in it the artist's profile seems to issue forth from the cut as from a Caesarean section. The photographer recounted: 'Up until that time I had simply taken pictures of Fontana; this time I wanted to understand what he was really about. Perhaps I was inspired by the presence of a large white canvas with a single slash, which he had just finished. I realized that his thought processes – which were basically resolved in an instant, in the cutting of the canvas – were more complex than that final gesture could portray.' For a moment, the artist becomes the actor, and the photographer becomes director. The set is his studio. In the first photograph, a canvas is in the background and Fontana has his back to us, Stanley knife in hand, waiting. His concentration is intense. Then he approaches the white surface, and places the blade on it. 'When we had done that photograph, we removed the canvas and replaced it with the one he had just finished, the one with a single slash. Fontana placed his hand at the lower end of the slash, and in the photograph the hand is blurred, as if he has just completed the action in that moment.' It is simple and elegant: a portrait of Fontana, and a self-portrait of Mulas.

Lucio Fontana, Milan, 1964

© *Estate of Ugo Mulas*

UGO MULAS was born in 1928 in Pozzolengo, Brescia. He began a law course in Milan, but abandoned his studies to go to the Brera Fine Arts Academy. In 1954 he started to work professionally, and photographed the Venice Biennale, which he continued to do until 1972. He also worked with Giorgio Strehler. In 1960 he completed a series of reportage projects in Europe. In 1962 he photographed the sculptor David Smith in his studio, where he met Alexander Calder. In 1964 he illustrated Eugenio Montale's *Ossi di seppia* (*The Bones of Cuttlefish*). That same year he met many of the protagonists of Pop Art. He travelled to New York, and produced an extraordinary documentary on American art. In 1968, before he became seriously ill, he began *Verifiche*, a reflection on the language of photography. He died in 1973.

NADAR

With his red hair and luxuriant moustache, Nadar was a creative and curious extrovert. He shared all the qualities of the wild bohemians living in Paris in the second half of the nineteenth century. A person of endless resources and progressive ideas, he first studied medicine, then became a journalist, caricaturist, novelist, painter and, finally, photographer. He was a breath of fresh air in the world of photography. His circle of friends comprised all the great artists and writers of the day, which provided Nadar with wonderful subject matter for his experiments. From 1854 he began to invite them to his studio on Rue Saint Lazare. He decked out his studio like a garden, and banished the headrest and other instruments of torture commonly used in portraits. He experimented with light, and conversed amiably with his subject until he clicked the shutter. He knew the exact moment in which to capture a natural and truthful pose. His success was prodigious: anyone important in Paris passed through his doors. His creativity with light and his sensitivity to human nature enabled him to produce portraits that are masterpieces in the history of photography. In 1860 he moved to the more prestigious Boulevard des Capucines, where his studio became a meeting place for emerging artists. In 1874 he hosted the first exhibition by the as-yet unknown Impressionists. His portraits, which show an unprecedented spontaneity, include Baudelaire, Michelet, Gautier, Dumas, Hugo, Rossini, and the 'divine' Sarah Bernhardt, among others. When visiting cards with a photograph came into vogue, his studio was besieged with clients, but he declared himself to be 'sick to death' of it all, and so the tireless inventor looked for fresh inspiration. He went up in a hot air balloon and took the first aerial photographs. He then went down into the sewers of Paris to experiment with artificial light and exposures of up to eighteen minutes: his mysterious underground shots amazed the Parisians. This pioneer of photography, who described himself as 'a dare-devil always in pursuit of tides to swim against' died at the age of ninety.

Sarah Bernhardt, c. 1860

© Bibliothèque Nationale de France

NADAR was the pseudonym of Gaspard-Félix Tournachon, born in Paris in 1820. He studied medicine, but then worked as a journalist and caricaturist. He became well-known through his collection of caricatures, *Panthéon Nadar* (1854). He began to take photographs in 1853, concentrating on portraits. He experimented with artificial light, and in 1858 took the first aerial photographs from a hot air balloon. In 1874 his studio on Boulevard des Capucines became the venue for the first Impressionist exhibition. He died in 1910 in Sénart.

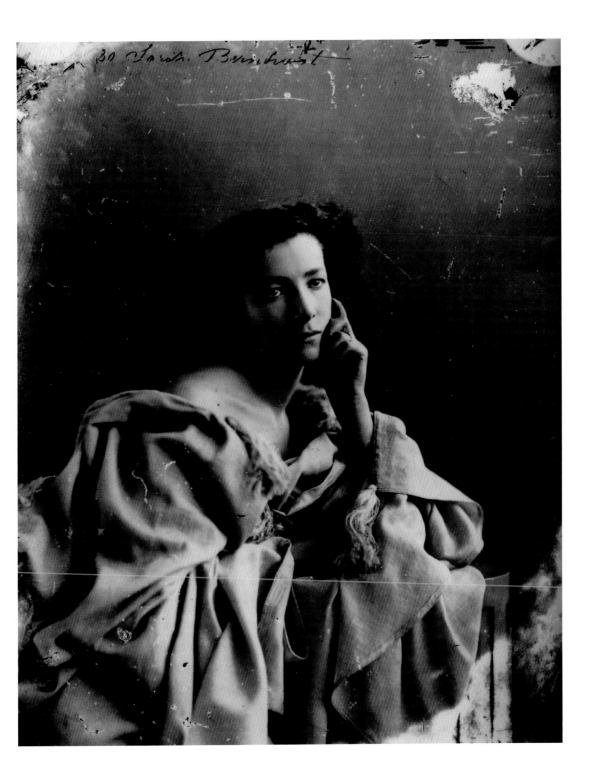

NIGEL PARRY

He does not use theatrical make-up, or strange sets, or eccentric costumes. Nigel Parry prefers to see the real person and has no interest in forms of disguise. Looking at a Polaroid the photographer had just taken, the architect Philip Johnson commented: 'People don't understand that the shade is more important than the light.' He understood Parry well: there is something special about the use of light in Parry's photographs, and the way in which the faces and figures fill the frame. He uses light to reveal, not to conceal. His light does not rest like a flat and uniform veil over faces, but seeks out cavities that will become shade. It seeks out pores in the skin, furrows on the brow, all the hieroglyphs with which to decipher the story of the face. The title of his first book, *Sharp*, well describes the nature of his use of light: it is incisive, clear-cut, unexpected. He not only photographs show-business personalities, but also the leading influential figures of our time, including Bill Clinton, George Bush and Queen Elizabeth II. His rules are the same for everyone, and he is equally interested in all. What is important is 'to see the image before taking it, to be flexible, and above all, to know what you want to say with the photograph you are about to take'. If you want to smile, smile. If you want to make a face, make it. That is his advice to his subjects, because every photograph is a challenge to find and reveal the truth. Asia Argento closes her eyes and throws her head sideways, casting a shadow over one side of her face. Famous as a sultry temptress, here there is something almost demure and childlike about her. Despite the bright lipstick and eye make-up, the face is almost one of an adolescent, and the light plays freely over a lascivious and rapt angel of the flesh.

Asia Argento, Rome, 1997

© Nigel Parry/ CPi-Syndication

NIGEL PARRY was born in 1961, and began his career as a photographer in London in 1987, before moving to New York in 1994. Since then he has been commissioned by many of the major publications, advertising agencies, and movie and music companies. His work has been exhibited all over the world in galleries and museums. He was the first portrait photographer to be invited to exhibit at the Cannes Film Festival. In 2000 he published his first book, *Sharp*, followed by *Precious* in 2004 and *Blunt* in 2006.

GIUSEPPE PINO

A few years ago the editor of *Jazz Magazine* paid tribute to Giuseppe Pino and his legendary photographs of the musical greats, writing that all jazz fans should seek out one of Milan's hidden gems, Pino's archives housed in the Pinacoteca. The archives are full of surprises, but the real jewel in the crown is this photograph of Miles Davis, taken in New York in 1982. The photograph was composed in detail, for Pino was not a fan of the snapshot; he preferred to take his time. The result is a combination of the spontaneity of the great musician's expression, with the sophisticated composition, which uses subtle shades of blue, from turquoise to sky blue to cobalt. If 'making jazz visible' was one of Pino's intentions when he began the project, the end result certainly succeeds in recreating the dynamics of performance. Miles Davis is improvising on his trumpet, against a background that defines the atmosphere and sets the tone. The photographer's main aim was to bring out the individuality of the subject, rather than to adhere to any typology, and that was true not only for the famous trumpeter who played 'Kind of Blue', but for all those musicians whose photographs Pino took, from Louis Armstrong to Keith Jarrett, from Thelonious Monk to Ella Fitzgerald. Many of them brought to the studio their own particular instrument, an indispensable part of their identity. Here, devoid of its voice, the shiny golden trumpet becomes a magical object of hard beauty, the photograph merely hinting at the sounds it can produce.

Miles Davis, New York, 1982

© *Giuseppe Pino/ Contrasto*

GIUSEPPE PINO was born in Milan in 1940. He began to work as a photographer in 1962, mainly working as a photojournalist for *Panorama*, for whom he produced many magazine covers after 1967. In 1973 he moved to the United States, where he concentrated on the portraits of jazz musicians that were to make him famous. After returning to Italy in the late 1980s, he became involved in advertising (he provided marketing images for several major Italian companies), and the study of the nude, but continued to do portraits of those in the public eye, whether in show business, fashion or politics. In 2002 he produced *Jazz My Love*, an extensive collection of photographs of the most famous personalities dominating the music scene in the second half of the twentieth century.

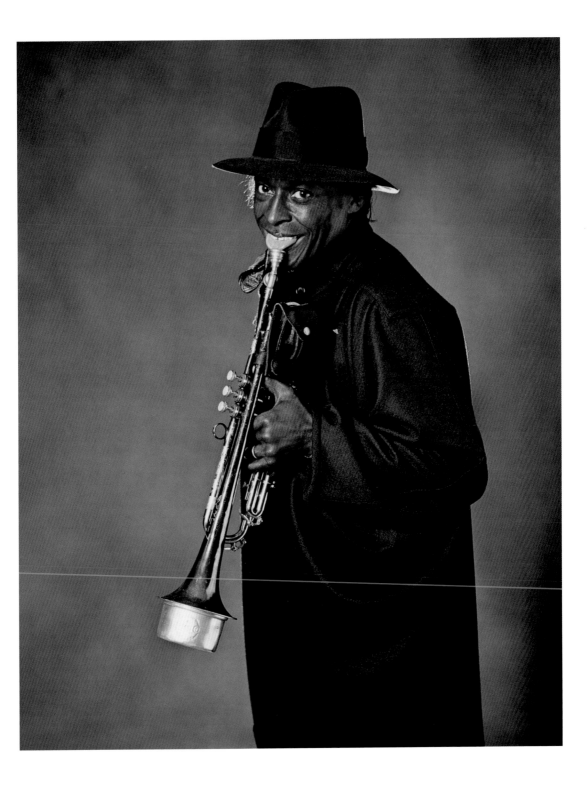

BETTINA RHEIMS

Bettina Rheims has a complex and contradictory relationship with the world of fashion photography, characterized by constant shifts and adjustments in attitude and aesthetics. An ex-model and journalist, with a creative and volatile personality, Rheims does not submit to the dictates of fashion, but strives to turn them upside down, aiming to mock and to scandalize. Central to all her photographs is the physical body of the model, which she observes and reproduces with a bold, intimate and feminine touch. This approach caused something of a sensation with her work 'I.N.R.I.'. The photograph here of the beautiful Milla Jovovich was chosen for the cover of Rheims's recent monograph *Heroines*, her latest voyage into the female universe. As with so much of her work, the immediate attraction lies in the absolute, formal perfection of the photograph, in which the scene is suspended between reality and artificiality. The observer approaches it with uncertainty, as it has clearly been posed, and yet it appears equally spontaneous. The expression and the posture are alluring, and yet disorientating. There is a palpable tension in the model as she nervously turns her foot in – a pose that echoes back to the classical iconography associated with the penitent Magdalene.

Milla Jovovich, 2005

© *Bettina Rheims,*
courtesy of Galerie Jérôme
de Noirmont, Paris, 2008

BETTINA RHEIMS was born in 1952, near Paris. She started her career as a model, journalist and gallery manager, turning to photography in 1978. In 1981 she mounted an exhibition at the Centre Pompidou featuring a series of photographs of acrobats and striptease artists. She worked for international publications such as *Elle* and *Paris Match*, and designed fashion advertising campaigns. In 1992 she published *Chambre close*, a book of female nudes, with Serge Bramly, which proved extremely popular. In 1995 she took the official portrait of Jacques Chirac. In 2004, her first large-scale retrospective was mounted by Helsinki City Art Museum. In 2008 her touring exhibition 'Can you find happiness?' opened at C/O Berlin, before moving to FORMA, the International Centre for Photography in Milan.

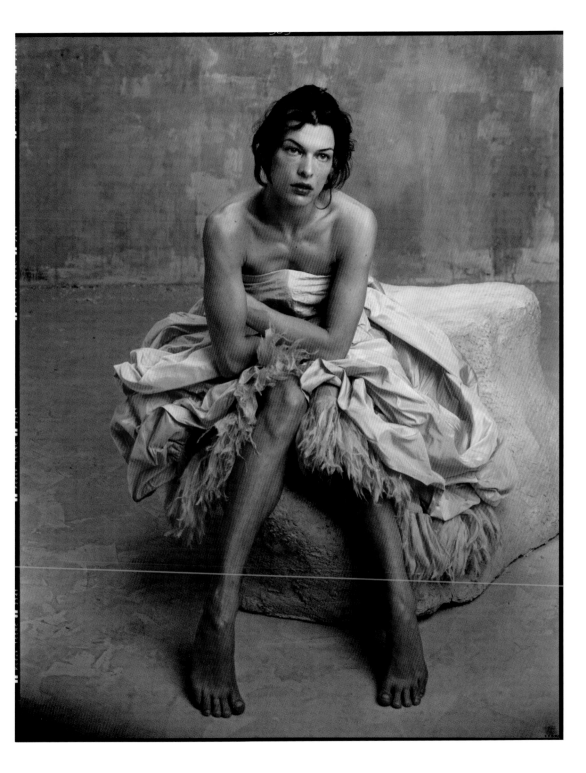

HERB RITTS

Their first meeting occurred in New York in 1983, around the time of the film *Desperately Seeking Susan*. Herb Ritts remembered it like this: 'She arrived early, and appeared extremely confident as she walked into the studio. She had brought her belts, black conical bra and silver crucifixes with her. She said to me: "I've seen all your photographs, so we can go ahead." She knew my work, even though I'd only been taking photographs for a couple of years. As we had some time in hand, I suggested that we took some photographs just of her before her troupe arrived, and she agreed. Madonna is an intelligent woman, and loves to pose for the camera. We have worked together since that moment. She is probably the person I have photographed the most, and over the last fifteen years I have watched her meteoric rise to stardom. I have also changed during that time.' One of the highlights of their collaboration was the album cover for 'True Blue', pictured here. It was only three years since their first meeting and, thanks to Ritts's advice, Madonna had left her old image behind. At twenty-eight, she was now a star, and her third album sold a record twenty million copies. This cover photograph signalled the transformation to diva. Her black leather jacket, symbol of masculinity and living on the wild side, slips from her shoulders with the delicacy of an evening gown, revealing her body, an object of desire, bathed in the sensuous Californian sunshine, the most natural and erotic light in America. It is a typical Hollywood pose: head tilted gently back, sculpted hair, eyes closed and lips slightly parted. Her shoulders balance the angle of the chin, which casts an incisive black shadow on her neck, like a knife blade cutting the skin of a forbidden fruit. This is no innocent Marilyn, despite the blonde hair; she is cultivating the allure of Bette Davis. Eve against Eve. Madonna taking on the world.

Madonna, Hollywood, 1986

© *Herb Ritts Foundation*

HERB RITTS was born in Los Angeles in 1952. His family owned a furniture business and, after graduating in economics, he took over management of the firm. During that time he also began to take photographs. Among his first was a series of photographs of Richard Gere, taken at a petrol station in the desert, two years before Gere made *American Gigolo*. The year was 1978, and when the photographs arrived on the desk in the offices of US *Vogue*, Ritts's impressive career was launched, a career that has included taking pictures for *Harper's Bazaar*, *Rolling Stone* and *Vanity Fair*, among others. He is also well known for his advertising campaigns for Versace, Armani, Chanel, Calvin Klein, Gap, Valentino, Levi's and Pirelli. Ritts died in 2002.

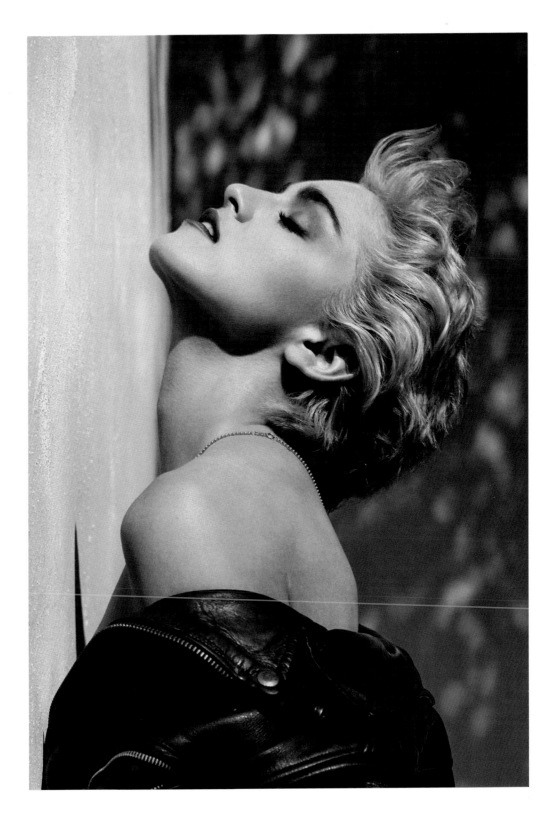

ALEXANDER RODCHENKO

Rodchenko's wife and constant companion, Varvara Stepanova, was herself a painter, and the life they shared was devoted to art. Her affectionate nickname for him was 'Anti': he was staunchly against convention, and his artistic temperament meant that he was sometimes a difficult person to be around. He preferred to be known by the diminutive form of his name, Rodcha. In Russian, 'rod' means 'species' or 'type', so both nicknames seem to be appropriate to the personality of Alexander Rodchenko, painter, sculptor, set and costume designer, teacher at the Vkhutemas (Soviet School of Art and Architecture), graphic designer, and above all, photographer. In short, he was one of the most influential artists of the twentieth century. He was a protagonist of Constructivism, and understood the social and artistic changes brought about by revolution. After having experimented with his famous collages as a means of dissecting and condensing reality, in 1924 Rodchenko turned his attention to photography. He concentrated on people close to him: Mayakovsky (the Russian poet and playwright), his wife and his mother. This is an historic portrait, which was re-cut from a larger version, which had included the object of her reading, a newspaper lying on a table. Rodcha's mother is herself a particular 'type', with her knotted head-scarf, her callused hand betraying years of hard work, the wedding ring on her little finger, although her husband has been dead for twenty years, one spectacle lens, like a monocle, and an air of such intense concentration that it almost burns a hole in the page. Olga Evdokimovna Paltusova, the artist's mother, was born in 1865, but only learned to read in the 1920s. Suddenly, a completely new world opened up to her. A few years later her son was to open up another new world, using new forms of perspective with unusual vantage points, different from the conventional ones. He was once more living up to his nickname.

Mother, 1924

© *A. Rodchenko &*
V. Stepanova Archive/
SIAE, Rome, 2008

ALEXANDER RODCHENKO was born in St Petersburg in 1891. In 1905 his family moved to Kazan, and in 1910 he enrolled in art school, where he was to meet his future wife, Varvara Stepanova, in 1914. In 1915 he moved to Moscow, and exhibited his first designs the following year. In 1918 he joined Profsoiuz, the artists' union. From 1920 to 1930 he taught 'Constructionism' at the Vkhutemas. He also designed covers for the magazine *LEF*. In 1923 he worked with the poet Mayakovsky, and in 1924 he began to take photographs. In 1925 he designed the poster for Eisenstein's film *The Battleship Potemkin*, and in 1928 he bought himself a Leica. In 1933 he photographed the controversial construction of the White Sea Canal for the magazine *USSR in Construction*. He died in 1956.

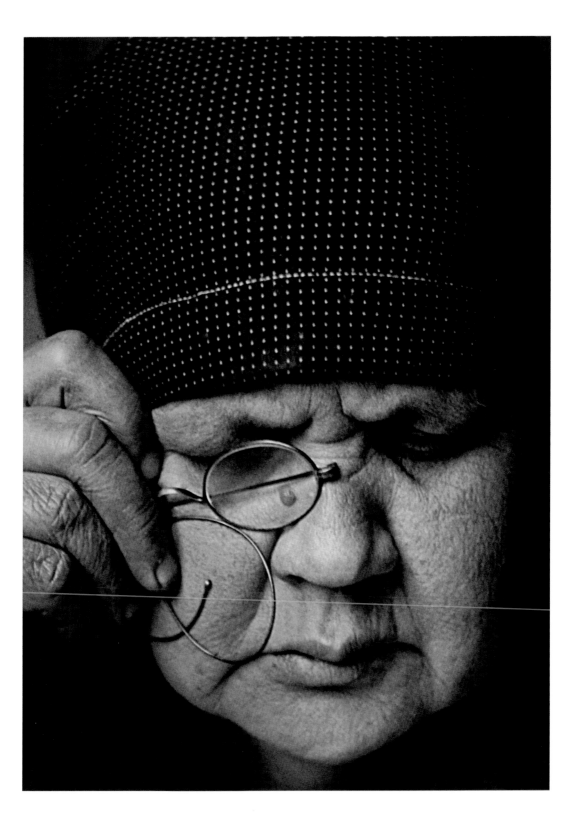

AUGUST SANDER

'The essence of photography is by nature documentary,' August Sander explained in 1931, and this conviction was to shape the vision of one of the most influential photographers in history. His large collection of portraits was groundbreaking because there was a political purpose behind it: Sander's aim was to replace the primarily aesthetic function of photography with a social one. The camera cannot be impartial, but in the hands of someone who is himself without prejudice, it can at least reveal the social masks that people wear. Sander began by photographing peasants in his village, a group of people who seemed to 'perfectly embody my idea of an archetype'. This led to the launch of 'People of the 20th Century', a magnum opus aimed at showing the 'typical' aspects of each social and professional group, and how their class, job, culture and daily habits might determine their typical postures and expressions. This work constitutes a sociological panorama of Germany in the 1920s and 1930s; a study of comparative photography which, according to Alfred Döblin, 'goes beyond the observance of detail and into the realms of scientific analysis'. Individuals pose for the photographer, looking at him with a clear and direct gaze. They often have the tools of their trade with them, so that they become the archetype of their own social group, or very nearly, according to Sander: 'A beautiful photograph is only the first step towards an intelligent application of photography... I cannot show my work in a single image, nor in two or three; photographs are fleeting moments. Photography is like a mosaic, which only makes sense when all the pieces are seen together in their entirety.' The work is divided into seven categories: The Farmer, The Skilled Tradesman, The Woman, Classes and Professions, The Artists, The City, and The Last People. Turning the pages of these volumes, the words of Walter Benjamin come to mind: 'This work of Sander's is more than a collection of photographs: it is an atlas with which to orientate yourself.'

Bricklayer, 1928

© *Die Photographische Sammlung/SK Stiftung Kultur – August Sander Archiv, Cologne; SIAE, Rome, 2008*

BORN IN 1876 in Herdorf, Germany, August Sander first worked in the local iron-ore mine, but was passionate about photography. In 1901 he worked in a photographic studio in Linz, Austria, of which he became proprietor. In 1910 he moved the enterprise to Cologne. In the mid-1920s, he began work on 'People of the 20th Century', exhibiting a few of the images in 1927. That same year he travelled to Sardinia, where he took hundreds of photographs. In 1929 he published his first volume of portraits, *Antlitz der Zeit*, but in 1936 the Gestapo confiscated the book and destroyed the negatives. Between 1933 and 1935 he published a series in six volumes called *German Country – German People*. During the war he took refuge in the country, saving most of his archive from the bombing. The pinnacle of his career was the exhibition 'The Family of Man' (1955). He died in Cologne in 1964.

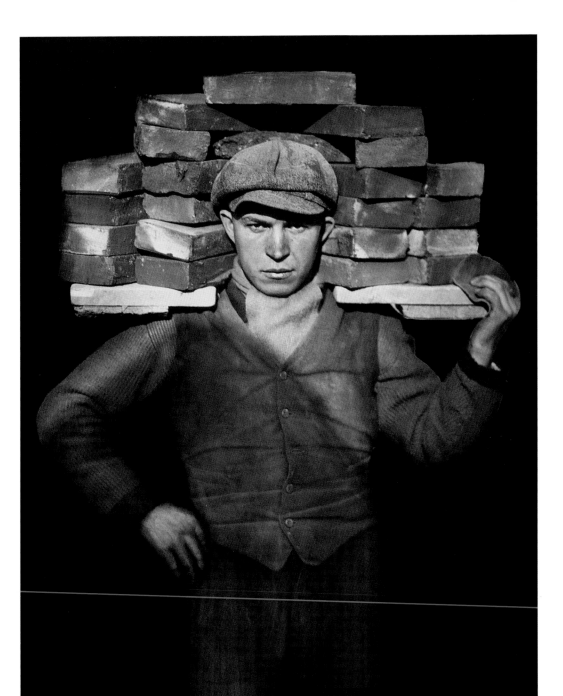

ALESSANDRA SANGUINETTI

PORTRAITS

Words are like beautiful flowers which blossom in our mouths; even our unspoken words, the words in our imagination and the words in our dreams. Like the girl in the photograph, Alessandra Sanguinetti has a flower in her mouth, albeit a metaphorical one, a beautiful wildflower, for, although born in New York, she was brought up in Argentina. For six years, between 1999 and 2005, she followed the hopes and dreams of two cousins, nine and ten years of age, in the idyllic setting of a farm in La Pampa. The collection is called 'The Adventures of Guille and Belinda and the Enigmatic Meaning of their Dreams'. It is like a diary of their dreams, written in the summer; vivid dreams from the scorching heat of the day and the soothing cool of the shade. Within the dimensions of the photograph, anything can happen: there is complete freedom. Close your eyes and let your mind drift into the future: the day when I will dance my first dance, and you will be a man, with a black moustache, and you will kiss me; the day when we will get married, and you will wear a white dress; the day on which our child will be born, and we will both feed him; the day when someone dies, I do not know who, and we will stand at their grave and weep, surrounded by the fresh grass of a meadow; and finally the day when we jump over a barbed wire fence, taking care not to scratch our legs, and make it to the other side. The other side of childhood, when flowers become fruit, and we, together with Alessandra, will turn to look at our fingers and see that they have become petals, and we have become adults.

Petals, Buenos Aires, 2002

© Alessandra Sanguinetti/ Magnum Photos

ALESSANDRA SANGUINETTI was born in New York in 1968, but lived in Argentina from 1970 to 2003. She received a fellowship from the Guggenheim Foundation, and a grant from the Hasselblad Foundation. She now lives in New York, where she works for the *New York Times Magazine*, *Life* and *Newsweek*. Her work is represented in the permanent collections of many important museums, such as the Museum of Modern Art in New York, the Museum of Fine Arts in Boston and the Museum of Modern Art in San Francisco. In 2007 she became an affiliate of Magnum.

MARTIN SCHOELLER

Close Up is the title of the book of portraits by the German photographer Martin Schoeller. Although still young, Schoeller has already been recognized as one of the most prominent and original photographers of his generation. The solid photographic tradition of his country, with the portraits of August Sander and the Becher school, taught him the necessity of finding a style that would clearly illustrate a photographer's visions and intentions. Since 1999 he has photographed many different celebrities: actors, politicians, musicians and athletes, as well as ordinary people. Each photograph is taken close up, with a strong and uniform light, which gives a particular brilliance to the eyes but does nothing to hide any imperfections in the skin. The frame barely contains the face with its penetrating gaze, making it appear powerful and mysterious. The use of the same formula for each portrait invites a comparison between them, and the complexities and contradictions of each face are clearly legible. During a shoot the photographer just waits; he gives no instructions to the subject, other than simply 'to be' in front of the lens, and he then waits for the unguarded moment when the mask falls and the true personality is revealed. The results have a strong visual impact. His method is ruthless: nothing is concealed, not a line, not a fold of skin, not an eyelid swollen with tears. Each face is stripped bare; reality is exposed.

Angelina Jolie, 2004

© Martin Schoeller/
vh-artists.com

MARTIN SCHOELLER was born in Monaco in 1968 and brought up in Germany. After high school he received a grant to study at photography school, and then moved to New York in 1992. From 1993 to 1996 he worked as assistant to Annie Leibovitz, and then started his freelance career. Since 1999 he has worked for the *New Yorker, Rolling Stone, GQ, Esquire, Entertainment Weekly, Vogue* and *Newsweek*.

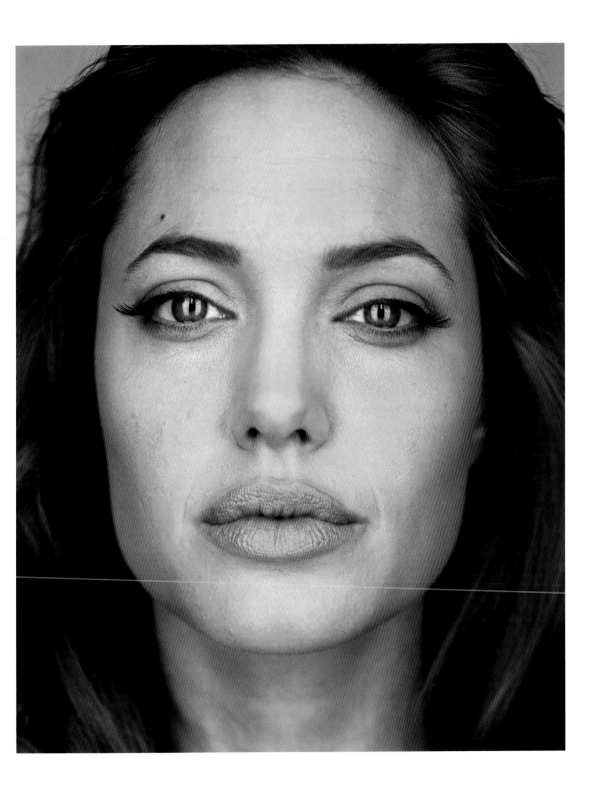

DENNIS STOCK

'I am not a spontaneous photographer. There are certain subjects which inspire me to take photographs.' In the course of his long career, Dennis Stock has captured the spirit of the American dream on film. He has been inspired by the social life of America, its contrasts and contradictions, and has cast his critical and unique gaze over a vast spectrum of activity. He has travelled widely throughout the country, documenting its festivals and its music scene, and following its alternative communities in their pursuit of a different lifestyle. In 1951 Robert Capa invited him to join Magnum, and he became their resident photographer in Hollywood. It was here that the director Nicholas Ray introduced him to a young actor by the name of James Dean, and that meeting marked the beginning of an enduring and close friendship. 'I became so impressed with his skills as an actor that in 1955 I decided that I wanted to produce a series of photographs about him and the environment which had shaped his character.' Stock accompanied Dean on a journey from New York to Fairmount, Indiana, where he had grown up with his uncle and aunt, and took some exceptional photographs along the way. The two men were about the same age, and the photographer succeeded in capturing the complexity of the young actor's tormented, disarming and fragile character. Stock was deeply affected by Dean's tragic death later in 1955, a death that immortalized his legendary image as a young rebel, and the intense, authentic photographs he took that year have perpetuated that image for all time.

James Dean in Times Square, New York City, 1955

© Dennis Stock/Magnum Photos

DENNIS STOCK was born in New York in 1928 and started to pursue photography after the Second World War. He was an assistant to Gjon Mili, and in 1951 his photo story on immigrants arriving into Manhattan by boat won first prize in *Life*'s Young Photographers contest. He joined Magnum and began a long career in Hollywood. Over the years he photographed prominent jazz musicians, and documented American music festivals and the lifestyles of alternative communities. During the 1970s and 1980s he worked on colour photographs emphasizing the beauty of nature. In later years he returned to his urban origins, exploring the modern architecture of large cities. His works are to be found in all the major international museums. He died in January 2010.

NICOLAS TIKHOMIROFF

'I have fought in and photographed numerous conflicts, and that is why I have a deep hatred of violence and intolerance. Therefore I now only photograph landscapes, portraits and nudes.' Nicolas Tikhomiroff felt compelled to make that profoundly personal decision in the late 1960s, having experienced war both as a soldier and as a photographer. He had been in Algeria, Vietnam and Cambodia, and now felt the need to focus on other subjects. He turned to the cinema and became fascinated by its protagonists, taking pictures of Fellini, Visconti, Brigitte Bardot, Romy Schneider and many other famous figures of the time. In 1962 Anthony Perkins introduced him to the legendary Orson Welles, and he visited the set of *The Trial*. Initially, the gruff, brilliant director was wary of having a photographer on set, but soon he was won over by Tikhomiroff's work and his humanity, and a strong friendship developed between the two. Tikhomiroff worked with Welles again on the set of *Falstaff* in Spain, where he took some of the most powerful and memorable portraits of Welles ever seen. In this example, Welles is directing on set, the ubiquitous cigar in his mouth. His figure emerges from the smoke and dust, lit by a cone of light from above, as if experiencing an epiphany. His severe profile is defined starkly in black and white, making him even more monumental and enigmatic. The photograph captures a unique and symbolic moment. Tikhomiroff once wrote: 'Photography must be the result of an emotion, a ray of enlightenment, or a moment full of love or sadness.'

Orson Welles, Spain, 1964

© *Nicolas Tikhomiroff/Magnum Photos*

NICOLAS TIKHOMIROFF was born in Paris in 1927, to Russian parents. During his military service he was sent to Germany, and then in 1945 and 1947 to Indochina. In 1950 he left the army and started to work for a fashion photographer. He became a freelance photographer for several fashion magazines. In 1956 he met the French journalist Michel Chevalier, with whom he produced various photo stories on the Soviet Union, Africa and the Middle East. He joined Magnum in 1959, and documented the various stages of the war in Algeria, and the situation in Indochina (Vietnam, Cambodia and Laos). He also worked extensively in the world of cinema, photographing Fellini, Visconti, Anthony Perkins and Orson Welles, among others. He retired from professional work in 1987, but continues to work on private projects.

ALFRED WERTHEIMER

When a publicist from RCA Records telephoned to ask him to photograph Elvis Presley during an appearance on the television programme *Stage Show* with Tommy and Jimmy Dorsey, Alfred Wertheimer responded: 'Elvis who?' It was 1956, and 'Elvis the Pelvis', 'The King' of rock and roll, was as yet relatively unknown. He had been booked to appear on the CBS show twice, but had caused such a sensation that the producers had decided to book him for another four shows. Wertheimer met him on 17 March, the date of his fifth performance. He knew nothing about the singer, but found him 'frankly fascinating. He was actually a shy person, just beginning to sense that he had something the public wanted.' Wertheimer had been working as assistant to a fashion photographer, but was tired of glossy, posed images. The twenty-one-year-old Elvis was the perfect subject with which to explore aspirations of realism, for he lived totally in the moment, and was able to block out the world and immerse himself completely in whatever he was doing. He was not afraid of closeness, because he was so absorbed in being Elvis that he hardly noticed the presence of the photographer. Here he is photographed getting ready to go on stage, in front of the mirror; no pose, just 'The King' concentrating on being himself, combing his hair in what was to become his trademark gesture. That year, Wertheimer worked with Presley for four months, taking a total of some 450 photographs. It was a golden year for Elvis: the album 'Heartbreak Hotel' hit number one in the charts, and the relatively unknown youngster began his meteoric rise to stardom. 'My instinct told me that this was no ordinary boy,' Wertheimer explained later. 'He had a talent that comes along every fifty or a hundred years. His voice was incredible. I didn't realize it at the time, but I think he had a feeling he was going to be somebody, and that's why he let me shadow him. If there's nobody there to record it, who's going to know it ever happened?'

Elvis Presley, New York, 1956

© Alfred Wertheimer/ Contact Press Images/ Grazia Neri

ALFRED WERTHEIMER was born in Germany in 1930. When he was a boy, his family moved to Brooklyn, New York. He graduated from Cooper Union in 1951. He carried out his military service as a photographer in the Army Signal Corps, and then worked for a brief period in the fashion industry, before devoting himself to photojournalism. In the spring of 1956, a series of assignments for RCA Records led to a shoot with a newly signed singer called Elvis Presley. Wertheimer was immediately impressed by him, and decided to shadow him for four months. The result was to be the most intimate encounter ever recorded with the future legend. More recently Wertheimer has been involved in producing documentary films.

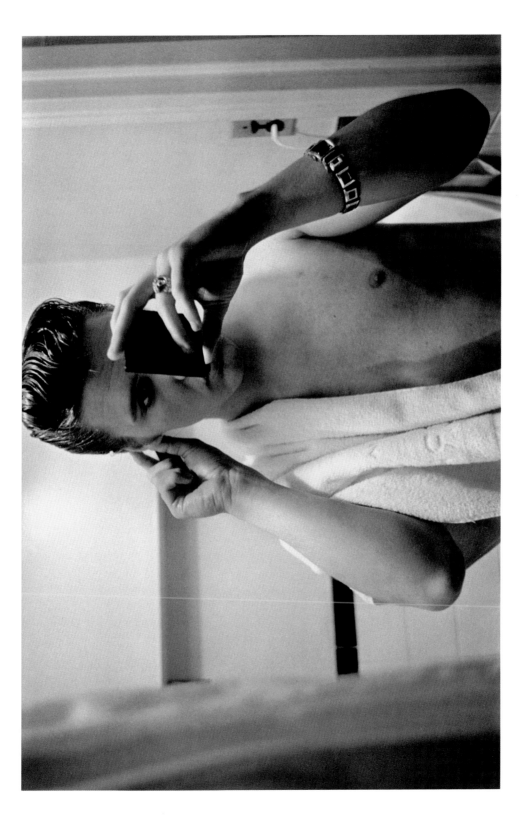

ANTOINE D'AGATA

Antoine D'Agata approaches the night as a man, not as a photographer. He loses himself there; it is a journey into darkness, where both words and thoughts unravel and identity becomes atomized. D'Agata's obsession is flesh, the physicality of bodies withered by addiction to pleasure and pain. His scenes are based on emotion rather than narrative, on the contact between reality and the observer; D'Agata does not seek to document the world, but rather to explain the photographer's role in it. 'In my photographs, in my daily practice of artifice, I cannot pretend to describe anything other than my very own situation – my daily state of mind, my own personal fluctuations.' Solitude, orgasms, eroticism, pain, change, danger, desire – his anxieties reflect those of the broken characters ravaged by alcohol, drugs and vice who appear in his work; and in the cracks and crevices of their used and abandoned bodies he explores the essence of their being. D'Agata's experiences occur in moments of intense sexual and existential tension: the camera scrutinizes the physical and emotional intimacy of writhing bodies, seen on the very limits of a reality that has been stripped of its false boundaries. There is no joy; life is brutal. Desire and pleasure are intersected by death and peril. His photography is one of violence and despair. D'Agata's interest is in exploring the unconscious, in unearthing the intense sensations that come from underground lifestyles and that defy the bourgeois social order. As there is no place for deviance in that order, his photography is one of protest: 'The pornographic gesture, paradoxically, becomes an explicit alternative to the monstrosity of social interactions that revolve around unfulfilled desire, frustration and paralysis.'

Japan, 2004

© Antoine D'Agata/ Magnum Photos

ANTOINE D'AGATA was born in Marseilles in 1961 and left his native France in 1983. In 1990 he went to New York, where his interest in photography led him to attend courses at the International Center of Photography. In 1993 he returned to France but did not photograph for four years. In 1998 his first books *De mala muerte* and *Mala noche* appeared, and in 1999 he joined the VU agency. In 2001 he published *Hometown* and was awarded the Niépce Prize. In 2003 his exhibition '1001 Nuits' opened in Paris and he published the books *Vortex* and *Insomnia*. In 2004 he joined Magnum as a nominee, and in the same year shot the short film *Le Ventre du monde*. In 2005 he published the book *Manifeste*. In 2006 he shot his first feature film *Aka Ana* in Tokyo. He became a full member of Magnum in 2008.

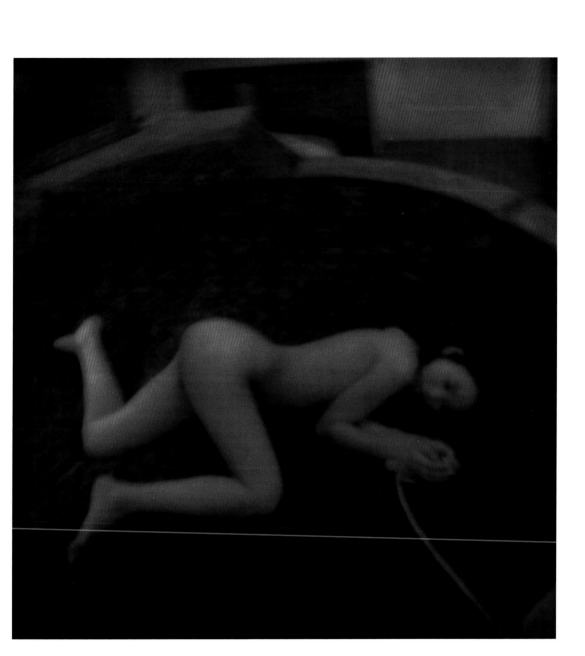

JEAN-PAUL GOUDE

Jean-Paul Goude is an eclectic, avant-garde artist whose work has enthralled the fashion world for over thirty years, and whose life and art are inextricably intertwined. He has expressed himself in various media – design, advertising, photography, cinema, video production and event design – in a career that has profoundly marked the development of fashion photography and the visual arts. He was art director of *Esquire* during the 1970s; he was Pygmalion and companion to the statuesque Grace Jones; and he designed the spectacular 1989 Bicentenary Parade in Paris which commemorated the French Revolution. He is also the creator of original and controversial billboard campaigns, such as the series for Galeries Lafayette, in which the model Laetitia Casta was cast as a series of characters in a fictional *feuilleton*. Goude has always intended to shock: his favoured subjects – sex and racial stereotypes – are intrinsically provocative. 'For me, the girl next door holds no interest.' What intrigues him is the unexplored potential of the body, and sexuality; he has a passion for the exotic, dating back to a childhood fascination with Native American culture and female tribal deities. His pictures of women are challenging, embodied by the *tableaux vivants* of Radiah Frye, Carolina, Toukie Smith and Grace Jones – his models, inspirational muses and, often, partners. In both photography and collage, Goude deconstructs, modifies and estranges the human body, rendering it as 'other', dreamlike and magical. He brings innovative concepts to life and creates an intense style which is irreverent and playful, yet sensual and provocative.

Carolina, painted photograph, New York, 1976

© *Jean-Paul Goude*

JEAN-PAUL GOUDE was born in 1940 in Saint-Mandé, France, to an American mother and a French father. He began his career as an illustrator in 1964. Six years later, he was named art director of *Esquire* magazine. He then moved to New York where he met the singer Grace Jones, becoming her manager and collaborating with her on what is still considered legendary photographic work, performance and video art. In 1982 he published his autobiography *Jungle Fever* and directed his first commercial. Since 1984 he has continued to work in advertising, in addition to his work in photography.

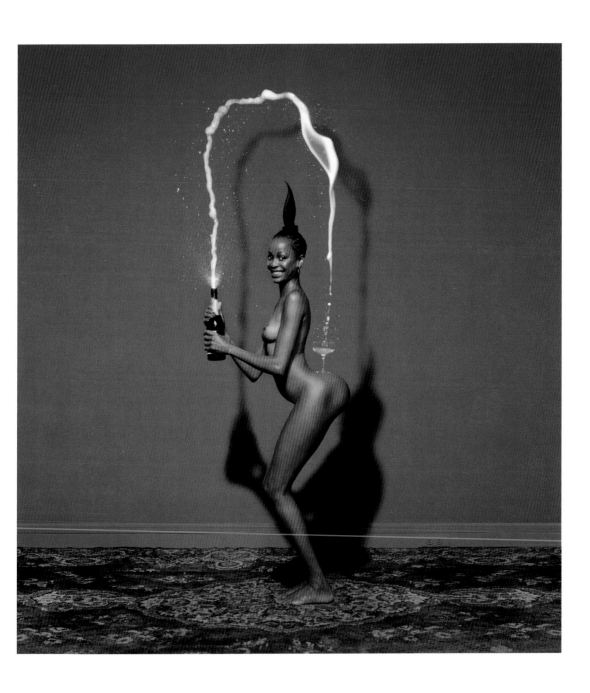

HORST P. HORST

It is 1939, war begins and Europe is bombed. The dance has come to an end, the lights have gone out and the curfew has begun. In an empty studio, after a round of exhausting poses, at four in the morning a photographer and his model suddenly create a ravishing and refined farewell to peace. It took Horst, a woman, *Vogue*, a corset from American fashion label Mainbocher and nothing more; and so a masterpiece was born. In the shimmer of her blonde hair, the histories of fashion, eroticism, women and, perhaps, even wartime photography itself, are encapsulated. A second longer and the scaffolding of her corset would have become rigid once again, restricting the breath and protecting the body under an evening dress. But Horst's style was never one for everyday life: it was reserved for the world of dreams, escapism and expectation. And the fantasy lingers in time, frozen in this image. It is not merely a space, a bedroom, a dressing room – nor even a balcony, as there is no sky in the grey background. The woman's back seems to radiate in the silk corset as she balances on a wooden balustrade that has been transformed into precious marble with lighting. She is an enigma. What she has done or is about to do, whether getting dressed or undressed, nobody knows. Horst remained silent. It is as though the same light which transformed that corset into the most elegant attire simultaneously, with the flick of a switch, extinguished every illusion of frivolity, joy and peace. The following morning, Horst left Paris in a whirl, leaving the success and freedom he had known in France, and leaving his family home – and the Nazi horrors – in Germany. Arriving in New York by passenger ship, an ocean away, he was not only far from all he loved, but also from that back which, only a short time before, had been rendered soft and supple under his gaze.

Mainbocher Corset, Paris, 1939

© Horst P. Horst/ Art+Commerce

HORST PAUL ALBERT BOHRMANN was born in Weissenfels-an-der-Saale, Germany, in 1906. In the 1920s he studied at the Hamburg School of Applied Arts and later moved to Paris to study alongside Le Corbusier. In 1931 he began working for *Vogue*, which published his first photograph in the French edition. In 1932 he took Bette Davis's portrait, the first in his series of female stars, and in 1936 he met Coco Chanel in New York, where he photographed her thirty-year contribution to fashion. He moved to the US in 1939 and, after gaining American citizenship, became an army photographer. In 1945 he took President Harry Truman's portrait and subsequently photographed every First Lady in the post-war period. In the 1960s he began to photograph the world of international high society. He died in Florida aged ninety-three.

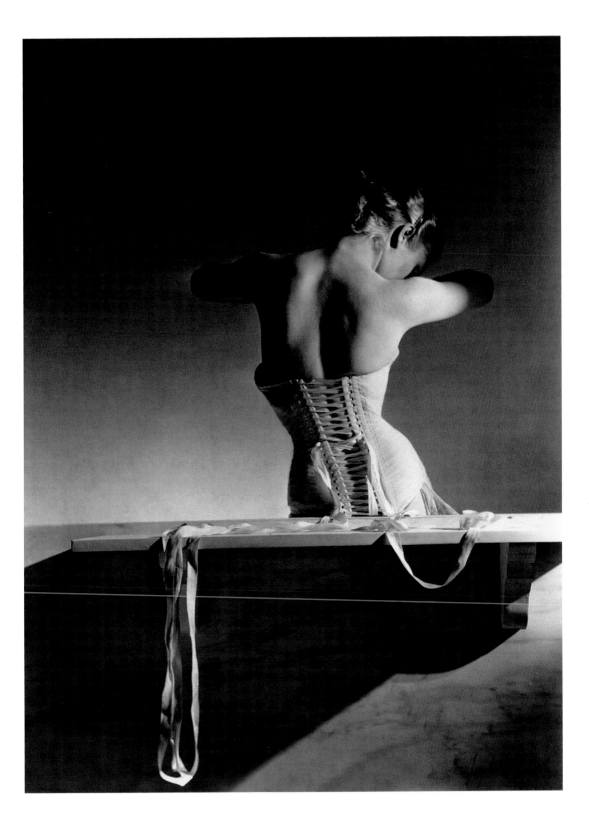

DAVID LACHAPELLE

When good children come to the table, they do certain things: they place
their napkins on their laps, cough very lightly to clear their throats, and then
come the magical words *bon appétit* – a little passé, vaguely dry, but certainly
elegant – and then dinner can commence. Since David LaChapelle is a mis-
chievous but very polite forty-five-year-old boy, he also wanted to begin his
meal as a dreamy and carnivorous photographer with the spectacular 'Bon
Appetite'. On the table lies the culinary dream of every male cannibal: a
splendid, lithe, feline Naomi Campbell, kitted out in silver chains. Food for
the eyes, *au naturel*, without dressing or garnish. On arrival, the diners will
perhaps fight over the best piece: for one the breast, for another the thighs,
and someone will sink their teeth into the tender neck. However, this is
only the beginning. LaChapelle's brilliant career, which he began at the
age of eighteen under the tutelage of Andy Warhol, includes a menu with
enough courses to feed every visual desire. There are countless Americans
and plenty of fast food, pop culture and comic strips, Technicolour fairy-
tales, fanzines, '50s glamour, and a little bit of healthy and very savoury
surrealism. There are heavy dishes: a grapefruit between Drew Barrymore's
breasts, a little cream on Brooke Shields's jeans, Lili Taylor with a milk-
shake among mushrooms and to follow, naturally, chocolate ice cream
cones, hotdogs, cream tarts and lollipops. In this image, amid the uniform
white tableware, appears a surprise egg – homage to womanhood – and close
by are four candles, the erect symbols of masculine power. All are invited to
decode the enigma concealed above and below the table, cooks and puzzle
lovers alike. LaChapelle's unmistakable and original style was celebrated in
a large retrospective (from 24 September 2007 to 6 June 2008) at the Palazzo
Reale, Milan, which included this image.

Naomi Campbell:
Bon Appetite, 1999

© *David LaChapelle/*
Art+Commerce

DAVID LACHAPELLE was born in Fairfield, Connecticut, in 1963. He took
his first 'glam' photo at the age of seven. The model was his mother in an Ursula
Andress-style bikini, with a blue carpet and red curtain – an indelible visual
imprint. At the age of fifteen, LaChapelle was in New York working in editorial
at *Interview*. His portfolio contained only pictures taken of classmates: a sketch of
secondary-school students. Three years later he began taking pictures, moving
from the black-and-white early photographs to very saturated and dazzling colours.
LaChapelle is a brand. His career took off, and in the early 1990s his work appeared
in *Vogue*, *Vanity Fair*, *GQ* and *Rolling Stone*. In 1996 his first book, *LaChapelle Land*,
was published, followed three years later by *Hotel LaChapelle*, and lastly *Heaven to
Hell* (2006).

LEHNERT & LANDROCK

This woman shares her name with a country. Better still to imagine that this beautiful anonymous body is nameless, a symbol of a hot and distant land, at least in the male imagination at the turn of the twentieth century. In 1904 Rudolf Franz Lehnert and Ernst Heinrich Landrock, the first a Bohemian-born photographer and the second a German businessman, found themselves in Tunisia. There, at the gateway between Africa and the East, in a place already familiar in fantasy and fashion, they established the legendary studio and brand Lehnert & Landrock. The exoticism of this new world caught the imagination of these young men and thrust them into a highly profitable adventure. Perhaps it was the heat, or perhaps an entirely Nordic interpretation of the local culture, but they found a people who loved to move between the walls of the kasbah and the dunes of the desert in the coolest state of dishabille. One click of the camera, and the images became postcards. These began to be circulated among certain groups, and in certain cafés, jealously guarded between the pages of a book or in a secret case. Their beauty snubbed the other strand of old pornography, destined for the barber shops; theirs was a world infused with the fragrances of sandalwood, incense, jasmine and dates. The staging included the minimum of accessories – a wraparound, two bracelets – a far cry from the artificial and cluttered effect of so much of the 'smutty' European photography of the time. This picture, 'Our Tunisian Lady', or 'Tunisian Woman', is a small masterpiece in harmony, almost at the peak of Saharan eroticism. It seems impossible to imagine that behind the sweet smile and graceful hands lies the horror, not only photographic, of our own colonialism.

Tunisia, c. 1910

© Rudolf Lehnert & Ernst Landrock. Courtesy Musée de l'Elysée, Lausanne

RUDOLF FRANZ LEHNERT and Ernst Heinrich Landrock were both born in 1878. In 1904 they went to Tunisia and set up a photographic studio. Lehnert took the pictures and Landrock ran the business. In 1914 the studio was confiscated by the English and the two associates were imprisoned. In 1923 Lehnert resumed his travels in the Middle East, and in 1925 he opened an office in Cairo but five years later left the partnership. In 1938 Landrock went to Germany, where he sold 80 per cent of his image rights to his son-in-law, Kurt Lambelet. Lehnert returned to Tunisia, where he married; after his wife's death he moved to Redeyef, in the Gafza Oasis. Lehnert died in 1948; Landrock in 1966. Their archives are currently housed in the Musée de l'Elysée in Lausanne.

HELMUT NEWTON

The light is cold as always, perfect as always. Everyone is in their position, meticulously arranged, and no detail is neglected. There are multiple points of view. The scene has a strong theatrical impact: we become the fifth player, the public. The roles, however, are confused. The photographer is there at the back of the picture, sandwiched between the statuesque frame of the model and his wife June, who observes the scene with a director's poise. He represents himself as small among the large women and hides his face behind the camera. The picture both deceives and surprises: there is static perfection within the formal composition, but there is also movement. As though part of a scene in a play, the legs which appear beside the mirror could quickly move forward and in a second take centre stage. Helmut Newton loved to wrong-foot the observer and left nothing to chance: 'I do all of my work in writing first. I always carry around a little notebook in which I can jot down the minutest details concerning photos that I'll take some other time. I can't draw. So I make notes on props, lighting, the compositional parts of my picture. Perspiration under the arms, puffed-up lips, a kiss, a man's shoulder, a woman's hand, the inside of the elbow, the interplay of muscles.' Newton forged a reputation as a fashion photographer, but his pictures are timeless in a way that fashion is not. He is essentially a photographer of women. His women are adults, beautiful and privileged creatures who exude security and determination; erotic Amazonian nudes poised in high heels. Their bodies, portrayed against the backdrop of urban scenes, or in clinical or baroque interiors, are the embodiment of eroticism, provocation, play, mystery and seduction. To those shocked when faced with his pictures, Helmut Newton would ironically reply: 'One must also be on a par with one's own bad reputation.'

Self-Portrait with Wife June and Models, Paris, 1981

BORN IN BERLIN in 1920 to a rich Jewish family, Helmut Newton graduated from the American School and began to assist the photographer du jour, Yva. In 1940 he arrived in Australia, fleeing Nazi persecution, where he gained citizenship and enrolled in the army. In 1956 he returned to Europe, and transferred to Paris the following year and began working for the most important fashion magazines, which competed over his pictures. He received countless awards and was nominated for Chevalier of the Order of Arts and Letters, first in France (1989) and later in Monaco (1992). In 2003 he left the entire body of his work to the city of Berlin. He died in 2004 in a car accident in Los Angeles, aged eighty-three.

WILLY RONIS

Willy Ronis had great respect and admiration for the beauty of the female form. He travelled across it, knew and exalted it, but always portrayed it with a reverent and restrained discretion. In 1949, the same year this photo was taken, he composed other nude images, such as *Provençal Nude*, in which his wife Marie Anne, with her back to us, washes herself with a basin of water on a scorching summer day. In this photograph the setting is a stripped and modest attic on the sixth floor of a building in the centre of Paris. The walls are cracked and the floor is stained. The pose recalls the great French nineteenth-century painting tradition, which Ronis knew and absorbed. Here he recreates and 'revisits' Gustave Courbet's *Femme au perroquet*, a female figure lying on an unmade bed, also depicted with stark realism and bold sensuality. Apparently caught in a moment of private nonchalance, with her hands behind her head and her hair ruffled, Ronis's model grants the photographer access to her unfettered physicality. The dark bedding highlights the harmonious lines of her pale body, every shade rendered in pure black and white. Her face, timidly turned away from the lens and the spectator, is bathed in a glow of light which strikes the door and diffuses throughout the room, setting the tone of the scene – somewhere between a reverie and sweeping passion.

Nude, Paris, 1949

© *Willy Ronis/RAPHO/ EYEDEA*

WILLY RONIS was born in Paris in 1910 and learned the art of photography in his father's studio, himself a portraitist from Montmartre. In the mid-1930s he published his first photo story in the magazine *Regards*. Immediately after the war, he became the first French photographer to work for *Life* magazine and joined the photo agency RAPHO. In 1953 Edward Steichen included him in an exhibition entitled 'Five French Photographers' (alongside Cartier-Bresson, Doisneau, Izis and Brassaï), organized at the Museum of Modern Art, New York. Two years later, Steichen again chose some of his pictures for the celebrated exhibition 'The Family of Man'. Ronis, essentially an interpreter of so-called 'humanistic photography', was awarded the Grand Prix des Arts et Lettres for Photography in 1979. He retired from photography in 2001, and died in September 2009.

PAOLO ROVERSI

For a time it was thought that photography was capable of seizing and steal- ing the soul of the subject; as though, when imprinted on film, the soul remained a mysterious presence, abstract but of profound substance. Paolo Roversi, using large-format Polaroid film, rediscovers the profound aesthetic quality of that belief, almost restoring a mythical and alchemical quality to photography. 'All photographs are revealing,' he maintains. 'However, the portrait is not only an aesthetic gesture, it also functions on a psychological level.' Photography is therefore the representation of the unknown, 'the exact moment in which the present is forever swallowed in the past'. In a world dominated by images, Roversi denies us our desire to see everything. He approaches faces and bodies delicately, without scrutinizing or plun- dering them. Often all that remain are traces of outlines which are barely accentuated and highlighted, or a glimpse of the face amid the monochro- matic whole, where the subject and the background discolour one another. Here the central figure, a childlike woman, is made of the same substance as her surroundings, looking at us through the eyes of the photographer. She stands, composed of a subtle line which accentuates her face and pubic area as the central visual points. Nearly transparent, her appearance is so minimal that she is transformed into something almost abstract. 'Posing nude is not easy,' says Roversi. 'There is intimacy, shyness, embarrassment and a moment of confrontation. Some find these images to be pure and innocent, others perverse and others still, very erotic. For some, they are not naked bodies; they are ghosts, devilish or provocative angels.' Roversi's portraits construct a subjective place between memory and dreams; his intangible, indecent or hallowed angels appear in a mysterious space, which he renders distant and untouchable.

Jaime, Paris, 1993

© Paolo Roversi

PAOLO ROVERSI was born in Ravenna in 1947. His interest in photography was ignited when he was seventeen during a trip to Spain, and at twenty he began working as a reporter for a photo agency. In 1970 he opened his first studio in Ravenna, where he focused on still lifes and portraits. In 1973 he moved to Paris and, on meeting Laurence Sackman, developed an interest in fashion photography, later becoming Sackman's assistant. Though Roversi's first works were far from the world of fashion, he soon found his path. He currently lives and works in Paris. He regularly collaborates with numerous publications, and works on advertising campaigns for renowned stylists.

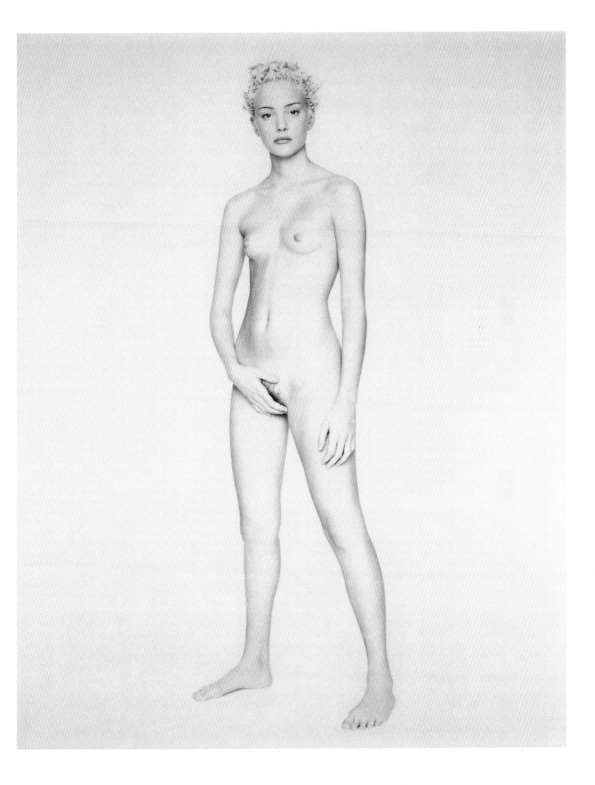

PATRIZIA SAVARESE

'I put water into a container and observed the movement. This is what I generally say to whoever asks me what is behind my years of work for the Teuco calendars, nearly all of which are staged under water.' Since the early 1980s, the Roman photographer Patrizia Savarese has carried out research-based work on nudes, initially in black-and-white and then in colour. She was among the first in Italy to experiment with the male form, and in the last few years she has managed to complete a thorough study of the nude and water due to her solid and profitable collaboration with the company Teuco Guzzini. This photograph belongs to the series 'Water Calligraphy', made in 1998 and inserted into an eight-year body of work entitled 'Water Trip'. Patrizia Savarese's pictures are built around her particular vision of light, which seems to become fluid; it is a stream which, like water, runs along bodies, traces motion and evokes a mysterious and unreal ambience. Through the combination and interplay of harmony, form, light and movement, Savarese carves out hypnotic fragments of time which are made for contemplation.

Water Trip, November '99
(model: Federica Lorusso)

© *Patrizia Savarese/*
Contrasto

BORN IN ROME, Patrizia Savarese studied in the 1970s at the Istituto Europeo di Design (IED) in the faculty of architecture, before graduating in interior design and later in photography. She began to work in the music business, following international rock stars at concerts and on tours throughout Europe. In the 1980s she was one of the most sought-after rock photographers, and she also began to work in the fashion and advertising industries. Recently, she has begun to teach courses and hold workshops while continuing to photograph.

HOWARD SCHATZ

If water had a memory, if it were true that all our journeys in this vital element leave traces, then water would surely remember the wonderful, acrobatic pictures of Howard Schatz. He is the American photographer who has dedicated his entire career to the beauty of the human form, to its plastic qualities and its eternal youth. In the book *Newborn*, that small masterpiece of sweetness, he paid homage to the fragility of babies in the first days of their lives, at the start of the journey which has led them from the waters of the womb to the weight of the world. In Schatz's work we find water, origins, peace, lightness, continuity, freedom, nostalgia, but also games, both single and double, as in this image, part of an extensive project begun in 1990 and still ongoing. In a swimming pool the bodies of two ballet dancers, archetypes of the male and female forms, dance through every emotion, through love and desire. Locked in an embrace they become one, break away and are again reunited; it is a romance. Schatz has captured this fluidity again and again in his other work, focusing on athletes and dancers on the ground. Here we can see only a single frame, a still, but this is an illusion. Both the photograph and the water seem to retain and transmit the entire sequence of movement, before and after the picture being taken. The positioning is perfect, the line is continuous; at this moment the bodies form an X, but within a few seconds they could take the shape of the entire alphabet. And who's to say that this grace is not the ABC of survival outside the water as well.

Underwater Study 2843, from H2O

© *Schatz Ornstein 2007/ Grazia Neri*

HOWARD SCHATZ is a multi award-winning American photographer with an illustrious career in advertising as the photographer and director of campaigns and commercials for Nike, Sony, Virgin Records, Mercedes-Benz, Wolford and Adidas, to name but a few of his clients. Throughout his long career he has published seventeen books, including *H2O* (2007), a symbiosis of water and the body; *In Character: Actors Acting* (2005), a portrait of one hundred actors on stage; *Athlete* (2002), a homage to the stars of American athletics; and *Botanica* (2005), beautiful images of flowers. His work has been published in *Time*, *Sports Illustrated*, *Vogue*, *Vogue Italia*, the *New Yorker*, *Stern* and *Life*. His long-time business partner is his wife, Beverly Ornstein.

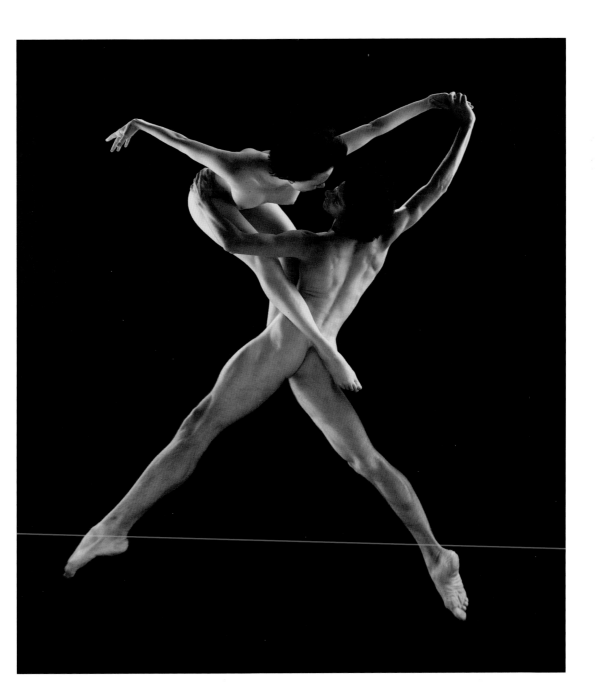

JEANLOUP SIEFF

'Sieff is a photographer of surfaces; he loves surfaces.' So affirms Frank Horvat, who knew him well and knows that his friend would be happy with such a description. Jeanloup Sieff himself confessed: 'I am totally superficial, I know. But I believe superficiality can be very serious, it can be a defence against the gravity of things, a manner of discretion.' If one decides that the crease in a hand or a dress could be revealing, it then becomes crucial. This is what Sieff meant by surface: a purely physical aspect, perhaps relating to the skin, the sky or a wall. He was attracted to a particular nuance in the substance from which he sought to convey an emotion or, at times, a concept. He worked on fashion, portraiture, reportage and, of course, his famous nudes. The sinuous lines of the female body were traced in smooth surroundings, in apparently stolen seconds of intimacy. Sieff's women were delicate, mysterious, elegant, but never languid. In simple and unadorned settings, he modelled bodies using a refined interplay between volume and light. He often portrayed them with a wide-angle lens, its distortions adding an unusual dimension to the image. Sieff's surfaces can be dense, like a memory which re-emerges in the mind. 'We live the present moment with little idea of the emotional intensity it will acquire in memory,' he said. The mystery in the image remains hidden, in the skin of a perfectly formed back, in the shadow of a neck which does not turn around, and in the profile of a face which cannot be seen.

Muscular back, 1992

© *The Estate of Jeanloup Sieff*
www.jeanloupsieff.com

NUDES

JEANLOUP SIEFF was born in Paris in 1933. He was a journalist and portraitist who photographed landscapes, fashion and nudes. He worked with several magazines, among them *Elle*, *Vogue*, *Harper's Bazaar*, *Esquire* and *Glamour*. He is the man behind the famous nude perfume adverts for Yves Saint Laurent and the memorable campaigns for Rosy lingerie and Carel shoes. In addition, he is the author of fifteen books, for which he often also wrote the text. He died in Paris in 2000. *Les Indiscrètes*, a collection of previously unpublished photographs, came out in 2008.

196

ELLEN VON UNWERTH

She loved Bettie Page, betrothed to the dark side of 1950s America. Hers was a domestic perversion in which basement New Yorkers lay between stools and night dressers in black lace lingerie and stockings with reinforced heels. She was playfully spanked, sometimes by a man and sometimes by another woman, always in the role of accomplice, friend and playmate in the yard. And it is this light-hearted sexuality, almost chaste despite the latex corsets and circus whip, which inspires the former model Ellen von Unwerth half a century later. She now stands on the other side of the lens. A lot of experience, some shrewdness, perhaps also a little spanking, and Ellen transforms into a photographer, video director, a symbol of the late-1990s 'girl power'. From now on it is both power and play for the girls, who let their hair down and spread the fun of a light and ironic spank across the globe. The scenes are no longer illuminated with a harsh light in a clandestine setting, but instead softened and legitimized with rosebud wallpaper. Perhaps it is a room by the hour, or a small hotel in Pigalle. Perhaps it is a break from the iron rules of fashion and the splendidly slick shoots that Von Unwerth has carried out for *Vogue*, *Interview* and *Vanity Fair*. What is certain is that working with Ellen – as model Eva Herzigova explains – 'is always fun because she lets you free yourself in front of the lens, and even when it is very sexy, it is never lewd'. But above all, in the words of Helena Christensen: 'Ellen brings out what goes on in the mind of another woman, which only a woman knows.' And it is sex, but this time there is also laughter.

Spank Me, New York, 1996

© *Ellen von Unwerth/ Art+Commerce*

ELLEN VON UNWERTH was born in Munich in 1954. She was working as a knife thrower's assistant when she was spotted by a talent scout and became a model. After a decade of regularly appearing in major publications, she passed to the other side of the lens, becoming a music video director and a photographer for American, Italian and French *Vogue*, *Interview* and *The Face*. Her advertising campaign for Guess Jeans is legendary; the now-famous Claudia Schiffer starred as the then-unknown protagonist. Ellen von Unwerth's images are strongly erotic in nature but with more irony than other masters of the genre, such as Helmut Newton. Her books include *Snaps* (1994) and *Revenge* (2002), both homages to the tales of the Marquis de Sade.

ALBERT WATSON

Breaunna is not a model. However, she is used to flaunting and exhibiting herself, becoming the object and subject of desire. She is a dominatrix, inhabiting the world of fetish, clothed in latex and high heels, masked, and with alternate looks: dominance and submission. Her moniker is Miss Beehayving, mistress and burlesque performer. She had never been in front of the camera before meeting one of the great living fashion and advertising photographers. Albert Watson saw her by chance in 2000 during a Rockabilly convention in Las Vegas. She immediately intrigued him. 'When you come from a small town in Scotland,' explains Watson, 'and years later you end up with a camera in Las Vegas, it's truly like being in another galaxy. And meeting somebody like Breaunna was inspiring. She lives in an exotic, erotic world, and that's what fascinated me.' Breaunna the dominatrix would go on to pose for him several times in the course of the following two years. She has a chameleon-like quality, a natural charisma. She knows how to move in front of the lens and the beauty of her white, velvety complexion makes her an ideal subject. Powerful images and technical virtuosity are two staples of Albert Watson's work, whether he is photographing a model or Tutankhamun's glove. Las Vegas bewitches him: the combination of excess and loneliness drives him to return. When freed from the pressures of commissioned work, he tours the city, recapturing the streets, showing us neon lights and his surreal landscape of circus acrobats, male strippers, mime artists, actors and, lastly, Breaunna. In a hotel room Watson graduates the lighting – this is his talent, his signature motif – which allows him to infuse the atmosphere with eroticism elevated to a meditative plane. The beautiful dominatrix lies on the bed, naked, without her latex or high heels. She wears only fire-engine red lipstick, and a faraway gaze, no longer haughty.

Breaunna, Las Vegas Hilton, Las Vegas, 2001

© Albert Watson

ALBERT WATSON was born in Edinburgh in 1942. Blind in one eye when he was born, he studied film when he was young and began photographing as a pastime. When he moved to Los Angeles in the 1970s, photography became his profession. He has created hundreds of publicity campaigns for labels such as Chanel, Levi's, Prada and Dior. He was the official Royal Photographer at the wedding of Prince Andrew to Sarah Ferguson. He has also taken numerous photographs of celebrities, including Uma Thurman, Johnny Depp, Alfred Hitchcock and Mick Jagger. As one of the most sought-after photographers in the world, he continues to work for renowned international publications. Over the years he has been the subject of many shows, and published *Cyclops* in 1997 and *Albert Watson: The Vienna Album* in 2005. He currently lives and works in New York.

EDWARD WESTON

'Naked, you are simple as one of your hands, smooth, earthy, small, round, transparent', in the words of one of Pablo Neruda's poems. Naked, sitting on the doorstep of their Santa Monica home, a faceless Charis Wilson, Edward Weston's partner and model, elegantly folds herself into her lithe and youthful body. In this portrait, Weston calls to mind shapes: the oval forms of the arms and head and the right angles of the legs and door convey his desire to find a symmetrical rhythm. However, the woman is made of flesh; he loves her sensuality, her femininity, her earthy round-ness, and he glorifies her in a light that magnifies her shape and ignites her perfection. Weston was convinced that the camera is better than the naked eye. He uses it as an amplifying lens to reveal that which already exists but often is not seen. And so a simple pepper is reborn as a sculp-tural shape, or the sinuous curves of a common toilet echo the hypnotic lines of the female nude. There are no technical tricks here: his is pure photography. 'The camera should be used for a recording of life, for ren-dering the very substance and quintessence of the thing itself, whether it be polished steel or palpitating flesh.' Weston seeks the forms within reality, then isolates and elevates them, and with a wonderful light reveals the unexpected. His abstraction is not detached from reality. It is instead an extraction, a concentration of elements, a discovery that searches for a universal value of form and beauty. Ansel Adams wrote of him: 'Weston is ... one of the few creative artists of today... His work illuminates man's inner journey toward perfection of the spirit.'

Nude, 1936

Collection Center for Creative Photography
© *1981 Arizona Board of Regents*

EDWARD WESTON was born in Highland Park, Illinois, in 1886. He took his first set of photographs in 1902. In 1906 he moved to California, then in 1908 he enrolled at the Illinois College of Photography. He drew inspiration from the photographic movement of Pictorialism. In 1911 he opened his first photographic studio and in 1922 he photographed the steelworks company ARMCO, ushering in a new style, abstract and sharp. In 1923 he opened a studio in Mexico City with Tina Modotti before moving back to California in 1926, where he created his most famous images. In 1932 he became a founding member of Group f/64 and published his first book, *The Art of Edward Weston*. In 1936 he started his series of nudes and in the following year became the first photographer to receive the Guggenheim Fellowship. He developed Parkinson's disease in 1946, and died in 1958.

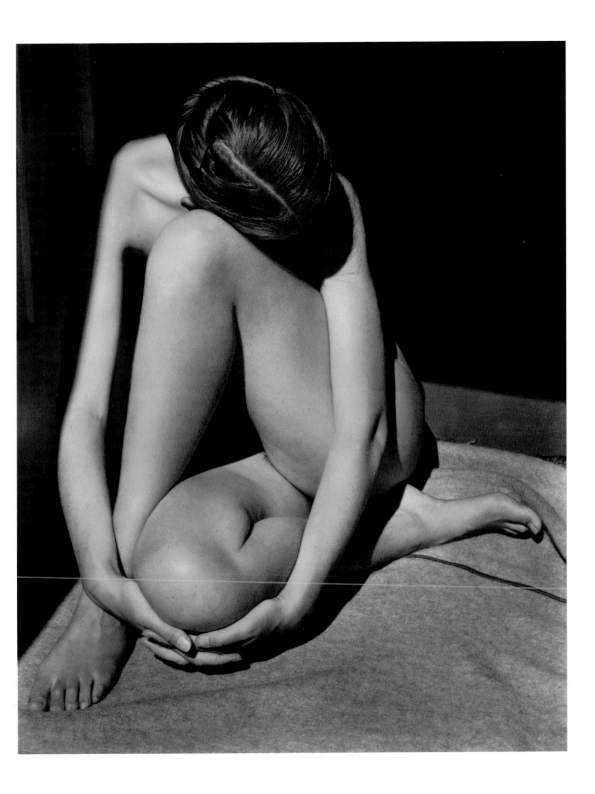

ABBAS

Islam – a body torn by extreme, irreconcilable forces; on the one hand, looking to the future and, on the other, seeking refuge in a glorious past, taking pride in its heart, its traditions and its sacred writings. A body torn in this way is destined to suffer and to make many of its believers suffer. This is the conclusion that the photographer, Abbas, seems to reach. In the 1970s in Iran, he saw at first hand how a civil and secular revolution to win independence was transformed into an intolerant and repressive religious revolution: the Islamic revolution. Inspired by his personal experiences which led him to exile in Paris, and a witness to the rise of fundamentalism, Abbas devoted seven years to exploring and photographing the world of militant Islam: from France to Sarajevo, and Iran to China, encompassing Egypt, Algeria, Afghanistan, Pakistan, Morocco, Senegal, Kuwait, Palestine, Malaysia and Indonesia. In the diary that accompanied his pictures, Abbas wrote: 'For me, Islam has always brought to mind the dusty grey tones of the plateaux, and the ochre of the sand dunes and steppes, refreshed with the sudden green of the oases. It is a religion of the desert, blue skies and the wind which sweeps away everything. In Indonesia, I discovered a religion of water, forests and coconut palms, interrupted by the graceful geometry of the rice fields. Here, Islam has been grafted into the ancient Buddhism, Hinduism and pagan traditions.' It is also a religion that puts out long, winding roots – especially for women. Abbas asked a girl wearing a white jilbab, the local version of the hijab, if she wasn't hot under that synthetic veil. A man answered for her: 'Nothing like in the fires of hell!'

Students of the Al Azhar College during Friday prayer, Jakarta, 1989

© *Abbas/Magnum Photos*

ABBAS WAS BORN in Iran in 1944. Since 1970 he has taken war photos in every corner of the earth: Biafra, Bangladesh, Northern Ireland, Vietnam, the Middle East, Chile, Cuba and South Africa. From 1978 to 1980 he documented the Iranian Revolution, before moving to Paris where he remained in voluntary exile for seventeen years, only returning to Tehran in 1997. He joined Magnum in 1981 and, during the period 1983 to 1986, travelled around Mexico. Between 1987 and 1994 Abbas composed a fresco on the Islamic religion, which appeared in the imposing volume *Allah O Akbar: A Journey through Militant Islam* (1994). In 2000 he published *Faces of Christianity: A Photographic Journey*, followed, in 2002, by *Iran Diary 1971–2002* and, in 2005, *Sur la route des esprits*, devoted to animism.

JANE EVELYN ATWOOD

The noise cannot be heard, but it can be seen – the noise of a door closing, marking the end of freedom and the start of a punishment that might last a few months, several years, or possibly forever. It may have been that echo of iron and soul in a mysterious, prohibited world that prompted a strong, obstinate woman like Jane Evelyn Atwood to start an undertaking that is unique – not only in the history of photography – for its length and geographic extent. Atwood spent ten years in the world of women's prisons, documenting life, suffering and the moment of release in forty institutions across America and Europe, as well as in lands further east. The work began with endless requests, papers, postponements and patience, until finally, in 1990, an iron door opened for her. Beyond that door lay the Ryazan penitentiary in the old Soviet Union. Five women, whose stories we don't know but whose poverty, family degradation and solitude we can imagine, are bathing themselves. This moment of intimacy is offered to Atwood unveiled: the photograph remains balanced, it doesn't exaggerate, and one senses the photographer as a sixth presence in the group. This sense of solidarity, of sober and painful closeness, is reflected in all of Atwood's prison pictures, which are gathered together in a book beautifully entitled *Too Much Time*. Too much time, but no time to see the children grow up. Too much time, but never a moment of peaceful solitude. Too much time, but an inability to imagine a future beyond that iron door.

Women prisoners in Ryazan Prison, USSR, 1990

© Jane Evelyn Atwood/ Grazia Neri

JANE EVELYN ATWOOD was born in New York and moved to Paris in 1971. Five years later she started to take photographs, her earliest themes being prostitution and blind children. In 1980 she won the W. Eugene Smith Award. This was followed by a photo story on the Foreign Legion. Then Atwood turned her attention to an AIDS sufferer, whom she photographed in the four and a half months before his death. In 1989 she embarked on a demanding ten-year project on women prisoners in forty prisons across nine countries, from the United States to Europe. The work was published in the book *Too Much Time: Women in Prison* (2000). Her latest work, *Sentinelles de l'ombre* (2004), is dedicated to landmine victims from Angola to Afghanistan and Mozambique.

MARTINE BARRAT

Martine Barrat's story is a story of love, friendship and assistance. The characters are a young Parisienne and the people of Harlem. On the local streets Barrat is known as the 'Picture Girl' – the girl who left Paris in 1968 with a desire to set up theatre and video workshops for the children of Harlem and the South Bronx. Every day she walks through the local streets with her camera, but she isn't there for the sake of reportage, she isn't on a hunt for pictures. As Barrat says, she photographs her life and sometimes she takes photographs: it isn't the same thing. She knows everyone she photographs, many of them are her friends, and she offers each of them their portrait. Her adopted father is Gordon Parks, who says of her: 'She photographs joy and pain with the same honesty, embracing those whom the world seems to have forgotten.' Her intense and intimate photos depict daily life, boxing gyms, gang violence and the games of children whose holidays she pays for. Her gaze is never voyeuristic. In her Harlem you breathe the street; it's a territory of exchanges, elegance and brotherhood, where Barrat has felt at home from the very first. Her work 'Harlem in my Heart' is not a rhetorical monument to the glory of African Americans, but simply a series of moments in their company. The girl in this photo is lovely and elegant; maybe she has an appointment, or perhaps she is going to spend the evening at the historic Rhythm Club where, from the 1920s, the people of Harlem came together to play cards or billiards and to listen to music. But Harlem is changing; it is becoming increasingly middle-class and bohemian. A culture is disappearing, and in 2006 the Rhythm Club closed. Martine Barrat has dedicated a moving film to the club's closure and to its people. Her pictures show a world which is now almost extinct.

Harlem, New York, 1985

© Martine Barrat/Contact Press Images/Grazia Neri

MARTINE BARRAT was born in Algeria and grew up in Paris. In 1968 she moved to New York and began her artistic journey as a photographer and filmmaker, working in the Harlem and South Bronx districts. Between 1973 and 1978 she created a series of videos and photos on gang life, entitled 'You Do the Crime, You Do the Time'. She is the author of *My Friends*, published in Japan in 1987, and *Do or Die* (1993), an intimate account of young boxers with a foreword by Martin Scorsese and an introduction by Gordon Parks. Her work has been exhibited throughout the world. In 2001 the French government awarded her the Medal of Honour of the Order of Arts and Letters. In 2007, her show 'Harlem in my Heart' was hosted by the Maison Européenne de la Photographie in Paris. Barrat lives in New York.

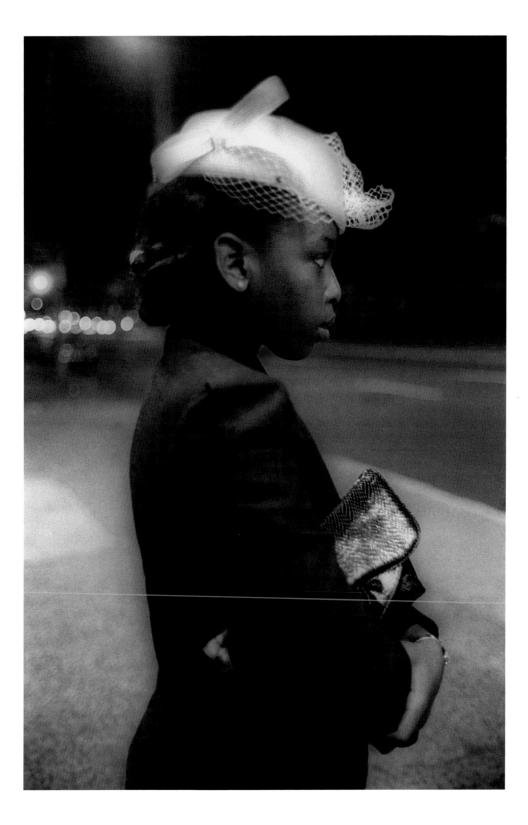

ÉDOUARD BOUBAT

WOMEN

By existential choice Édouard Boubat was in love with life and with that dizziness of life that is love. Only French photographers, from Doisneau to Izis, and Brassaï to Rony, have truly known how to sing the praises of this love and how to offer it to the world almost as if it were a national product, a trademark. It was to love and to his passion for Lella Concarneau, known simply as Lella, that Boubat dedicated his best works – the most copied but the least copiable. It is indeed hard for other photographers to achieve the same grace and delicacy, but, above all, the same devotion to others. Each photo is a present received, 'a benevolent gift of providence', said Boubat. For him, a singular photographer without presumptuousness, providence lay in his meeting with Lella, with her luminous, rosy face and her wavy copper hair ruffled by the soft Breton breeze. But providence was 'to become nothing in front of the model, because the photograph belongs to the other', claimed the photographer. So it belongs to us, not to be reproduced, as happened in many amateur photographic clubs in the 1950s, but to be enjoyed in full, to be at peace with Lella if only for a few minutes. A 'peace correspondent' was how French poet Jacques Prévert defined his friend Boubat. And with the same gentleness and passion, the same lyrical sensuality, Boubat took photos of the world, from Spain to India, Japan to Mexico. Everywhere, without repeating himself, it was the same photo. It was as if Lella was not before his eyes but inside them.

Lella, Brittany, France, 1947

© Édouard Boubat/ RAPHO/EYEDEA

ÉDOUARD BOUBAT was born in Paris in 1923. At twenty, he worked in a photo-engraving laboratory, and produced his first photographs in 1946. In 1950 he published pictures of daily life in Paris in the magazine *Camera*. The following year he exhibited his photos at Galerie La Hune in Paris in a joint exhibition with Brassaï, Doisneau, Facchetti and Izis, and began to work with the magazine *Réalités*. Two years later he spent four months in the United States, then travelled throughout the world. Boubat joined the agency RAPHO in 1970, and received the Octavius Hill Prize in 1973 and the Hasselblad Prize in 1988. He died in 1999. His pictures are published in *Édouard Boubat: A Gentle Eye* (2004), compiled by his son Bernard Boubat and Geneviève Anhoury.

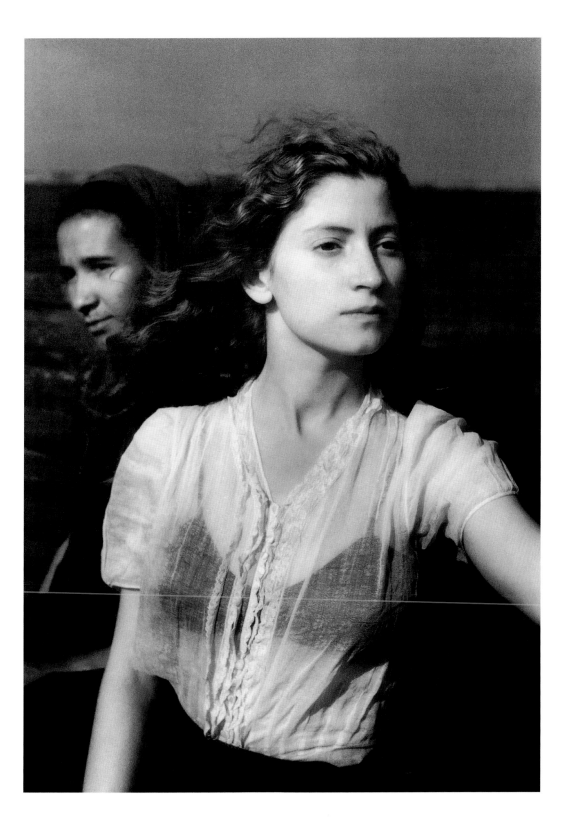

ALEXANDRA BOULAT

She watched them close up, as nobody had done before. A woman among women, Alexandra Boulat explored the world of Muslim women with amazing sensitivity and journalistic sense. It was her combination of kindness and determination, pictorial elegance and intimacy with her subjects, that made her one of the best war reporters of recent years – from the Balkans to Afghanistan, Pakistan to Iran, and Iraq to Palestine. Everywhere, she found a woman's face to tell a tragic tale: if censured by a veil, a detail was all that was needed to recount the tragedy. Thus, these hands are like an open book telling of hate, a cup eager to receive God's blessing from heaven. On 20 October 2001, a few weeks after the attack on the Twin Towers, Boulat was in Pakistan. General Musharraf had just allied himself with the United States against the Taliban. The people were in revolt. At Peshawar men burned an effigy of President Bush; at Quetta women prayed for curses to fall on America. Yet, amid the violence, Boulat managed to dwell on the small details and nuances – a henna embroidery, the coming together of sky and smoke among the veils, and, again, hands that seem empty of hope. 'You can tell the story of a war without showing a gun,' Boulat used to say. Not everyone can. But she succeeded, with her depiction of two black, feminine shapes in Baghdad, fleeing with their miserable spoils after looting the ministerial palaces. Or in Gaza, where a tragic group of children, holding chairs, hunt for a classroom after their school has been bombed. Or in Tehran bus station, where an Afghan refugee, returning home, writes, 'I hate you, Iran', the tragedy of exile portrayed by a hand that seeks love but writes hate.

Pakistan, 2001

© *Alexandra Boulat/VII*

ALEXANDRA BOULAT was born in Paris in 1962. Her father was Pierre Boulat, a photographer for *Life* magazine for twenty-five years. In compliance with her family's wishes, Boulat enrolled at the École des Beaux-Arts. In 1989, however, her passion for photography prevailed, and in the 1990s she documented the wars in the former Yugoslavia. Then it was the turn of the fall of the Taliban regime, life in Iraq during the embargo, and the invasion of Baghdad in 2003. In 2001 Boulat photographed Yves Saint Laurent's last fashion show, and that same year became one of the founders of the VII Photo Agency. She compiled photo stories in Indonesia and Albania, and was working on a project on Muslim women in the Middle East and in Gaza when she suffered a brain haemorrhage in June 2007. She died in Paris later that year, on 5 October.

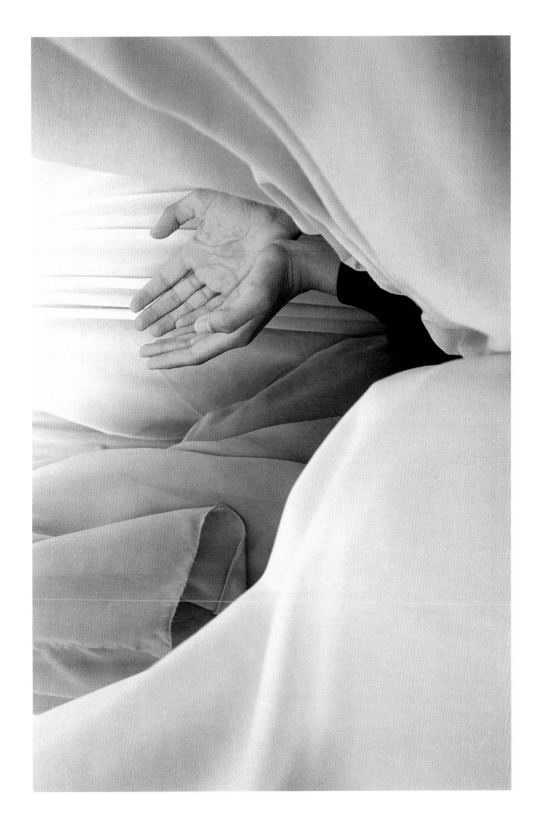

GUY BOURDIN

A woman disappears into a background of homogeneous red and yellow surfaces, leaving only the lower part of her body visible. Her legs are long and slender, and on her feet she wears a pair of black high-heeled shoes strapped around the ankles. Guy Bourdin's images invoke an imaginary world that corresponds most closely to Surrealism and film noir. With the former, they share a sense of paradox and the absurd, displaying a fineness of detail distributed across a meticulously orchestrated scene, like that of a painter or film director. From the latter, on the other hand, they adopt a taste for suspense, combined with a sensuality somewhere between glamour and eroticism. Here, Bourdin's narrative is reduced to a minimum, yet what he includes in this, as in many of his other pictures, is enough to define the outline of a story, of which we are favoured and unseen observers. Thrown into the scene of the crime, without proof and without action, we remain fascinated by an atmosphere that alarms and disquiets us at the same time. Constant tension and perfection of form are thus the qualities that define the worlds of this French photographer, strewn with enigmas to which no solutions are found except in beauty.

Charles Jourdan campaign, Spring 1979

© *Guy Bourdin Estate*

GUY BOURDIN was born in Paris in 1928. Man Ray wrote the foreword to one of his catalogues in 1952, and in 1955 he started working for French *Vogue*. An original and provocative fashion photographer, he produced some famous advertising campaigns in the 1970s but, because of his desire for anonymity, it was only after his death in 1991 that his work was acknowledged in museums across the world. In 2003 the Victoria and Albert Museum in London staged a retrospective of his work, and 2006 saw the publication of *A Message for You*, a book of previously unpublished material. *Guy Bourdin: Photofile* was published in 2008.

CARLA CERATI

She would like to have been a sculptor, but Carla Cerati found a camera and pen and became a photographer and writer instead. 'I use photography to document the present, and words to recover the past.' Both are ways of looking outside and within oneself, ways of using one's own natural curiosity. 'Curiosity pushed me to deal with different subjects and environments. I would move from the world of intellectuals to that of factory workers, from dance school to building site, from middle-class youth to commuters, from tenement dwellers to shoppers in city-centre boutiques.' Over time, these themes became interwoven into a large fresco reflecting the society of her age. In the early 1970s Cerati became interested in the body and the elegance of the female nude. Earlier, she had photographed the hidden faces and alienated bodies of men and women locked up within the walls of mental hospitals, abandoned and marginalized by society. She had used her photography to document and denounce cruel practices, and to fight for change. Now, she sought beauty, perfection and abstraction of lines, where female body fragments are a malleable material, tools for an aesthetic exploration of shape and abstract form. The female body becomes landscape, or, as in Bill Brandt's work, a detail of a landscape: the breast becomes a sand dune, the curve of the hips the outline of a hill. The fresco of those years was enriched by a further element: Italy was experiencing change, women were fighting for emancipation, society was becoming more secular, and the body, freed from past constraints, was at last being shown. But, despite this, the nude continued essentially to remain taboo, with Cerati's work one of the few exceptions worthy of admiration.

Nude study, 1973

© Carla Cerati

CARLA CERATI was born in Bergamo in 1926, and began to take photographs in 1960 as a stage photographer for the theatrical productions of Franco Enriquez. Over the years, she paid particular attention to portraits and social reportage, and her portraits were published in major international publications. In 1968, with Gianni Berengo Gardin, she carried out a photo story on mental institutions in Italy, published the following year in the book *Morire di classe*. In 1973 she began her writing career with *Un amore fraterno*. Since then she has published many novels. In 2007 her photos of nudes were exhibited at the Antonia Jannone Gallery in Milan and published in Paolo Morello's book *Carla Cerati. Nudi.*

ELLIOTT ERWITT

It is 1953 and great events are taking place around the globe: Everest is conquered by Edmund Hillary and Tenzing Norgay, Stalin dies in Moscow, and in New York Charlie Chaplin packs his suitcases and leaves the United States, accused by Senator McCarthy of being a Communist. This same year, also in New York, twenty-five-year-old Elliott Erwitt takes a photograph of his wife with their first child, a scene delicately bathed in natural light. Looking on, suggesting a desire for caresses, is a cat, its point of view curious and attentive, superior but complicit, reflecting that of the photographer himself, who in silence takes this touching family snap. The image is an archetype of motherhood in modern times. What is striking is the clear perfection of the composition, the natural simplicity of the mother's expression, with that vague hint of a smile. Her love is an emotion that gains strength in silence. It is no surprise that in that year of 1953 Erwitt was asked to join the large, extended Magnum family; two years later the image was chosen by Edward Steichen for his historic exhibition 'The Family of Man'. This picture, however, is a tender pause in the career of a photographer who, in nearly sixty years of work, favoured the tones of irony and surrealism. But there were at least two other great exceptions: Robert Capa's mother embracing her son's tomb in 1954, and Jacqueline Kennedy weeping at her husband's funeral, her tears held momentarily on the veil covering her face. In their own way, these pictures, too, are family snaps.

New York, 1953

© *Elliott Erwitt/*
Magnum Photos

ELLIOTT ERWITT was born in 1928 in Paris to Russian émigré parents. He attended primary school in Italy but in 1939 his family moved to the United States to escape Fascism. He studied film in New York, and spent his military service in Europe as an assistant photographer with the US Army Signal Corps. In 1953 he was invited to join Magnum by one of its founders, Robert Capa. Erwitt began working for some of the world's most prestigious magazines, and a year later became a full member of the agency (he would later be elected as its president twice). In 1970 he also started making films. His work has been exhibited in major museums and galleries around the world, and his photography books have become bestsellers.

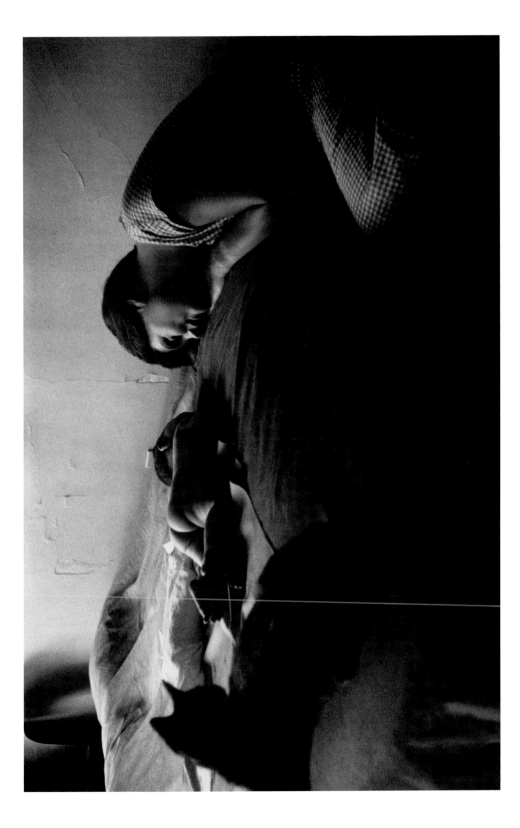

NAN GOLDIN

It takes strength and courage to transform one's own existence into a work of art. Nan Goldin, one of the most innovative photographers of the last twenty years, has succeeded in doing so, living and taking photographs of herself without limits, without fear and without shame. Her journey is one that completes the path started by another woman, Diane Arbus. The difference is that the memories are not those of others, but her own. The scene is New York in the 1980s, among the dying embers of punk and the eternal smoke of the Times Square clubs. The music, above the noise of the traffic and the shouts from the next-door apartment, is that of a danse macabre that speaks of love, violence, possession, dependency and, finally, death. *The Ballad of Sexual Dependency* is the title of the book from which this picture is taken, a book which in 1986 introduced the tiny but very powerful figure of Nan Goldin onto the art scene. On the cover and between the pages Goldin is depicted next to Brian, the object and poison of every passion. Then her friends appear: Cookie Mueller, Sharon Niesp, David Armstrong and Suzanne Fletcher. It is a portrait of a family, a diverse family that may replace Goldin's original one, giving voice to a never-resolved trauma. In 1965, aged eighteen, Goldin's sister, Barbara, took her own life. The sisters' parents chose to live in silence and repression, believing 'it was an accident, not a choice'. But, at this point, in the empty space in the family photographs, a new figure appeared: Nan the photographer, Nan who wanted to testify to every pain, every loss, every spark of happiness, every bruise, every passage of time. And when, at the start of the 1980s, the spectre of AIDS appeared, the urgency of preserving memories became even more intense. Death was coming ever closer, and no one has ever sung such an agonizing ballad as Nan Goldin.

Nan and Brian in bed, New York, 1983

© *Nan Goldin, courtesy of the artist and Matthew Marks Gallery, New York*

NAN GOLDIN was born in Washington, DC, in 1953. In 1969 she enrolled at the Satya Community School, which she nicknamed the 'Hippie Free School'; it was here at the age of fifteen that she started taking photographs. She met David Armstrong and Suzanne Fletcher, and photographed the drag queens of The Other Side nightclub in Boston. In 1978 Goldin moved to New York, where she took colour photographs of the Times Square clubs and started documenting her life and the lives of her closest friends. She entered a detoxification clinic and organized the first exhibition on AIDS in New York. In 1986 she published *The Ballad of Sexual Dependency*. Her other books include *The Other Side: 1972–1992* (1993), *I'll Be Your Mirror* (1996), and *Soeurs, saintes et sibylles* (2005).

LAUREN GREENFIELD

It is as if the mirror and its basic function of reproducing and multiplying the body was everywhere: not only in the home and in the changing rooms of clothes shops but also in the street, where girls look at themselves, love themselves, hate themselves in the reflection of a shop window. Society is held up to a mirror – our superficial and shiny society. It is a slippery slide into superficiality that nothing can hold back, unless it is American photographer Lauren Greenfield's amazingly acute pictures. For years she has been engaged in extraordinary research into youth culture, girl culture in particular – its myths, its ever smaller measurements, its hungry and painful social unease. In 2002, when *Girl Culture* was published, Greenfield brought this world out into the open, inviting us to look at ourselves in the mirror for the first time, at the full horror and cruelty of our society. For, undoubtedly, we would need to be cruel to force a whole generation of girls to grow up so fast, and to feel themselves continually the wrong size, the wrong shape, in the wrong group – what's more, the wrong caste. How can girls take their place in the ranks of this new, disciplined and tough army of beauty? By obeying orders: spending money, starving themselves, pumping up the body where advertising dictates a 36-inch bust, and flattening it where nature might otherwise allow some gentle curves. Women's bodies are to be squeezed into push-up padding, just as Sheena, this fourteen-year-old Californian, is trying to do under the vigilant eyes of a friend. But this time there are two mirrors at work, one in the changing room and, fortunately for us, one in the form of Lauren Greenfield's camera.

Girl Culture, 2002

© *Lauren Greenfield/VII*

LAUREN GREENFIELD is considered one of the most authoritative chroniclers of American youth culture. After graduating from Harvard in 1987, she started working for *National Geographic*. In 2002 she published *Girl Culture*, since when an exhibition of this work has toured the globe. In 2004 came *Fast Forward*, a survey of the impact of Hollywood and its myths on young people. In 2006 Greenfield brought out *Thin*, a chilling chronicle of a journey into the world of anorexia, which won an International Photography Award. Together with the book, she also made a documentary. Recently she presented the film *Kids + Money* at the Sundance Festival. Lauren Greenfield is a member of the VII Photo Agency.

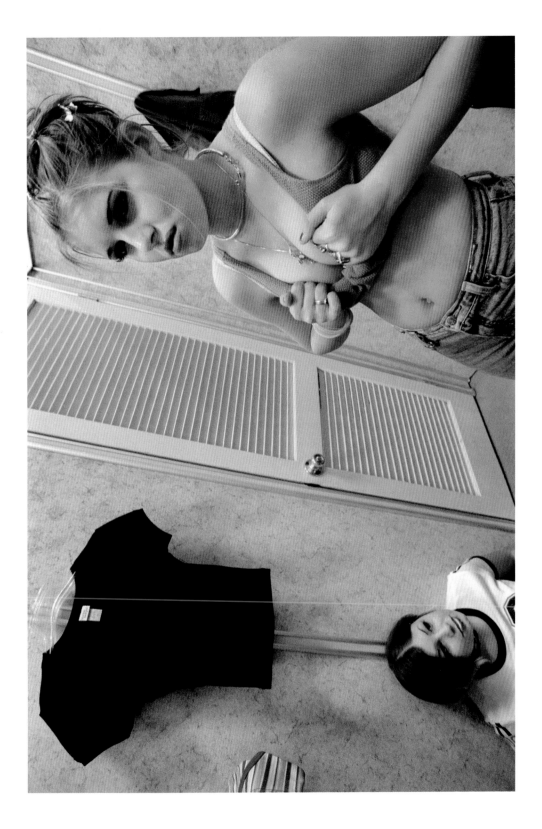

PHILIPPE HALSMAN

A symbol of free and exuberant sexuality, with arms open wide, a young Brigitte Bardot flies into the air, along with the desires of millions of men and the imagination of a photographer. Shot in the mid-1950s, Bardot is at the start of her career, before Roger Vadim has dyed her hair blonde. And the photographer is Philippe Halsman, the creator of a theory on jumping, which he called 'jumpology', and which, between 1950 and 1956, inspired an outstanding gallery of portraits showing famous people leaping into the air. The first series was commissioned by NBC. In the lens were the television channel's most famous comedians, from Groucho Marx to Bob Hope. Then it was the turn of the complete Ford family, on the occasion of the company's fiftieth anniversary. Then Marilyn Monroe came freewheeling onto the cover of *Life*, followed by Salvador Dalí, Marc Chagall, Gina Lollobrigida, Aldous Huxley and many others. These pictures were unique, not only because they were non-conformist in their own way, with those bare, tights-clad or stockinged feet, but above all because they were revealing pictures. 'When you ask a person to jump,' Halsman explained, 'his concentration is mostly directed toward the act of jumping and the mask falls so that the real person appears.' It was only a few years before the first man went into space, when Gagarin's smile seemed to fill the whole universe. Yet these photographs already spoke of that dream; they were almost test launches. It might only be a matter of a few inches and a few seconds, but nobody flew higher than the lucky astronauts in Philippe Halsman's heaven.

Brigitte Bardot, La Madrague, 1955

© Philippe Halsman/ Magnum Photos

PHILIPPE HALSMAN was born into a family of Jewish origin in Riga, Latvia, in 1906. He studied engineering but discovered his real passion, photography, when he was fifteen. In 1930 he moved to Paris and worked as a portraitist. Two years later his photographs appeared in *Vogue*. In 1940 he escaped to America with his family; helping him with his visa was a friend, Albert Einstein. By November 1940 Halsman was in New York where, in 1942, he started working with *Life*. He would go on to produce more than a hundred cover pictures for the magazine. In 1949, with Fernandel, he produced *The Frenchman*, and, in 1954, as a homage to Surrealism, he brought out a book dedicated to Salvador Dalí. His *Jump Book* followed in 1959. He died in 1979.

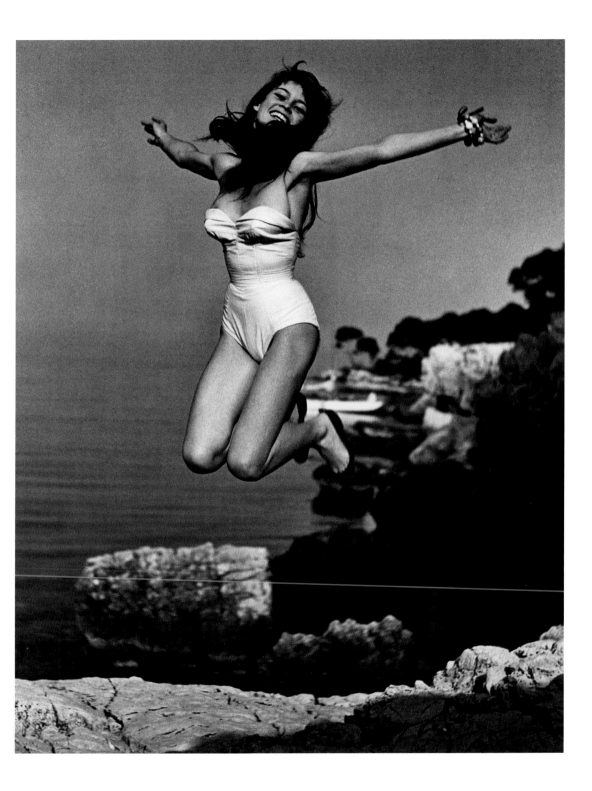

ANDRÉ KERTÉSZ

Henri Cartier-Bresson was to say of him, 'Whatever we have done, Kertész did first.' André Kertész started taking photographs in around 1912 and, for more than seventy years, his subtle and penetrating eye helped to define and mould the language of modern photography. He claimed never to document, but to give an interpretation, and from the start he looked for the unexpected detail, the ephemeral moment, those fortuitous instants of grace that fix the characteristics of things. His pictures, with their abstract compositions and their novel quality of inventive form, showed new directions for photography, on the poetic edges of realism. 'Satiric Dancer' is one of Kertész's most reproduced photos. It dates from the central period of his career, which he spent in Paris, when he associated with members of the artistic avant-garde and when his photography was enriched by the characteristic forms of modernist painting. The picture has a clownish aspect: a young, scantily dressed woman in high heels is lying in a contorted position on an oval sofa next to a marble sculpture in the modernist style, the male bust twisted to reflect the contortions of the woman. The reflection in the mirror adds an extra element to the play of shapes and black and white. The rigour of the composition is striking: it is a decisive moment, when everything is perfectly organized. As Kertész said, that moment is not when an external action produces an intriguing formal arrangement, but when the world is permeated with personal meaning.

Satiric Dancer, Paris, 1926

Kertész Andor, known as André Kertész © RMN, All Rights Reserved © Ministry of Culture – Médiathèque du Patrimoine, dist. RMN/ André Kertész

ANDRÉ KERTÉSZ was born in Budapest in 1894. He acquired his first camera in 1912 and started to take photographs of acquaintances and street scenes. In 1925 he emigrated to Paris, where he became involved in the avant-garde art movement and where he worked as a freelance photographer for several magazines, including *VU*. In 1933 he shot the famous series 'Distortions'. In 1936 he and his wife moved to New York, where he worked for *Harper's Bazaar*, *Vogue* and *Look*, all the while pursuing his personal photography projects. In 1984 he donated all his negatives and personal documents to the French state archives. He died in 1985.

WOMEN

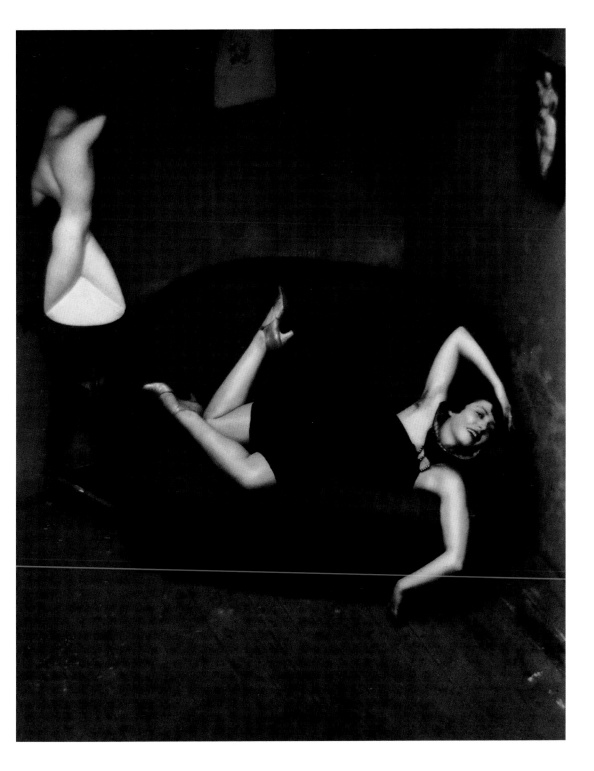

DOROTHEA LANGE

Her name is Florence Thompson. She is homeless, thirty-two years of age, and has seven children to feed. She lives a downtrodden existence through the 'bitter years' that follow the Wall Street Crash of 1929 – years of economic crisis and disastrous drought. She is a countrywoman, a pea-picker, but the land has nothing more to give and she has nothing left to pick. So, like thousands of other workers, she is forced to abandon her home and to travel across the United States in search of whatever work she can find. Dorothea Lange followed these migrants and told of their poverty, despair, dignity and pride. She was one of the Farm Security Administration's group of photographers, set up in 1935 to document the condition of rural American life in those difficult years: it was to be one of the most important experiences of photographic reportage of the twentieth century. Lange told of how it was raining that day and how she was in the car returning home. The long journey through the American countryside was ending and on the seat next to her lay her box of photos, the result of her work. Suddenly, she saw this family, and drew closer to the desperate mother as if attracted by a magnet. Lange took various pictures, getting ever closer to her subject. She speeded up the shot until she captured the expression on that face, marked and worn out with tiredness and poverty, staring into the distance with dejection, courage and determination. With her children huddled round her, the mother assumes the stature of a modern heroine. The picture became an icon of socially engaged photography. The director of the FSA, Roy Stryker, claimed this was *the* photo of Farm Security. It was as if the woman, with her strange, discreet and private courage, held within herself all the suffering of humanity, along with all the perseverance.

Migrant Mother, California, 1936

© *Dorothea Lange/ Library of Congress*

DOROTHEA LANGE was born in New Jersey in 1895. She studied photography in New York and worked with various photographic studios. In 1928 she moved to San Francisco and opened a studio. During the Great Depression she went through the city's streets documenting the misery of those years. She joined the Farm Security Administration's group of photographers in 1935 and, from then until 1939, along with her economist husband Paul S. Taylor, she documented the conditions of the immigrants and labourers. In 1940 she became the first woman to receive a Guggenheim Fellowship for photography. During the 1950s and 1960s Lange produced a series of photo stories on Ireland, Asia and Egypt, and in 1952 she was one of the founders of the magazine *Aperture*. She died of cancer in 1965.

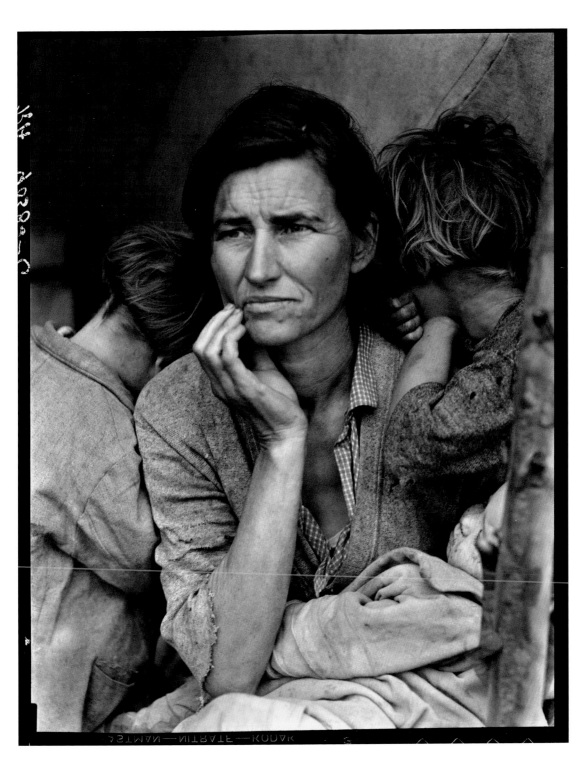

LISETTE MODEL

Never photograph anything you are not passionately interested in. That was the advice Lisette Model's friend, photographer Rogi André, gave her. Model was over thirty when she left Paris for the South of France with the intention of putting her eye to the test. Music was her main love, but one day she borrowed her sister's Rolleiflex and started to take photos. She became a photographer by chance, but on Nice's Promenade des Anglais she discovered that her eye was direct and acute, and at times ruthless. The photos she took in the South of France, published by *PM* magazine under the title 'Why France Fell', would make Model's fortune in America. Here, where she moved with her husband after the rise of Nazism, she continued to photograph matrons and the waifs of society, reflecting their mutual coarseness. She found in American vulgarity the perfect counterpoint to European decadence. In 'Coney Island Bather', the sun illuminates a corpulent working-class woman at leisure, and shows a misshapen, almost bestial, side to Model's subjects. Humanity is grotesque and her portraits are almost caricatures. Model saw the world like this and printed it in large format: coarse, grainy pictures, often out of focus or blurred. The bather she met on Coney Island beach fills the frame with imposing exuberance. She is happy and vital, but there is something abnormal in the picture, a disproportion that relates not only to the body and that creates a false note, a subtle unease. Nothing recalling conventional beauty ever aroused any interest in Model, and her most memorable pictures portray people we might well imagine to be corrupt, greedy, miserly or cruel.

Coney Island Bather, New York, c. 1939–41

© Lisette Model/National Gallery of Canada

LISETTE MODEL was born in Vienna in 1901. At seventeen she started studying the piano with Arnold Schoenberg. Then she took up painting and moved to Paris, where she married the Russian Jewish painter Evsa Model and devoted herself to singing. In 1934 she took her first photographs in the South of France: they would become some of her most famous pictures. With the arrival of Nazism in 1940, the couple moved to the United States, where Model's photos began to be published regularly in *Harper's Bazaar*, *Vogue* and *Cosmopolitan*. Model explored the dark side of New York, producing the 'Running Legs' and 'Reflections' series. From 1950 to 1983 she taught photography at the New School for Social Research in New York; among her pupils was Diane Arbus, over whom she had a profound influence. Model died in 1983.

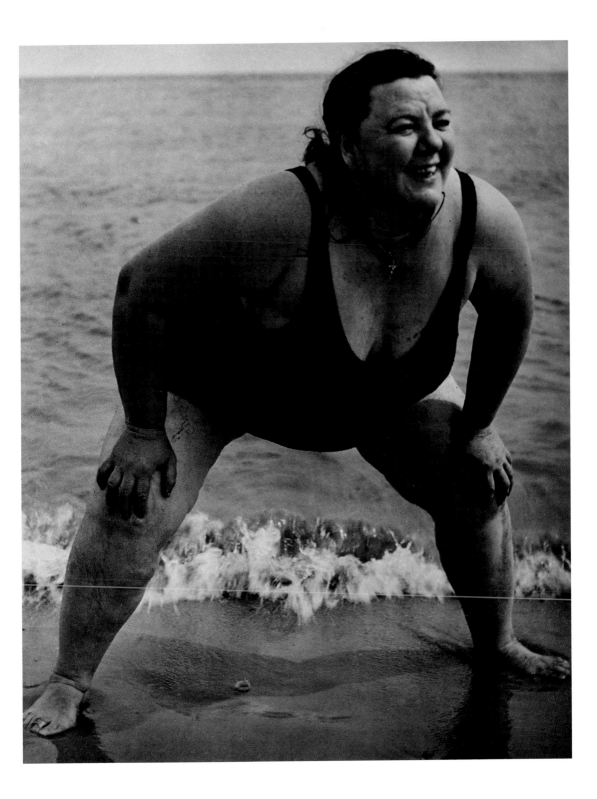

LORENZO PESCE

To be twenty years old and to have been born in the mid-1980s, when great events were about to revolutionize Europe and the political world. To have grown up in a Europe without walls, a continent with a rich past, full of traditions, languages, pride and pain, seeking to break down barriers and open itself up. A united Europe is the culmination of the dream of a generation that has seen the continent split by the violence of war. Fifteen years after the fall of the Berlin Wall, there was another step forward, another event of historic significance. In May 2004 seven former Soviet-bloc countries joined the European Union, together with Cyprus, Malta and Slovenia. This was a social, political and cultural challenge. In the build-up to the occasion, a group of fourteen photographers travelled through the EU countries to understand and convey who young Europeans were and how they lived. The reality is, of course, more complex than any declaration of intent or signing of treaties: there are contradictions, social marginalization, struggles to find work, and the rise of already infamous political extremist movements. But the encounters and exchanges, both real and virtual, generated a sharing of aspirations, doubts and hopes. So it was that Estonians, British, Slovaks and Cypriots resembled each other in unexpected ways. Here, a Slovene girl with an almost Scandinavian appearance attracts the lens of Lorenzo Pesce, a young Italian photographer who had grown up in the United States. Nearby is the Union brewery (a highly indicative name): the photographer blurs the background and, with an expressive use of colour, portrays a clear, smiling face full of peace and hope.

Girl at the railway station near the Union brewery, Ljubljana, Slovenia, 2003

© Lorenzo Pesce/Contrasto

LORENZO PESCE was born in Rome in 1973. In 1992 he moved with his family to the United States, where he took a degree in photography at the Art Center College of Design in Pasadena. He lived between Los Angeles, London and New York for ten years, and produced photo stories for travel magazines and advertising campaigns. His pictures were exhibited in Rome at the 'Chiaroscuri Americani' exhibition in 2001, and in 2003 the American magazine *PDN* (Photo District News) named him as one of thirty young emerging photographers. In the same year Pesce moved to Rome and joined the Contrasto agency, for which he took part in the 'Eurogeneration' project. His work has been published in many national and international magazines.

MAN RAY

It must have been a soft, silent cascade before the guillotine struck: a cascade of sun-ray hair, a vein of gold in the surrounding darkness. Man Ray, the spiritual father of Surrealist photography, seems to sense this as he arranges that magnificent, angelic head of hair, almost breaking the girl's body in half. Sadism and misogyny are a definite part of this artist's oneiric vocabulary. More than others Man Ray loved women, and like no one else he cut them into pieces: erasing their arms under long black gloves, carving two f-holes of a cello into the softness of their flesh, burning every inch of skin in the silver of solarization. Here, he agonizingly stretches a woman's body over an uncomfortable wooden parallelepiped, like a magnificent upturned caryatid. There is no sign of pain on the model's face. The only concession is the closed eyes that open the way to desire and to dreams. And with dreams, the dimension dearest to the Surrealists, everything becomes possible. Man Ray always loved taking photographs of his friends, muses and lovers while they were sleeping, from Mina Loy, an English poet, photographed with her eyes closed and a thermometer as an earring, to Kiki de Montparnasse, a pale sleeping oval next to the ebony of an African mask. Then there was Lee Miller, solarized like one of Michelangelo's 'Prisoners', but with a totally feminine grace and gentleness. And lastly 'Julia', Man Ray's wife and muse, her face sealed in a black stocking as if she were in a cocoon ready to be transformed, or lying on a sofa in domestic abandonment.

Woman with long hair, 1929

© Man Ray Trust/ ADAGP-SIAE/ Telimage – Paris, 2008

MAN RAY, the pseudonym of Emmanuel Radnitzky, was born in Philadelphia in 1890. He moved to New York and, in 1904, began to draw. Eleven years later, he put on his first solo show, taking his own photographs of his paintings for the catalogue. It was the start of a dual career as a painter and photographer which he continued throughout his life. He met Marcel Duchamp and, in 1921, moved to Paris, where he discovered the 'off camera' process and invented his famous 'rayographs'. He was an established photographer by the time he photographed Cocteau, Braque and Joyce. In 1929 he met Lee Miller and together they discovered the technique known as solarization. Man Ray returned to America in 1940 and married Juliet Browner. In 1951 he went back to Paris, where he died in 1976.

ELI REED

For Eli Reed, documentary photography means simply recording what he sees as he walks across Planet Earth. And Eli Reed has done a lot of walking. He has walked the streets of Latin America, and those of Beirut as a Magnum correspondent, and he has crossed the arid land of Africa's distant origins. Above all, he has walked the streets of the deprived districts of his own country, the United States, where the blacks of America – his people – live, taking photographs that depict pain and sorrow, joy and triumph. His journey has also taken him into the golden world of Hollywood. Reed loves films and, in the 1990s, started taking photographs on sets for a bit of fun while working on John Singleton's film *Higher Learning* (1995). In Hollywood he met many young people who were busy working as actors, interesting people who pushed him to ask himself what it meant to be young, worried and already in business. He spent a long time as a stage photographer in a series of films directed by Robert Altman and Spike Lee, as well as John Singleton. He pays homage, almost giving thanks, to a world which, as he himself admits, helped him to open his eyes and start to walk through the streets of 'planet earth'. He claims he started taking photographs in part thanks to two films, *Lawrence of Arabia* and *Z*, both foreign films that caught his imagination and pushed him to discover the world beyond his home, and to look intensely at what might be hidden behind the golden door. As Reed himself says, 'What is at the core of my work is, in essence, a mediation on being a human being.'

Model and actress Tyra Banks embraces film director John Singleton, Los Angeles, 1994

© Eli Reed/Magnum Photos

ELI REED was born in New Jersey in 1946 and studied pictorial illustration at the Newark School of Fine and Industrial Arts. In 1982 he went to Harvard University and studied political sciences. He started as a freelance photographer in 1970, since when he has worked for many of America's most important publications. In 1988 he became a member of Magnum and began to work on the project that was to culminate in his most famous book, *Black in America*. That same year he photographed the effects of poverty in his country, producing the documentary *Poorest in the Land of Plenty*. From 1992 to 2004 Reed worked as a stage photographer. His documentary *Getting Out* was presented at the New York Film Festival in 1993. He teaches photojournalism at the University of Texas in Austin.

BETTINA RHEIMS

The model's white back is an unexplored country, virtually a new continent in the geography of eroticism. The humble hotel room where Bettina Rheims chose to set her highly individual voyage into a feminine world is like a port without a sea, a place where ships of desire might run aground. She put aside all fear, all vulgarity, and followed the memorable advice of her mentor Helmut Newton: be bold until you reach the point at which the thread of elegance is about to break, and stop just a moment before. And here on the pages of *Chambre close*, Rheims's first international success, the acrobat's performance contributes further layers of complexity. Two women, the photographer and the model, set out to defy dizziness, be provocative and cast aside all sense of modesty. It is quite another story when it is a pair of female eyes that are behind the camera. And it is quite another sensation when it is a woman who searches Parisian flea markets for early twentieth-century pornographic postcards of models posed like porcelain statuettes, although in frank dishabille, in bourgeois drawing-room scenes complete with wallpaper and perhaps an armchair, a flowery sofa or a day bed. 'For me it was a tribute to an era, but I didn't want my images to have an antique look. And so I decided to use colour, intense colour, truly colourful colour. And my starting point was the model's skin. I wanted the women in these photographs to look like a Rodin sculpture. I wanted the spectator to be able to imagine stretching out a hand and touching them. And it was such a powerful experience that I haven't taken any black-and-white photos since then.' Rheims has continued, in her own very personal way, with her investigation of feminine sensual desire. However, few of her images achieve the intensity and beauty of this photograph, in which a woman, dressed only in her own skin and surrounded by red velvet oozing passion, becomes a voyeur of both herself and her own startling fantasies.

4 July II, Paris, 1991, from the book Chambre close

© *Bettina Rheims, courtesy Galerie Jérôme de Noirmont, Paris*

WOMEN

BETTINA RHEIMS was born in Neuilly-sur-Seine in 1952. She has been a model and a journalist, has opened her own art gallery and, in 1978, she became a photographer. Her subjects are the female body and feminine sensual desire. In 1989 she published *Female Trouble*, a collection of her portraits of women. She subsequently produced *Modern Lovers*, which celebrated the physical beauty of androgynous teenagers. Between 1990 and 1992 she collaborated with Serge Bramly in photographing a series of female nudes that were collected in the internationally successful book *Chambre close*. Several other books have since been published. In 1995 she took Jacques Chirac's official portrait. In 2008 FORMA in Milan held the exhibition 'Can you find happiness?', which was organized in collaboration with the Galerie Jérôme de Noirmont in Paris.

MIGUEL RIO BRANCO

'Painting meeting photography. Drawing meeting collage. Photography meeting cinema. Music meeting poetry. Poetry meeting montage. All these meetings are part of the many crossroads in the search for a comprehension and expression of myself in relation to the world.' Engaged in a constant dialogue with the rules of representation and perception, Miguel Rio Branco's work defies any easy definition. The artist weaves a complex pattern in his exploration of various expressive techniques, forming a discourse that becomes an abundant and dense flow. The son of a Brazilian diplomat, Rio Branco grew up in numerous cultural contexts: Argentina, Portugal, Switzerland, New York – and, finally, Brazil. He is a painter by training, and was a filmmaker before becoming a photographer. His photography is made of flesh, skin, blood, saliva, and pulsating, human material. Above all, it is made of colour and light, and an eroticism and sensuality that draw on the material culture of Brazil. 'I was not aware of the harsh conditions in Brazil until I went back there at the end of the '60s. It shocked me and I felt an overwhelming need for rebellion and intolerance of injustice.' Here then is his work on prostitutes, produced during the mid-1970s, in which, as Rio Branco says, 'the marks on the crumbling colonial houses or the wounds on the skin of men and women are not traces of the past, but present suffering'. His eye seeks out the unadorned details of daily life, directed towards the dark places inhabited by those on the margin of society, and towards situations that evoke solitude, sex, power, pleasure and violence. Colour and light are the tools with which he composes his particular baroque universe. The red of blood, of vitality, passion and pain, is everywhere – a colour that stains everything around it.

Mona Lisa, Luziana, Brazil, 1974

© Miguel Rio Branco/ Magnum Photos

MIGUEL RIO BRANCO was born in the Canary Islands in 1946 into a family of Brazilian diplomats, and spent his childhood in a variety of countries. He moved to New York in 1976, where he graduated in art and took courses at the New York Institute of Photography. In 1978 he studied at the Escola Superior de Desenho Industrial in Rio de Janeiro. He worked as a photographer and director of photography on films before becoming Brazil correspondent and an associate of Magnum Photos in 1980. He won first prize at the São Paulo Triennale of Photography in 1980, and the following year won the prize for best photograph at the Brazilian Film Festival. Rio Branco continues to work on complex projects, such as installations and books, as his last work, *Plaisir la douleur* (2005), confirms.

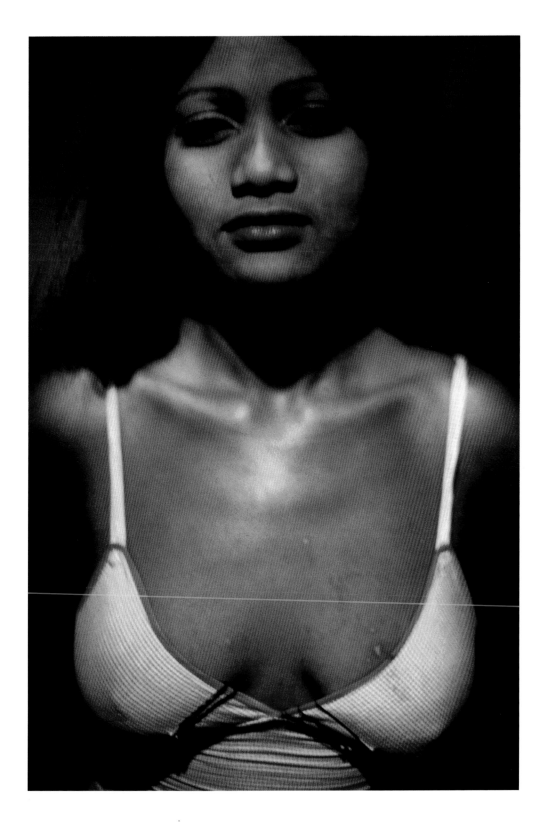

ALESSANDRA SANGUINETTI

On a farm in the Argentine Pampas, not far from Buenos Aires, two cousins, Guille and Belinda, grow up together, experiencing as they move towards adolescence a special, deep closeness created during their childhood years. The photographer Alessandra Sanguinetti, born in New York but raised in Argentina, has established a relationship of special trust with the cousins, which allows her to recount over a period of four years not only their life but also the unique world of two children in the midst of change. The girls are at an age when they are coming out of childhood, and when dreams, fears and fables are interwoven to nourish their personal space. Taking an interest in the fruit of Guille and Belinda's particularly fertile imaginations, and through her sincere creative collaboration with the girls, Sanguinetti is able to encourage them to tell each other about the characters and stories born out of their fantasies and to act them out in front of her lens, using objects from their daily lives as accessories. The photographer distances herself from her documentary purpose as she watches the children become adolescents, observing them playing at dressing up and exploring their possible future lives. Sanguinetti observed that, towards the end, their adventures changed: they increasingly put themselves on stage in the role of fiancées or mothers, preparing themselves for their future as women. The result is 'The Adventures of Guille and Belinda and the Enigmatic Meaning of their Dreams', a work that tells through delicate pictures of the profound psychological changes that accompany the move to adolescence. It reveals a world that belongs to everyone and that, for everyone, ultimately disappears.

Ophelias, Buenos Aires, 2001

© Alessandra Sanguinetti/ Magnum Photos

ALESSANDRA SANGUINETTI was born in New York in 1968, but lived in Argentina from 1970 to 2003. She received a fellowship from the Guggenheim Foundation and a grant from the Hasselblad Foundation. She now lives in New York, where she works for the *New York Times Magazine*, *Life* and *Newsweek*. Her work is represented in the permanent collections of many important museums, such as the Museum of Modern Art in New York, the Museum of Fine Arts in Boston and the Museum of Modern Art in San Francisco. In 2007 she joined Magnum as a nominee.

LISE SARFATI

WOMEN

At first glance the young Americans portrayed by Lise Sarfati seem lifeless, mere copies of real teenagers, replicas without flesh and blood, lost in a state of semi-sleep that nothing and nobody can shake them out of. Their eyes are fixed, lost in themselves, or possibly in a tangible void. In 2003 Sarfati travelled across the United States and photographed young adults and their apparently solitary lives in cities such as Austin, Oakland, Los Angeles and New Orleans. Adolescence is photogenic and exhaustingly complex, worrying, slippery, rich and stimulating. The photographer does not simply portray this complexity but dramatizes it, finding, with an acute and instinctive sense of composition and colour, connections between her subjects, their surroundings and their daily experiences. She creates psychological spaces: an inaccessible world of pensive teenagers who are remote inside the universe of their rooms. Detached, fastidiously isolated and inert, they seem trapped, yet at the same time suspended, as if at any moment they could break free and escape to distant parts. In reality, in the space between one cigarette puff and the next, what is really worrying is the uncertainty about what lies outside the bedroom door. The teenagers are asking questions about a new life, one that will draw them across the threshold that separates them from the responsibilities of adulthood. Sarfati suggests that it is the uncertainty over the next step, that void, both elusive and fascinating, that absorbs her subjects and upon which their eyes are fixed.

Sasha & Sloane #21, Oakland, California, 2003

© Lise Sarfati/ Magnum Photos

LISE SARFATI was born in Algeria in 1958 of French parents and started taking photographs as a teenager. She graduated from the Sorbonne with a thesis on Russian photography in the 1920s, and in 1986 became the official photographer at the Académie des Beaux-Arts in Paris. In 1989 she went to Russia, where she stayed for ten years, documenting the life of a country in transition. For this work she received the Niépce Prize and the Infinity Award from the International Center of Photography in New York. Her first monograph, *Acta Est*, was published in 2000, and the following year she became a member of Magnum. She travelled through the United States and produced a series of photos of adolescents, which was published in 2005 in *The New Life*. In 2004 the Nicolaj Centre of Contemporary Art in Copenhagen dedicated a retrospective to her. She currently works in the United States.

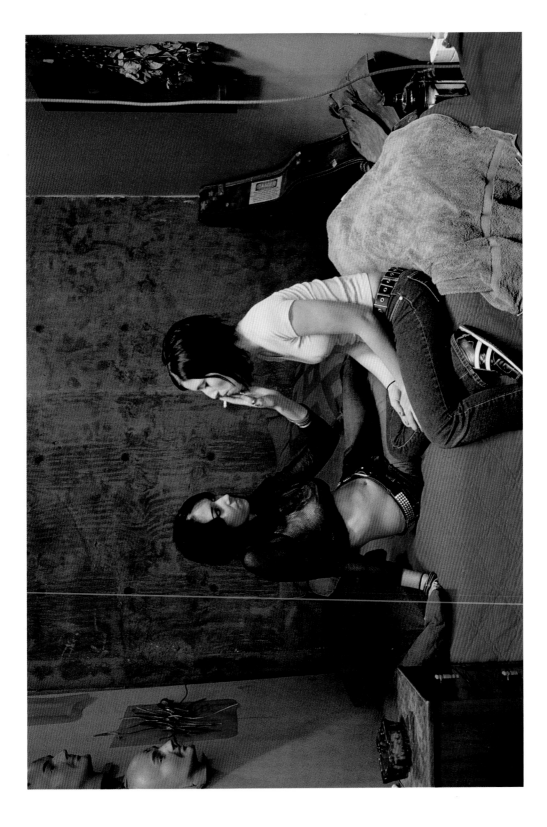

FERDINANDO SCIANNA

Formed in the shadows between half-closed shutters, and in the tragic absolute of the colour black, this marvellous picture by Ferdinando Scianna was the start of a parallel journey of reportage – that of fashion photography and photojournalism. There is pretence here, a taboo for every photo-journalist who by all the laws should respect the limits of reality, yet it is a pretence that broadens the narrative, that allows memories to emerge, bringing them out of the shadows and giving them body. The real body is that of Marpessa, a Dutch model with parents in Suriname, who is miraculously at home in Bagheria, Caltagirone, Palermo and Porticello, where Scianna lived and where he decided to set one of Dolce & Gabbana's first collections. His theme, for the designers too, was the Sicily of childhood, its day turned to night, brought to life by teasing the fabrics, widening the clear circle of the necklines, undoing the buttons and, as a surprise, letting the shapes of femininity emerge beneath a black veil. He didn't need to say anything – tiny signs and the game between photographer and model began. Then, as in every story of seduction, it became a game between man and woman, and finally an autobiographical game between the Sicilian photo stories that had made Scianna famous and his new fashion pictures – beautiful, strong and authentic in their own way, without pretence, because they were nourished with life and so much experience.

Marpessa, 1987

© Ferdinando Scianna/
Magnum Photos

FERDINANDO SCIANNA was born in Bagheria, Sicily, in 1943. He started taking photographs in the 1960s while attending the Faculty of Arts and Philosophy at Palermo University. During this period, he systematically photographed Sicily, its people and its festivals, publishing *Feste religiose in Sicilia* in 1965. The book won the Prix Nadar. In 1966 Scianna moved to Milan and worked for the magazine *L'Europeo* as a photographer and then as its correspondent in Paris, where he lived for ten years. In 1977 he published *Les Siciliens* in France and *Villa dei mostri* in Italy. He got to know Henri Cartier-Bresson and, in 1982, joined Magnum. Since 1987 he has alternated reportage with fashion photography. His many books include *Kami* (1988), *Marpessa* (1993) and *Dormire, forse sognare* (1997; English edition, *To Sleep, Perchance to Dream*, published 1998).

ALEC SOTH

Alec Soth doesn't take photos furtively and he doesn't hide his presence. It's a matter of sensitivity and technique. He chooses to use a large-format camera, which is cumbersome and complicated, and he chooses to slow time down. He can take twenty minutes to prepare a shot and, hidden under the cloth of his camera, he can fix his subject. He gives his eye time to register the subtle nuances, the particular expressive gesture. In the slowness, the look becomes penetrating and the desire to pose melts into relaxation and a wait full of stimulation. Faced with a subject, 'I'm interested in the beauty of the mystery,' he says. 'I'm standing here, she's standing there. In the space between there is a gulf, a mystery, and for me, an attraction.' Capturing that invisible gulf, that space that connects us to another person and draws us into a relationship, that is what a portrait is for Soth. The girl with the pink hair rests her head on the table, waiting for the photography session to finish. With her serious face, either absorbed or bored, she loses herself in her dreams. The colours are soft, the shades delicate. The whole picture evokes an interior and surreal landscape. We don't need to know that it was Halloween and that Sydney was dressed up, ready for her witches' night. This child with her wise and thoughtful eyes becomes almost an archetype, a timeless creature who belongs as much to the past as to the future. There is a silent atmosphere of solitude, nostalgia and dreams. Soth concentrates his attention on the details, the external signs of an inner grace. And we remain enchanted, like this girl, without really knowing why. We too are caught in that mysterious gulf, that wait, but we are less alone, absorbed and dreamy than the subject portrayed.

Sydney, dreamy girl with pink hair, Florida, 2004

© Alec Soth/Magnum Photos

ALEC SOTH was born in 1969 in Minneapolis, where he still lives and works. He graduated in art from Sarah Lawrence College and, in 1999, started work on his 'Sleeping by the Mississippi' project, a two-year journey along the river banks that was turned into a book in 2004. That same year, Soth joined Magnum. He has received fellowships from the McKnight and Jerome Foundations and, in 2003, he was awarded the Santa Fe Prize for Photography. In 2004 he took part in the Whitney and São Paulo Biennials, and two years later published *Niagara*, the study of a symbol of the American imagination. In 2007 he published *Dog Days*, a photo story made in Bogotá, and the following year the Jeu de Paume in Paris dedicated a retrospective exhibition to him.

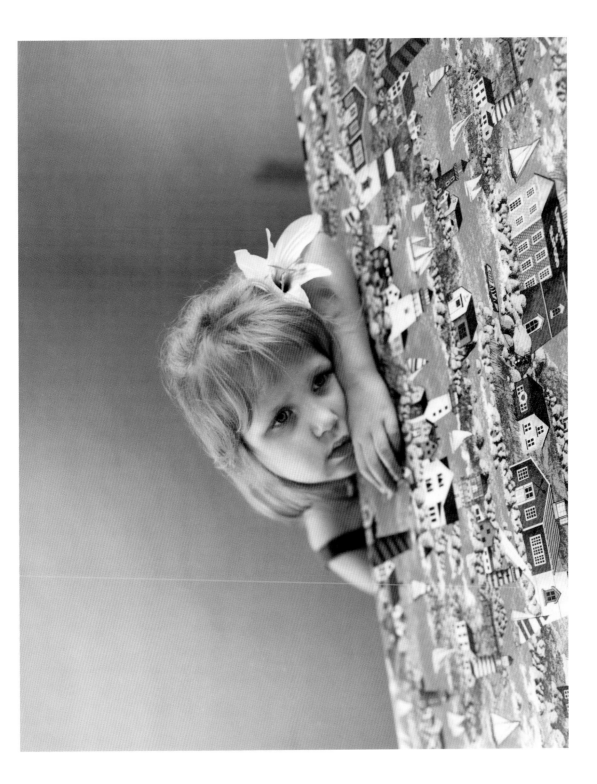

EDWARD STEICHEN

Edward Steichen is one of the most eclectic and extraordinary figures in the history of photography. During his long life he experimented with various techniques and schools, continually innovating not only with style but also with trends in photography. He was a painter and photographer, an extremely refined printer of his pictures, a fashion photographer, and an acclaimed portraitist; he was also a war reporter in both world wars, and a gallery director, museum curator, exhibition organizer and talent scout. Steichen put his genius to work in everything vital and new that happened in the world of art and photography in the twentieth century. After the First World War he became chief photographer for *Vogue* and *Vanity Fair* and his style changed, revolutionizing editorial photography: the lighting became more theatrical, the sets were bare and the focus sharp. He produced many portraits of actors and actresses who wanted nothing more than to take part in his *mises en scène*. Gloria Swanson posed for Steichen in 1924 and he recalled this experience in his book *A Life in Photography*: '[We] had had a long session, with many changes of costume and different lighting effects. At the end of the session, I took a piece of black lace veil and hung it in front of her face. She recognized the idea at once. Her eyes dilated, and her look was that of a leopardess lurking behind leafy shrubbery, watching her prey. You don't have to explain things to a dynamic and intelligent personality like Miss Swanson.' Right to the end of his life, Steichen disapproved of habit and routine and was on his guard against schools of thought, singing the praises of independent and free-spirited photographers, those who sought and who dared, the explorers of new horizons.

Gloria Swanson, 1924

© Condé Nast Archive/ Corbis

EDWARD STEICHEN was born in Luxembourg in 1879. In 1882 he emigrated with his family to the United States, taking out citizenship in 1900. To begin with he was a painter, but he drew closer to photography through the influence of Alfred Stieglitz. In 1902 he was involved in setting up the Photo Secession group and created the cover of *Camera Work*, the movement's magazine. He became chief photographer at Condé Nast in 1923 and worked with *Vogue* and *Vanity Fair*. During the Second World War he was head of an American Navy department in charge of documenting the war at sea. In 1947 he became director of the photography department of the Museum of Modern Art in New York where, in 1955, he organized the historic exhibition 'The Family of Man'. He died in 1973 at the age of ninety-four.

FRANCESCA WOODMAN

Each of Francesca Woodman's pictures carries with it a strong sense of ambiguity, the expression of a mature respect for her internal world and of the exercise of curiosity that is never banal, producing a fragmentary but deeply felt reality. The American photographer's artistic journey was as short as it was intense. Most of the photographs she took were of herself, her own body, often nude, within spaces that are nearly always enclosed, threadbare and decadent. Her work developed around an exploration of the relationship between the visible landscape of her own physical adolescence and the invisible landscape of her rich and complex inner nature. In this untitled photo, the artist's curved body, slightly out of focus, is stretched out across the floor, enveloping a white bowl with a shiny-skinned eel tightly coiled inside. Woodman printed at least two versions of this picture, with her body on either side of the eel. The play of lines and focus, the contrast between the shapes, knowledgeably modelled from the black and white, suggest a profound intimacy in which the alternation between hiding and revealing forces the observer to look closely, carefully and indiscreetly. Both subject and object of the photos, both artist and model, Woodman uses her body for a dialogue with herself, projecting images and symbols, hopes and fears, onto it and carrying out an investigation into the symbologies that encircle and translate what it is to be a woman.

From the 'Eel' series, Rome, 1977–78

© Francesca Woodman Courtesy George and Betty Woodman

FRANCESCA WOODMAN was born in 1958 in Denver, Colorado. She grew up in a family of artists and discovered photography early, beginning to develop her own pictures at the age of thirteen. She attended the Rhode Island School of Design, then in 1977–78 spent a year in Rome where she frequented the Maldoror bookshop-gallery and the haunts of the Roman Transavanguardia. Back in America, she moved to New York. In 1981 *Some Disordered Interior Geometries* was published, one of the six photographic exercise books planned during her stay in Rome. In that same year, at the age of twenty-two, she took her own life. Her photographs have been shown in many exhibitions and form part of many museum collections.

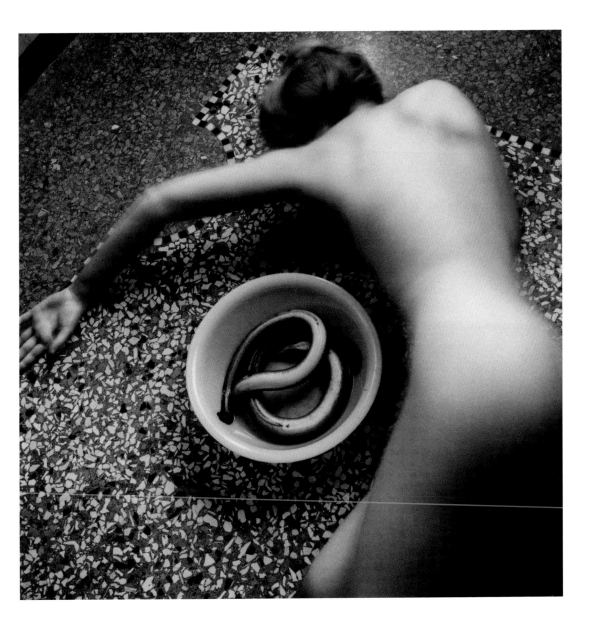

GIANNI BERENGO GARDIN

'Right from the start, when I discovered the Italian working-class and peasant culture, so neglected by everyone, my real interest has always been in Italy in all its aspects. An extraordinary culture.' For more than fifty years Gianni Berengo Gardin has been taking photographs with the humility and passion of a great craftsman. His broad body of work, gathered together in nearly 200 books, documents the social history of Italy over the past five decades, from the rural and enchanting deep south to the foggy industrial cities of the north. A fascinating picture of modern Italy emerges, revealing its changes and contradictions, and the daily lives and aspirations of ordinary people. Berengo Gardin is renowned for his overtly political works, including his probing examination of living conditions in Italian mental institutions in 1968. He has also profiled gypsy communities. His black-and-white images, composed with a serene eye and a deft ironic touch, display a warm empathy with his subjects and a search for the truth. In his landscape shots, vast country vistas acquire added value through a human presence, even if this only forms a tiny part of the overall composition. This is true of the Tuscan landscape opposite: a road winds elegantly up the hill between cypresses, and yet it is not so much the formal black-and-white harmony that makes the scene worthy of immortalizing, as the tiny figures in the foreground venturing into it.

Tuscany, 1965

© Gianni Berengo Gardin/Contrasto

BORN IN Santa Margherita Ligure in 1930, Gianni Berengo Gardin first began to take photographs in 1954. After living in Rome, Venice, Lugano and Paris, he settled in Milan in 1965 and began his professional career. He has worked with the Italian and international press, but has mainly focused on books. From 1954 to 1965 he collaborated with the magazine *Il Mondo*. He has often worked with companies on reports and monographs. He has received several prizes, among them a World Press Photo Award in 1963, and the Leica Oskar Barnack Award in 1995 for the book *La disperata allegria. Vivere da zingari a Firenze*. He has held more than 200 exhibitions in Italy and abroad, and his photographs are housed in numerous museums.

254

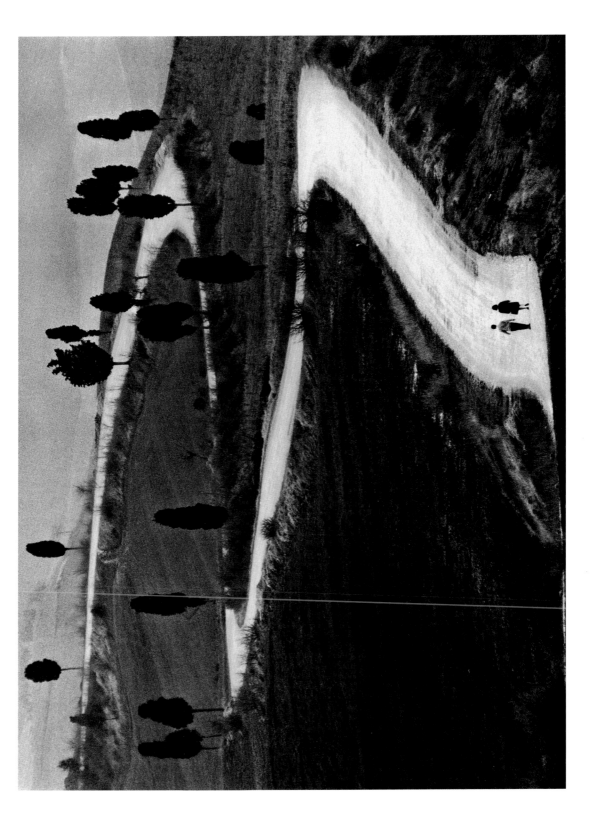

BETTMANN ARCHIVE

On 6 May 1937 the innovative rigid airship *Hindenburg* went up in flames while trying to dock at the mooring mast of Lakehurst Naval Air Station in New Jersey. In a matter of minutes the jewel of German technology was reduced to ashes, and 36 of the 97 people on board lost their lives. The disaster received extraordinary media coverage in newsreels, in photographs and on the radio. This image, which captured the moment the airship caught fire, became famous overnight: its author is unknown but has made history. At times a photograph commands attention not only because of its aesthetic quality, but because it manages to encapsulate both individual and collective stories. There is no recognizable signature style or vision here, only the power of an image that crystallizes an event in human history and comes to symbolize it. On that day in May 1937, the airship, and with it the belief that these aircraft were a fast and safe mode of transport, able to reach any corner of the earth, went up in flames. The rock band Led Zeppelin famously revisited this photograph for the cover of their first album. The image is part of the Bettmann Archive, one of the most important collections of pictures worldwide, which safeguards our visual memory of the past 150 years.

The Hindenburg Disaster, Lakehurst, New Jersey, 1937

© *Bettmann/Corbis*

TRAVEL

IN 1935 OTTO BETTMANN, a German Jew fleeing Nazism, arrived in New York with two trunks full of photographs that he had collected while working at the Berlin State Library. Over the years, what began as a bibliophile's passion was transformed into a huge cultural endeavour. His arrival coincided with the golden age of photojournalism, and the former librarian became involved in editorial work while continuing to collect images. His first clients were magazines such as *Look* and *Life*, and all the while his archive continued to grow. The result is one of the most precious 'image banks' of our times, acquired by Corbis, a digital stock company, in 1995. Eleven million negatives, prints and slides are preserved in a vast refrigerated archive housed in a former mine in Pennsylvania.

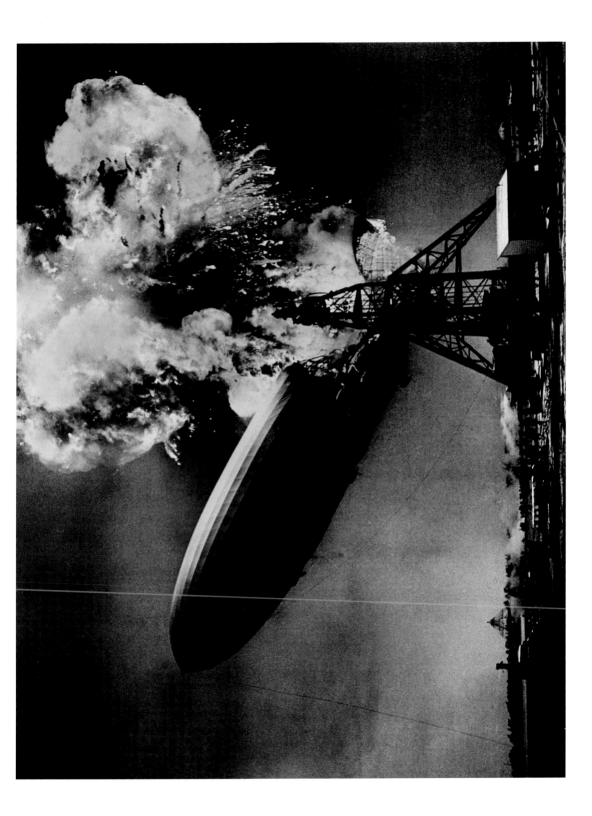

WERNER BISCHOF

When Werner Bischof travelled through a ravaged post-war Europe, he was confronted with chaos. He had spent thirty years in the neutral, safe and comfortable surroundings of Switzerland, isolated from the dramas of the Second World War, which raged only a short distance away. In those years he trained his eye in the rigours of formal composition, acquired a feeling for the interplay of light and shadows, and worked for the advertising world from the confines of a photographic studio. However, he left his country in 1945 to see what had happened elsewhere, and it became the turning point in his career. 'I felt compelled to venture forth and explore the true face of the world. Leading a satisfying life of plenty had blinded many of us to the immense hardships beyond our borders.' He crossed Europe from one end to the other, creating a portrait of devastation and laborious reconstruction. He continued to travel and document, concentrating on peripheral faces and stories rather than major events. He never liked to define himself as a reporter, which to him meant surrendering to the necessary fabrication of sensationalist stories. His path eventually took him to India and Japan, and during his stay in the latter his pictorial spirit seems to have been infused with the surrounding Zen harmony. Bischof was fascinated by the traditional aspects of Japanese culture. In order to regain his everyday powers of observation, he relaxed his eye and stopped reflecting. He photographed street life, kabuki actors, workers in the paddyfields, sumo wrestlers – and, as in the photograph opposite, the calm spirituality of Shinto shrines, where figures cloaked in white gently step through light snow. In Bischof's pictures the chaos in the world finds its own formal order, one that does not turn its back on reality, but rather defines a space for humanity and hope.

Courtyard of the Meiji temple, Tokyo, 1951

© Werner Bischof/ Magnum Photos

WERNER BISCHOF was born in Switzerland in 1916. After studying photography and graphic design at the Zurich School of Applied Arts, he set up a studio and worked for an advertising agency, and in 1942 he was a contributor to the magazine *Du*. From 1945 he travelled through Europe, photographing war-ravaged areas. In 1949 he joined Magnum and worked for publications such as *Picture Post*, *Life* and *Epoca*. Between 1951 and 1952 he travelled through the Far East. He gained wide recognition for his photo story on the famine in Bihar, India, which was published in *Life*. As a war correspondent for *Paris Match*, he visited South Korea, Japan, Hong Kong and Indochina. He died in 1954 in a road accident in the Peruvian Andes. The following year his book *Japan* was awarded the Prix Nadar.

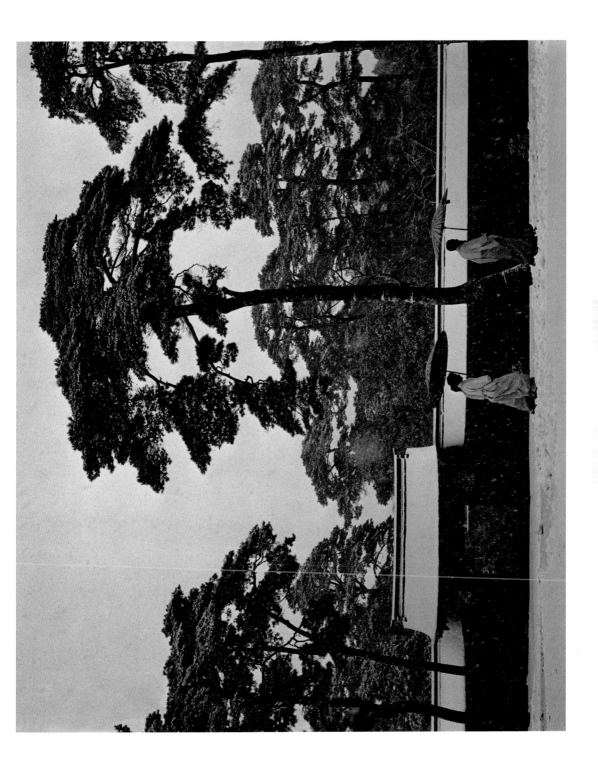

SAMUEL BOLLENDORFF

A desolate and inhospitable landscape stretches out before a father and son, who might be trying to catch a glimpse of their future from the top of the hill. The location is Gujiao, a mining city in the Chinese province of Shanxi. Here, tens of thousands of workers, often illegal, descend into the bowels of the earth and risk their lives for a stipend that does not even feed their own families. These are China's new poor, left behind by the recent economic boom, and also the protagonists of Samuel Bollendorff's reportage series 'Forced March'. 'Initially we were respected as miners, now we are at the bottom of the social hierarchy,' an interviewee explains. The composition of the picture recalls traditional romantic iconography: the protagonists have their backs to us, absorbed in the contemplation of the scene that opens out before them. But here the panorama of nature is replaced by a hellish artificial landscape, and the warm golden glow is merely the product of dense pollution. While all around the rebirth of a nation and triumph of capitalism are celebrated, this picture observes a daily apocalypse.

Coal miners, China, 2006

© *Samuel Bollendorff/*
Oeil Public/Grazia Neri

TRAVEL

SAMUEL BOLLENDORFF was born in 1974 and is a member of the photo agency Oeil Public, based in Paris. His work is highly political, and he sets out to investigate what he calls 'totalitarian institutions'. In 2004 he published *Silence*, which compiles four years' work looking at health institutions and issues, and includes a series of portraits of AIDS sufferers. In 2005 Bollendorff carried out a detailed, year-long project in the troubled Parisian suburbs for a weekly chronicle in the French daily newspaper *Libération*. Since 2006, thanks to funding from the French Ministry of Culture, he has examined poverty in China, and exhibited in the 2007 international photojournalism festival 'Visa pour l'Image' in Perpignan.

ALESSANDRO COSMELLI

Coney Island has always been a place of dreams: sunny Sundays, cotton candy, and the thrills of the rollercoaster and other rides. The Native Americans who once inhabited the area called it 'the land without shadows', and the first Dutch settlers in 1639 renamed it Konijn Eiland, meaning 'Rabbit Island'. This mythical American site, rising from the sea fifty minutes away from Manhattan, is now falling into disrepair and risks being lost forever. Alessandro Cosmelli, perhaps as a result of his background in geochemistry, has decided to uncover the base elements that combine to form the alchemy of this unique place. He uses a square, the most stable of formats, to frame images of rushing fairground rides, the absence of gravity, and vertiginous dives. Woody Allen's testimony serves as a guide for this collection of images and how they piece together into a mosaic. Allen frequented these rides as a boy and later directed the film *Annie Hall* (1977), which is partly set on Coney Island: the protagonist, Alvy, grows up under the arc of a rollercoaster, and it is here, in a house that shakes with each circuit of the ride, that the character develops his neuroses. However, it meant much more. As Allen explains, Coney Island was the hope of a wonderful world where everyone knew how to be happy. It was a microcosm of the American dream.

Coney Island, 2007

© *Alessandro Cosmelli/ Contrasto*

TRAVEL

ALESSANDRO COSMELLI was born in Livorno, Italy, in 1972. As a boy he used to visit his uncle's painting restoration studio, which sparked his interest in art and eventually led him into photography. He completed a degree in geochemistry. Following a period of study in the United States, between 1997 and 2003 he did a series of photo stories in Ghana, Suriname, Western Sahara, Haiti, Nigeria, Eritrea, Côte d'Ivoire and Azerbaijan. In 2003 he became a professional photographer and joined the photo agency Contrasto. He currently lives and works in New York.

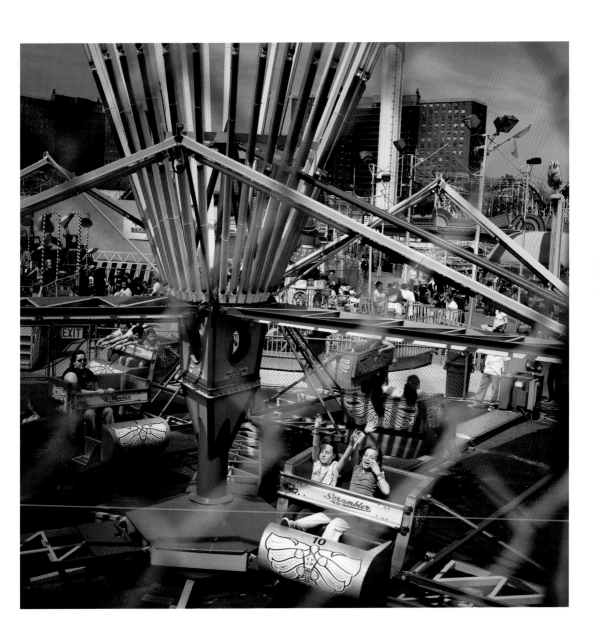

CARL DE KEYZER

It is said that we owe our modern vision of landscape to the seventeenth-century Dutch painter Gaspar van Wittel. Gone were the excesses of the baroque, with its characteristic trompe-l'œils. In its place, Van Wittel produced crisp, precise views, probably using a camera obscura to define perspective. Only by adhering to such exactitude, with its real harmonies of form and proportion, is it possible to see a landscape clearly and understand it. We would do well to keep this noble tradition in mind when looking at the extraordinary, solemn panoramas of Carl De Keyzer. He often produces photo stories that are not only visual but also thematic journeys, revolving around complex and difficult concepts such as memory and history. De Keyzer's style is reminiscent of large tableaux or frescoes. His photographs have allegorical dimensions, but they are also very real, for he wants to both illustrate and instruct. The location of this scene is Afghanistan. The vista, dominated by a derelict building and a couple of large trees, is a bare landscape, bathed in a hazy and desolate light. In the foreground, in the midst of this wasteland, is the solitary figure of a soldier, suggesting the irrationality of war. This image is taken from De Keyzer's recent work, 'Trinity', in which he depicts history, politics and war as the three governing forces that control the destiny and rhythm of life. Here, the inauspicious nature of these three has scarred the face of Afghanistan. In an age when pastoral dreams are now unequivocally shattered, the new 'landscape painting' that emerges in De Keyzer's work is one of power, destruction, spectacle and setting.

Afghanistan, 2003

© Carl De Keyzer/ Magnum Photos

CARL DE KEYZER was born in Belgium in 1958. He studied photography and film in Ghent. After becoming a freelance photographer, he taught the subject between 1982 and 1989. He is one of the founding members of the XYZ Photography Gallery. He has worked in India and the Soviet Union (he published *Homo Sovieticus* in 1989), and investigated the ties between religion and patriotism in the United States. He became a member of Magnum in 1994. Two years later he returned to the former states of the Communist bloc and published *East of Eden*. In 2002 he published *Zona*, looking at the prison camps in Siberia. He has been widely recognized internationally, and his awards include the Prix du Livre at the Rencontres d'Arles International Photography Festival and the W. Eugene Smith Award, both in 1990. In 2008 he published *Trinity*, which accompanied an exhibition at the Bibliothèque Nationale de France, Paris. He lives in Ghent, Belgium.

RAYMOND DEPARDON

It could be argued that both the desert and the sea share a characteristic of photographic film: man makes imprints that are momentarily captured in the sand or water, before disappearing. 'The desert is always bigger than in images, bigger than in the photographs or on the screen where a film is projected,' says Raymond Depardon. 'The desert is like a religion, and there one leads a life which is very similar to a monastic existence.' From among the world's deserts, this photographer and filmmaker chose to capture the Tibesti, the highest mountain range in the Sahara, where the tallest peak, Emi Koussi, reaches 3,415 m (11,200 ft). Depardon's first encounter with the area was in the 1960s, when he did a reportage series in which the grains of sand seem to become the trickle of an hourglass that runs parallel to the photographer's life. In 1970 Depardon shot the short film *Tchad 1*, followed by *Tchad 2* and *Tchad 3* five years later. In 1976 he filmed *Tibesti Too*, a documentary on the life of the Toubou, a mysterious, fascinating people who have made the desert their home and traded with Carthaginian merchants since as far back as 500 BC. In this photograph we are faced with the void of the desert, populated by just a few tiny figures in the foreground. Fragile marks on the sand are preserved on film before being erased by the wind. The photographer offers no direction, but limits himself to observation. The next day the massive void will become a new blank canvas.

Tibesti, Chad, 1979

© *Raymond Depardon/ Magnum Photos*

RAYMOND DEPARDON was born in France in 1942. He began to take pictures at the age of twelve at the family farmstead. After completing an apprenticeship in photographic optics, he moved to Paris in 1958. In 1960 he joined the agency Dalmas as a reporter, and six years later co-founded the Gamma photo agency. In 1974 he filmed his first documentaries, *Une partie de campagne* and *San Clemente*. In 1978 he joined Magnum, and in 1984 he became part of the DATAR project. In 2006 he was artistic director at the Rencontres d'Arles. He has published forty-six books and directed seventeen feature-length films, including *Un homme sans l'Occident/ Untouched by the West* (2002). He is currently working on a photographic project on French territories.

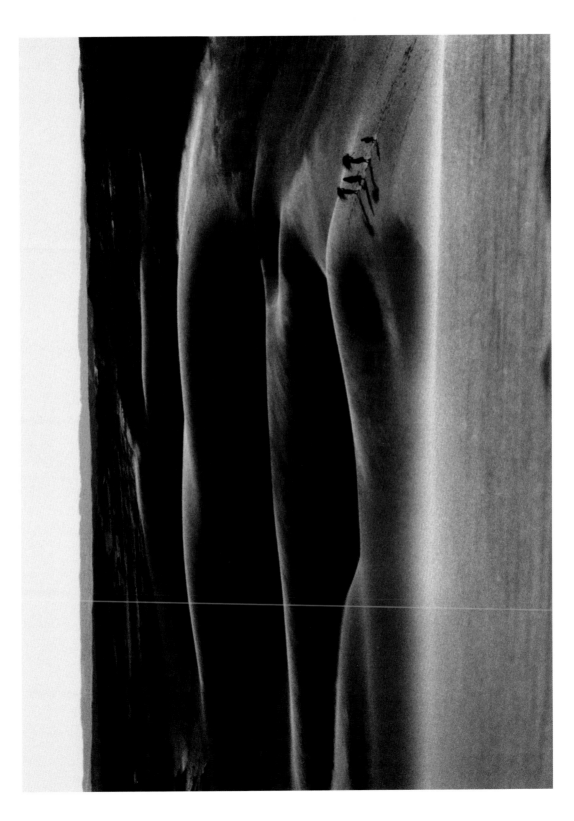

MARTINE FRANCK

Martine Franck trained her eye in the best schools of photography – at museums such as the Louvre, in art history books, and then on the street. Practice often shapes instinct, and this is certainly true of Franck: 'I do come from a background of looking at painting. And I think composition is important. But it's instinctive in my work; I don't try and make a certain sort of composition. I just have it in me.' Photography is the only art form that allows you to engage with the unexpected. The unexpected can reveal itself in the tender, childlike expression of an old woman, or in a harmonious arrangement of volume and line. What matters is being able to see and capture the aesthetic potential. In the photograph opposite, Franck's eye transforms an everyday scene. The elegant swimming pool designed by Alain Capeilleres becomes an enigmatic De Chirico vision. The geometry directs the eye to a space and a moment that seem unreal. The fine lines of the hammock in the foreground glisten against the black of the shadow it casts, contrasting subtly with the square flooring. The curve of the edge of the terrace encounters the dark shades of the gentle slope, and the polished white of the large decorative globes. A second hammock in the background creates a perfect diagonal, where the rigid and upright positioning of the man contrasts with the gentle relaxation of the woman. But geometry alone is not enough. As Henri Cartier-Bresson said, a photographer's greatness lies in his ability to 'align the head, the eye and the heart'. Franck chooses the position and height from which to frame the moment and animate the lines, which seem to communicate a sunny, nostalgic and solitary serenity.

Swimming pool designed by Alain Capeilleres, Le Brusc, Provence, 1976

© *Martine Franck/ Magnum Photos*

MARTINE FRANCK was born in 1938 in Antwerp and spent her childhood in England and the United States. She studied art history at the University of Madrid and at the École du Louvre in Paris. She travelled in the Far East with the director Ariane Mnouchkine, and on her return became the assistant of the photographer Gjon Mili at *Life*. In 1972 she co-founded the agency Viva, and in 1983 became a full member of Magnum. She has photographed the famous Théâtre du Soleil stage ensemble since its inception. Since 1985 she has been involved with the charity Petits Frères des Pauvres. In 2000 she published the book *Tibetan Tulkus: Images of Continuity* about Tibetan Buddhist children in India and Nepal. She was married to Henri Cartier-Bresson, and in 2003 she co-founded the Fondation Henri Cartier-Bresson in Paris. In 2004 she published *Fables*.

TRAVEL

HARRY GRUYAERT

A beach is a threshold: the place where the sky meets the water, the land meets the ocean, and the waves merge with the clouds. It is a meeting point, where everything is reduced to basic elements; it is a place to walk, run, meditate, or take photographs. In his book *Edges*, Harry Gruyaert devotes special attention to beaches. He finds them on all his travels, from his homeland of Belgium to France, from Israel to Ireland, then Italy, Spain, Egypt and Mali. Wherever he goes, he finds himself looking out to sea, seeking it out and capturing it as easily as picking up a shell on the beach. Focused and committed, he is a virtuoso in his colour work, finding surprising shades and tints everywhere: porcelain blue reflecting delicately on untouched sands; the black expanse of sky that signals an oncoming storm; the startling lapis lazuli of the Red Sea in Egypt; the dark silhouettes of Barcelona set against the light of the port; and a cross in Galicia, Spain, in remembrance of those who died at sea. A beach can become the place where life ends, but there too it may also be reborn in the waves. It seems no coincidence that these striking images were taken at a turning point in time, when one millennium was about to end and another was about to begin.

Beach at Fort Mahon, Picardie region, France, 1991

© Harry Gruyaert/ Magnum Photos

TRAVEL

HARRY GRUYAERT was born in Belgium in 1941. He studied at the School for Photography and Cinema in Brussels from 1959 to 1962, then moved to Paris where he began to work in fashion and advertising. In 1969 he made his first trip to Morocco, and became fascinated by light, its intensity and its colours. In 1972 he covered the Munich Olympics and the Apollo space launches. In 1976 he won the Kodak Prize. He travelled in India and Egypt, and in 1990 he published the book *Morocco*. In 1981 he joined Magnum. His books include *Made in Belgium* (2000), *Photo Poche* (2006), *TV Shots* (2007) and *Edges* (2008). More recently, he has given up cibachrome work in favour of digital prints.

DAVID ALAN HARVEY

'Son of a fisherman in the moonlight.' It is a description that conjures up an idyllic scene. In the centre of the image there is a vertical pole, like the great mast of a sunken ship, on which a naked boy, the son of a fisherman, leans. We find ourselves lingering on the refined simplicity of the composition, the perfect proportions, the matching tones and pastel shades, and the respite of evening after a hot day. But the backdrop, a desert landscape of sand and desolation, tells a very different story. David Alan Harvey has a deep knowledge of Central America, Cuba and Mexico. In pre-Columbian times the shores of Chacahua were inhabited by the Zapotec civilization, one of the most powerful and sophisticated peoples in the region. They developed a writing system and a sophisticated calendar, and they dominated the immense valley of Oaxaca. Today Oaxaca is among the poorest states in Mexico. All traces of this ancient cultural richness have vanished, except for the area's linguistic variety, which includes fourteen indigenous languages and ninety different dialects. In the face of so much poverty, Harvey has chosen to dim the chromatic scale. He is a virtuoso in saturated colours: his reds, shocking pinks, electric blues and emerald greens give Central America a bold character. But even amid the softer tones there is still a despair, as if Harvey has managed to take to heart the Italian Futurist Filippo Tommaso Marinetti's injunction: 'Let's Murder the Moonshine.'

Chacahua, Oaxaca, Mexico, 1992: son of a fisherman in the moonlight

© David Alan Harvey/ Magnum Photos

TRAVEL

DAVID ALAN HARVEY was born in San Francisco in 1944 but was raised in Virginia. At the age of eleven he discovered photography. He graduated with a degree in journalism. At twenty he began to document the life of an Afro-American family in Norfolk, Virginia, a study that was published under the title *Tell It Like It Is* (1966). In 1978 Harvey was named Magazine Photographer of the Year by the National Press Photographers Association. He began to work for *National Geographic*, covering current affairs, from the situation in Vietnam to the fall of the Berlin Wall. He then focused on Hispanic culture and published two books, *Cuba* in 1999 and *Divided Soul* in 2003. He became a full member of Magnum in 1997. He also edits *Burn*, an online photography magazine.

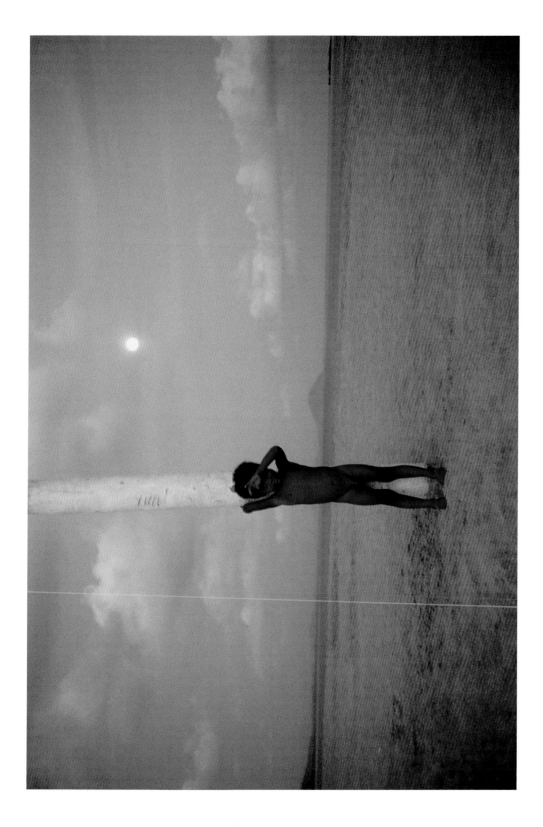

HIROJI KUBOTA

It is an awe-inspiring sight. The Golden Rock, resplendent in the sun, stands precariously balanced on a precipice, while a group of Buddhist monks, huddled together in the shadow of the great boulder, look on. The essence of the sacred Burmese site is palpable in this image – the contemplation, the strength, the stillness, the sense of freedom from the willing submission to natural order. For Buddhists this is a place of meditation and prayer. Hiroji Kubota succeeds in communicating the profound relationship between the earth and the sky that is so characteristic of Burmese culture and essential to its spirituality. His talent lies in capturing the *genius loci* of places, the intimate connection between people and their surroundings. He frequently travels throughout Asia, visiting countries such as North Korea, China and Burma, which for a long time remained shut away from the West. Armed with his 35mm film, he observes human beings in their environment: 'I think that whoever maintains that photographing landscapes is not particularly intellectual is mistaken. I learned this in China. Landscapes tell us about society and nature and what constitutes beauty.' Elliott Erwitt is an admirer of Kubota's work, once writing of the photography world's indebtedness to him. Rather than entering the family business in Tokyo, Kubota chose to follow the uncertain destiny of the freelance photographer, driven by the desire to create uplifting photographs, and it is something for which we should all be grateful.

The Golden Rock at Shwe Pyi Daw, the Buddhist holy place, 1978

© Hiroji Kubota/ Magnum Photos

HIROJI KUBOTA was born in 1939 in Japan. After graduating in political science from Tokyo's Waseda University in 1962, he decided to become a photographer. He moved to New York and became acquainted with Magnum photographers. After a few assignments he returned to Japan in 1968. In 1970 he joined Magnum, and in 1975 documented the fall of Phnom Penh and Saigon. Later he travelled in Korea, and in 1979 obtained permission from the Chinese authorities to remain in China for 1,000 days, a record period for a foreign photographer at that time. He investigated the topic of malnutrition, which culminated in the 1999 project 'Can We Feed Ourselves?', and led to a book and a touring exhibition of the same name. He is well known for his spectacular colour photographs, and in 2004 completed the book *Japan*, an in-depth look at his native country.

JOACHIM LADEFOGED

During the break-up of Yugoslavia, the Belgrade objective was to have control over Kosovo, where ethnic Albanians made up 90 per cent of the population. In 1998 President Milosevic extended his strategy of terror by forcing them to leave, having already succeeded in Bosnia. In February of that same year the first Serbian bombings took place and the region witnessed its first civilian massacre. A desperate exodus then began, as civilians fled to neighbouring countries such as Albania, Montenegro, Macedonia, Italy, and eventually the rest of Western Europe. This proved to be the largest exodus in European history after the Second World War. At this point the young Danish photographer Joachim Ladefoged had already been working for a year in Albania, the poorest country in Europe and also then in the throes of an economic crisis. This first phase of his travels became the first chapter of his book *Albanians*, which developed into a chronicle of the tragedy that befell the Kosovans. The second chapter contains images of conflict and incomprehensible violence: people fleeing Kosovo for their lives, and by every means possible. The third chapter of the book looks at the exodus – the plight of the refugees. In the fourth chapter, there are images of bodies being buried, acts of revenge, the rebuilding of ruins and of lives. The book ends with this image of a dive into an artificial lake. It is a fearless dive, naked, arms forward and eyes closed.

A young Kosovar Albanian boy jumps into an artificial lake outside the city of Gnjilane, 1999

© Joachim Ladefoged/VII

JOACHIM LADEFOGED was born in Denmark in 1970. At sixteen his dream of becoming a football player was shattered when he was struck down with severe rheumatism. A year later he bought a camera. He began working for a local newspaper and in 1995 became a staff photographer at the Danish national newspaper *Politiken*. Since then he has worked in over fifty countries, documenting war, conflict and everyday life around the world. In 2000 he published the book *Albanians*, which examines the turbulent period between 1997 and 1999. His photographs have won several prestigious prizes and appear in leading international publications. In 2008 he published the book *Mirror*, which looks at the body-building world in Scandinavia.

276

TRAVEL

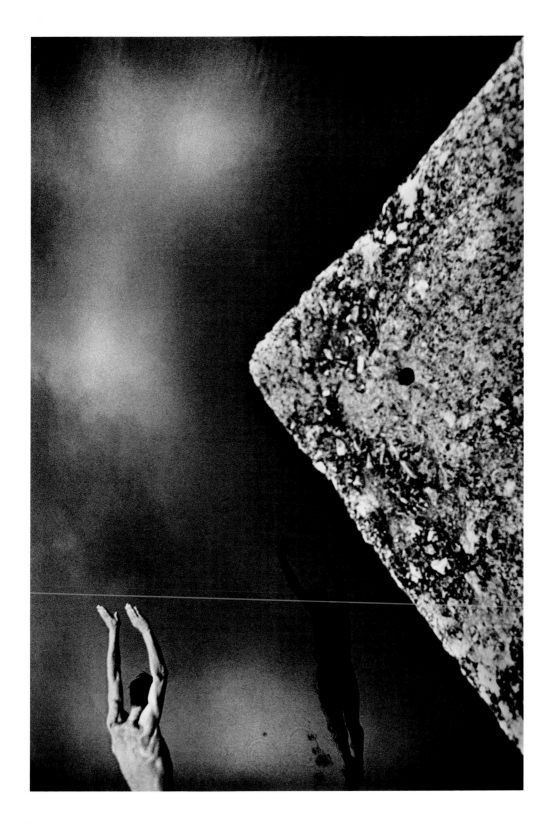

ALEX MAJOLI

Alex Majoli was one of ten Magnum photographers who participated in the 2004 project 'Euro Visions', a photographic exploration of the ten countries that joined the European Union on 1 May of that year. His pictures of Latvia are characterized by sadness and bewilderment in the eyes of his subjects. One sees splinters, cool as the snow that falls on the ground. The only visible traces that give perspective to his studies are the tram-lines and trees. Majoli makes no comment about the subject's background – where he comes from, the conflicts and oppression he may have seen. And the men and women he portrays also keep their silence. 'I didn't know our country was so sad,' one of them is reported to have said. It was as if that man, looking in a mirror held up by someone else, saw only the tragic, painful absurdity of his existence, fragmented, incomplete and immobile. Like a gash that has been stitched up but could start to bleed again at any moment, the tracks seem to tear the snowy landscape in two and ensnare the man in the division. While it can be relatively easy to tackle the stories of our own homeland, the responsibility of documenting the worlds of others weighs much more heavily on our shoulders.

Cesis, Latvia, 2004

© Alex Majoli/
Magnum Photos

BORN IN RAVENNA in 1971, Alex Majoli covered the conflict in Yugoslavia between 1992 and 1993, and over the next few years all major events in Kosovo and Albania. In 1994 he began an intimate photo story on a psychiatric hospital on the Greek island of Leros, which became the subject of his first book *Leros* (1999). In 1995 he went to South America, where he started the ongoing project 'Requiem in Samba'. In 1998 he began work on 'Hotel Marinum', a project on harbour cities around the world. In 2001 he joined Magnum, and two years later he won the Infinity Award for Photojournalism from the International Center of Photography. Together with Thomas Dworzak, Paolo Pellegrin and Ilkka Uimonen, he put together the installation 'Off Broadway', exhibited initially in New York in 2004, and then in Arles, Germany, and Milan in 2006. He works for *Newsweek*, the *New York Times Magazine* and *National Geographic*.

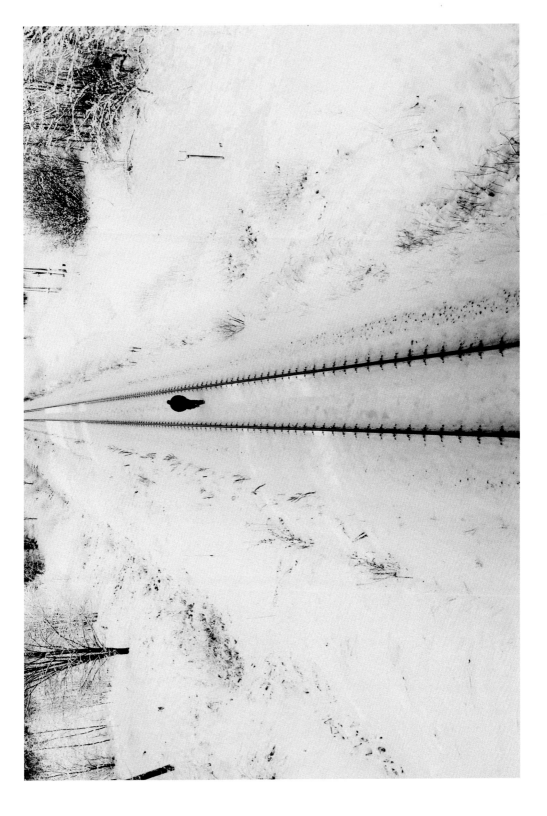

PETER MARLOW

Travelling is easy, but becoming a traveller is entirely a different matter. You need a mind capable of calm reflection, and an eye that can search out the unfamiliar and respond to it. You also need to understand that any trip is a combination of your own preconceptions and the realities that you experience there. The British photographer Peter Marlow is a traveller in the true sense of the word. He had barely finished his studies when, armed with a portfolio of wedding photos, he secured a job as a photographer on a cruise ship. In the warm waters of Central America and the Caribbean, he took personal pictures alongside his professional work, and began his own journey of exploration. A true visionary was born. Finding the right viewpoint is a matter of intuition and knowledge: for Marlow it means a unique opportunity, both in professional and personal terms, to work as he wishes while always offering an original and individual interpretation. His photographs are in the documentary style, but in an unusual way: there is something elusive about them, mysterious and yet charming. We want to know more about this austere Shinto group and their ritual in the surf, which speaks of an exoticism and the boundaries of spirituality. The photograph retains a sheen of mystery.

Shinto festival on the beach at Shingu, Japan, 1998

© Peter Marlow/ Magnum Photos

TRAVEL

PETER MARLOW was born in 1952 in England. He graduated in psychology from Manchester University, and spent two years in South America (1975–76) before documenting the conflict in Lebanon and Northern Ireland for the agency Sygma between 1977 and 1980. He joined Magnum in 1981. In 1983 the Arts Council of Great Britain gave him a grant for the project 'London by Night'. In 1988 he obtained funding from the Photographers' Gallery in London to create the book *Liverpool: Looking Out To Sea* (1993). An ardent follower of technology and architecture, in 2003 he covered the last Concorde flights and the plane's fans in Heathrow Airport. He lives in London.

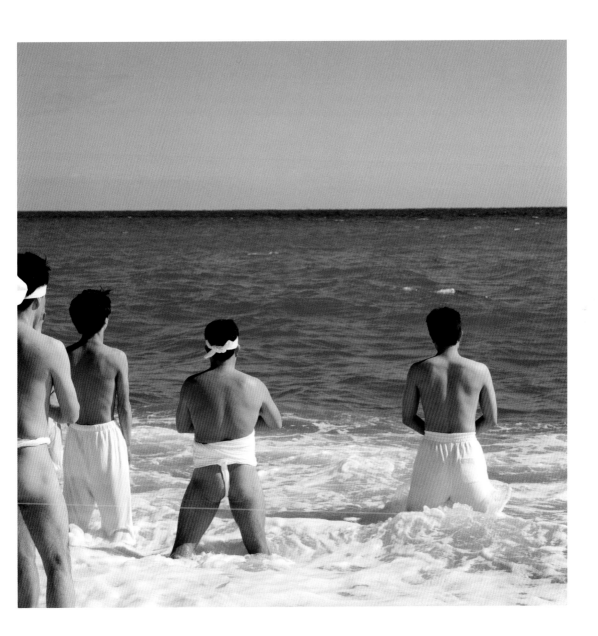

STEVE MCCURRY

When he was in his twenties, Steve McCurry left America, and his native Philadelphia, and travelled east. It was a journey that took him from India to Pakistan. The Indian subcontinent of Gandhi and the Ganges, of rebel warriors and anthropomorphic deities informs some of the most important chapters of his work. This is a part of the world he would return to again and again, capturing it in its delicacy and strength of colour. From India and Pakistan he went to Afghanistan, where he documented the Soviet invasion in 1979. McCurry's genius lies in his ability to find a moment of beauty within tragedy, whether it be war or poverty. He finds it in the face of an Afghan refugee girl in Peshawar, her large green eyes conveying her innocence and fear. Or in a scene at Varanasi, India, where people risk their lives in streets flooded by the waters of the Ganges. Or in the flight of hundreds of white doves in front of the mosque of Mazar-e-Sharif in Afghanistan. In the photograph opposite we see fishermen at Weligama, Sri Lanka, balancing like acrobats on their stilts. There may be an underlying reality of poverty and exhaustion, but McCurry again manages a triple somersault and transforms these fishermen on their poles into a group of incredibly elegant ballet dancers. They seem to be suspended in the air – all delicate gestures and exotic beauty, each at a different height that balances the composition. This highly skilled act is made to look so effortless.

Fishermen, Sri Lanka, 1995

© *Steve McCurry/ Magnum Photos*

STEVE MCCURRY was born in Philadelphia in 1950. After studying cinematography at university, he worked for a newspaper for two years before turning freelance and travelling to India. The turning point came in 1979: he crossed Pakistan into rebel-controlled Afghanistan just before the Soviet invasion, and took photos which earned him the Robert Capa Gold Medal Award. More wars and more photo stories followed on Yugoslavia, Lebanon, Cambodia, the Philippines, Kuwait and again Afghanistan. Many of his famous photo stories on Tibet, Burma, India, Iraq and Yemen were published in *National Geographic*. His publications include *Monsoon* (1988), *Sanctuary: The Temples of Angkor Wat* (2002), and *In the Shadow of Mountains* (2007).

JAMES MOLLISON

James Mollison has made the art of portraiture his raison d'être. In his work he often explores physiognomic similarities and differences; those facial characteristics that define the portrait as the 'mirror' of the individual, and make each one of us unique. For example, Mollison undertook an enlightening body of work on primates. He visited ape sanctuaries in various countries, built relationships with these threatened animals, and captured their individual personalities in a series of extraordinarily moving portraits. The images reveal just how much a portrait can tell us about a primate, whether human or animal, and make us reassess the differences between man and ape. The series was turned into a book, *James and Other Apes* (2005), and an advertising campaign for Benetton. The photograph opposite was a break from Mollison's exploration of similarities and differences. This group shot was taken at a centre for men recovering from mental health problems in the village of Bouake, Côte d'Ivoire. All of them have suffered violence and abuse, and were chained to trees for various periods, some for up to twenty years. The centre where they live and work offers them a fresh start, an opportunity to slowly but surely rebuild their lives, and retrace the thread of their own destiny and human dignity. By telling part of their story, Mollison may participate in his own way in their 'recovery'. He uses the camera in his hand as a way of inserting himself into the space, of placing himself among the group. And the group responds by revealing its dynamic in front of the lens: a unique ensemble of individuals with a common link.

Healed madmen, Bouake, Côte d'Ivoire, 2001

© James Mollison/Colors/ Contrasto

BORN IN 1973 in Kenya, James Mollison studied art and design at Oxford Brookes University, and documentary photography at the Newport School of Art, Media and Design in the UK. Since 1998 he has lived in Venice, working with Fabrica, Benetton's creative laboratory. His work includes the 2001 Benetton campaign, supported by the United Nations, and the 2002 campaign in collaboration with the World Food Programme. His publications include *Lavoratori* (1999), a study of immigrant workers in Venice, *Kosovars* (2000) and *James and Other Apes* (2005). His images are published in prestigious international magazines.

284

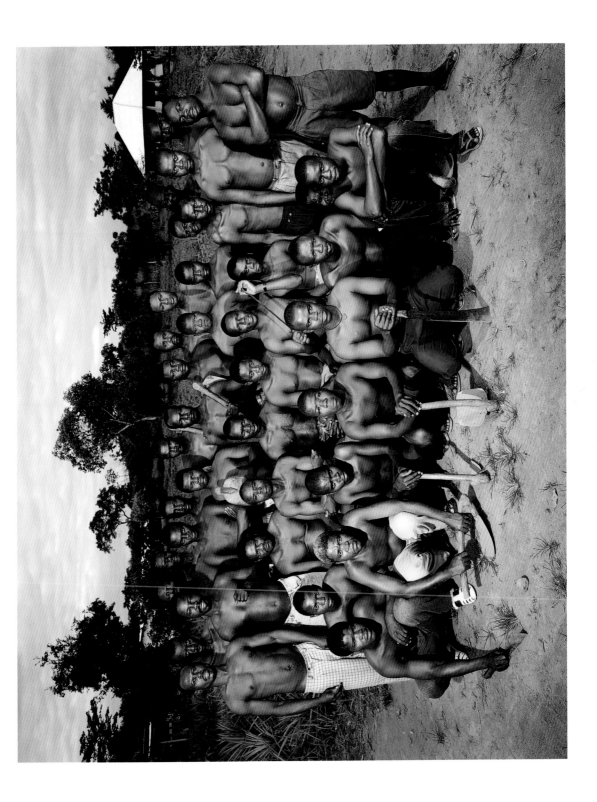

DAVIDE MONTELEONE

'Dusha' is Russian for 'soul': the spirit of a nation, fellowship, the feeling of not being alone. It may be a difficult concept to understand for those not living in the boundless spaces where greyness shapes the long, harsh winter. Winston Churchill said that Russia 'is a riddle, wrapped in a mystery, inside an enigma'. In 2002 Davide Monteleone went to Moscow, where he remained for a year and a half. He continued to travel across the vast country until 2007, attempting to document the enigma. He left the capital to visit the provinces, where the splendid lights of Moscow and St Petersburg are absent, where little has changed over the past twenty years, and where there is nothing but cold and squalor. Monteleone knows these people, he speaks with them. His narrative gradually becomes more visionary, shot through with subtle colours which evoke a dreamlike ambience where white dominates, mesmerizing the eyes. 'I have been greatly influenced by Russia in this series,' he explains. 'It starts and ends with a bed, to restore a semiconscious state as if in a dream. The Russians are apathetic, melancholic and nostalgic.' Monteleone's photo story is woven into the forty medium-format pictures in the book *Dusha: Russian Soul*. As Margherita Belgiojoso writes in the introduction to the 2007 publication: 'For those who know little about the country, don't understand it or even fear it, Davide Monteleone offers a glimpse into the intimate and everyday life of Russians ... the reputedly dangerous and nostalgic Soviets, racist and nationalistic, are perceived as orphans of a past in which they blindly believe.' There is an understanding and empathy for these people, themselves rendered tiny by the immense landscape, often silhouettes ploughing through the snow, imperturbable faces that carry a symbolic history within.

St Petersburg, 2004

© Davide Monteleone/ Contrasto

BORN IN 1974 in Potenza, Italy, Davide Monteleone began working as a photojournalist in 1998. Over the years his work has been published in the most prestigious publications both in Italy and internationally. He primarily focuses on news, conflict and social issues. In 2002 he moved to Moscow, which resulted in extensive work on the former Soviet Union. In 2007 he won a World Press Photo Award for his images of conflict in Lebanon. Since 2001 he has been represented by the agency Contrasto. In 2007 he published *Dusha: Russian Soul*, which in 2008 was named the best photography book at the FotoGrafia International Festival in Rome.

TRAVEL

MICHAEL NICHOLS

Michael 'Nick' Nichols photographs some of the remotest places on earth. 'I like nobody being around, nobody talking to me. I'm the only photographer on the planet. That's why I don't photograph when there are other photographers... The one time I photographed in the White House I blew it completely.' This urge takes him to the densest jungles, the green abyss, far removed from the toxic presence of mankind. Nichols's photographs could be described as militant, subtly waging war on our voracious consumerist society and our appetite for primary resources. He hopes to contribute to the protection of the environment through his work, and *National Geographic* enables him to effect change. Nichols's coverage of Mike Fay's extraordinary fifteen-month Megatransect expedition across wild Africa – finishing on the Gabon coast – is a case in point: the articles and accompanying images contributed to the creation of parks and reserves in the area. This is a world which remains wild and where man is an unwelcome and endangered guest. The picture opposite is vital, immediate. It was taken just as the elephant was about to charge. Nichols was behind a tree but left his cover to point his camera. He caught the elephant's eyes, but had only seconds to flee. However, he seems unfazed by such hazards. He is happy to pay this price to feel like the only man on earth.

Charging elephant, near Dzanga Bai, Central African Republic, 1993

© Michael Nichols/ National Geographic Image Collection

MICHAEL 'NICK' NICHOLS was born in Alabama in 1952. He began taking pictures during military service and then enrolled on a photography course at the University of North Alabama, where he met his mentor Charles Moore, a photographer for *Life* magazine. From 1982 to 1995 he was a member of Magnum. In 1996 he joined *National Geographic* as a staff photographer and has since completed over twenty stories for the prestigious publication on the world's remaining natural paradises. His participation in the famous 1999 Megatransect Expedition, which saw Mike Fay cross a distance of 3,219 kilometres (2,000 miles) from the Congo to Gabon over a fifteen-month period, was published in *National Geographic* in three instalments. The last project was dedicated to the elephants of Chad, which are endangered. Nichols lives in Sugar Hollow, Virginia.

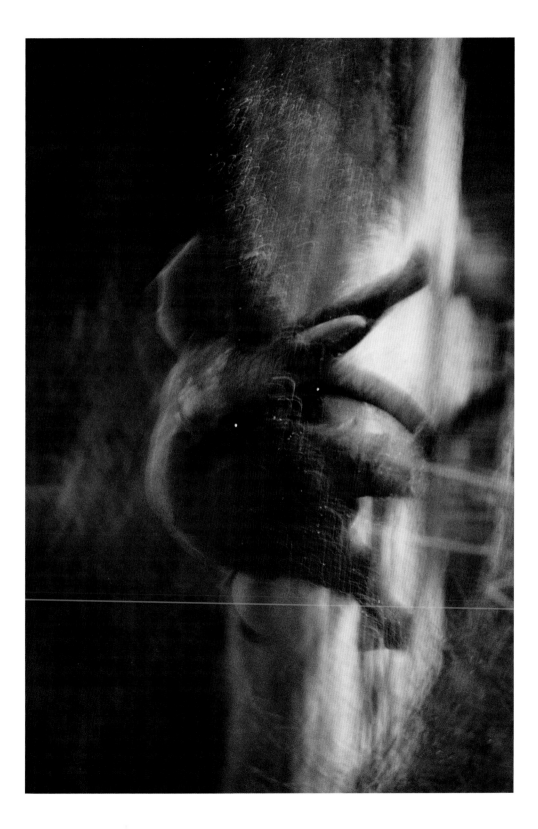

SIMON NORFOLK

Only the balloons are left. The rest has been blown away – the old teahouse in the Shah Shahid district, Kabul, its customers, and the scent of mint leaves and honey which used to soften the cold evening air. This is all that is left of the daily normality in an Afghanistan ravaged by years of war. Before our eyes is a ruined country. Simon Norfolk is a landscape photographer in the loosest sense of the term, with a disenchanted view of the world. Between 2001 and 2002 he worked on a project that centred around one of the most celebrated romantic motifs: ruins. But the ruins that Norfolk depicts are a far cry from those we see in the paintings of Claude Lorrain or Piranesi. His ruins have not been excavated to reveal the traces of solitary columns, crumbling arenas or pagan temples swept away by monotheism. Instead we have a charred bus, burial grounds destroyed by planes, artillery stations, roofless cinemas, the remains of an armoured car that look like the backbone of a dinosaur; still more bombs, unexploded fallen missiles collected and heaped on the ground; and even a noose hanging from a tree in an Al-Qaeda camp in Rishkor. Norfolk chose an antique-looking field camera to photograph these tranquil horrors: a cumbersome instrument that used 'plates' and required a tripod, but this is what gave the photographs their great detail and smooth tonalities. All around there is silence; then there is the sound of a balloon-seller's footsteps as he enters the frame, plying a trade once forbidden under the Taliban. The man stops and the balloons bob about in the air. It seemed an eternity since that gentle sound of peace had been heard.

Former teahouse in a park, Kabul, Afghanistan, 2001. From the book/ exhibition Afghanistan Chronotopia

© *Simon Norfolk/NB pictures/Grazia Neri*

SIMON NORFOLK was born in Lagos, Nigeria, in 1963. He studied philosophy and sociology at Oxford and Bristol universities, later enrolling in a documentary photography course. He produced a reportage series on the far-right British National Party. In 1994 he decided to abandon photojournalism in favour of landscape photography. His first book, *For Most Of It I Have No Words: Genocide, Landscape, Memory* (1998), was internationally acclaimed. In 2002 Afghanistan took centre stage in the book *Afghanistan Chronotopia*, which won the European Publishers' Award. In 2004 Norfolk received the Infinity Award from the International Center of Photography in New York.

TRENT PARKE

As with all good magic, you never see the trick. Trent Parke's trick is to make you believe that there is a car, a single roaring rally car, kicking up that marvellous dust trail. However, from a bird's-eye view, the perfect point from which to contemplate the Australian panorama, the eye catches an hallucinatory glimpse of something more. Perhaps we are actually looking at a wave of light-coloured sediment on the ploughed bed of the ocean. Or better still, perhaps it is a massive boomerang, thrown thousands of years ago but forever spinning through the sky. Parke's work does not refute hypotheses. All suggestions carry with them a grain of truth. It could not be otherwise for a man who began taking pictures as a child and one day chanced upon the magic power of the camera, as he turned around to retrace his footsteps and was fascinated by footprints in the mud. That was his first photograph, and since then all his black-and-white photographs have preserved a little of that childhood magic, an amazement at our journey on the earth that almost seems to come from a parallel dimension. One need only look at his rendering of bodies in water: in one photo his pregnant wife becomes the very embodiment of the sea in which she is floating. And then there is Parke's afterlife universe animated by black shapes and incandescent white ghosts that are on the verge of disappearing.

World Rally Championships, Australia, 2003

© *Trent Parke/ Magnum Photos*

TRAVEL

TRENT PARKE was born in 1971 in Newcastle, Australia. He began taking pictures aged twelve, using his mother's Pentax Spotmatic and the laundry room as a dark room. Today he is considered one of the most original photojournalists of his generation. In 1999 he published the book *Dream Life*, the story of a dreamlike journey through the streets of Sydney. In 2000 he published *The Seventh Wave*, a collaborative project with his wife, Narelle Autio. In 2002 he joined Magnum. In 2003 he drove 90,000 kilometres (56,000 miles) around Australia with his wife, portraying the melancholic vitality of his country: this won him the W. Eugene Smith Award in 2003. The images were published in 2005 in the book *Minutes to Midnight*.

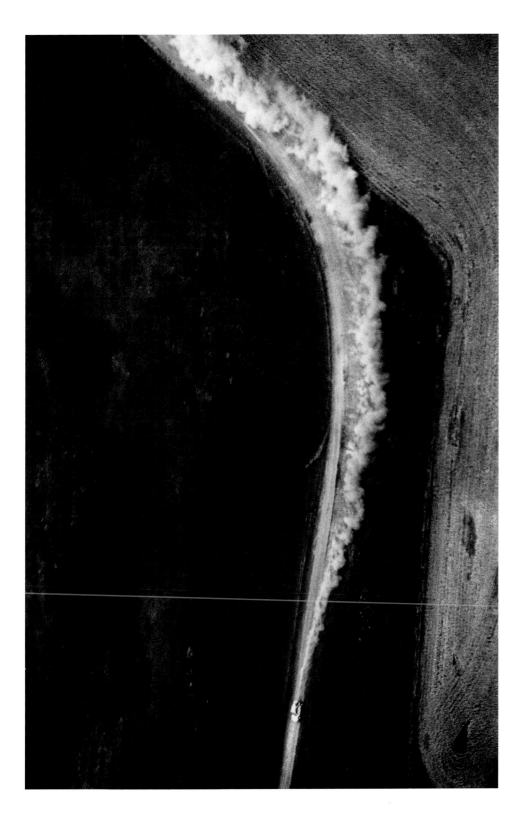

MARTIN PARR

'This is Jurmala, a beach resort near Riga, capital of Latvia. I love seasides, particularly old Communist seasides. I've got a mental image of a vast number of people being forced to enjoy themselves. This was a Sunday in July, and it had started to rain.' Martin Parr juxtaposes his mental images with reality. He finds that these Balkan beaches are ultimately not that different from the one he photographed at New Brighton, Merseyside, England. The only difference is the Soviet-style buildings littering the seafront, and the cafés selling stale, ring-shaped pastries and cheap vodka in plastic cups. The people who holiday at Jurmala are ordinary, very much like the visitors to New Brighton. However, in Martin Parr's photographs, attention to the ordinary is never insignificant. He discovers in the apparent banality of the everyday a core of inconsistency: his use of ring flash and macro lenses enables him to put his subjects under the microscope. Detail becomes grotesque, and the grotesque is often disquieting. Parr documents social decline, mass consumerism and the beast of vanity, and is attracted to locations that bear the signs of wholesale change or mass tourism. His original perspective captures the banal in unusual ways. He combines an analysis of the visible signs of globalization with unusual visual experiences, showing us how we live, how we present ourselves to others, and what we value. Saturated colours enliven sugary grease, and the rotten detritus of the Western world. Reporters conventionally travel the world, often on the trail of human catastrophes: famine, war, poverty. Martin Parr leaves his house and goes to the supermarket around the corner: 'This to me is the front line.'

Jurmala, Latvia, 1999

© Martin Parr/ Magnum Photos

BORN IN 1952 in Epsom, Surrey, Martin Parr studied photography at Manchester Polytechnic. In the late 1970s he won the Arts Council of Great Britain prize three years in a row. From 1975 to the early 1990s he taught a series of photography courses. His provocative style created intense debate. He became a member of Magnum in 1994. His work has been widely exhibited, and his photographs are held in major collections. He has shot film documentaries and a television series, 'Think of England'. 'Parrworld', his largest exhibition to date, was held in 2008.

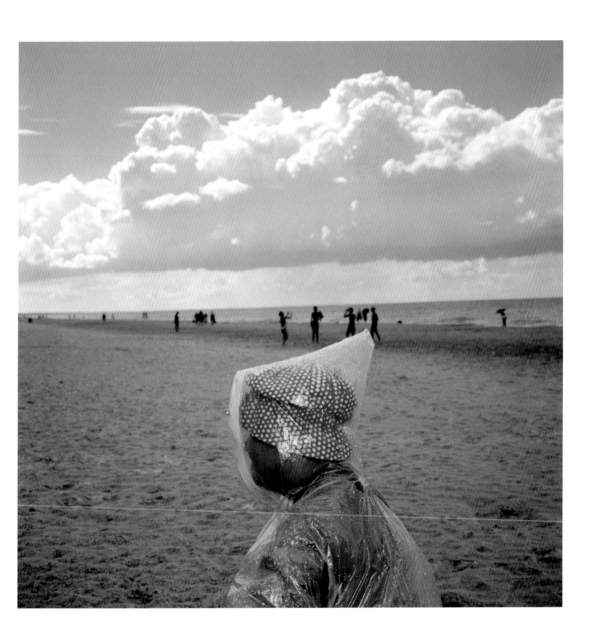

MARCO PESARESI

The London Underground is one of the best places to lose yourself. Marco Pesaresi went on a journey that took him to the subway stations of a further nine cities. For two years he travelled through Berlin, New York, Calcutta, Mexico City, Moscow, Madrid, Tokyo, Milan and Paris. One of the most intuitive photojournalists of the new generation, he succeeded in one of the hardest undertakings – transforming public places, which are frequented by everyone and nearly exhausted in our imagination, into a primordial source of inspiration, study, and discovery of oneself and others. He managed to do this with a subtle and discreet eye. Everything races by in the underground city, and everyone can be anonymous. As the director Francis Ford Coppola writes in his introduction to Pesaresi's book *Underground*, the imagination can take over as you observe strangers and try to work out what they're thinking or feeling. Pesaresi must have tried a similar exercise, choosing the colours, the neon nuances, as a common thread in ten journeys. He must also have had the strong sensation that his solitude as a photographer was perhaps the best, most authentic and most honest way to capture the solitude of others in passing.

King's Cross St Pancras, London, 1995

© Marco Pesaresi/ Contrasto

TRAVEL

MARCO PESARESI was born in Rimini, Italy, in 1964. After completing college, he studied at the Istituto Europeo di Design in Milan, where he began his career as a professional photographer. He travelled through Africa and Europe, focusing on immigrants, prostitution, the marginalized, and the drugs world. In 1990 he joined the agency Contrasto, and in 1994 won the Premio Linea d'Ombra. He also undertook a project on the most important underground transport systems in the world, which was published in 1998 in the book *Underground*, with an introduction by Francis Ford Coppola. He died in Rimini in 2001.

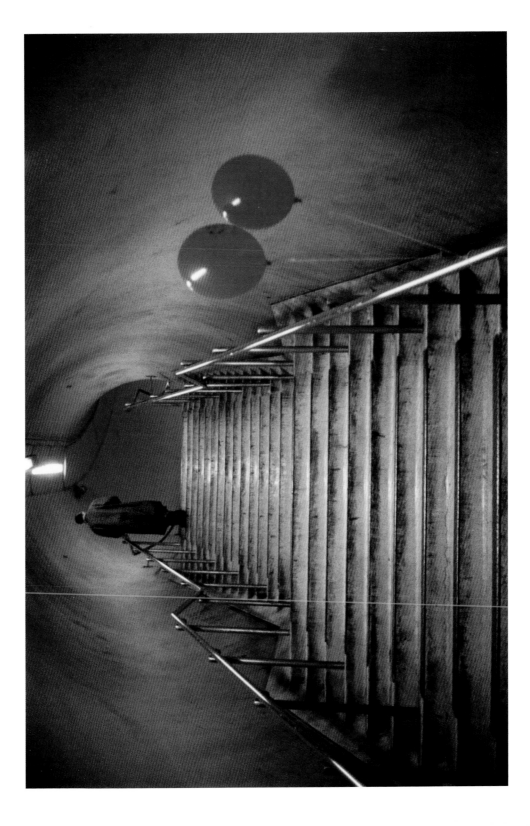

MARK POWER

The heartbeat of a country in the centre of Europe is regulated by two rhythms, East and West, the layers of the past and the illusions of the future. Mark Power has heard them and entitled his ongoing work on Poland 'The Sound of Two Songs'. The melodies overlap: sometimes they are in harmony and at other times they clash. It can be a piercing noise as easily as a background hum. Power continues to listen carefully. In 2004 Magnum commissioned the project 'Euro Visions', in which ten photographers documented the ten new member states to join the European Union that year. The British photographer chose Poland because it seemed to him to be the country least visually defined. The vague imagery brought with it the challenge not to fall into clichés; it required a thorough approach. As Power observes: 'I didn't set out to try and prove a preconceived thesis. I'm wary of the problems associated with working towards a specific goal in a foreign land: there is the danger that you only see what you want to see. Instead I like to remain intuitive, to learn as I go and be open-minded.' You cannot get under the skin of a foreign country in a few weeks, and Power therefore returned over several years. What had started off as a collective project became a personal interest. His work resembles a topographic study, discovering a landscape which bears the marks of a long history. He has created a dialogue between real spaces and imaginings using fragments of everyday existence. Roads, gardens and cities are often captured in a phantom light that transcends the everyday and suggests a dream. The remnants of abandoned structures serve as both a memory of the past and a testimony of a capitalist dream, in some cases becoming a nightmare. The people are hardly ever actually there, though one feels an eloquent presence.

Warsaw, February 2005

© *Mark Power/Magnum Photos*

TRAVEL

BORN IN THE UK in 1959, Mark Power studied fine art at Brighton Polytechnic, and in 1982 became a freelance photographer. His first monograph, *The Shipping Forecast* (1996), was inspired by the shipping weather forecasts broadcast on BBC radio. The book was recognized with the Mosaique European Photography Award and the Leica Oskar Barnack Award (Special Jury Prize). Power documented the construction of the Millennium Dome in Greenwich, London, and published *Superstructure* in 1998. In 2002 he joined Magnum, and in 2004 participated in the project 'Euro Visions' with his photo story on Poland. In 2007 he published *26 Different Endings*, a project on the scenery beyond the margins of the London *A to Z* road atlas. He currently lives and works in Brighton, where he lectures in photography at the University of Brighton.

RAGHU RAI

Raghu Rai photographs India. He depicts a throbbing existence, sometimes painful to witness, always charged and imbued with great pathos and with an inexpiable and unique poetry. This photograph was taken at the Chawri Bazaar, in the centre of Old Delhi. It is captured in a moment of daily bustle, at the peak of trading, with swarms of people on the street. The photographer observes everything from an elevated point of view, almost with an entomologist's eye, on one level seeming impersonal, but on another full of profound empathy which binds him to his country. Wherever you look within the frame there are details to stimulate the eye. A bundle of light-coloured wood enters the scene from the bottom left-hand corner, beckoning us to follow. Here you can admire every fine detail and lose yourself in the heady aromas of an Indian metropolis, amid the hubbub of trade and the rhythmic sounds of horses' hooves. Rai has said of himself: 'I am a pilgrim. I travel all over the country with complete faith. India, to me, is the whole world. I need ten lives to do something about my country, but unfortunately I have only one. One thing is certain: I am getting closer to things now.'

Chawri Bazaar, Delhi, 1972

© Raghu Rai/Magnum Photos

TRAVEL

RAGHU RAI was born in 1942 in Jhang, at that time a small village in India but now part of Pakistan. He took up photography in 1965, and the following year joined the New Delhi newspaper *The Statesman* as its chief photographer. He joined Magnum in 1977 on Henri Cartier-Bresson's nomination. Rai has specialized in extensive coverage of India and has dedicated many books to the country. His photo story on the chemical disaster at Bhopal in 1984 won acclaim, as did his series on Delhi, Calcutta, the Taj Mahal, Indira Gandhi and Mother Teresa. He currently lives and works in Delhi.

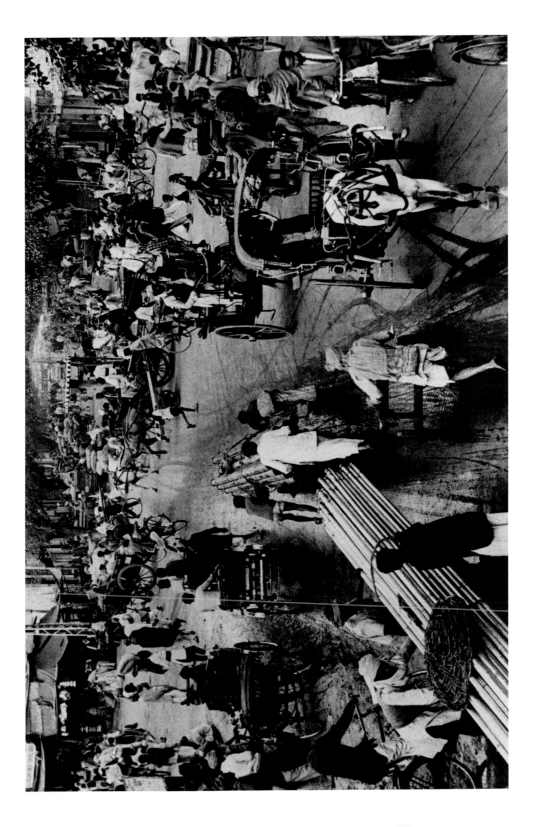

GEORGE STEINMETZ

George Steinmetz does a great deal of aerial photography from a motorized paraglider, the lightest engine-driven aircraft in the world. He is passionate about heights, the sky and the weather, Africa, geography, people, the earth and, naturally, photography. Lake Natron is located in Africa's Great Rift Valley between Tanzania and Kenya. It owes its characteristic reddish colour, intense and surreal, to the colonies of micro-organisms which thrive as salinity levels rise in the dry season. In the hottest months the temperatures of the basin can soar to 50°C (122°F), with a high degree of evaporation occurring. On this occasion Steinmetz used an aeroplane to photograph the lake and wanted to include the shadow cast within the frame. It is the only evident anchor in reality in an image otherwise marked by strong abstraction. We travel across a strip of Africa that resembles an open, bleeding wound in the earth. The picture hinges on its beauty and mystery, indistinct qualities that encourage the viewer to scan every detail of the scene. Under Steinmetz's touch the colour of the earth becomes an extraordinary sight.

Airplane Shadow, Lake Natron, Tanzania, 2005

© George Steinmetz/ Contrasto

GEORGE STEINMETZ was born in Beverly Hills in 1957. He graduated in geophysics from Stanford University and took up photography after a long trip to Africa. He specializes in representing remote and often little known lands and peoples. Since 1986 he has done many assignments for *National Geographic* and the German edition of *GEO* magazine. He is the author of spectacular photo stories on the Gobi and Sahara deserts. He is also credited with rare visual documentation, including his work on the West Papua tree-dwelling tribes of New Guinea. He has won several international prizes, and in 2008 published the book *African Air*, a collection of his most famous images.

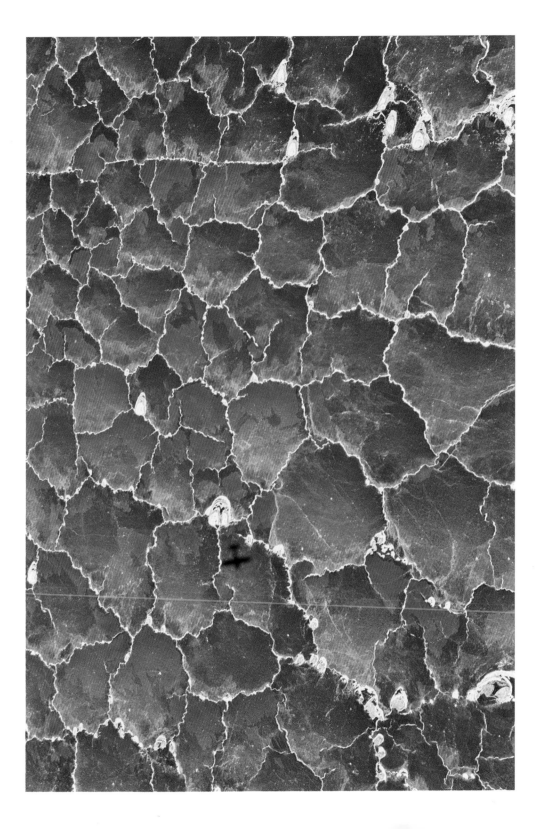

ALEX WEBB

Alex Webb thinks of himself as a witness of the story in the broadest sense of the term, primarily photographing the daily happenings of everyday people. He is a street photographer, strolling around without a set idea of what he will find and of what is worth photographing. 'I only know how to approach a place by walking,' Webb explains. 'For what does a street photographer do but walk and watch and wait and talk, and then watch and wait some more, trying to remain confident that the unexpected, the unknown, or the secret heart of the known awaits just around the corner.' He loves the southern parts of the world, particularly the tropics: South America and Africa, borderline countries dominated by sun and light and the intermingling of cultures. This is where he is at his best, exploring the possibilities of colour, which becomes his strong narrative signature, the tool with which to penetrate a complex and contradictory reality. In 1998 Webb visited Istanbul and has remained enthralled by its people and street life, and its layers of culture and history which join East and West. He did not go to Istanbul with the predetermined idea of photographing a city that was at once western and eastern; he simply went there, wandered around, allowing the experiences direct from the street to speak before and above all other things, and absorbed those experiences. The result is an intense œuvre which successfully conveys the fascination and frisson of a culture that is in transition and yet firmly rooted in a complex history.

Outside of the Blue Mosque during Ramadan, Istanbul, 2001

© Alex Webb/ Magnum Photos

TRAVEL

BORN IN SAN FRANCISCO in 1952, Alex Webb majored in history and literature at Harvard University and went on to study photography at the Carpenter Center for the Visual Arts, also at Harvard. In 1974 he began working as a professional photographer and soon appeared in important publications. In 1976 he joined Magnum, becoming a full member three years later. He has done long photo series on the American South, the Caribbean, Mexico and Africa. His pictures have been published in several books and have received much acclaim, including the Hasselblad Foundation Award in 1998 and the Leica Medal of Excellence in 2000. He has exhibited several times in Europe and the United States.

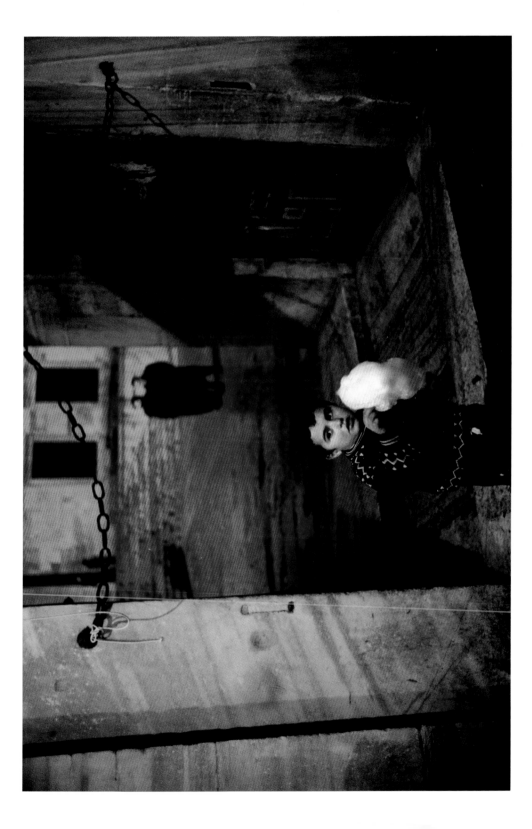

MICHAEL YAMASHITA

Marco Polo's travels through China began here at a wintry Kashgar, nestled between the Pamir Mountains and the Taklimakan Desert. A spectacular portal, which Michael Yamashita succeeds in transforming into a poetic, delicate image with his mastery of post-impressionist technique. The photograph could come straight out of *The Travels of Marco Polo*, but this is modern-day China. Our eyes are drawn to the warm core of the image, the red umbrella, a small touch of colour that seemingly holds together the entire scene. In the foreground two men dressed in suits, and smiling, have tucked their hems into their socks to prevent them being soiled by the slush, while all around there is a flurry of figures milling about. Marco Polo wrote: 'Cascar is a region lying between north-east and east, and constituted a kingdom in former days, but now it is subject to the Great Kaan. The people worship Mahommet.' This is true to this day, but there are other lines of continuity. Yamashita's skill lies in forgetting the present and travelling back to the thirteenth century, following in the footsteps of the great explorer. The results, gathered together in the book *Marco Polo: A Photographer's Journey*, are extraordinary. What began as a four-month project for *National Geographic* turned into an obsession, and Yamashita returned to the sites again and again. As Jonathan Spence, professor of history at Yale University, said: 'The Polo-fever is a strange illness. It can strike at any moment in time, and often without forewarning. It especially affects older and middle-aged men. As of today there are no cures for this illness.'

Kashgar, China, 2002

© *Michael S. Yamashita/ National Geographic Image Collection*

TRAVEL

MICHAEL YAMASHITA is an American photographer and has worked steadily for *National Geographic* since 1979. He has travelled every continent, but Asia remains his special area of interest. He has visited Singapore, Thailand, Hong Kong and Japan. Among his books, *Mekong: A Journey on the Mother of Waters* (1995) was the result of a project for *National Geographic*, for which he followed the river from source to delta. *Marco Polo: A Photographer's Journey* was published in 2002.

OLIVO BARBIERI

For Olivo Barbieri the night is made up of light and colours. His lens, which is open for long exposure times, reveals the shades of colour hidden in the darkness. For many years, Barbieri has conducted an intense and personal study of artificial light, concentrating on both landscape and architecture, and their visual and structural relationship with the night. 'The idea of the modern city was born with artificial lighting... I have photographed every light source in Europe, China and Japan, both during the day and at night, and have tried to bring a classical, objective approach to the interpretation of urban reality. By going against the prevailing ideas, I discovered it was possible instead to describe a fantastic and incredible world, in formal terms similar to the parallel reality of synthetic images, which more than anything else today can suggest futuristic scenes to us.' His images hover at the boundary between truth and fiction, between dreams and theatrical scenery, in a darkness that can be imagined and filled. His research takes account of changes in cities, and the relationship between the real and the virtual which is becoming ever less defined in modern urban and social spaces. In his current work, Barbieri has developed a game with perception: by adopting an aerial perspective and using careful blurring, he gives an artificial dimension to elements of reality, transforming urban spaces into gigantic scale models. In this photograph, the artist has slowed down and intensified the process of observation and representation by allowing the light to define the subjective dimension of a landscape that seems both deserted and vibrating with movement. As Enrico Ghezzi writes: 'the luminous trails appear here as phantasms of light in amongst other shapes made of light, and not just as bizarre, skeletal flashes in the darkness.'

Rome, 1995

© *Olivo Barbieri*
Courtesy Brancolini
Grimaldi Arte
Contemporanea

OLIVO BARBIERI was born in Carpi, Modena, in 1954, and began exhibiting in 1978. From the early 1980s onwards he made an in-depth study of artificial illumination. Since 1989, he has travelled regularly to Asia, and China in particular, and has taken part in numerous international events dedicated to the visual arts. During 1999 and 2000 Barbieri concentrated on portraying the reality and spaces of his own country, having planned an original series of images depicting new and old cities in both the north and south of Italy. In 2004 he presented the project 'site specific_roma04' at the FotoGrafia International Festival in Rome, in which, by using an aerial perspective and elegant blurring, he transformed Rome into a gigantic scale model, lending an artificial atmosphere to elements of reality.

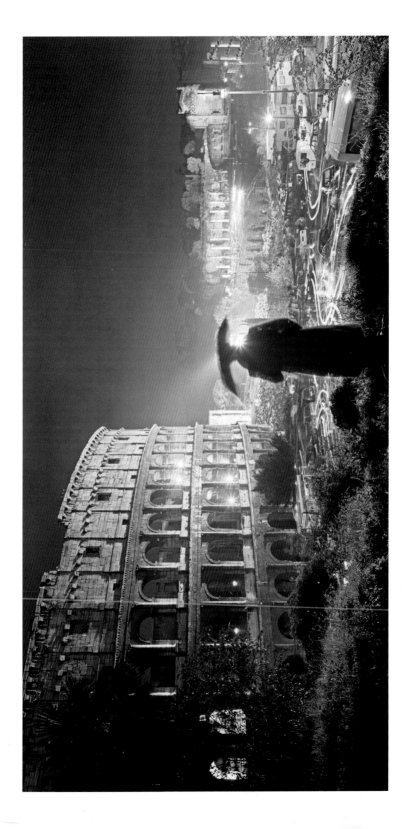

GABRIELE BASILICO

In 1991 Gabriele Basilico, together with five other photographers, was invited by the Lebanese writer Dominique Eddé to document the centre of Beirut at the end of the devastating civil war, which had lasted for fifteen years. Known all over the world for his photographic study of the urban landscape, the artist recalls: 'It was not simply a question of drawing up a report or taking stock of the situation but also of outlining a "state of things", a direct experience of the place, through a free and personal interpretation of a very delicate, unrepeatable moment in the history of Beirut: the year 1990, the end of an exhausting war that had started fifteen years earlier in 1975, and the expectancy of an announced reconstruction... Photography was tasked with the civil duty of contributing to the construction of historical memory with an account of human madness.' The result is a powerful document, in which a bruised city shows itself and its wounds, revealing the offence that man has perpetrated on it with a gruelling and absurd war, a war fought in the streets in the centre of the city, even in the most sacred places. Guilty man is absent from the images, in which the apartment blocks and streets are the only protagonists. A heavy silence seems to reign over everything, as powerless as the buildings themselves, evoking an atmosphere of expectation and suspense. This is a moment of stillness, caught between the past and the future. In 2003 Gabriele Basilico returned to Beirut to document its reconstruction: he attempted to use the same framings as a decade previously, even the same views as before, in order to show if, and how, time had begun to flow again in the city.

Rue Dakar, Beirut, 1991

© *Gabriele Basilico*
Castello di Rivoli Museo
d'Arte Contemporanea

GABRIELE BASILICO, born in Milan in 1944, is an architect and photographer. Between 1978 and 1980, he carried out his first project: 'Milano: Ritratti di fabbriche'. In 1983 he was the only Italian to be invited to take part in a photographic campaign for DATAR, organized by the French government. In the 1990s he resumed his study of the physicality and flux of urban landscapes. He won the Osella d'Oro Prize for architectural photography at the Venice Biennale in 1996 and, in 2000, received a prize from the Istituto Nazionale di Urbanistica. His works are included in many public and private collections. Of his many exhibitions, the retrospective in 2006, which the Maison Européenne de la Photographie (MEP) in Paris dedicated to him, is particularly memorable: it was accompanied by the catalogue *Gabriele Basilico: Carnet de travail 1969–2006*.

CITIES

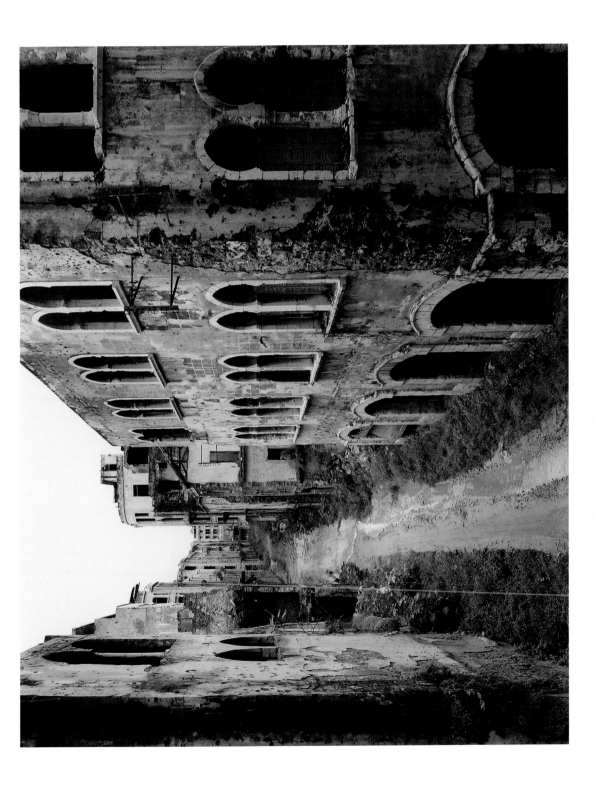

GIANNI BERENGO GARDIN

It looks like a crime scene, but clearly one from an absurd detective film. The setting is out of doors in haute-bourgeois surroundings, and it is a summer's day. A man has turned his back on the scene and is slowly and calmly walking away, hands in pockets. Behind him, on the far side of a table set for lunch, a woman's legs are visible on the ground. The table is laid, the plate is ready and the glass is full, but no one has sat down nor, it seems, will anyone do so. Who knows what has happened in the brief moments since the previous scene, although the woman's hand, which can just be glimpsed beyond the chair, and her left foot resting so calmly on her right one, both open up a path to innumerable hypotheses and multiple scenarios. Gianni Berengo Gardin has a keen, quick eye. In fifty years of taking photographs he has told the story of contemporary Italy – its society, its times, its contradictions. He has told it all with a sense of curiosity, always paying attention to reality and to people, and with a charming touch of irony that leans towards the bizarre, but never outrageous, anecdote. More than anything else, he has a passion for subtle detail and for paradoxes that create exciting ironic tension in his pictures, where meanings are allowed to multiply and proliferate. This image is from 1987: Italy's deceptive boom of the 1980s is over, inflation is soaring, employment is falling, public debt is growing at a dizzying rate, society has atomized and the family has fragmented. The party is over. No one sits at the laid table any more, a man leaves, and a tired woman stretches out on the ground to rest.

Work break, Milan, 1987

© *Gianni Berengo Gardin/ Contrasto*

GIANNI BERENGO GARDIN was born in Santa Margherita Ligure in 1930 and began taking photographs in 1954. In 1965 he settled in Milan and began his professional career. He has worked with many important Italian and foreign magazines, but has mainly concentrated on producing books. From 1954 to 1965 he worked with *Il Mondo*, then edited by Mario Pannunzio. He has received numerous prizes, including one from World Press Photo in 1963, and he received the Leica Oskar Barnack Award in 1995 for his book *La disperata allegria. Vivere da zingari a Firenze.* Of his many solo exhibitions, the retrospective 'Gianni Berengo Gardin' in 2005 is particularly memorable: it was accompanied by a catalogue of the same name, and was shown at MEP in Paris and at FORMA in Milan.

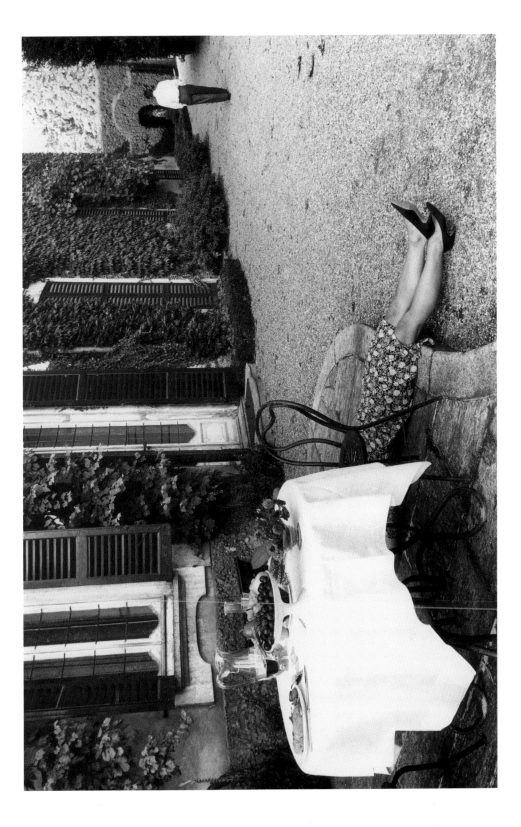

PETER BIALOBRZESKI

German photographer Peter Bialobrzeski's vision of the towering new Asian megacities is nourished by film images and sci-fi computer games, from *Blade Runner* to *Star Wars*, from *Sin City* to *Neuromancer*. References to these myths and fantasies are interwoven with the photographer's observation of a reality that is not so far removed from fiction. Shanghai, Hong Kong, Kuala Lumpur and Singapore are multilayered cities with high-density populations; they are in continual flux as they are shaped by a disposable architecture, and their skylines change every day. Bialobrzeski's dazzling images show us the most striking examples of this new trend in Asian city planning, presenting a highly original vision that is as unlike reportage as it is unlike classical architectural photography. 'It is always my aim that the photo should have the power to enchant,' Bialobrzeski declares, and he uses neither digital processing nor special effects to achieve this. Instead, he walks through these cities with a plate camera, always at the same time of day, between 4 and 7 pm, looking for an elevated position where he can set up his tripod, and using long exposure times that allow him to play with the delicate natural twilight and the overwhelming artificial lighting. His careful framings enable him to capture the profiles of new city quarters, the enormous contrasts between the glitter of the new and the decayed texture of the old urban fabric, and to hint at the chaos that lurks beneath the surface. His colours are soft, and human presence is rare and phantasmal. Silence reigns in his photographs, letting urban confusion subside and creating the illusion that all of these cities are simply one vast metropolis in a hyper-modern fantasy world.

Nanpu Bridge, Shanghai, 2001

© *Peter Bialobrzeski/Laif*

CITIES

PETER BIALOBRZESKI was born in Wolfsburg, Germany, and studied political science before becoming a photographer. He travelled extensively in Asia, then returned to studying by taking a course in photography and editorial design. Since 1989 his photographs have appeared in the most important international publications. In 2000 he founded the virtual gallery Photosinstore.com. He was a member of the jury for the prestigious Fuji European Press Awards in 2001 and 2002, and won the art category of the 2003 World Press Photo Awards. In 2004 his work on Asian megacities was published as a book, *Neon Tigers*.

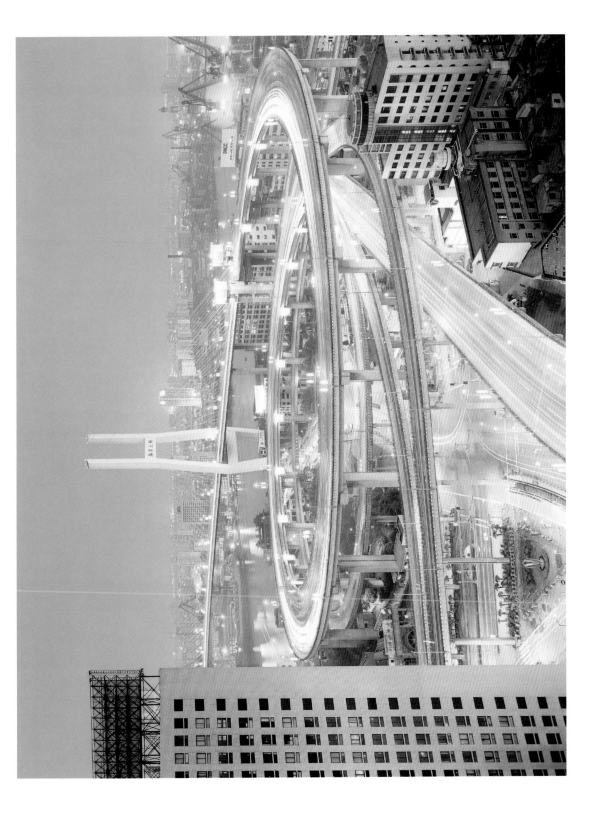

RENÉ BURRI

His first photographs taken against the light were of some little coffee cups immersed in sunshine streaming through a house window. And it was this simple domestic experiment that taught René Burri, a student of Bauhaus severity, that a flat, black silhouette with no detailing could tell more of a story than a well-lit face. This was an unforgettable lesson to be applied, above all, where the light of the sun has the narrative force of exposure. São Paulo, Brazil, is a city wounded by social and geometric conflicts. On the one hand, there is the horizontality of the favelas, just a few feet high, which is all that the timber of the illegal buildings can support. On the other, there is the verticality of power, the skyscrapers, the elite, a few millionaires in an ocean of poverty. This image shows the scandalous truth: some faceless figures seen against the light, mere outlines moving across the terrace of a skyscraper, while far below the crowd rushes headlong. It is indistinct but composed of two different worlds, one right next to the other. It may be that there is no more powerful portrait of our society, an image that is dramatic and at the same time austere, incisive but not scolding. And, more than anything else, it is this tragic composure, this Calvinistic but curious morality so open to the world, that has distinguished Burri's extraordinary career. He has been a Magnum photographer since 1959, and for almost half a century has photographed historic figures – Picasso, Churchill, Maria Callas, Le Corbusier, Giacometti and, famously, Che Guevara with a cigar. But, alongside the famous, he has also photographed unknown men, women and children, and their historical representatives, from the crowd attending the inauguration of Le Corbusier's chapel of Notre Dame du Haut to American soldiers in Vietnam. If life could only be like Burri's photographs, everyone might live on this same elevated level.

Brazil, São Paulo, 1960

© René Burri/Magnum Photos

RENÉ BURRI was born in Zurich in 1933, and studied at the School of Applied Arts in his native city. He began to use a Leica during military service. In 1955 he was introduced to Magnum by Werner Bischof, and his first photo story on deaf and hard-of-hearing children was published by *Life* and other European magazines. Magnum sent him on many assignments in Europe and the Middle East, and he worked as a reporter in war zones. During these years he produced renowned reportage stories, and also photographed creative artists such as Picasso, Giacometti and Le Corbusier. He became president of Magnum Photos in 1982. In 1991 he was made Chevalier of the Order of Arts and Letters in France.

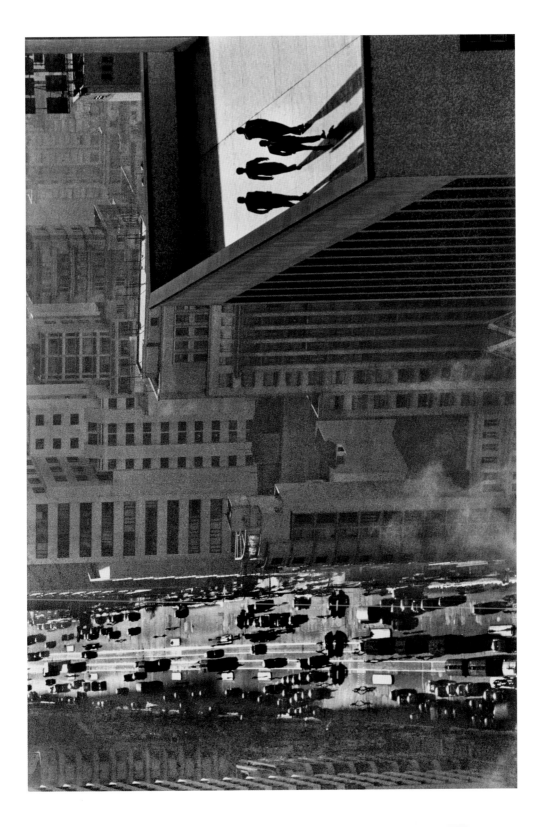

LUCA CAMPIGOTTO

Venice is capricious and secretive, shameless and self-conscious, gloomy and intensely theatrical. She has been described, painted and photographed so many times that it is difficult to find any freshness of vision when attempting to portray her. Luca Campigotto was born here, and it is to his city that he has made this gesture of love and challenge, by attempting to tell her story in an unusual, profound and sincere way. 'By using the artifice of photography – its ambiguous nature, its inevitable falseness – I have tried to reconstruct the scenes from my own imagination. Venice has been a widow for centuries. Sublime and feverish, each night she is left alone to herself, to the cats, and to the hordes of rejected lovers. In the darkness she is a body that can be explored, an archive that reveals its panoramic archaeology and grants the privilege of a journey through time.' The photographer observes his city at night, in her hours of abandonment, silence and rest from the noisy and colourful swarms of tourists. He tries to capture her mystery by reducing her to a gleaming black and white which restores her theatrical atmosphere, in which one seems to feel the moisture in the air. The darkness of the canals creates a foreshortened backdrop through which the light penetrates, powerfully shaping and revealing poetic landscapes that are unique in the world. There is no one else here during these nocturnal hours, only the photographer and his city, no one to pass in front of the tripod and disturb the enchantment of the empty streets. The waters of the lagoon and the crumbling walls are frozen in a dreamlike atmosphere. As Campigotto writes: 'It is in the persuasive infidelity of black and white that the dream can become intentional.'

Rio de San Marcuola, Venice, 1992

© *Luca Campigotto*

BORN IN VENICE in 1962, Luca Campigotto graduated in modern history and began to take photographs in the early 1980s, concentrating on social reportage and landscape. He has exhibited in Italy and abroad, and his work is included in important private and public collections. His photos of Venice were published in 2006 in a book entitled *Venezia. Immaginario notturno.*

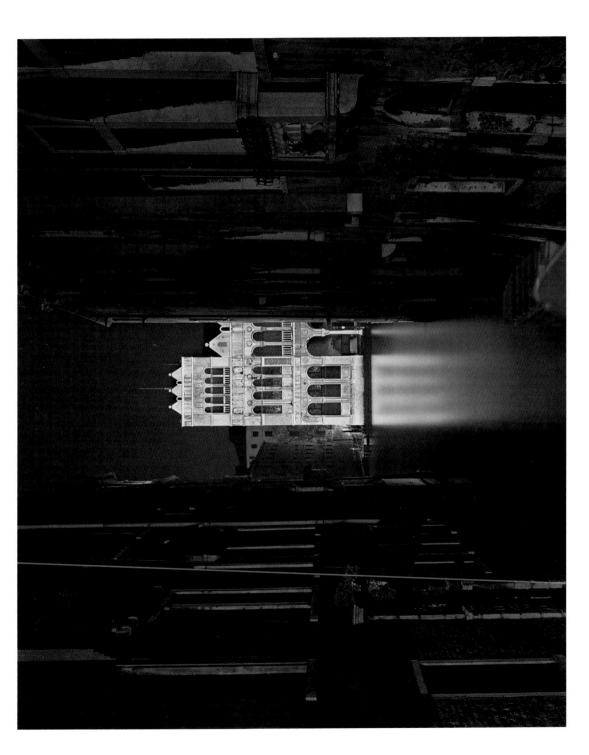

DANIELE DAINELLI

Daniele Dainelli captures the movement of a skater in front of Milan's Central Station. In the centre of the framing, caught in a moment of rapid movement, a boy seems to be about to rise into the air, his arms raised up as if he were beating his wings. The space between him and the ground has become the narrative centrepoint of an image that fits perfectly into the body of work by an artist who has made mystery, ambiguity and a kind of futuristic visionary imagination his signature. The only human subjects in this scene are dark outlines, elusive, quite unrecognizable and thus without identity. They are reminiscent of Henri Cartier-Bresson's famous action shot taken behind Saint-Lazare station in Paris, in which a man is frozen in the decisive moment of jumping over a pool of water. In Dainelli's image everything happens in a twilight atmosphere, halfway between day and night, characterized by acid and surreal colourings, with a purplish sky and reddish street surfaces. Every detail, every particular, comes together to give definition to a pervasive feeling of disquiet – the result of Dainelli's depiction of a banal, everyday scene – and it may be precisely this disquiet that makes the image so confusing and disturbing to the viewer.

Piazza Duca d'Aosta, Milan, 2000

© *Daniele Dainelli/ Contrasto*

DANIELE DAINELLI was born in Livorno in 1967. He began to take photographs when he was very young, and started to work for the Contrasto agency in 1999. He attracted international public attention with his 'Metropolis' project, a series of colour reports on the world's major cities. He received the Canon Prize for the best photographic project in 2002 with a work on artists and their places of creation. In 2004 he moved to Tokyo, where he produced a complex account of the city which was the subject of an exhibition at the 2008 FotoGrafia, Rome's international festival of photography. In 2007 he took part in the 'Paesaggio Prossimo' project on the Milan region. The collective book, *Solo in Italia*, which combines Dainelli's work with that of three other photographers, was published in 2008.

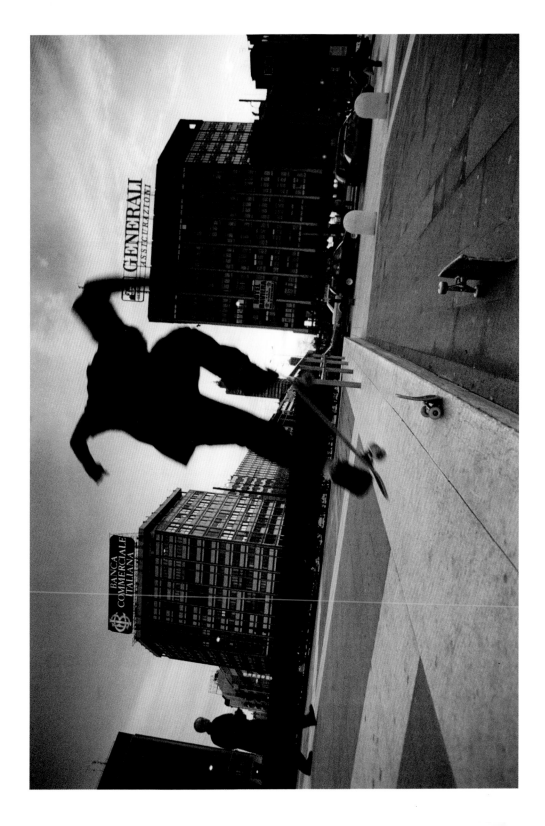

BRUCE DAVIDSON

Bruce Davidson has been a member of Magnum since 1959, and is an intrepid explorer of urban spaces. City streets are wonderful places for observing and discovering different social landscapes, teeming as they are with stories waiting to be told and understood. Davidson explains that most of his photos are designed to form compact groups of images that have the potential to penetrate into a world, or space, that he fears profoundly, or doesn't know, or feels himself drawn to. From the photographs of the circus dwarf to the Brooklyn gang, or East 100th Street to Central Park, even if the results are different the process is the same. Central Park is a microcosm within New York, the heart of a complex and fascinating city. Davidson's exploration of the life of the park was begun as an assignment for *National Geographic*, but continued for many years until it became an extremely personal project of great visual and metaphorical power. Davidson changed from colour to black and white, and his style became more introspective. He was able to reveal the magic of this island of nature surrounded by the chaotic metropolis: a place made up of poetic encounters, of living spaces in which the everyday hurly-burly slows down, where the homeless find refuge and lovers find intimacy. Little by little, as these images go by, the park reveals its true nature as a great poetic theatre of human life. In his work, Davidson doesn't look for the decisive moment. If anything, his photography is the study of a series of decisive moments: when added one to the other, they produce a cumulative effect. Each image is only a transitory part. If it is removed and considered on its own, the chain of conscience and consciousness is interrupted.

Central Park in winter, New York, 1992

© Bruce Davidson/ Magnum Photos

BORN IN 1933, Bruce Davidson started taking pictures at an early age. In 1957 he began working as a freelance photographer for *Life* magazine, and two years later he became a full member of Magnum. He has reported on the Civil Rights Movement in America and documented daily life in a housing block in New York's East Harlem – the famous series 'East 100th Street' which was exhibited at MoMA in 1970. Other projects have focused on the New York subway (1980) and New York's Central Park (1991–95). His book *Brooklyn Gang* features the work he shot in 1959 on young members of the Brooklyn gang called 'The Jokers'. He currently lives in New York.

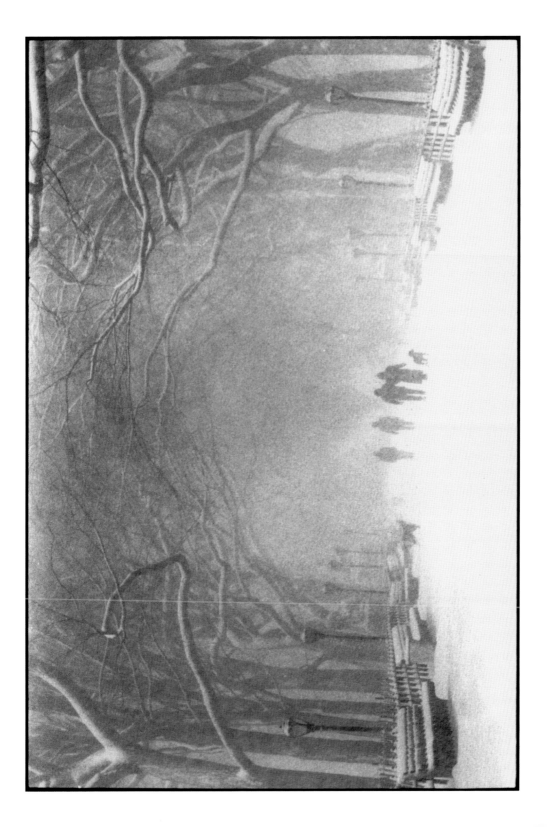

FRANCO FONTANA

All is still in the city. A window is open but no one leans out to detract from the colour, and the red of the car becomes a magnet to attract our gaze. Franco Fontana was just beginning his astonishing artistic study of colour, in which he invented not just a style but a whole way of seeing. Here, he is looking at Prague from above. The city before him is silent, staying true to the imagination that wants it to be magical and mysterious. Fontana's vision clothes it in soft chromatic tonalities, in delicate colours, so different from the bursts of light that will dazzle in future landscape images. Although the contrast of the lines dominates this composition, as always, it is colour that creates the atmosphere of a fairy-tale illustration. Fontana does not document places, but transforms them by seeking out shapes and geometries. His view becomes a vision, and the contemplation of reality is transformed into an original creation. An unexpected world appears organized into rigid visual structures, composed of lines of colour, and of constricted and precise framings. The simple and the basic are a construct, the result of conscious study. Whether the subject is a wall, shadow, apartment block, meadow, body or tree, it is recognizable when reduced to its fundamental shapes and becomes both real and invented, recognized and lost in the same moment. It is said of Fontana that he paints with colour, but his work does not compete with painting. He discovered and declared that creativity in photography is not limited to variations of black and white, and that the camera has its own particular system of signs that can be explored to liberate 'that power which', as he wrote, 'allows us to feel the man behind the camera and not a reproducer of images'.

Prague, 1967

© *Franco Fontana*

FRANCO FONTANA was born in Modena in 1933 and started to take photographs for pleasure in 1961. After a solo exhibition in Modena in 1968, he began actively to exhibit and study. His works are held in the world's major museums, and his most significant exhibitions include 'Tokyo' in the Metropolitan Museum of Photography in 1993, and those held in Scavi Scaligeri, Verona, in 2000, Palazzo Reale, Milan, in 2004, MEP in Paris and Museo de Arte in Buenos Aires in 2006. He has published more than sixty books, including a retrospective monograph in 2003. He received the XXVIII Ragno D'Oro UNESCO Award for Arts in 1984, and was awarded an honorary degree in eco-compatible design by Turin's Polytechnic in 2006.

CITIES

324

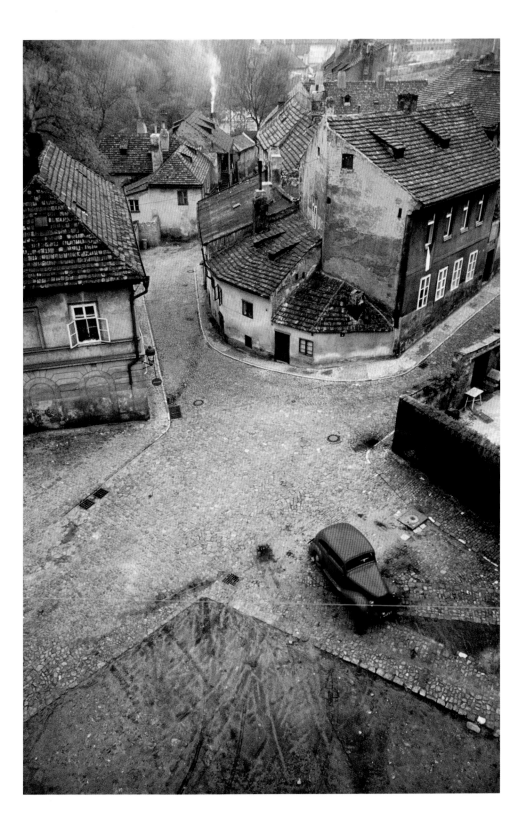

STUART FRANKLIN

Mexico City, a vast, urban sprawl plagued by negative records: it has one of the largest populations in the world, with over twenty million inhabitants; it is one of the world's most polluted cities, a natural pollution trap sitting 2,240 m (7,350 ft) above sea level; and, of course, it is one of the most dangerous cities in the world. Stuart Franklin is not frightened, but he is aware of the relationships of power between man and nature, and between man and his fellow creatures. Before taking this picture he had photographed the tragedy of the Sahel famine and the courage of a student in front of the tanks in Tiananmen Square (see pages 94–95): two faces of history. But here, in Mexico's capital, it is the monster city with its borderless, limitless anonymity that lays down the law, suggesting a unit of measurement for disaster. Once upon a time this valley gleamed with lakes and forests. The water in the mirror-like pools and drainage ponds was the first to go. Then the woods, along with their fallow deer, disappeared. And in their place came industry, freeways and dense urban areas. Franklin has chosen an aerial perspective to frame the disaster, a long landing strip running towards an imaginary and distant point where all the roads converge. It is daytime, and the harsh sunlight carves out the edge of every wall, every architectural variation, to reveal an irregular surface, somewhere between ageing skin and the rusting board of an old electric circuit. And yet the photograph is not closed off, it does not lose itself in this labyrinth of tiny, desperate variations, but leaves an opening for the imagination. There is still a strip of barren land, of desert, at the margin of the photo, cruelly suggesting that beyond this labyrinth there is only a void. You can never flee from here because you are already lost.

Mexico City, 1996

© *Stuart Franklin/
Magnum Photos*

BORN IN LONDON in 1956, Stuart Franklin studied photography at the West Surrey College of Art and Design, and geography at Oxford University. In the early 1980s he worked as a correspondent for the agency Sygma in Paris. He was invited to join Magnum in 1985 and has been a full member since 1990. His first important report documented the Sahel famine, but fame came to him in 1989 with his image of an unarmed Chinese student confronting the tanks in Tiananmen Square. Since 1990 he has produced numerous reports for *National Geographic*, from places as varied as Central America, China and Europe. Since 2004 he has concentrated on investigating the relationships between man and the environment. He has published several books, including *The Time of Trees* (1999), *The Dynamic City* (2003), *Tiananmen Square* (2005), *Sea Fever* (2005) and *Hotel Afrique* (2007).

CITIES

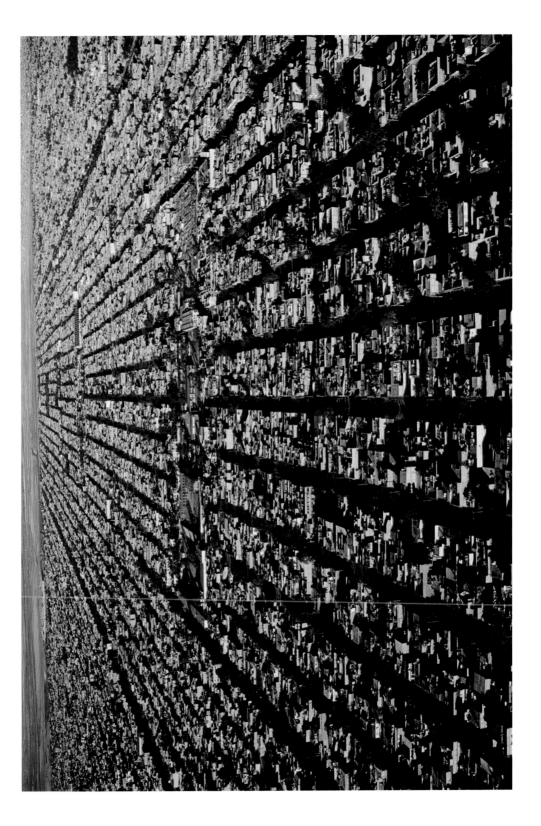

LEONARD FREED

Leonard Freed was still a young, inexperienced photographer when he met Edward Steichen in 1954. The pioneering photographer, who was in charge of the Museum of Modern Art's photographic department in New York, was struck by Freed's images and gave him some advice: not to let the purity of his vision become corrupted by the need for money. Rather than pursuing commercial work, he told him, he should keep photography for pure moments and 'preferably, be a truck driver' in order to make a living. Steichen's lesson did not go unheeded. All his life Freed was committed to maintaining a free and unsullied vision. 'Ultimately photography is about who you are. It's the seeking of truth in relation to yourself. And seeking truth becomes a habit.' Photography became Freed's instrument for exploring complex themes, from the American Civil Rights Movement to the world of the New York police, from racial discrimination to violence in society. It was also his opportunity to travel. He loved Rome and he loved Italy, and returned to the country many times in the course of his life. He loved images that were able to tell a story on their own, but which still preserved their ambiguity and never became propaganda. And he loved imperfect images, provided the imperfection was authentic. 'A good photograph', he said, 'must have the element of good design: everything within the photograph has to be essential. It's never like a painting where you can have it perfect. It shouldn't be absolutely perfect. That would kill it.' In the case of this image of the priests playing in the snow at St Peter's, Freed explained how he had attached a hood to protect his lens, but it wasn't quite right and had blacked out the four corners of the frame. Being authentic, the photo's imperfections did not upset Freed.

Vatican City, Rome, 1958

© Leonard Freed/
Magnum Photos

LEONARD FREED was born in 1929, in Brooklyn, New York, to a family of Jewish descent. He showed an interest in painting from an early age and took his first photos around the age of twenty while travelling in the Netherlands. In 1954 he returned to the United States and studied with Alexey Brodovitch. The head of MoMA's photography department, Edward Steichen, bought some of his photographs for his museum and proclaimed him one of the most promising young artists in America. Freed produced photo stories on the Jewish experience, the reconstruction of Germany after the Second World War, African-American communities and the New York police. He was a member of Magnum from 1972, and died in Garrison, New York, in 2006. In 2007 a large exhibition celebrating his work was held in the Musée de l'Elysée in Lausanne, accompanied by a retrospective catalogue.

MAURIZIO GALIMBERTI

A versatile and experimental artist, Maurizio Galimberti chose the Polaroid as his preferred instrument of personal expression at the start of the 1980s. He studied rhythm and movement in avant-garde styles such as Bauhaus, Cubism and Futurism, and created his own original and recognizable style, expanding the possibilities of the 'photographic mosaic'. Using single instantaneous photos as tiles in a more complex composition, the artist cuts up elements of the urban landscape and faces of film stars to create a series of details, which he then joins up, allowing them to multiply but never to repeat each other exactly. 'Palace with horse in motion' is part of the work 'Metacittàfisica', in which Galimberti fractures the modern architecture of buildings from various cities by adopting different shooting angles. Multiplicity and fragmentation are highly suitable formal and linguistic elements for describing the complexity of the urban landscape in the twentieth century. Here, the Palazzo della Civiltà del Lavoro, one of the symbols of the EUR district of Rome, is not depicted in a single view but from different perspectives, which are then combined in a strictly rhythmic composition. The result is a harmonious, almost mathematical image in which rhythm and movement combine to provide an unexpected three-dimensionality of great expressive power.

Palace with horse in motion, Rome, 2005

© Maurizio Galimberti

CITIES

MAURIZIO GALIMBERTI was born in the Como region of Italy in 1956 and is an artist of international renown. He began by using a Widelux camera, which he later replaced with a Polaroid, becoming the principal figure in the Polaroid Pro Art movement. Above all, Galimberti is known for his 'mosaic' portraits and landscapes. In 2007 he published *New York Polaroid…* and *METAMORFOSI*. He has received numerous prizes and awards in the photographic and artistic field. His work is included in the most important artistic collections in museums around the world.

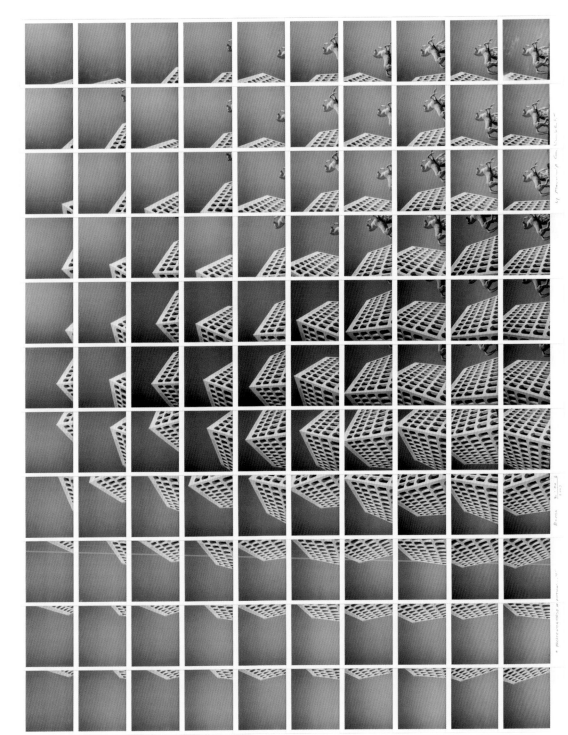

LUIGI GHIRRI

When anyone asked him about the nature of photography, Luigi Ghirri would often respond by quoting Giordano Bruno: 'Images are enigmas which are solved by the heart.' It all started with a family album and an atlas, and the wonder in a child's eyes as he leafed through their pages. Like a small, private, secular bible and a large public bible, 'these two books, so very different, and seemingly so banal, contained two categories of the world and showed it as I understood it. There was the domestic sphere and the world outside, my place and my history, and the places and the history of the world.' This recollection led Ghirri to the challenge of constructing a personal atlas, of creating a synthesis of the two 'bibles' that had once so enchanted him. This work forced the artist to pinpoint his own interior world through the outside world. There is no dualism between these two, nor is there a fracture, or, if there is, photography is the instrument that can bring them together again. For Ghirri, this was never simply work, mere art, or just a technique: it was a great adventure in vision and thought, one that enabled him to construct images that provided new opportunities for perception. To do this, however, meant he had to rediscover the wonder in the gaze of that child who had once leafed through the two books so intently. His gaze dismisses nothing as insignificant, but is able to discover the possibility of a new vision when looking at a landscape, a colour or a moment in life. This is what makes his images so enigmatic and peaceful. Places and the landscape are once again inhabited by mystery and secrecy. It may be the delicate colouring of Versailles or a suburban scene but, just like Tom Thumb's pebbles, Ghirri's photographs become vital instruments for reorientating oneself in space and time.

Versailles, 1985

© *Luigi Ghirri*

LUIGI GHIRRI was born in Scandiano, Italy, in 1943, and studied and worked as a quantity surveyor until 1969, when he began to take photographs full time. He was one of the 'discoveries' of *Time Life Photography Year 1975*, and, in 1982, was presented by Photokina in Cologne as one of the most significant photographers of the twentieth century. He founded the publishing company Punto e Virgola (1978–80), and organized exhibitions such as 'Iconicittà' (1980) and 'Viaggio in Italia' (1984). His long study of landscape culminated at the end of the 1980s with two books: *Paesaggio italiano* and *Il profilo delle nuvole*. He died at Roncocesi in 1992. The monograph *Bello qui, non è vero?* was published in 2008.

SIMONA GHIZZONI

'Ich bin ein Berliner' – I am a Berliner: a declaration of belonging exclaimed in clipped tones by John F. Kennedy in front of the Schöneberg Town Hall in West Berlin on 26 June 1963. The American president had just arrived in the troubled city, so recently divided by the Berlin Wall, and his affirmation was intended to communicate a sense of nearness and friendship. A mutual feeling on the part of someone who, despite being from the other side of the Atlantic Ocean, nonetheless truly shared in the drama of a nation and, above all, of a city split by a long and infamous wall, which, like an open and running sore, would not heal for decades. More than forty-five years have passed since that moment but, even now that the wall has gone and Germany is reunited, Berlin is still a symbolic city, a place belonging to the past and the present. It is a point of reference, at least for all Europeans. The talented young Italian photographer, Simona Ghizzoni, has captured this pervasive atmosphere in her recent work and has succeeded in bearing witness to it with perfect colouring and feeling. This is the deep heart of a Europe which knows that after being wounded you have to begin again: Berlin today is live-lier and more artistically exciting than almost any other capital city. But it is still scarred and its walls, just like its 'air' so full of images and voices, remind us that modernity does not just mean futuristic buildings and the latest generation of computer; it is also about having a difficult history, unresolved disputes, unpleasant memories, remnants of the past that, for better or worse, continue to disturb our dreams of progress.

Tacheles, historic art centre in the Mitte district of Berlin, 2008

© Simona Ghizzoni/ Contrasto

SIMONA GHIZZONI was born in Reggio Emilia in 1977. In 2002 she was awarded a diploma by the Istituto Superiore di Arti Visive e Fotografia in Padua, and subsequently gained an MA in the history of photography from the University of Bologna in 2007. She works with numerous photographers and as a production assistant at the Toscana Photographic Workshop. She concentrates exclusively on social photojournalism, above all on the conditions of women. In 2006 she was selected for a Reflexions Masterclass. In the same year, she tied for first prize at the FNAC photo contest with 'Scars', an essay on Sarajevo. Her photo story 'Anorexia', from an investigation into problems related to eating disorders, won her third prize in the portrait category of the 2008 World Press Photo Awards. Ghizzoni has been represented by Contrasto since 2007.

THOMAS HOEPKER

Thomas Hoepker has always maintained that: 'I am not an artist; I am an image maker.' His professional career has been long, varied and coherent. Few other photographers have been able to work with anything like his continuity and variety: he has combined the art of reportage with work for illustrated magazines, and harmonized his expectations as a photojournalist with the demands imposed by the press. His vision is nourished by a profound respect for life and humanity, and by an unbounded desire for knowledge. 'Photojournalism is all about being curious, and going out and seeing what happens. I always enjoy that first morning when you're in a country you've never been to before. It's a moment of discovery and it's very exciting. You're curious and you've no idea what may happen.' At the start, believes Hoepker, it's good to be wide-eyed, naive and, quite simply, just go. But after taking photographs for a while, perhaps having read a lot about a subject, that's when a photographer realizes how much he's missed. In this photo, the repetition of the shapes, of the bold lines in the foreground set against the light, and of those barely delineated silhouettes in the distance, immersed in haze, draws the evocative Manhattan skyline in which the Twin Towers still stand. Some twenty years later, on 11 September 2001, the same Thomas Hoepker took a photograph of Manhattan at the precise moment at which its profile was changed forever as the towers collapsed.

View of the Manhattan skyline from Queens, New York City, 1983

© Thomas Hoepker/ Magnum Photos

CITIES

THOMAS HOEPKER was born in Germany in 1936, and studied art history and archaeology before starting to work as a photographer, compiling reports from all over the world. In 1964 he began a long association with *Stern* magazine and, in the same year, Magnum began to distribute his archive photographs. In 1972 he worked as a cameraman and producer for a series of documentary films for German television. Together with his ex-wife Eva Windmöller, a journalist, he completed a long and detailed photo story on East Germany. He then moved to New York as the correspondent for *Stern* in 1976, and from 1978 to 1981 he was photo editor of the American edition of *GEO* magazine. From 1987 to 1989 he worked as *Stern*'s art director in Hamburg. He joined Magnum in 1989.

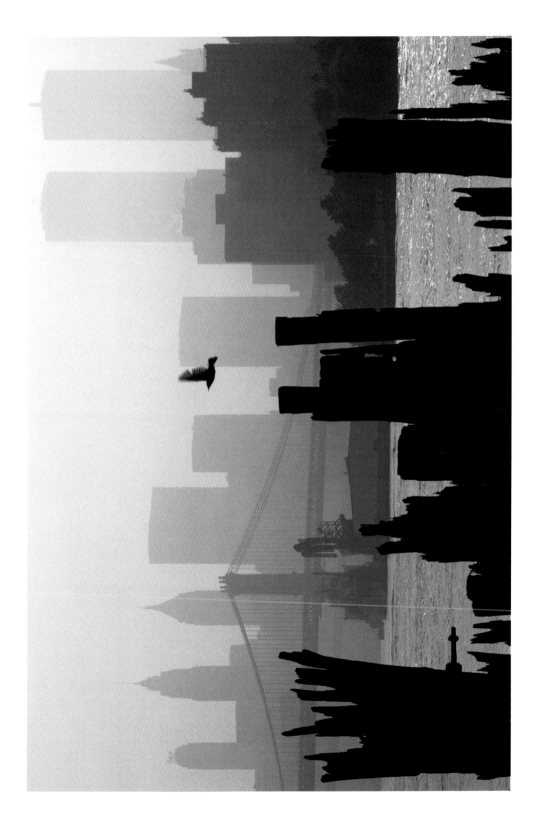

KENNETH JARECKE

All the horror in the world; all the purity in the world. Kenneth Jarecke is a reportage photographer who seeks out the story, who knows all too well the extreme outcomes of its emotional power, and how his own work plays on the shifting balance between these two extremes. He leapt onto the front pages of newspapers in 1991 with a photograph from the first Gulf War. The image, taken between Nasiriya and Basra, shows a completely charred Iraqi soldier, his body leaning on the front window of a destroyed truck. The portrait of the incinerated soldier went around the world, inevitably accompanied by a storm of accusations of sheer sensationalism. 'If I don't make pictures like this,' was the photographer's simple reply, 'people like my mother will think what they see in war is what they see in movies.' Thus, the realization emerges that you must be silent about nothing and you must show everything, a maxim true for both the photographer and the viewer. Years later, in an exhibition for Amnesty International, Jarecke showed this image: a child running under the beams of a pier on the beach on Coney Island. The light filtering through the boards and the child's joy, the mystery of a game of which only he knows the rules, these things also become ours. We don't see his face or the enthusiasm that inspires him, whatever discovery it is that excites him, all that remains a secret that must be preserved and respected. This is a moment to breathe; it is a gulp of fresh air, a discreetly captured delight. The distance between terror and joy is vast, but it is the same eye that observes and records them both, and knows what is right to show and understand, knows what it means to bear witness to horror, but also to tell stories about hope.

Coney Island, New York City

© Kenneth Jarecke/ Contact Press Images/ Grazia Neri

KENNETH JARECKE was born in the United States in 1963. He established himself as a photojournalist during the years of Ronald Reagan's presidency (1980–88), and in 1986 was one of the founding members of Contact Press Images. He followed the student demonstrations in Tiananmen Square in China in 1989; in the same year he worked as a staff photographer with the editorial office of US News & World Report, producing various significant reports on AIDS in Africa, the unrest in Afghanistan, and the famine in Ethiopia. In 1991 he published *Just Another War*, a diary from the Gulf War. He now lives in Montana.

CITIES

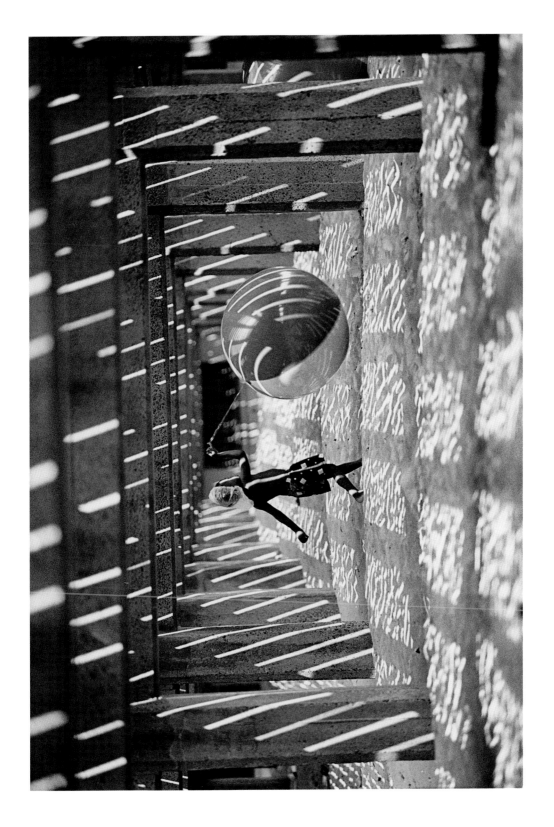

WILLIAM KLEIN

The eleventh of November is a holiday, the day when France commemorates the end of the First World War. This is also 1968, the year of revolution, just a few months after the student uprisings. Paris has stopped to remember the date and its history; people are in the street, at windows, even perched on the ledges of apartment blocks. William Klein, then forty years old and an American living in Paris, walks through the crowd, his favourite subject. With his controversial book on New York he had successfully entered into the craziness, chaos and vulgarity of an undefined mass of humanity, presenting it to us just as it is, without any of the geometric humanism so beloved of most French photographers. This image is perhaps an exception to Klein's more eccentric, experimental shots because of its compositional and molecular structure and his choice of course-textured graining. The image stays firmly, intrusively, in the foreground, and the black and white seems taut, extreme. It remains a complex reading of a society and its stratification, the student couple in the foreground juxtaposed against an elegant middle-class couple diagonally behind them, the woman with a cigarette in her hand, perhaps confiding a secret, or maybe just giving a kiss. And then there is the man hurrying past, so correct in his flat-collared raincoat that he seems to be without any masculine vanity. Finally, in the distance, are the faces of people with so many memories, some of whom remember that year, 1918, because they lived through it. By bringing all these elements together in the click of the shutter, Klein creates the portrait of an era and of a nation. To find a photographic equivalent we must return to Paris again, to the end of another war, the Second World War, when it was Robert Capa who photographed the celebrating crowd. But twenty years on, when the tragedy is far away in Vietnam, it is no longer possible to truly celebrate the end.

Paris, 11 November 1968

© William Klein

CITIES

WILLIAM KLEIN was born in New York in 1928 to a Jewish family of Hungarian descent. From the age of eighteen, he spent two years in the US Army, stationed in Europe, and then settled in Paris to become a painter. In 1954 he returned to New York and worked on a photographic diary, which was published two years later in a book designed by the artist himself, *Life is Good & Good for You in New York*, and which won him the Prix Nadar. He went to Rome to be an assistant to Federico Fellini, and at the end of the 1950s he became more involved with cinema, concentrating on it exclusively and making several films. In the 1980s Klein returned to photography and published numerous books. His work is shown all over the world, and he has received countless prizes and awards.

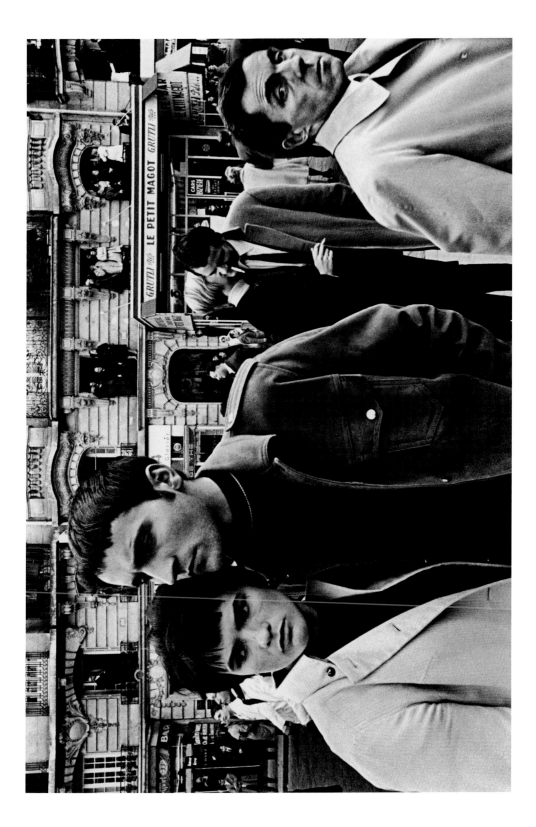

SERGIO LARRAIN

You are beloved because you are insane. You are beloved because you are gloriously unkempt and naked, 'because you never had time to get dressed and because life always takes you by surprise'. This is how Pablo Neruda, the great Chilean poet, described his city of adoption, Valparaíso – the valley of paradise. The city is the last major stop before the Magellan Straits, the last call for ships leaving the Pacific Ocean and entering the Atlantic. At the beginning of the 1960s, on behalf of the famous Swiss magazine *Du*, Sergio Larrain walked with Neruda through this little human paradise, one that is all too human, but still beautiful enough to be declared a UNESCO World Heritage Site. Neruda and Larrain's text and images were published in 1965, but the air in the streets seems so much older as conveyed to us by the photographer and the poet, who play interchangeable roles – the poet-photographer and the photographer-poet. It is as if time idles by here. Time has nothing to do in this place; it can only slip by slowly, as sleepy as the dogs in the streets, dawdling and daydreaming like a child, maybe waiting for a ship to arrive or depart. With few certainties and little money, it is a piratical time, and Larrain was one of its greatest interpreters. As he walked the streets of the port, he got to know every face, every dance step, every human and animal smell. And, in many of his images, he even adopted the point of view of dogs and cats, because it was the most authentic and the most free. He took pictures during the day in the sunshine, and of the port at night, where, in 1578, the privateer Francis Drake had arrived and sacked the city, when, once again, Valparaíso had not 'had time to get dressed'.

Valparaíso, Chile, 1963

© Sergio Larrain/
Magnum Photos

SERGIO LARRAIN was born in Santiago, Chile, in 1931. He studied music before taking up photography in 1949. After university, where he studied agronomy, he travelled in Europe and the Middle East, working as a freelance photographer. He joined the staff of the Brazilian magazine *O Cruzeiro* and, in 1956, MoMA in New York bought some of his photographs. In 1958, with a study grant from the British Council, he began a photographic essay on London (the book was published in London, Paris and Rome in 1998). Henri Cartier-Bresson invited him to join Magnum in 1959, and two years later he returned to Chile on an invitation from Pablo Neruda. He met the Bolivian guru Oscar Ichazo in 1968 and started to study oriental culture and mysticism, since when he has lived apart from the world in accordance with these ideals.

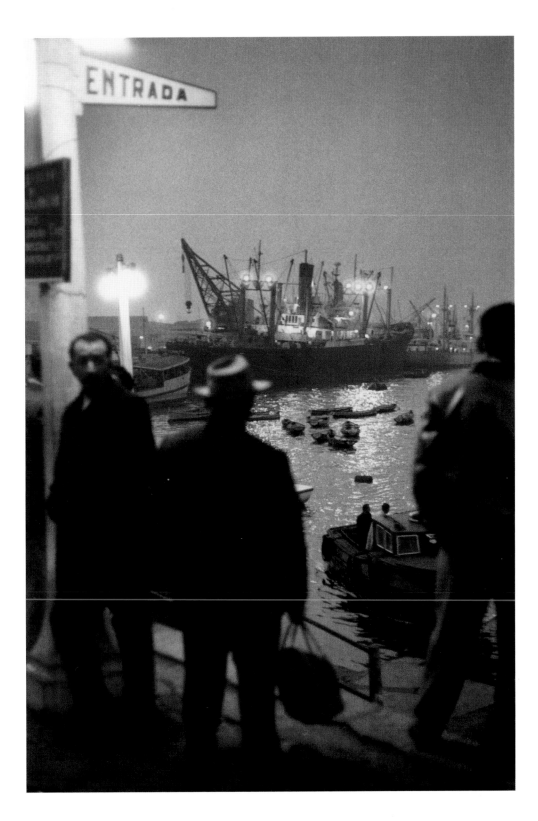

ROBERT POLIDORI

As a reporter for the *New Yorker*, Robert Polidori has travelled the world documenting contemporary and ancient architectural glories. He is interested in the relationships between people's everyday lives and architecture, how culture changes the building style, and he dwells on the effects of the passage of time on structures, attempting to capture and restore the sense of decay and abandonment. People are strikingly absent in many of his works, as are any evident traces of their former presence. Polidori photographed Havana at the end of the 1990s, and the lens of his panoramic camera shows us a captivating and melancholy city: a place of pastel colours, peeling stucco and decaying Baroque architecture. The crumbling apartment blocks in the old colonial quarters stand out against skies of vivid tropical colours. Polidori looks below the surface and tries to bring out the contrast between the mouldering of the city and the existing traces of its former magnificence. The artist captures a phantasmal, mysterious city which, semi-abandoned in its decline, continues to cling onto life. These are intense images of a unique place in which squalor and splendour are contrasted with one another and sometimes overlap in a present drenched with the past.

Building façades on the Malecón, Havana

© *Robert Polidori/GM*

CITIES

ROBERT POLIDORI was born in Montreal, Canada, in 1951, and now lives in New York. He concentrates on studying architecture and the urban landscape, and has carried out work on shelled apartment blocks in Beirut, abandoned houses in New York, dusty disordered rooms in the Palace of Versailles, the crumbling streets of Havana, the contaminated cities of Chernobyl and Pripyat, and, recently, the aftermath of Hurricane Katrina in the city of New Orleans. He has received numerous prizes and his work has been exhibited in the world's major cities. He regularly works with the *New Yorker*.

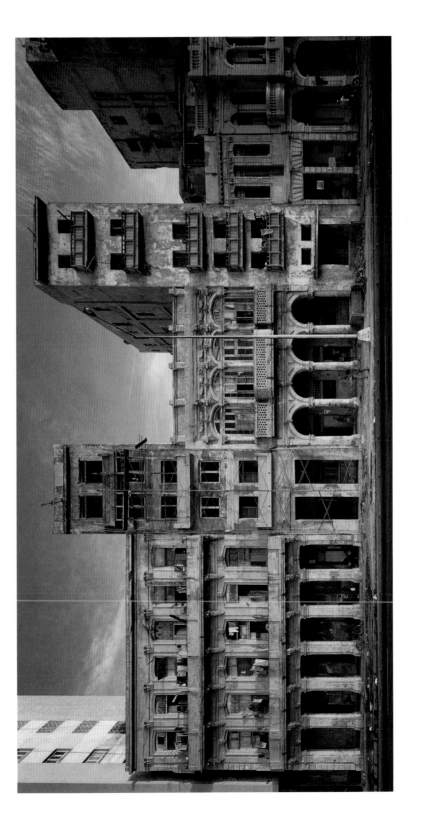

EUGENE RICHARDS

He says he is shy, and this is why he gets so close to his subjects, almost near enough to touch them. He says he loves complexity and instability, and this is why he prefers wide angles; it is as if he sees with his arms outstretched, wholeheartedly and generously. Eugene Richards brings us a lesson in commitment and democracy, in denunciation and solidarity. It starts with the title of his book, *Americans We* (1994), from which this famous image is taken, snapped at the foot of the Manhattan Bridge in the sweltering summer of 1993. 'We' – in all its meaning – was this artist's philosophy, a philosophy that had almost religious significance at the time for a new generation of photographers. First person plural, no one is excluded. From the very beginning of his career Richards has dedicated himself to society and to those who live at the edges of the community, bereft of their quiet comforts. Thus one chapter follows another, each one more tragic than the last, each exploring one of the many faces of desperation. When Richards looks at drugs in neighbourhoods already abandoned by the law, his subject is not just physical torment but also urban torment. When his subject is breast cancer, this time it is Dorothea Lynch, his wife and co-author of the book *Exploding into Life* (1986), who asks him to accompany her visually on her journey. Or his subject might be violence, a new drug, prostitution, or murder, such as the story of an Irish policeman, Tommy Clarke, who witnessed the death of his colleagues. Finally, it might simply, tragically, be the end of a life, such as the death of Richards's own mother. We see a lone man – Richards's father – a house deserted for a move to Florida, a couple's possessions packed up, the wait for the truck, and then it is goodbye. And, thanks to the photographer's unlimited honesty, we are also there, looking on and sharing the emotion.

Brooklyn, 1993

© *Eugene Richards/VII*

EUGENE RICHARDS was born in Dorchester, Massachusetts. He graduated in English literature and journalism, and studied photography at MIT under the supervision of Minor White. He was invited to join Magnum because of his first two books, *Few Comforts or Surprises: The Arkansas Delta* (1973) and *Dorchester Days* (1978). He left the organization in 1995, returning in 2002, only to leave for good in 2005; he was also a member of the VII Photo Agency. Richards won the W. Eugene Smith Memorial Award in 1981. He is known for the powerful themes of his work, and has focused on pain, from cancer to drugs, poverty to health emergencies, AIDS to psychiatric hospitals. His books include *Cocaine True, Cocaine Blue* (1994), *Stepping through the Ashes* (2002) and *The Fat Baby* (2004).

CITIES

346

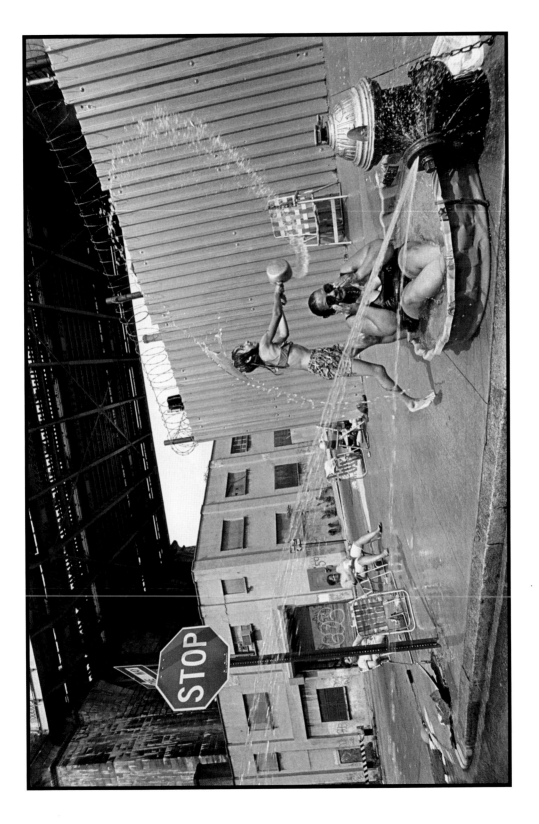

MARCO ZANTA

It is a simple question: how far should the sun's rays be allowed to penetrate our skin and mark, age or simply become part of the historic cycle of our faces, our lives, our surroundings? In an attempt to answer this question, the cultured and highly sophisticated architectural photographer, Marco Zanta, offers us an alternative, a 'space in the middle' that includes us, and where architecture becomes primarily a discussion about man and his relationship with the world, and with that strange phenomenon that is the measure or mis-measure of man: the city. Here, two buildings are contrasted in the centre of Birmingham, in the heart of England. They may be far apart in age but they have been juxtaposed deliberately: St Martin's Church dates from the thirteenth century and was reconstructed in 1875, and the famous Selfridges building is a shopping centre opened in 2003, designed by the architectural practice Future Systems. The bodies of the two buildings are almost touching, their surfaces communicate with one another, telling stories – about themselves and about us. One is made of brick and absorbs the light, highlighting every neogothic relief and every mark caused by the passage of time. The other is a gentle wave, smooth-faced for centuries to come, almost like a synthetic skin that will never change. In the middle, uniting these two extremes, and making a shadowless, model-like atmosphere vibrate, is the moving presence of some passers-by. Theirs is a little history, nothing more than the flutter of a butterfly in the long exposure time. But, Zanta seems to say, it is up to them, or rather up to us, to choose which skin to live with.

Birmingham, 2004

© *Marco Zanta*

BERND AND HILLA BECHER

Bernd and Hilla Becher's work is a survey, an anthology, an inventory. It belongs to the archiving tradition, like the one to which photographers such as August Sander and Eugène Atget belonged. From 1959 the Bechers travelled the industrialized world taking photographs of disused factories, rusty machinery, mineral deposits, gasometers, water silos and cooling towers, creating an inventory of industrial objects. They married in 1961 and as photographers shared a common purpose. Hilla Becher tells how it was difficult in the beginning. In the early 1960s there was still a strong feeling of post-war trauma in Germany and there were times when someone would call the police, suspecting them of being spies. People thought they were identifying targets for a military attack, 'because why else would someone want to photograph mining towers?' The Bechers were looking for relics of the glorious industrial age, with a backdrop of changed urban and social landscapes. To begin with they concentrated on the Ruhr area, later travelling in Holland, Belgium, France, England and the United States. They always used the same method and the same technique. They took the photographs early in the morning, generally with a grey sky to eliminate shadows and to give a homogeneous light. They placed the subject in the centre, alone in the frame. No person, animal or breath of wind disturbs the neutrality of the composition. They are 'Anonymous Sculptures' (as one of their first collections of pictures was entitled), often displayed side by side in grids to encourage comparisons between the photographs. The impersonal and involuntary aesthetic of these industrial buildings is released by the removal of any subjectivity from the picture. But photography is never neutral or indifferent: the buildings seem to emerge from a dimension outside time, bringing a repressed emotion, a humble and silent respect for the subjects and their own past.

Blast Furnaces, 1963–95

© Bernd and Hilla Becher/Kunstsammlung Nordrhein-Westfalen, Düsseldorf

ART

BERND BECHER was born in Siegen, Germany, in 1931, and Hilla Wobeser was born in Potsdam, Germany, in 1934. Bernd studied painting and lithography at the Stuttgart Academy of Fine Arts (1953–56) and typography at the Düsseldorf Academy of Fine Arts (1956–61), where he met Hilla who was taking the painting course. They married in 1961 but from 1959 they photographed together, systematically documenting industrial buildings. Initially they concentrated on the industrial area of Siegen and the Ruhr; later they went abroad. Bernd taught at the Düsseldorf Academy from 1976 to 1996. In 2004 the Bechers won the Hasselblad Award. They had many solo and joint exhibitions of their work in galleries and museums throughout the world. Bernd died in 2007.

GUY BOURDIN

Guy Bourdin's photographs come to life in the tragic darkness of a black-painted studio. He was the master of fashion photography, of glamour charged with colour and eroticism. He used black to reject the sun and the light, possibly banal, part of day. A friend of Man Ray, he used black to rediscover the roots of Surrealism, the photographer's favourite movement. And he used black – *noir*, which sounds so evocative in French – because it is the colour of crime and of passion, indeed of the violence of all passions. Bourdin was the first photographer, with his unprecedented skill and boldness, to combine the beauty of a garment or a pair of shoes, as in his historic campaigns for Charles Jourdan, with the aesthetics and chronicling of murder. Never have models fallen victim to mysterious assassins as in the work of this extraordinary photographer and painter – he who depicted a pair of legs, crushed by Pop-sized objects or cut into pieces by a razor-sharp imagination, crossing a Parisian street. But above all is his desire to provoke – to play with revolution – a magician's trick. Nobody can say what has happened within this photo, maybe in a hotel bedroom or on a film set. What is certain is that Bourdin, who photographed for French *Vogue* for twenty years, has reached the scene of the crime quickly. Coming from the lips, leaving the one-night stand devoid of all desire, is a sea of red paint, dense and still warm. And the magic of the photograph, in its elegance and originality, is that it is not only beautiful, but also incredibly sexy and even fun. A moment later and the model will get up and everyone will clap. Yet another moment later and the photographer will go back and immerse himself in the vital darkness of his imagination.

Pentax Calendar, 1980

© Guy Bourdin Estate

GUY LOUIS BANARÈS was born in Paris in 1928. When he was a year old, he was adopted by Maurice Désiré Bourdin. During his military service in the aeronautics industry, he began to take photographs. In 1952 he exhibited at Galerie 29 in Paris (the catalogue foreword was written by Man Ray). From 1955 Bourdin published his photos in French *Vogue*. His collaborative ventures grew with *Harper's Bazaar*, Italian *Vogue* and British *Vogue*, followed by campaigns for Issey Miyake, Bloomingdale's, Versace and Claude Montana. In 1985 he refused the Grand Prix National de la Photographie, offered by the French ministry of culture, because he considered it to be 'totally pointless'. Three years later he accepted the Infinity prize, presented by Annie Leibovitz, from the International Center of Photography in New York. He died in 1991.

ART

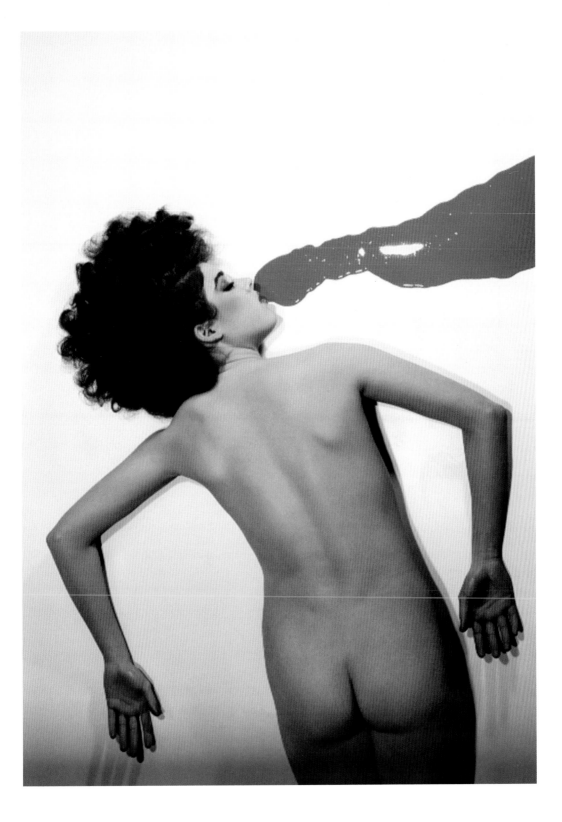

BILL BRANDT

In one of the most innovative photographs of all time, the seascape becomes the subject. With a wide-angle lens, which Bill Brandt first mounted on an old wooden camera belonging to the British police, and then on a modern Hasselblad, he worked on his post-Second World War productions relating the front of the foreground to the background, and allowing each portion of the frame to be perfectly clear and comprehensible. Here the close-up of an ear becomes an integral part of the panorama. The resemblance between the dark shape of its cavity and the indentation in the rock, which continues the line of the horizon, completes the fusion between human and natural landscape, suggesting to the observer unusual references and new meanings. On the south coast of England, Brandt placed his camera close to the ground, choosing to capture the scene from an unusual point of view, as he did for other photographs published in 1961 in a book of his work entitled *Perspective of Nudes*. Guided by Orson Welles's lesson in *Citizen Kane*, where the height and orientation of the cine-camera assume a precise semantic value, Brandt reaches the heightened outcomes required by the aesthetics of metaphysics and surrealism by pushing himself to the limits of abstraction. Balthus- and Magritte-like atmospheres are mixed with Henry Moore's sinuous shapes and the memory of André Kertész's distortions, all under a dramatic sky and in a theatrical light, which reveals the disturbing union between the organic and the inorganic.

Nude, East Sussex, 1957

© *Bill Brandt Archive*

ART

BILL BRANDT was born in 1904 in Hamburg. After the end of the First World War he lived in Vienna, where he developed an interest in photography working as an assistant in a portraitist's studio. While he was there he met Ezra Pound before spending a few months in Paris alongside Man Ray. In 1931 he settled in London, where he began a complex work analysing British social life between the wars. In 1936 he published *The English at Home* and in 1938 *A Night in London*. During the Second World War he continued to document daily life in London, and in 1940 the government authorities asked him to cover the German blitz of the city. His work also included portraits, nudes and landscapes. Brandt died in London in 1983.

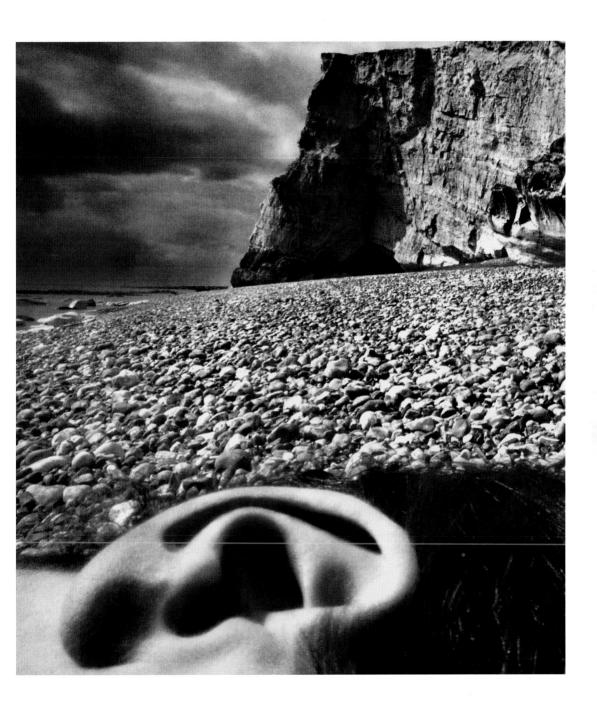

LEWIS CARROLL

When Lewis Carroll bought his photographic equipment in 1856, he was twenty-four years old and photography was in its infancy. This image-generating machine must have seemed like a 'box of wonders' to him. A mathematical genius, a writer and a poet, he was able to work freely through photography without being confined by the austerity of British philosophy and religion. Carroll had a 'childish' imagination and was capable of candidly observing life, bearing the absurdities and inconsistencies of adulthood. A strange and gifted character, he devoted himself to making portraits with the eye of a visionary pioneer. He mainly photographed young girls but, rather than portraying them as well-brought-up young ladies, he kicked against heavy Victorian symbolism and made them free spirits of the woods, with the grace of an age of innocence. Ten-year-old Alice Liddell poses, pouting, dressed as a little beggar girl. Her name was to become known and this picture was to become famous. It is considered by some to be the most beautiful photograph of a child ever taken, by others a 'profanation of childhood'. Morality judged Carroll and found him guilty, but he kept his distance from it. On a sunny July morning, during a boat trip, the young Alice asked him to tell her a story, and he outlined a fantastic tale that was to become one of the most famous books in English literature. *Alice's Adventures in Wonderland* does not teach any moral lessons but only the wonder of imagination, a sense of humour and a taste for paradox. It teaches the importance of a renewed and genuine wonder about life. Marguerite Duras said: 'The world's masterpieces should be discovered by children on waste grounds and be read in secret, unbeknownst to parents and teachers.' Lewis Carroll would surely have agreed with those sentiments.

Portrait of Alice Liddell, c. 1862

© *Bettmann/Corbis*

ART

CHARLES LUTWIDGE DODGSON, who used the pseudonym Lewis Carroll, was born in 1832 in Daresbury, Cheshire. He studied at Rugby School and at Christ Church, Oxford, where he stayed until 1881 as a lecturer in pure mathematics, a subject to which he devoted many treatises. In 1856 he became interested in photography. He was ordained a priest at Christ Church, Oxford, in 1862. In 1865 he published the renowned *Alice's Adventures in Wonderland* and in 1871 the sequel, *Through the Looking-Glass*. He continued to write novels and epic poems, and also published a series of treatises on logic. He died of bronchitis in 1898 in Guildford, Surrey. A major prize in children's literature was dedicated to him: the Lewis Carroll Shelf Award.

LOUIS-JACQUES-MANDÉ DAGUERRE

The view here is from a window looking down upon a world whose exist-
ence could now be explored and recorded 'photographically'. Joseph
Nicéphore Niépce had already looked out of the window of his studio and
recorded the same view. Not long afterwards William Henry Fox Talbot,
the inventor of the negative–positive process, would do the same with his
'Boulevard des Capucines'. Louis-Jacques-Mandé Daguerre's father had
wanted him to be a post office clerk but, a resourceful man of the world, he
chose to become a painter, a set designer and an inventor. The lighting and
movement effects of his Diorama had already captivated Paris in the 1820s.
His studies of painting, perspective and optics led to his interest in fixing
pictures using the sun. In 1829 he and Niépce became partners, the latter
'bestowed his invention on society, and Daguerre brought a new assembly
to it with the camera obscura'. A year later Daguerre had a stroke of luck. He
accidentally left a spoon on an iodized silver plate and realized that a clear
image of the spoon had remained on the plate. It was an important discov-
ery: silver iodide is sensitive to light. In 1833 Niépce died poor and his work
unrecognized. Daguerre continued his experiments and discovered that
mercury has the property of revealing and fixing an image. He placed his
camera obscura on the window, adjusting the lenses towards the Boulevard
du Temple below. He wanted to produce a detailed image that would be
considered the symbol of the birth of a new and revolutionary art. It was
indeed the precision of the lines and detail that amazed the first people
who saw it. The exposure time was long, so moving subjects did not remain,
making the usually crowded street seem deserted. Only one shape can be
glimpsed – someone at the edge of the street having his boots cleaned. He
stood still, one leg raised, for long enough to become the first man in history
to be photographed.

*Boulevard du Temple,
Paris, 1838*

© *Louis-Jacques-Mandé
Daguerre/Bayerisches
Nationalmuseum, Munich*

LOUIS-JACQUES-MANDÉ DAGUERRE was born in France in 1787. He began
his career as a painter specializing in stage decoration. In 1822, with Charles Bouton,
he created the Diorama, a type of theatre with special light effects. Meanwhile,
he devoted himself to the camera obscura, and at the end of 1829 signed a contract
with Joseph Nicéphore Niépce which lasted until Niépce's death in 1833. In
1839, following many experiments and methodological developments, Daguerre
announced the invention of the daguerreotype, the historic basis of photography.
In the same year he marketed the invention, the machines and products, leaving
others to develop his work. He retired to Bry-sur-Marne and lived there until his
death in 1855.

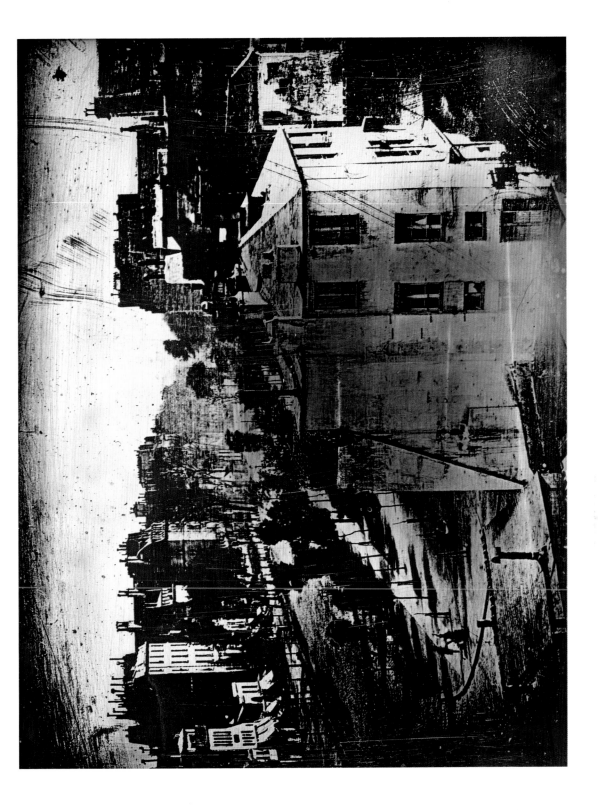

MARIO GIACOMELLI

Mario Giacomelli had been visiting the diocesan seminary in Senigallia for a year (he always spent long periods of time in the locations he photographed). In the seminary he was 'attracted by the black, the humble people and the long cassocks', and was motivated and stimulated by a poem by Father David Maria Turoldo entitled 'There are no hands to caress my face'. These words must have aroused a profound feeling of piety and human compassion in him. 'When I look at the seminarists, the waiting rooms ... I remember the father who looks at his son and cries, and I cried too ... maybe it is because it reminds me of my sister in the orphanage.' On a snowy day, Giacomelli increased the exposure time of this photograph because he wanted slowness and a lack of focus, constructing a white that, burned by the flash, invades and consumes the space. The photo was taken from an unusual angle, making the priests appear to skip and float on a sea of whiteness. The contrast between the white and black is the essence of a picture suspended between lightness and melancholy. The young men playing in a surreal place, with no boundaries and no reference points, disturb the seriousness of the bearing that we associate with priests' clothing. But, softened by the game, these figures express a profound feeling of solitude. Giacomelli explored this condition and this feeling with the same intensity with which he recounted the poetry of existence, the power of love and piety, the anguish of passing time and the nostalgia of memory. He moulded photography to his vision, discovering the latent possibilities of disturbing the usual way of looking at things. For him each individual photo was not important, but rather the series or the story. He developed the print, and removed and added reality to the imaginary – or the imaginary to reality. 'My need is to create a form to express what grows in my mind.'

From the series 'There are No Hands to Caress my Face', Senigallia, Italy, 1962–63

© Mario Giacomelli Estate

MARIO GIACOMELLI was born in Senigallia in Italy in 1925 and started working for a printer at the age of thirteen. In 1952 he bought a camera and took his first picture, 'The Landing'. From then on, a non-professional photographer by choice, he devoted himself to creating his intense photographic series: life in an old people's home, landscapes, in particular of Scanno, and country life. In 1953 he joined the Misa photography group and in 1956 the Bussola group. From 1955 he began to be recognized and to exhibit in Italy and abroad. His works are part of public and private collections across the world. He died in Senigallia in 2000. In 2001 his work was brought together in a large retrospective held at the Palazzo delle Esposizioni in Rome, accompanied by a book.

PAOLO GIOLI

'My work would like to be a re-examination of the history of photography and it is pure chance that the material I work with is sensitive.' For Paolo Gioli the material comes before anything else: his research begins at that point and develops from that point. And it is to the material that he returns after creative metamorphoses and transformations. Gioli began as a painter, but abandoned painting in 1975 to devote himself fully to film and photography. But nothing is lost and not all is abandoned: the influence of painting provides models for new styles and languages, and it suggests new techniques. Since 1969 Gioli has used pinhole cameras, bringing the mechanical image back to its most essential historical and philosophical roots; he has also used a camera obscura and the photo-finish technique. In 1977 he started using Polaroid film to produce a simultaneous image, in a moment of real time with 'the speed of a pencil'. 'What interests me enormously is the impressive capacity of light-sensitive material to manipulate and create imaginary representations, through whatever it touches.' Gioli experimented with Polaroid film over a number of years. After obtaining the image on the film, he fixes it by pressing with a roller on various, more noble materials such as drawing paper, silk or wood. He works on the body. 'Personally, I believe strongly in two great themes in the history of art and photography: portraits and nudes.' The material is transformed and it transforms the image. In such works as the one shown here, there is a sense of painting, a happy coexistence with photography. The iconography is inspired by the classical forms of Western art. The torso is statuary, but the classic immobility is disturbed, marked with lighting which reveals and hides. The black eats up part of the image, and the body emerges from it crossed by rays of burning light.

Male Torso, 2007

© Paolo Gioli

ART

PAOLO GIOLI was born at Sarzano di Rovigo in Italy in 1942. In the second half of the 1960s he studied painting, and lived and worked in Venice and New York. Between 1969 and 1975 he lived in Rome. He began to take an interest in lithography, cinema and photography using pinhole cameras. He presented his first films at the FilmStudio in Rome. In 1973 he started using the photo-finish technique, which he revisited creatively. From 1976 to 1981 he lived in Milan. He started working with Polaroid film and developed techniques to transfer the image onto different media. He has exhibited in solo and joint shows in countless private and public galleries, and in European and American museums. He now lives and works in Lendinara.

FRANCESCO JODICE

The Phi Phi Islands in Thailand are home to one of the most beautiful beaches in the world – in a place a long way from the West – invaded by mass tourism after it appeared in 2000 as the setting for the film *The Beach*, starring Leonardo DiCaprio. Francesco Jodice's photograph is part of the *What We Want* project, a complex survey of a constantly changing world, carried out over more than eight years across five continents. In this photograph we see ancient spurs of rock covered with vegetation, fine white sand, the crystalline ocean with people and motorboats invading the scene. This is the new social landscape. The photographer's eye observes what is in front of him with an almost scientific approach, and the protagonists themselves are caught in the act of contemplating with amazement the spectacle of nature. The view is configured like the first gesture of conquest. The social transformations reverberate in the changing physical space, crossed and exploited by thousands of tourists, ready to relive a scene from a film or to satisfy their desire for the exotic. Jodice combines perfectly his interests in anthropological photography and landscape photography. The photograph was taken in 2003: one year later the tsunami would make another violent change to this beach.

Phi Phi Ley, Thailand, 2003

© *Francesco Jodice*

FRANCESCO JODICE was born in Naples in 1967. In 1995 he started working with photography and video. He became an architect in 1996, and in 1998 took part in the work to transform the port in Naples. He started the *Secret Traces* project in various cities around the world. In 2000 he co-founded Multiplicity, an international collective of architects and artists. He has been a university lecturer since 2004, and has published articles and curated exhibitions on new trends in Italian photography. In 2007 he took part in the 'Global Cities' exhibition organized by Tate Modern in London with the film *São Paulo – Citytellers*. He currently lives and works in Milan.

MIMMO JODICE

These two young athletes seem to be on the point of moving, racing to the finishing line with their blazing ivory eyes. It is the moment before the start, a moment of concentration when the facial expression reveals the determination that will lead the athlete to victory. Where do these living statues, these athletes immobilized in the supreme moment of effort, come from? Maybe from dreams, from images generated by the subconscious. These visions emerge from the ashes of Vesuvius. Mimmo Jodice observes and takes a second look at his country. And he asks questions. His lens looks behind the fences, through torn curtains, behind and below the scaffolding of the time, and points at its foundations. The present becomes a layer of things past, the countryside a place of memories. It is a journey towards the distant roots of Mediterranean culture. 'On this journey, I have lost myself a number of times, deliberately. I was not looking for any strong sensation; I waited for the space to tell me one of its possible stories. It is the tale of strong presences which survive the fate of the places – presences capable of disturbing you with their silent vitality.' A sense of estrangement lies on the surface of things together with a dense silence. The monuments are signs and icons that direct us in space and the labyrinth of time. Jodice's spectacular black and white works on the contrast between ornament and sobriety, poetry and meaninglessness; the light creates an evocative, suspended universe made up of sublime details. His moment has a metaphysical immobility which is not outside time but carries time within it as the geography of memory and a reflection on the present. These photographs are 'testimonies to things past or things still to come; a way of exorcizing doubts and the worries of living'.

Athletes from the Villa of the Papyri, Herculaneum, Italy, 1985

© *Mimmo Jodice*

MIMMO JODICE was born in Naples in 1934 and developed an interest in photography in the late 1950s. His interests range from experimentation to social statements. In 1968 he had a decisive meeting with Lucio Amelio and artists such as Andy Warhol, Robert Rauschenberg, Joseph Beuys, Jannis Kounellis, Alberto Burri and Michelangelo Pistoletto. At the end of the 1980s he concentrated on analysis of the urban environment, first of all in Naples and then in other European cities. In 1990 he published *Le città invisibili*. Then he turned to classicism: the Mediterranean, the persistence of the past in the present. His research is contained in the books *Mediterranean* and *Eden* and completed in *Lost in Seeing* (2007), which accompanied the retrospective of his work presented at FORMA, Milan.

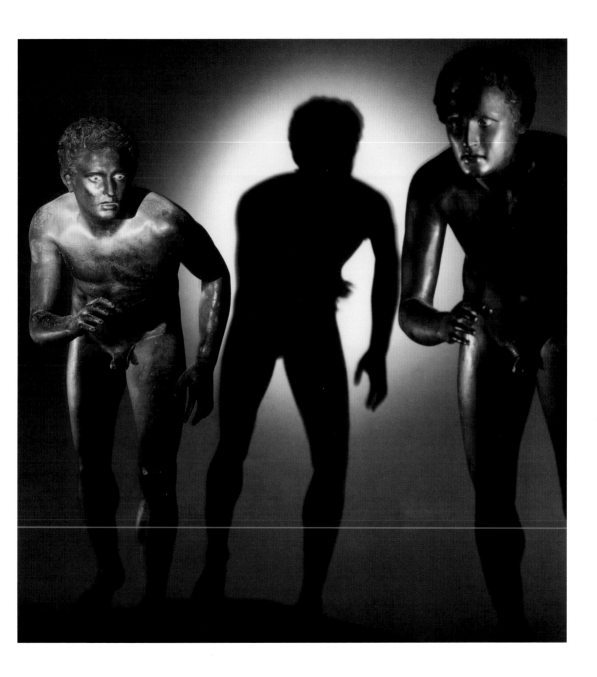

WILLIAM KLEIN

Robert Delpire described William Klein as a 'one-off'. As a photographer, painter, graphic designer, filmmaker and writer, Klein has experimented with every expressive form, moving agilely from one to the other, demolishing and innovating throughout. He breaks with tradition and imposes a new violent and graphic style, mixing black humour, social criticism, satire and poetry. He rejected the obsession with the objective view. In 1954 he composed a photographic diary of the streets of New York, armed 'with an incomparable secret weapon, the truth machine … everything was in the lens… I didn't know what to do with the ethics of the day, the alleged objectivity.' Finding the 50mm lens too restrictive, Klein had to absorb as many things as possible through his eyes. He bought a 28mm lens and pointed it at faces, breaking all the taboos that used to paralyse photography: grain, contrast, lack of focus, irregularities, being out of the frame – everything was used to express a visceral subjectivity. The image of a child pointing a gun at the photographer, taken on the street in 1955, became an icon. But Klein, rebelling against any idea of making art sacred, said, 'The photo of that kid with the gun, I can't stand it any longer. It's like a summer hit tune which we can no longer hear.' And then, in the late 1990s, he decided to remix the summer hit tune and infuse it with new life. Over-painted contact sheets were the opportunity to reinterpret some of his most famous pictures, to attack them, deny them and mock them. Showing the 'before' and 'after' of the picture means clashing with the myth and with the decisive moment of the shot. A complex game was thus established between the photographic framing of the image and the expressive framing of the pictorial gesture, which is almost angry. Nothing is fixed; everything moves and changes. A hybrid form above all others, the contact sheet allows Klein to combine the expectations of the photographer, filmmaker and painter, to avoid the iconic nature of the single picture and to make his work non-sacred.

Gun 1, 1955 (over-painted in 1999)

© *William Klein*

WILLIAM KLEIN was born in New York in 1928 to a Jewish family of Hungarian descent. From the age of eighteen, he spent two years in the US army, stationed in Europe, and then settled in Paris to become a painter. In 1954 he returned to New York and worked on a photographic diary, which was published two years later in a book designed by the artist himself, *Life is Good & Good for You in New York*, and which won him the Prix Nadar. Klein went to Rome to be an assistant to Federico Fellini, and at the end of the 1950s he became more involved with cinema, concentrating on it exclusively and making several films. In the 1980s he returned to photography and published numerous books. His work is shown all over the world, and he has received countless prizes and awards.

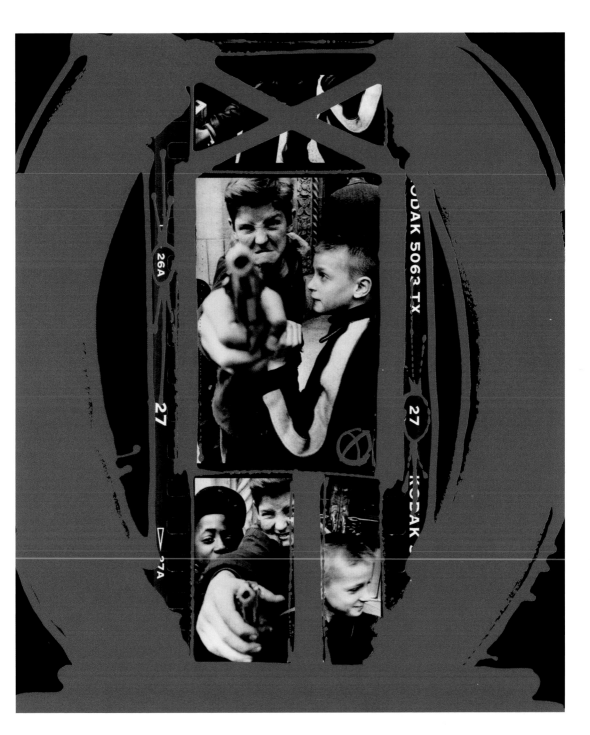

DAVID LACHAPELLE

David LaChapelle, one of the world's most famous contemporary photographers, has always said: 'My work is honest because it's not parading itself as reality.' His art is pretence and artifice. His photographs deliberately distance themselves from reality, which is considered grey and melancholy, in order to create and display a world overflowing with violent colours, sensuality, irony and a spirit of irreverence. His pictures are provocative, iconoclastic and theatrical, woven through with a kind of baroque and blasphemous mysticism, full of references to and quotations from the world of art whose aesthetics merge with the language of advertising. Trained in the Pop Art school and a pupil of Andy Warhol, LaChapelle emphasizes the visual traits of our society, often transforming the sparkling into the disgusting through exaggeration and reduction. Famous for his work in fashion and entertainment, he recently decided to abandon commissioned photography so he could devote himself to his own experiments and to the themes that interest him most – the degradation of consumer society, the relationship with the divine, eroticism, the surreal, fear of death and a sense of the sublime. Whether the familiar blond Jesus of sacred pictures eating the Last Supper among twelve tattoo-covered rappers, as in this photograph, or the well-known provocative portraits of show-business celebrities, or the recent apocalyptic visions inspired by Michelangelo's Sistine Chapel – everything, in LaChapelle's world, is complex and examined in great detail. It is all formed by playing with irony and the grotesque.

The Last Supper, 2003

© *David LaChapelle/*
Art+Commerce

ART

DAVID LACHAPELLE was born in 1963 in Connecticut. He moved to New York, where he studied art. Andy Warhol had him hired by *Interview* magazine when he was only eighteen years old. His career took off in the 1990s, when his photographs were published in many high-profile magazines. His first collection of photographs won the Art Directors Award. He has been responsible for major advertising campaigns and has photographed many celebrities. He was named as one of the world's ten most important photographers by *American Photo* magazine. He has also directed many video clips, and in 2005 his documentary *Rize* was released. In 2007 a solo exhibition celebrated his work at Palazzo Reale in Milan.

SERGIO LARRAIN

Valparaíso is on the coast of Chile, a city at the edge of the world. Like the fictional Macondo in Gabriel García Márquez's *One Hundred Years of Solitude*, it is not only a city but a state of mind – a dream, an image. To the Western mind, it connotes a romantic idea of distance, the thought of something other than oneself where one can be amazed. It is here in this small and paradoxical 'paradise valley', among its lanes and infinite ups and downs, that the legendary Sergio Larrain pursued light and shade – and took some of his most famous photographs. Larrain is legendary because he is mysterious, enigmatic and fascinating, like the pictures he creates. Born in Chile, he possesses – like his country – that Latin American magical realism which transforms places into timeless myths that defy every age. Everything that happens is both natural and miraculous, explicable and inexplicable, old and new, necessary and gratuitous, shared and unique. Just as in his photograph of two girls going, one after the other, one similar to the other, down one of the thousands of hills leading to the port, the start and end of the city. The first is about to leave the light; the other is just entering it. Both of them, step by step, neatly, will disappear by being immersed in a horizon that is not there, hidden by a wall that is the door to our imagination. It is a moment of perfection: a combination of lines which is so marvellously fleeting that it seems eternal. Physical and mental worlds are blended into a fragile equilibrium, and we can do nothing other than believe Larrain when he says that this is 'the first magical photograph ever presented'.

Valparaíso, Chile, 1957

© Sergio Larrain/ Magnum Photos

ART

SERGIO LARRAIN was born in Santiago, Chile, in 1931. He studied music before taking up photography in 1949. After university, where he studied agronomy, he travelled in Europe and the Middle East, working as a freelance photographer. He joined the staff of the Brazilian magazine *O Cruzeiro* and, in 1956, MoMA in New York bought some of his photographs. In 1958, with a study grant from the British Council, he began a photographic essay on London (the book was published in London, Paris and Rome in 1998). Henri Cartier-Bresson invited him to join Magnum in 1959, and two years later he returned to Chile on an invitation from Pablo Neruda. He met the Bolivian guru Oscar Ichazo in 1968 and started to study oriental culture and mysticism, since when he has lived apart from the world in accordance with these ideals.

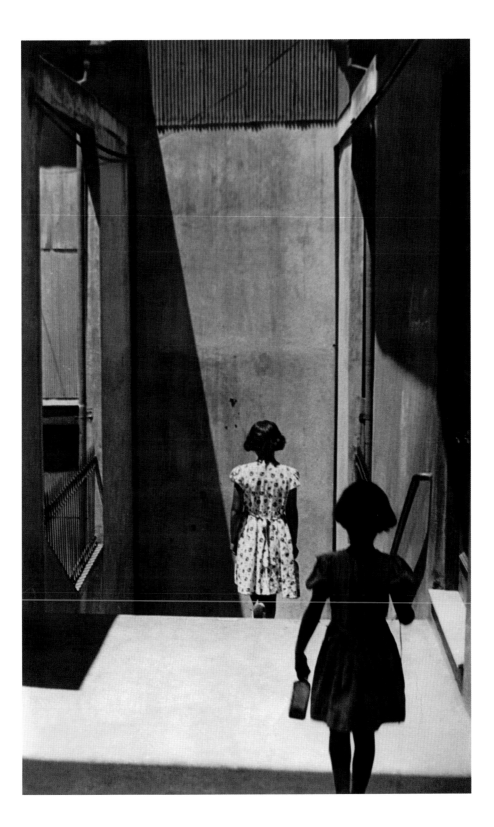

SAUL LEITER

To be unknown moving in the heart of the city, to see and not be seen, to observe, with amused or at times horrified eyes, apparently trivial but actually significant details of the great urban movement: a fresco of objects, cars and people which expresses itself in contradictory movements, producing a rhythm of unexpected improvisations. Saul Leiter followed the philosophy of the real street photographer who leaves his studio and walks along the pavements to seek the pulsating rhythm of his age in the neon signs and the faces of passers-by. Born in 1923 in Pittsburgh, Leiter abandoned his studies early, attracted to New York. He wanted to become a painter and quickly struck up friendships with Mark Rothko and the Abstract Expressionists. But alongside painting, which he continued to develop over the years, he turned to photography. He met Henri Cartier-Bresson and it was partly because of his influence that he started to take an interest in 'street photography'. However, there are no particular influences on his photographic work: he puts together, photograph by photograph, a set of coherent images with unusual originality. Black-and-white and colour accumulate and chase each other in his work, but it was to colour that he turned to find new forms, to confuse and clarify the sense of a city vision in the eyes of the viewer: tarnished glass, reflections, a mirror that reveals and suggests, and an artist's blurriness. Leiter's transparencies are extremely sophisticated and simple, direct and comprehensible to everyone. It is the details, sometimes found at the extreme edge of the frame, that provide the significance of the foreshortening, the view, the flash of light, the particular day. And then, when titles like 'Straw Hat' were no longer sufficient, there were many photos simply called street, street, street: an amazing stage, the kingdom of voyeurism and detachment.

Untitled, New York, 1960

© Saul Leiter
Courtesy Howard
Greenberg, New York

ART

SAUL LEITER was born in 1923 in Pittsburgh and began his studies at the theology school in Cleveland. When he was twenty-three, he abandoned theology to take up a career as a painter in New York. He became interested in photography, partly due to the influences of Richard Pousette-Dart and W. Eugene Smith. His first black-and-white photos were exhibited at MoMA in New York. In the late 1950s he began a career as a fashion photographer, and his pictures appeared in *Esquire* and *Harper's Bazaar.* Over the next twenty years he continued to work for the fashion industry, and his work was published in *Show, Elle*, British *Vogue, Queen* and *Nova*. Leiter lives, paints and photographs in New York. In 2008 the Fondation Henri Cartier-Bresson hosted a solo exhibition to coincide with the publication of *Saul Leiter: Photofile.*

HERBERT LIST

To begin with it was coffee: the intense aroma saturated every aspect of family life. And it was that smell – exotic and domestic at the same time, part of a daily ritual, which speaks of sun and suntans – that led Herbert List, the son of a Hamburg coffee trader, to dream of another, hotter life, another, more distant land, and above all another age. This age was not the menacing age that was advancing upon him, in his thirties when Nazism was established in Germany, but a more remote and classical age, an age whose living vestiges could still be sought. So List, like many Germans before and after him, sought in Italy and Greece a return to a mysterious and suspended classicism. It was the work of Giorgio de Chirico, René Magritte and Man Ray that opened the way for him, as well as his friendship with another extraordinary and magical photographer, George Hoyningen-Huene. In 1937 they set off together to Greece, stopping off at Portofino in Italy, which was so exclusive and elegant, and so sunny that it sculpted bodies and profiles. It must have been midday when the sun illuminated the scene of this symbolic image in List's career and in the history of metaphysics. It is almost a worldly version of the Sphinx and its terrible enigmas.

Portofino, 1936

© Herbert List/ Magnum Photos

HERBERT LIST was born in 1903 in Hamburg. He started taking photographs under the influence of Surrealism and the Bauhaus. In 1936 he left Germany and worked in Paris and London as a photographer, but the war forced him to return to his country in 1941. In 1946 he photographed the ruins of Munich and became art editor of *Heute*. In 1951 he met Robert Capa, who convinced him to work as a Magnum contributor. From the mid-1960s he lost interest in photography and devoted himself to collecting drawings by great Italian masters. He died in Munich in 1975. The exhibition *Lo sguardo sulla bellezza*, which opened at the Capitoline Museums in Rome in 2007, covered the different stages of his art.

ART

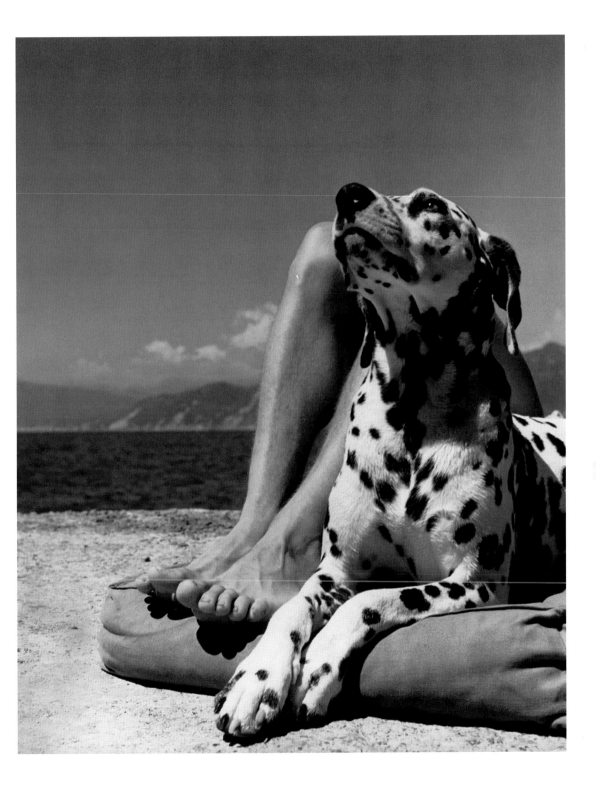

MAX & DOUGLAS

All it takes is a snowfall and the city changes. New sounds are heard, new shapes soften the classical profiles, but above all new histories arise. All it takes is a snowfall, in short, and the page is turned. And on this suddenly blank page, in the wonder of a morning different from others, two vision-ary photographers like Max & Douglas, with no other names than those of a famous trademark in the fashion and advertising world, organized the first and last heats of a very special slalom. This slalom was not between the fixed obstacles of a normal skiing event, but between the flexible obstacles of narrative genres and tenses. To create the new city fresco all they needed was a computer screen and the descent began. On one level it seems like an extremely fast calligraphy exercise, as shown by the crown of snow that an urban snowboarder raises as he passes through the gates on the route. From the start Max & Douglas invented a new limit between past and present and between dignified classicism and the aftermath of a polar disaster. Halfway through the event there is a mix of surrealism and hyperrealism, freedom to dream and surgical precision in every detail. Finally, at the finishing line they slide, arms raised, under that large gate which is at the start of every story and of every snowfall in the world. That gate marks the entry into another world, both real and fantastic. Max & Douglas speed through it, as happy as all children are when it snows in the city and schools are closed.

Giacomo Kratter, Turin Olympics, 2006

© Max & Douglas/Grazia Neri, post-production Martin Rainone

ART

MAX & DOUGLAS were 'born' professionally in Milan, on the benches of the Istituto Europeo di Design. They have worked together since 1997, mainly in advertising, for Sony, Romeo Gigli, Invicta, Telecom Italia, Adidas, *Sportweek*, *GQ*, *Ventiquattro* and *Rolling Stone*. In 2002 they exhibited their collection of portraits, 'MTV Stills', in Milan, produced by the Grazia Neri Photo Agency, which represents them.

DUANE MICHALS

'I am not able to talk about Duane Michals's photographs, about their processes, about their plasticity,' wrote Michel Foucault. 'They appeal to me as an experience. They are not his experiences; but ... as they come gliding towards me – and, I think, towards anyone who looks at them – they arouse feelings of pleasure, a sense of foreboding, ways of seeing, sensations which I have already had, or which I expect I must experience some day, and so I constantly ask myself if these feelings are mine or his, although I know they must belong to Duane Michals.' Experiences are never just visual, but appeal to and involve all the senses. This clearly includes sexuality. Michals's images are as dense as metaphors, as complex as questions without answers, skilfully blurring and confusing the boundaries between photography, philosophy and poetry. His eye searches to the very edges of photography, because he is interested in showing his own thoughts. Therefore he does not simply take a picture, but he often writes poetry and texts on his images, because it is not true that a photograph is worth more than a thousand words, and because the potential narrative offered by the human condition will always elude the sacredness of the single image. The reality to be depicted is made up of dreams, fears, desires, emotions and mystery. There are often apparitions in his photos, epiphanies of the invisible 'so much more interesting than what I can see', he says. The 'sacred' sets up an opposition to the ordinary, to the 'profane', and its advent in the everyday is charged with multiple meanings. The archangel Gabriel was summoned to foretell the incarnation of the Son of God. Perception becomes distorted in the darkened room; the blurred wings almost take on the appearance of a tail on the nude figure. A partially undressed woman sleeps, unaware. As the angel approaches, is it in the guise of the Angel of the Annunciation, or in his second biblical role as the Angel of Death? Or, much more simply, is it possible that this presence will lay down his wings by the bed to celebrate an earthly carnality? Contradictory meanings: as always, with Michals, it is the questions that count.

DUANE STEVEN MICHALS was born in McKeesport, Pennsylvania, in 1932 to an immigrant Czech family. He attended the University of Denver with the assistance of a scholarship, and in 1956 enrolled at Parsons the New School for Design in New York to study graphic design. In 1958 he discovered photography during a journey to the Soviet Union. He had his first exhibition in 1963 at the Underground Gallery in New York. In 1966 he started to work on photographic sequences (*Sequences*, 1970), and in 1974 began to include texts in the margins of his photographs, as in *Private Acts* (1977). He has been awarded numerous prizes, including the Infinity Award for Art from the International Center of Photography in 1991.

The Annunciation, from the series 'The Fallen Angel'

© Courtesy Pace/ MacGill Gallery, New York

THE FALLEN ANGEL

NINO MIGLIORI

Nino Migliori's artistic journey is one of the most interesting of those undertaken by European photographers of the late 1940s. His career began on the streets of Bologna where he was born. He was fascinated by the architecture, the inhabitants and the artists, but he was fascinated above all by the walls on which were deposited the life and history of a living, breathing town. His study of the walls became formal and aesthetic, but also sociological: his research carried on for over thirty years. He was not much interested in the publishing market and the documentary photography that was in vogue during those years, but rather associated with artists and intellectuals of his generation; the experimental aspect dominated and came to characterize all his subsequent work. In his 'Off Camera' experiments, for example, he used hitherto unused materials and techniques such as bleaching, cliché verre, manipulations on Polaroid, collage, montages, video stills and abrasions. He has been described as an 'architect of sight': for him the camera is not only a tool to objectify real life, but also a powerful opportunity for invention and change. Migliori has used the eclectic nature of photography better than others: a medium that enables documentary but takes on the content and values linked to art, experimentation and play. In the photograph of the diver he combines a neo-realist spirit with the desire to produce creative and abstract pictures. The photograph proves to be unique and significant in its 'articulated' simplicity. The centres of gravity are arranged in a nearly abstract way and the boys' game in the sea becomes a pure constructivist composition. The photo is linked to chance, yet an important connection between fortuitousness and the subconscious emerges within it.

The Diver, Rimini, 1951

© *Nino Migliori*

ART

ANTONIO (NINO) MIGLIORI was born in 1926 in Bologna, where he currently lives and works. When he was about twenty years old, he became interested in photography and soon found himself, with Luigi Veronesi, Raphael Grignani and Bruno Munari, continuing the research carried out by the avant-garde – by Man Ray, László Moholy-Nagy, Christian Schad and Kurt Schwitters. His interest in experimentation led to a focus on didactics. In 1975 he presented *Trois photographes italiens* in Paris. In 1982 he started the Abrecal group. In 2002 he exhibited *Le avanguardie e il realismo, Ombre di luce–50 anni di ricerca sul potere della visione* and *Materie e memorie nelle scritture fotografiche* in Turin. In 2005 he was in New York with the 'Signs' exhibition, and in 2007 he exhibited at 'Neorealismo: Die neue Fotografie in Italien, 1932–1960' at Winterthur in Switzerland.

ARNO RAFAEL MINKKINEN

There are two main characters in this shot: the photographer and untamed nature. A perfect fusion is made within the rectangular frame. One penetrates the other silently, but with depth. There are no tricks or manipulations. What we see in the picture corresponds to what happened in front of the lens. Arno Rafael Minkkinen submerged himself in a lake in Massachusetts leaving only a thin white leg, bent just enough for its profile to harmonize perfectly with the background, sticking out of the water. The photographer is swallowed up in the water, yet there is no tension, just silence and calm. This is because the surface of the lake seems clear, almost as if it shone with its own light (Minkkinen's refined black and white, broken down into medium tones without violent contrasts, emphasizes this impression), and it is perfectly flat, with no ripples, as if the limb had always been fixed there, like a fallen dry branch. Thus the leaves that enter the scene from the top edge complete this illusion, and man conquers his own limits and his own immortality through photography.

Fosters Pond, 9.9.1999

© *Arno Rafael Minkkinen*

ARNO RAFAEL MINKKINEN was born in Helsinki in 1945, and moved with his family to the United States when he was just six years old. After graduating in English literature, he produced his first self-portrait in 1971 and then completed his apprenticeship taking lessons from George Tice, Harry Callahan and Aaron Siskind. His naked body is his main subject and he has repeatedly used it in a career dedicated to research into forms in delicate black and white. He teaches at the University of Art and Design in Helsinki and at the École Supérieure d'Arts Appliqués in Vevey, and exhibits his photographs internationally. In 2005 *Saga*, the first anthology of his work, was published.

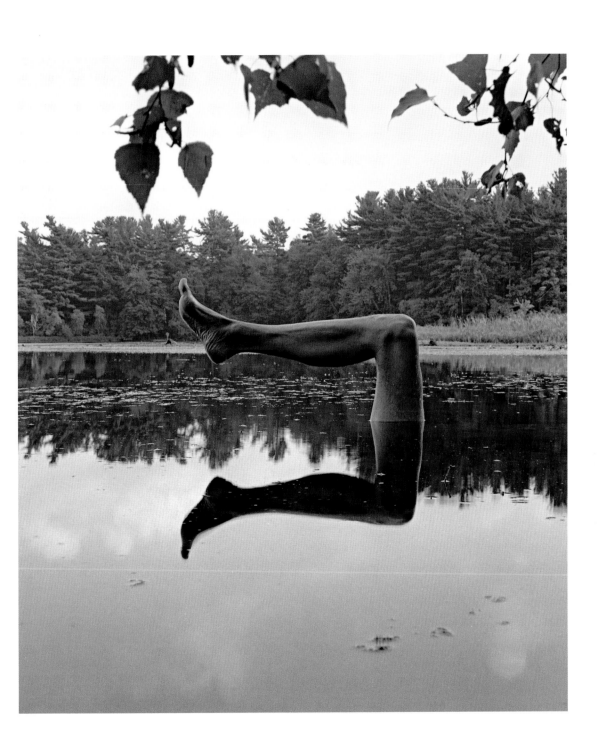

SARAH MOON

A girl stands, still and composed, with her arms by her sides and face turned to the light. She closes her eyes. Maybe she is waiting, or hoping, for the miracle of the story to be repeated, which will allow her, a new Alice, to enter wonderland – at the moment a two-dimensional square of trees behind her. Sarah Moon seeks to turn the evidence upside down, she closes her eyes and sees mirages, she believes in miracles. She stages her fantasies, studies every detail, but then looks for what she has not planned: she waits to recognize what she has forgotten, hopes for chance, for the appearance of the unexpected which she predicts will seize her at the very moment she frames the world. For her, black and white is the tonality of introspection, an almost colourless, imprecise tonality, more a feeling than a picture. There are no true whites: there are no flashes of light in her skies. There are many closed eyes and a sense of nostalgia for the apparitions and dreams of childhood. Memories have a material, memory has a colour: Moon turns gently towards a mysterious and dreamy sepia. Blurred outlines, alternative printing and developing processes, the hazy lenses of toy cameras: hers is an anti-narrative language that evokes moments, feelings and coincidences. Moon's world is populated with ethereal women moving in a timeless space under low, grey skies. Nature, a crumpled background in front of which a girl stages her dreams, seems almost inaccessible, as if tied to a lost past that can survive only in one's memory. 'I have always known that I should close my eyes before opening them and that my eye, from when it started choosing what to see, was no longer mine, it was not its age, it was seeing for the first time, and discovering what I recognized in my soul and in my subconscious.' Wonder: wonder for grace and poetry, for silence, for a mute desire to roam.

Morgan, 1983

© *Sarah Moon*

SARAH MOON was born in England in 1941, to a French mother and an English father, but grew up in France where she studied design at art school. Between 1960 and 1970 she worked as a model in Paris and London. In 1967 she started her career as a photographer, later also becoming a film director. She worked with important magazines such as *Marie Claire, Harper's Bazaar, Vogue, Elle* and *Stern*. In 1972 she was the first woman to take the photographs for the Pirelli calendar. She has made various films, including *Mississipi One* (1991), biographies of Henri Cartier-Bresson and Lillian Bassman, and shorts accompanying and supplementing her revisited visual 'fables' such as *Circuss* (2003), *L'effraie* (2005) and *Le fil rouge* (2006). In 2001 her comprehensive monograph, *Coincidences*, was published.

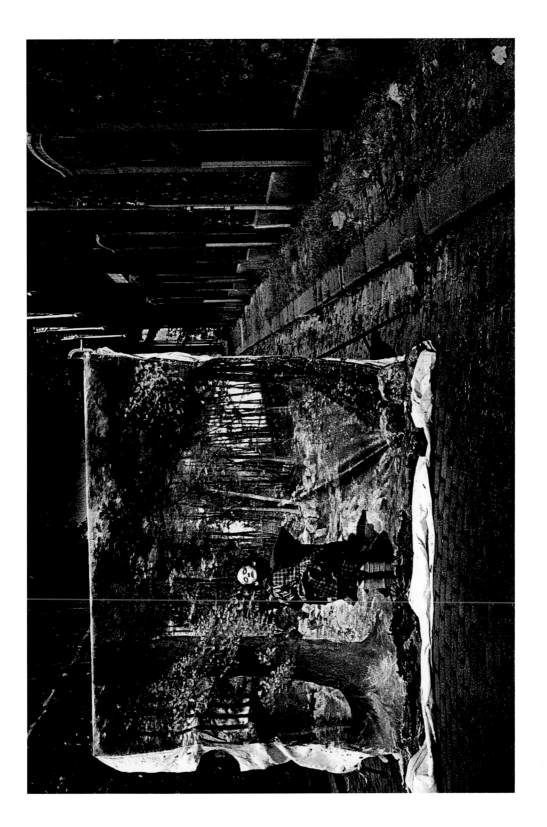

EADWEARD MUYBRIDGE

It started out as a bet, a whim of Governor Leland Stanford, a railway magnate and horse lover. The question was: when galloping, do horses lift all four hooves from the ground at the same time? Stanford, who was later to found Stanford University, bet that it was so and, to confirm his thesis, asked Eadweard Muybridge to assist. At the time Muybridge was one of the world's most esteemed landscape photographers, with a keen interest in the open horizon of the American West and its heroes – including horses. It took six years of research, working with John D. Isaacs, chief engineer on the Southern Pacific Railroad, to achieve the desired result. To produce the prodigious series of pictures Muybridge electronically released the shutters of twelve stereoscopic cameras, placed in a battery, one next to the other over a distance of approximately 7 metres (23 feet), activated by a tripwire triggered by the horse as it passed. Then came the fateful day: 19 June 1878, when this famous series was produced on the Palo Alto course. The heroine of this memorable undertaking was Sallie Gardner, a mare owned by Stanford. The proto-cinematic results were taken on a world tour. The bet had been won, and a new photographic record had been achieved: shots at a thousandth of a second – the speed of a bullet. In 1874 the photographer shot his wife's lover, Major Harry Larkyns, with a pistol, but was acquitted of his murder.

The Horse in Motion, 1878

© Eadweard Muybridge/ Corbis

EADWEARD MUYBRIDGE was born in Kingston upon Thames in England in 1830. In 1855 he moved to San Francisco and worked as a publisher and a bookseller. He returned to England for a few years and then went back to San Francisco in 1866. By profession he was a photographer, mainly concentrating on landscape and architecture. He published many pictures under the pseudonym Helios. In the early 1870s he carried out research into human and animal motion. In 1878 he took photographs of a running horse using twelve stereoscopic cameras, activated by a tripwire triggered by the horse's hooves. It was the start of successful photographic research into motion. In 1894 Muybridge returned again to England, where he died in 1904.

JOSEPH NICÉPHORE NIÉPCE

This view, which must have been very familiar to the photographer, would become known to the whole world. It is the window of Joseph Nicéphore Niépce's studio. From 1816 onwards, the inventor, together with his brother Claude, undertook experiments in fixing light through a camera obscura. Niépce's interest in producing images without human intervention came from lithography. He assessed the light sensitivity of various materials such as silver chloride, guaiacum resin, phosphorus and oil on various media such as paper, glass, metal and stone. On 5 May 1816 he wrote to his brother: 'I put my machine on the open window of the room where I work, pointing it at the pigeon loft. I carried out the experiment in my usual way and I obtained that part of the pigeon loft which you can see from the window on the white paper.' Niépce doggedly continued his experiments on materials until *c*. 1826, when he had a breakthrough. He set up a camera obscura on his window-sill, placed within it a polished pewter plate coated with bitumen of Judea, and uncapped the lens. After eight hours of exposure, the plate was removed and the image of the view from the window was visible. This is the earliest known photograph. At that moment, for Niépce, it was like drawing without brushes, locking a fragment of time and representing the world using only light. And so he called his process 'heliography' ('sun writing'), a forerunner of modern photography, which in 1839 Daguerre arbitrarily took full credit for discovering. Two reproductions exist of the original image produced on a pewter plate. They were made in 1952 by the Helmut Gernsheim & Kodak Research Laboratory. One of the two has been worked with colours and water to make the shapes and outlines clearer.

View from the Window at Le Gras, c. 1826

© Joseph Nicéphore Niépce, Harry Ransom Humanities Research Center, Gernsheim Collection, The University of Texas at Austin

ART

JOSEPH NICÉPHORE NIÉPCE was born into a rich middle-class family in 1765 at Chalon-sur-Saône. He considered entering the priesthood and was part of the revolutionary army, but became interested, with his brother Claude, in the phenomena of light and the camera obscura. He experimented with various techniques, and in around 1826 managed to produce the first image drawn by light, a process he called heliography. In 1827, during a trip to Paris, he got to know Louis-Jacques-Mandé Daguerre and Augustin Lemaître, who would subsequently work with him. In 1828 he and Daguerre founded an association to perfect heliography. Niépce died in 1833 at Saint-Loup-de-Varennes before the importance of his research was recognized.

ERWIN OLAF

'I've always sought to be ironic about beauty to try to offer a new perspective on the whole stupid grossly over-valued fashion industry.' For Dutch photographer Erwin Olaf fashion is understood not only as high fashion, but as a passive interpretation of the approved models proposed by the media. His strategy is provocative: parades of octogenarian pin-ups, lascivious and violent clowns, and nude men and women with envelopes signed by famous designers on their heads, all appear in his work. In recent years he has adapted his style to new needs. 'Both advertising and fashion photographs use the image of the body "shouting" to attract attention. I believe that this device no longer works. I feel more led to looking for the detail, for a more intellectual dimension.' In the 'Hope' series, from which this photo is taken, the silent atmosphere is meant to evoke 'the expansion of the moment between action and reaction. The people are suspended in the moment before reacting to what has just occurred. It's like a couple when one says that they don't love the other any more... I wanted to represent the moment after that emotional split, before the reaction.' Beyond the intentions, what is striking is the richly enigmatic nature of the picture. 'The inclined foot of the girl in the yellow dress may reveal something of her relationship with the man ... but what? Even I don't know the story I am telling, and the signs are built up in the picture often independently of my will or knowledge.' In these scenes from the 1950s and 1960s people are immobilized in a limbo of perfection and melancholy, in which the recording of reality leaves room for the staging of the imaginary.

The Corridor, from the 'Hope' series, 2005

© *Erwin Olaf*
www.erwinolaf.com
Management miss
S. den Hartog

BORN IN HOLLAND in 1959, Erwin Olaf has held major solo exhibitions in prestigious institutions in Europe and the United States. In 1988 he won the Young European Photographer prize in Germany, in 1998 the Silver Lion at Cannes for his Diesel advertising campaign and again in 2001 for his Heineken advertising campaign. One of his photographs was chosen as the poster for the 2001 Bienal de Valencia. He has recently devoted himself to video art, and in 2006 his film *Le Dernier cri* received a prize at the International Film Festival Rotterdam.

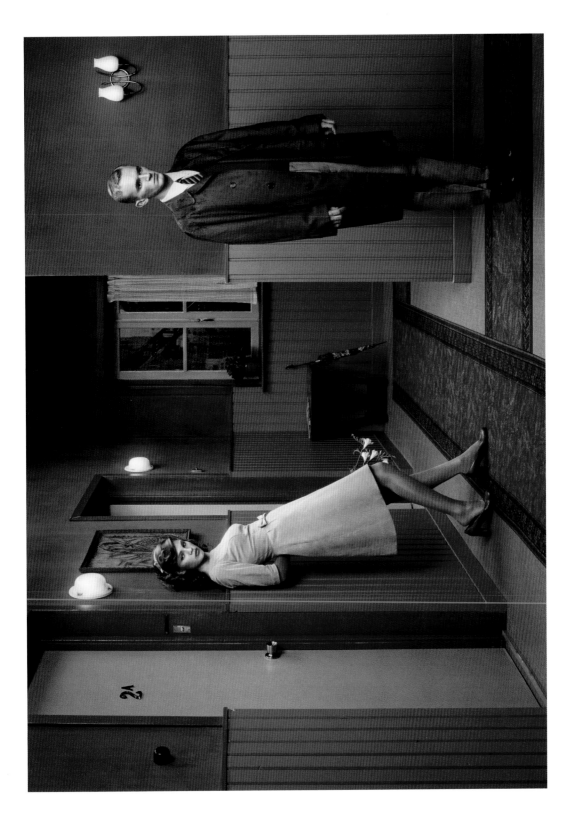

PIERRE ET GILLES

Pierre et Gilles' album of figures is typical of their work, which for thirty years, due to their fairy-tale and autobiographical vision, has populated the days and nights of the homosexual community in every corner of the world that wishes to be considered free – free to enjoy any iconographic genre, sacred or profane. No shades of machismo or drawing-room politeness are left out of the Pierre et Gilles catalogue. This starts with the traditional icons of gay love, sailors, with a tear on their face, then there are the Apaches, policemen in black leather, astronauts flying among flowers, and even Casanova in the mirror, undressed but with powdered hair, then finally the real novelty – footballers, the heroes of the new millennium, the stars of boys' and girls' dreams, the princes, in synthetic shorts, of that kingdom of passion and hate, fairness and disloyalty, healthy competition and devastating violence, which we usually call the stadium. 'Vive la France!' declaims the title of this picture, which dodges every sporting comment and scores a marvellous goal of irony. In the anatomical spectacle of the athletes, in the sincerity of their smiles, and the lightness of golden rain, it talks of what sport, and football in particular, should be about: a game, and that's all. We'll let the silver shoes and socks pass, but the rest is definitely superfluous. Maybe this is why, with a gesture of convincing moralism, Pierre et Gilles wanted to do without their usual parade of special effects: few finishing touches, no Hollywood-style tones, no mother-of-pearl kitsch. Although that takes nothing away from the fact that there are good reasons to cheer.

Vive la France!, 2006

© *Pierre et Gilles*
Courtesy Galerie Jérôme de Noirmont

IN THE REAL WORLD Pierre et Gilles are Pierre Commoy and Gilles Blanchard. Pierre was born in La Roche-sur-Yon in 1953 and is a photographer; Gilles was born in Le Havre in 1953 and is a painter. They met in 1976 and have worked together ever since. This thirty-year association was celebrated with the publication of *Pierre et Gilles: Double Je, 1976–2007*, from which this picture is taken. The style of their work – classical quotations, religious pictures, pop icons, Hollywood stars and a 'soft-porn' tone – makes their photographs unmistakeable, whether they are portraits or advertising campaigns. Against every facile accusation, the two artists declare: 'We started with self-portraits – real tests of the twentieth century. And these pictures show and reflect exactly what we are.'

PAOLO VENTURA

Each photograph is a mystery. Each picture establishes a complex and enigmatic game of reality and pretence. Paolo Ventura intervenes in this genetic condition of photographic images by increasing the mystery and the questions exponentially. 'I wanted to play with ambiguity. You can think that it's real, and then after a while you start to see that they are not real. Or there's something that bothers you because it looks real, but it's not.' Ventura works on the collective memory of real events, reconstructing them in a narrative context that he creates with his own hands. The scene is the Second World War and the actors are dummies in a kind of posed theatre. Men and women are toys or clay figures, and the scenes and objects among which they move are all meticulously reproduced to scale. Each scene is amazingly full of obsessive details of costume and style. Ventura himself built the characters, painted the scratched walls and the rain-soaked newspapers, and invented atmosphere and mood. The pictures have the mysterious power to call to mind tales that were true, memories that are part of the collective imagination. The war atmosphere seeps through even in this picture, in which the only obvious war reference is a poster announcing a call to arms. It seeps from the desolation and silence of the snowy street, from the profile of the man glimpsed through the window, and from the hats pulled down over the eyes to hide faces. Everything is immersed in an aura of real melancholy. In the introduction to the book *War Souvenir*, Francine Prose writes: 'Looking at these photos creates a moment of suspension, a melancholy hush in which we almost imagine we can hear whispers about the riddles of life and death, time and age ... and such questions as "What are we seeing?", "What do we think we are seeing?", and "What are we concluding about what we think we are seeing?"'

Christmas, 1944, shortly before curfew, from the 'War Souvenir' series, 2005

© Paolo Ventura

PAOLO VENTURA was born in Milan in 1968 and studied at the Accademia di Belle Arti di Brera. After ten years as a fashion photographer, he now devotes himself to personal projects. His work has been published in magazines such as the *New Yorker, Harper's Bazaar, Aperture* and the *New York Times Magazine.* His first book, *War Souvenir,* came out in 2006. Ventura has had solo exhibitions at FORMA in Milan, Hasted Hunt Gallery in New York, Rencontres d'Arles International Photography Festival, FotoGrafia International Festival in Rome, and he has had joint exhibitions such as 'Une histoire privée' at the Maison Européenne de la Photographie in Paris. He lives and works in New York and in Anghiari, Tuscany.

ART

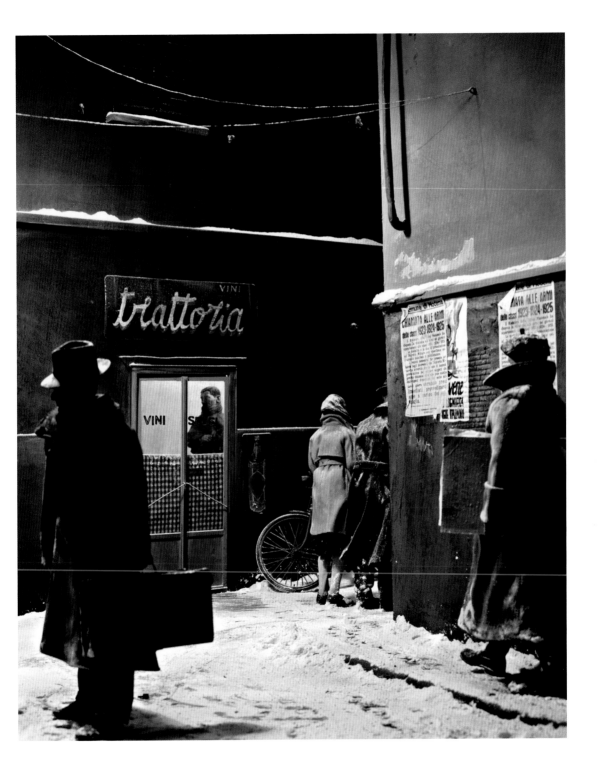

MASSIMO VITALI

It is said to be the ultimate beach, and it is true. And the beach is an oppor-
tunity to show who we really are: in shorts, bikinis, or naked. The choice
is limited, but there are no limits to how the individual elements can be
put together. What is extraordinary about the beach is that it seems to be
a free place, with no rules, almost wild, or at least we delude ourselves that
this is so, yet, on the other hand, it is one of the cruellest social markers. It
is indelible, more than a suntan, more than a tattoo. And it is there, on that
thin line between being and appearing, from the top of his 8-metre-high
(13-foot) lighthouse, balanced on his Tower of Babel (not a linguistic one
but a visual one) that Massimo Vitali observes and takes photographs – from
the Adriatic to the Caribbean, from California to Thailand. The endless sea
and the waves that eternally stir and renew the water are behind him. In
front is an expanse of warmed bodies, dense in certain areas, less crowded in
others, in motion like an anthill, or standing still contemplating the sky and
the summer. Holidays, rest, this is my umbrella, this is my scrap of peace,
the rest of you out, further over there please... Vitali takes pictures, every
half an hour on the dot, from dawn till dusk. A chromatic breath of wind
cools the sky and the sand, and on earth the bathers remain, clothed in their
nudity. Vitali describes them as 'butterflies run through with the needle of a
sunray'. He adds, as a former photojournalist and now a landscape entomolo-
gist: 'It is like studying beings in vitro who reproduce the rigid laws of social
living on the most amorphous of backdrops – sand.'

*Crowd on the beach to see
the Air Show, Viareggio,
1995, from the book*
Landscape and Figures

© *Massimo Vitali*

MASSIMO VITALI was born in Como in 1944. In 1964 he studied photography
at the London College of Printing (now the London College of Communication).
During the 1960s he worked as a photojournalist with various magazines and
agencies, and met Simon Guttmann, founder of the Report agency, who influenced
his development as a photographer. At the end of the 1980s, disillusioned with
the impact of social photography, he turned to advertising and film as a director
of photography. In 1993 he returned to photography, choosing a large format, and
followed the currents of contemporary art. Two years later he began his successful
research into the landscape of beaches. His pictures are exhibited in museums and
galleries around the world.

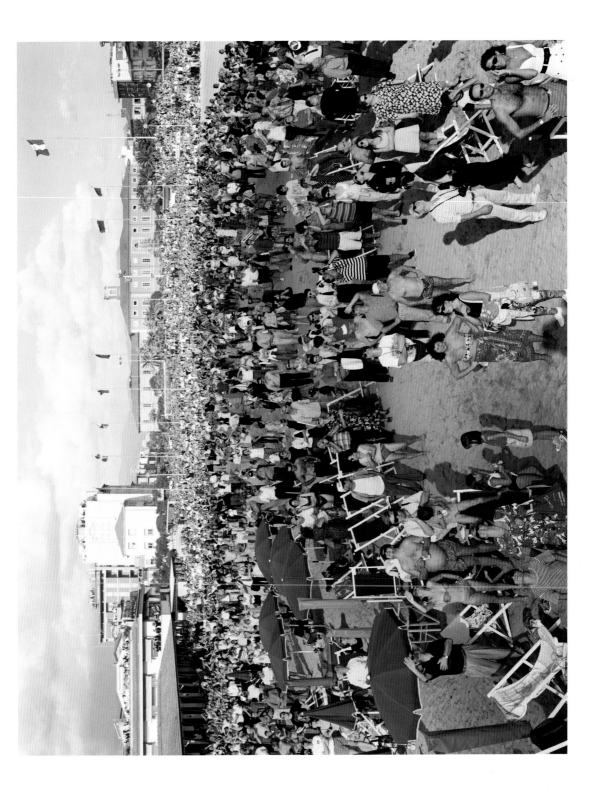

MILES ALDRIDGE

'When Antonioni came to London to make the film *Blow-Up*, he had all of the grass in the park painted green because it wasn't colourful enough for him. That's why an hour and a half of an Antonioni movie is so much more interesting to me than an hour and a half of real life. Because it is condensed emotion, condensed colour, condensed light.' For Miles Aldridge, the real world is often a counterpoint to his intensely saturated and highly stylized images. If only the world were sufficiently interesting and 'beautiful', he would shoot on location all the time, 'but the world is just not being designed with aesthetics as a priority', and so the English photographer prefers to rebuild it in his studio. This is called the 'Cinecittà approach': a drive to condense, an obsession with detail and an insistence on remaining faithful to one's own vision of the real, which was the reason why Fellini constructed many of his sets in his studio. Cinema is a constant point of reference for this young fashion photographer overflowing with imagination. His erotic, urbane, dreamlike style, often a little spooky and subtly disquieting, is reminiscent of the atmosphere in films by David Lynch, Fellini and Buñuel. In his saturated images everything is in focus, everything is clearly visible; the dense colour does not decorate but dictates the mood, creating a visceral experience for the viewer. Aldridge loves acid yellow, green and grey-blue. He loves blue shadows and the colour tonalities of old Hollywood films, with their sombre and mysterious ambience. 'My work is not just about a dream, but a dream of reality. It's all amplified – but it is essentially from reality and essentially contemporary.'

A dazzling beauty, Italian Vogue, 2008

© Miles Aldridge/ D+V Management/ trunkimages.com

FASHION

MILES ALDRIDGE was born in London in 1964. As the son of the art director Alan Aldridge (creator of many album covers for The Beatles, Rolling Stones, and The Who), he grew up surrounded by rock music and Pop Art. After studying illustration at Central Saint Martin's College of Art and Design, he became interested in video art. For three years he worked as a director of music videos, while taking photographs of his then-girlfriend, an aspiring model. The portfolio came to the attention of the editor of British *Vogue*, who requested to meet him immediately. This was the beginning of his career as a photographer, and he has since worked for the most famous fashion magazines and in major advertising campaigns. His clients include Yves Saint Laurent, Armani, Longchamp, L'Oréal, Hugo Boss and Paul Smith.

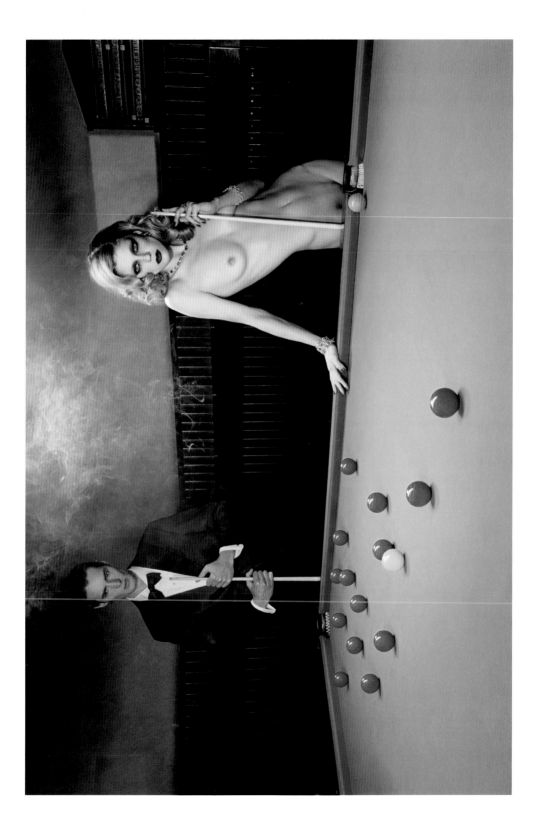

RICHARD AVEDON

This image by Richard Avedon is immediately recognizable. A master of contemporary photography, his unconventional approach marked an era and a style. His unique vision revolutionized portrait photography and transformed fashion photography from often being static and monotonous into something living and topical. Fashion was one of Avedon's subjects. He was much harsher on his fashion work than the contemporary young curators and critics. Roberta Smith in the *New York Times* suggested that his fashion work and the innovations he made to this subject are comparable to those of Jackson Pollock and Jasper Johns. Avedon took his models out into city streets, cafés, all manner of places; he allowed reality to penetrate the artificial world of fashion and imbued even the most elaborate artifice with narrative depth. When Avedon photographed his models, he would often dance along with them, following their movements, but always focusing on their gestures and eyes, revealing their human qualities to the viewer. In 1955 he portrayed the model Dovima wearing a Dior dress as she stood in an elegant and sinuous pose between two circus elephants. The slenderness of her body, the theatrical immobility of her gesture and her ethereal beauty all stand out against the physical power and majesty of the elephants moving behind her. The woman is portrayed as a dreamlike image; she is almost surreal. This elegant and daring visual design has made 'Dovima with the Elephants' one of the most famous fashion photographs of all time. Together with more than two hundred other photographs, it was part of a large posthumous retrospective exhibition that opened at FORMA International Centre for Photography in Milan on 13 February 2008.

Dovima with the Elephants – evening dress by Dior, Cirque d'Hiver, Paris, 1955

Richard Avedon © 2008 The Richard Avedon Foundation

FASHION

BORN IN 1923 in New York, Richard Avedon began to work for the fashion magazine *Harper's Bazaar* in 1944. He became its artistic director in 1961 and revolutionized fashion photography. He collaborated with the most prestigious magazines and worked incessantly on memorable and psychologically revealing portraits. He died in 2004, at the age of eighty-one, following complications from a cerebral haemorrhage.

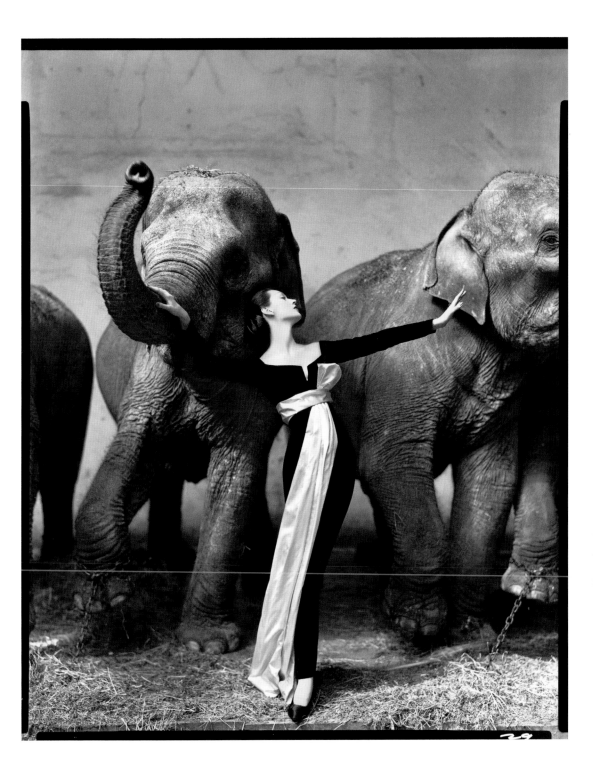

BELA BORSODI

Ever since its inception, photography has told stories about individuals. It has focused on people's noble or wretched features; it has enhanced elegant clothes or sympathized with the rags of poverty; and it has depicted its subjects with brilliant precision. In practice, however, photography has always been about fashion. And when fashion became an industry, it turned to photography to enhance its products and celebrate its notions of affluence, glamour and leisure. The fashion industry has its rule – to make goods and objects that would otherwise be completely superfluous indispensable. In the sudden flash of something sparkling, in an oblique light that gently caresses surfaces, or in blurred backgrounds, we can lose ourselves as though in a fairy tale. The images vie with one another to make us wish for a more perfect and fascinating personality, for a different life, in which these objects are a feature and our ownership of them is an inalienable right. Bela Borsodi's 'Foot Fetish' image, created for *V Magazine* in September 2007, is like an amalgamation of fashion and still life: it takes components of a symbolic relationship and displays them directly, almost listing them. The photograph was accused of sexism but, when examined carefully, it is more suggestive of a skilful game, based on the subtle irony that is an essential element of all great fashion images. Borsodi takes the composition to extremes. In many of his collages he depicts beautiful women in an exotic or elegant setting, but in this image he chooses to abolish both model and background. While other photographers aim to enhance brand name accessories with a feminine personality, we can see nothing here of the woman other than her outline. Her elegantly contorted shadow seems almost to be moaning in pleasure, as if she were lost in her own vanity and eroticism. The viewer is left only with the clearly lit fetishes on her body, the remnants of an industry that exists to produce, create and consume dreams.

Foot Fetish, 2007

© Bela Borsodi/ art-dept.com/ trunkimages.com

BELA BORSODI was born in Hungary. For several years he worked in editing and advertising photography. He has an innovative vision and seeks to combine unexpected still lifes with fashion, design and the latest trends in international style. Objects seem to take on new life in his creations. He now lives and works in New York.

GIOVANNI GASTEL

The viewer's gaze becomes bewildered by this image; it is caught off-guard by the impact of a bizarre metamorphosis. A cheetah and a woman's profile are fusing into something indefinable. The dissolution of boundaries stems from Giovanni Gastel's desire to resist definition and leave interpretation open: the transformation may still be happening, not yet complete, or it may already be on the point of vanishing. Germano Celant wrote that 'the necessity of making the ordinary wonderful is revealed in his interpretation of reality, and is the key theme of Gastel's photographic exploration'. Gastel is an artist who works on different levels, simultaneously both part of, and outside, advertising and fashion. He plays with borders; he blurs the contours of the human figure and confounds the rules of perception. His method is to work with large formats and old Polaroid cameras with movable lenses and then to mix up the two. His camera might be old, but his techniques belong to the digital age. He brings colouring, montage, collage and lighting together to create his singular visions, in which the body becomes an enigmatic space. Gastel is the creative force behind many major advertising campaigns and is the photographer of choice for numerous designers, even though he obstructs our identification with the product, a mechanism that fashion photography is conventionally meant to trigger. The surreal and fantastic atmosphere he creates makes bodies both present and absent, rendering them unfathomable, simultaneously familiar and unfamiliar, but always imbued with an elegant, disturbing beauty.

*Madame Germania,
Zofia Borucka, Milan,
1996*

© *Giovanni Gastel
www.giovannigastel.it*

GIOVANNI GASTEL, Luchino Visconti's nephew, was born in Milan in 1955. He discovered his passion for photography at a young age. When he was seventeen, he began to work as a photographer for Christie's auction house and for various trade magazines. By the time he was twenty, he had already worked for some major Italian fashion magazines and was soon known in other countries. He is one of the best-known names in fashion and advertising photography, and his books include *Gastel per donna*, *I gioielli della fantasia* and *Gastel. La fotografia velata*. In 2007 the Milan Triennale dedicated an exhibition to him. He has recently published a book which brings together his work on discovering the magic of pearls.

FASHION

JIM GOLDBERG

Jim Goldberg is not a fashion photographer; he is a photojournalist. He does not follow the rhythm of news stories, but that of his own personal investigations. Goldberg's work belongs to the traditional territory of documentary photography, of 'concerned photography' that becomes involved with the story it tells, takes a particular point of view and speaks to the world about its darkest corners. He experiments with method within this tradition, adopting his own personal approach, though occasionally crossing over into other areas of expression and testing himself with different linguistic codes. Goldberg introduces his own syntax to the language of fashion photography and emphasizes its narrative aspect. For this shoot he took Dolce & Gabbana models into a hotel elevator and made it stop at the first floor. As he leads the viewer's gaze past the girl's jewel-encrusted jacket to the couple locked in an embrace behind her, the colours are warm and subdued, but there is nothing slick about the atmosphere. The teasing torment of an erotic and sentimental triangle creates a sense of melancholic claustrophobia. The image is part of a sequence that takes the form of a story, in which the models are portrayed in gloomy locations, in bleakly lit rooms with unmade beds. Goldberg shuts the glittering realm of fashion into the world of short-stay hotels that he discovered and described in his first work, *Rich and Poor.* This is a timeless, airless place where people at the margins of society live out their lives without hope for the future.

San Francisco, California, 2000

© Jim Goldberg/ Magnum Photos

FASHION

BORN IN 1953 in New Haven, Connecticut, Jim Goldberg studied photography at San Francisco Art Institute and his first work was a photo story, *Rich and Poor* (1985), an original investigation into the nature of the American dream. This was followed by *Raised by Wolves* (1995), a book and a multimedia exhibition, in which Goldberg documented the lives of street children in Los Angeles and San Francisco. In 1993 he made a photographic record of his father's illness and death in a Florida hospital, and this formed part of the book and exhibition *Hospice: A Photographic Inquiry* (1996). Goldberg has been working on two projects: a multimedia imaginary autobiography and an investigation into immigration in Europe. He has been a member of Magnum since 2006, and lives in San Francisco, where he teaches art at the California College of Arts and Crafts.

FRANK HORVAT

Frank Horvat calls himself a 'wandering Jew', a nomad in a labyrinth of languages and diverse cultural references. In his artistic career he has never limited himself to a single subject, nor to a single technique. He has produced fashion photography and serious reportage, has made studies of trees and of Degas and Robert Couturier's sculptures, and has even worked with digital processes. He thus moves easily from one genre to another, always enriching and renewing his style by exploiting different forms of expression. He traces the roots of his many-sided eclecticism back to his experience of life: 'I had lived and worked in seven countries: Italy, Switzerland, France, Pakistan, India, England and the US, and I was fluent in all their languages.' A born photojournalist and reporter, he came to the world of fashion almost by chance, bringing his own personal style with him and continuing to enrich and expand his vocabulary. 'I always seem to have been at odds with my era, always searching for this illusion of timeless fashion photography.' In 1957 Jacques Moutin, the director of the magazine *Jardin des modes*, asked him to work as a fashion photographer. He knew that Horvat came from a photojournalistic background and he admired his work, so advised him not to worry about technique, but just to take his photographs in his own way. The result was a series of highly innovative images that were much more spontaneous than any contemporary artificial studio poses. Horvat's models are placed in everyday contexts, often peculiar ones, and shot in apparently natural lighting. But his photographs are far from simple: his spontaneity has a refined and accomplished artistic quality, and his shots are carefully conceived portraits. All of Horvat's work can be interpreted as a dialogue between chance and premeditation.

Givenchy hat at the Longchamp racetrack, Paris, 1958

© *Frank Horvat*
www.horvatland.com

FASHION

FRANK HORVAT was born in 1928 in Opatija, Croatia, which was then known as Abbazia as it was still part of Italian territory. He studied art at the Accademia di Belle Arti di Brera in Milan. He bought a camera and began to work for some Italian magazines before travelling extensively in Pakistan and India as a freelance photographer. After his travels he settled first in London, where he worked for *Life* and *Picture Post*, and then in Paris, where he embarked on his career as a fashion photographer and began working for major magazines. In 1989 he began to experiment with digital imaging.

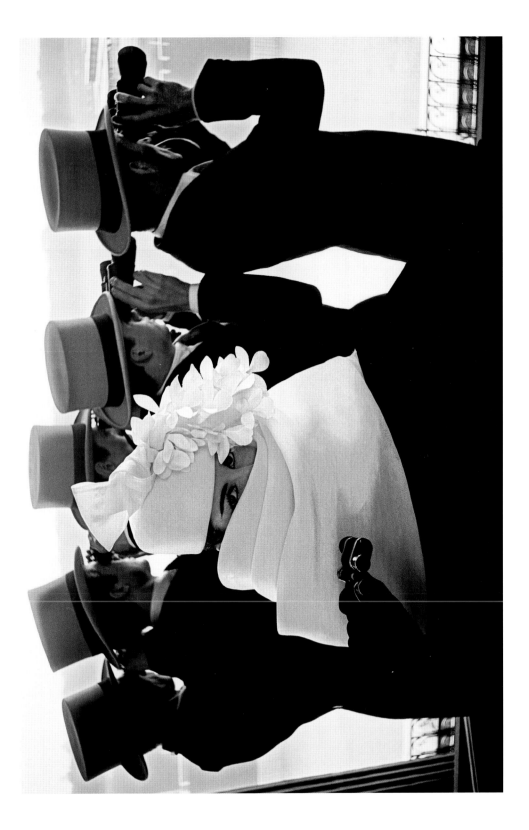

NICK KNIGHT

Nick Knight is undoubtedly one of the most visionary photographers of the contemporary scene. In his creative collaborations with today's most important and innovative designers, such as Yohji Yamamoto, John Galliano and Alexander McQueen, he has constantly challenged conventional stylistic elements of beauty and fashion photography. He has also expanded the limits of commercial photography by working with the biggest names in contemporary art, music and design. His images are visual sculptures with a futuristic appeal that comes from a symbiotic relationship between traditional photography and digital art. Knight does not rely on his fame or on an established style; he is always searching for something new, and is always ready to experiment. 'When I'm producing a piece of work, I'm looking for something I haven't seen before, and once I've produced it I'll want to see something else.' In 2000 he designed and organized his website SHOWstudio.com as a laboratory in which it is possible to experiment with digital technologies. More than 250 projects have now been created by Knight and other artists using this tool, and this has placed the English photographer at the cutting edge of development in 3-D scanning, digital sculpture and interactive film. His style consists of astonishingly elegant imagery and perfect compositions: 'Working behind the camera, I am waiting for the moment when the colours and shapes form themselves into a harmonious series of patterns. It's about the purity of the note, like a musical composition. Everything is in discord until I hit the note and the image feels correct.'

Yohji Yamamoto catalogue, 1986

© Nick Knight

BORN IN ENGLAND in 1958, Nick Knight is one of the most influential photographers in the world. He is also the founder and director of SHOWstudio.com. In 1982, while still a student at Bournemouth and Poole College of Art and Design, he published his first book of photographs, *Skinheads*. The editor of *i-D* commissioned a series of one hundred portraits from him for the magazine's fifth anniversary issue. This work caught the attention of art director Marc Ascoli, who recruited Knight to produce a catalogue for the designer Yohji Yamamoto in 1986. Knight has been awarded numerous prizes since then for his editorial work and for his advertising and fashion projects. He has created several album covers for Björk, David Bowie and Massive Attack. In 1997 he published *Flora*, a series of flower pictures. His works have also been exhibited in many major museums.

PETER LINDBERGH

A vision emerges from the back of the mind. The remnants of a dream, the recollection of a scene from a film, or some childhood memory: these different elements allow themselves to be interwoven by an artist of extraordinary creativity. Peter Lindbergh took this memorable and striking image of Helena Christensen wearing a cocktail dress walking along a dusty and deserted country road. Her head is bowed, she is barely recognizable, and beside her a bizarre alien being gazes around with a benign air. The scene is immersed in silence and its blurred edges suggest a mirage. The photo was published in 1990 in Italian *Vogue* and its impact on the world of fashion photography was shattering. This had nothing to do with the customary glittering surface of fashion images of the time; the viewer is simply left open-mouthed when confronted with Lindbergh's photographs. As Wim Wenders writes, his creations are 'utterly different. They defy all laws of gravity in this realm. They redefine the very world they depict.' A particular light and a perfect composition are not enough; it is only when the spirit of the person being photographed comes through that Lindbergh feels he has come close to his goal. He works with the most celebrated models and insists that they be as natural as possible, wearing minimal make-up and styling their hair simply, so that all their individual feminine mystery may appear in front of his camera. Wenders writes that this is the 'science fiction aspect of Peter's work, the complete utopia... He turns those goddesses into human beings, without taking any of their aura away!'

*Helena Christensen
& alien, El Mirage,
California, 1990*

© Peter Lindbergh

FASHION

PETER LINDBERGH was born in 1944 in Poland and grew up in West Germany. He first used a camera at the age of twenty-seven and shortly afterwards became an assistant to the photographer Hans Lux. After two years he started to work as an advertising photographer. In 1978 he moved to Paris, and since then his images have appeared in every major fashion magazine in the world. He is considered a master of black-and-white photography, and has produced advertising campaigns for the greatest designers. He has also directed short commercials, documentaries and music videos. In 2002 his work *Inner Voices* on the theme of self-expression was awarded a prize for best documentary film at the International Festival of Cinema in Toronto. In 2006 FORMA in Milan held the retrospective exhibition 'Visioni', which Lindbergh conceived especially for the space.

SARAH MOON

Everything could fit under that hat, which looms as large as a black sun cutting across the horizon. In this image it seems as though day is beginning, and so too is the spectacle of a fashion show. This is a film, a story. The designer Yohji Yamamoto is the performer, and Sarah Moon the photographer. Yamamoto is one of the most visually original and refined brands in haute couture and prêt-à-porter. Moon begins with an interior shot on the catwalk, her camera moving between bodies, hands and skin: her angle of view seems to enliven every garment. Her past experience as a model means she can easily avoid any tedious or outmoded play of manners, and from the very beginning of her career she aimed for a highly individual style. Her images are semi-autobiographical, a little cloudy, a little out of focus. They are suffused with delicacy, whether they are in colour or black-and-white, or are taken with a Polaroid or a 35mm camera: the artist's short-sightedness influences what she describes and enhances. With these images she evokes dreamy stories from past eras: Pre-Raphaelite girls with long wavy hair, white faces and eyes so large they overwhelm every other feature, black with mascara and shining with innocence. She evokes satin ribbons about to slip from the shoulders. And there are her recent images, stories she tells us in painted colours, in a semi-constructivist style, with a hint of Malevich. Throughout Moon's career, from her Cacharel advertising campaigns to her recent work for the most celebrated Japanese designers, physical daintiness has always set the rules, yet it is at the same time always strong and active, because that elusiveness is her brand.

Yohji Yamamoto, 1997
*(*Elle*)*

© *Sarah Moon*

FASHION

SARAH MOON was born in England in 1941, to a French mother and an English father, but grew up in France where she studied design at art school. Between 1960 and 1970 she worked as a model in Paris and London. In 1967 she started her career as a photographer, later also becoming a film director. She worked with important magazines such as *Marie Claire, Harper's Bazaar, Vogue, Elle* and *Stern*. In 1972 she was the first woman to take the photographs for the Pirelli calendar. She has made various films, including *Mississipi One* (1991), biographies of Henri Cartier-Bresson and Lillian Bassman, and shorts accompanying and supplementing her revisited visual 'fables' such as *Circuss* (2003), *L'effraie* (2005) and *Le fil rouge* (2006). In 2001 her comprehensive monograph, *Coincidences*, was published.

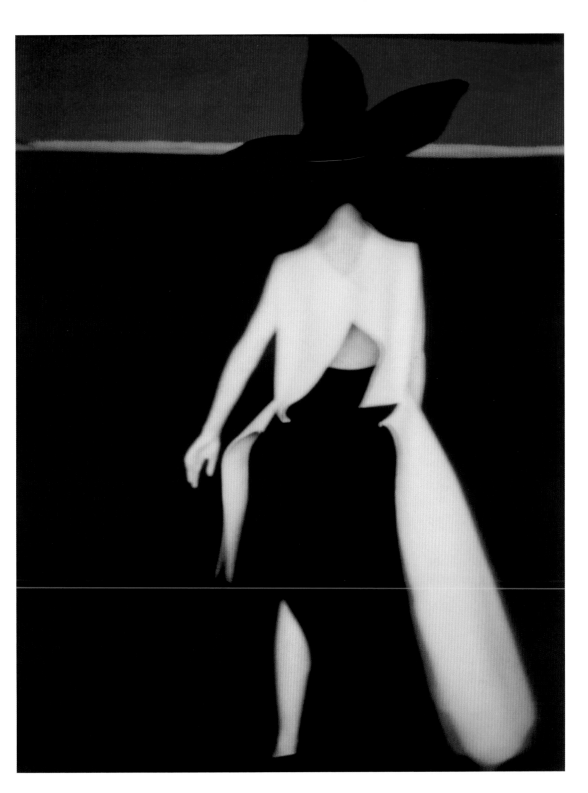

MARTIN MUNKACSI

Dynamism, speed and a modern rhythm: Martin Munkacsi brought some fresh air to photography, the dream of a different world made up of movement, intuition and deftness. Legend has it that this Hungarian photographer's career began in the 1920s, when by chance he recorded a brutal fight. His photographs were a vital part of the prosecution case and they earned him notoriety. By 1928, he had already worked for the *Berliner Illustrierte Zeitung* and *Die Dame*. His favourite subjects were fashion, sport and photographs 'snatched' in the streets of Berlin. He then moved on to aerial photographs, which were bold visual experiments, and travel photography from his many journeys. His vision was always fresh; he was ironic but never banal; and he worked as quickly as modern times demanded. In 1934 he began a collaboration with *Harper's Bazaar* and then with *Life* magazine in New York. Portraits and photographic innovations became his distinctive signatures. The atmosphere in his pictures is fascinating and enchanting, as is his ability to be light but never superficial, elegant but never bombastic. With Munkacsi, fashion photography became exciting again, so much so that the young Richard Avedon, then just eleven years old, covered the walls of his bedroom with Munkacsi photographs cut out from magazines. This image of a woman with an umbrella in her hand skipping onto the pavement on a rainy day fascinated Avedon and he took it as a model for some of his own creations. Where there was once immobility, now there is movement; where clichéd formulas were endlessly repeated, now the street, inventive techniques and, above all, emotion are part of the image. Avedon was to encounter his hero only once, in front of the Plaza Hotel in New York. It was a brief but significant meeting: 'I saw a bald man with a camera posing a very beautiful woman against a tree. He lifted his head, adjusted her dress a little bit and took some photographs. Later, I saw the picture in *Harper's Bazaar*. I didn't understand why he'd taken her against that tree until I got to Paris a few years later. The tree in front of the Plaza had that same peeling bark that you see all over the Champs-Elysées.'

Marianne Winkelstern, London, 1933

© *Munkacsi/Ullsteinbild www.ullsteinbild.de*

MARTIN MUNKACSI was born in 1896 in Kolozsvár, then part of Hungary. He worked as a sports photographer in Budapest before moving to Berlin in 1928. In 1934 he moved to New York to escape from the Nazi regime. In America he worked for the major fashion magazine *Harper's Bazaar* and achieved great success. His habit was to take the models out of the studio, and he produced one of the first articles with nude illustrations in a popular magazine. He also worked as a portraitist of Hollywood stars. Munkacsi died in poverty in 1963, by which time he was almost forgotten by the world. In 2007 F. C. Gundlach dedicated a major exhibition to him.

HERB RITTS

Helmut Newton once told Herb Ritts that 'choosing the model represents ninety-five per cent of a photograph'. And, when you count up these super-models, you will see that Ritts has chosen five creatures who can define an era. In order, they are Stephanie Seymour, Cindy Crawford, Christy Turlington, Tatjana Patiz and Naomi Campbell. They are all here, a hymn to the 1980s, and this in itself is something exceptional. By wearing nothing, they display their natural beauty, but each tells her story in her face, her eyes or her lips, which are either closed or slightly apart: Stephanie is fragile, Cindy is cool, Christy is eternally feminine, Tatjana is dreamy and Naomi is sensual. The combined elegance of their bodies, the light and the setting is all due to Herb Ritts, who stands on the other side of the lens. He was one of the most sensitive, gentle and kind men ever to take up a camera. His secret was his naturalness, which did not come from his parents' house in Los Angeles being next door to Steve McQueen's, nor from his motorbike races in the desert and his barbecues on Sundays. It came from the fact that Ritts understood how to look at everyone: he regarded men and women with the same dedication. His images were always a tribute to the splendour of the human body, either men suntanned and muscular with veins raised in relief, or girls with pneumatic curves that were athletic but never over-developed, their hair blown by the wind or slicked back, and always deeply feminine. Herb could always be trusted, that was guaranteed. His vision drew on classic figures of fashion and masculine glamour from Horst to List, from Platt Lynes to Hoyningen-Huene. He also had a touch-sensitive understanding of Californian nature. Finally, he had a confidence in dealing with celebrity, and he knew how to peel away its every useless excess on our behalf.

Stephanie, Cindy, Christy, Tatjana, Naomi, Hollywood, 1989

© Herb Ritts Foundation

FASHION

HERB RITTS was born in Los Angeles in 1952. His family had a furniture business and, after graduating in economics, Ritts became its travelling salesman. At this time he started to take photographs. Among his first images, taken in 1978, was a series of portraits of Richard Gere that were to become historic: they show the desert, a gas station and the actor wearing jeans and a T-shirt, two years before he appeared in *American Gigolo*. The photos reached *Vogue* and this was the start of Ritts's brilliant career with *Harper's Bazaar*, *Rolling Stone* and *Vanity Fair*. His advertising campaigns for Versace, Armani, Chanel, Calvin Klein, Gap, Valentino, Levi's and Pirelli are all memorable. He created portraits of many celebrities, especially Madonna, with whom he worked for many years. Ritts died on 26 December 2002.

PAOLO ROVERSI

Paolo Roversi is a great fashion photographer, an artist who revolutionized this style of photography. He is an Italian who has lived in Paris since the early 1970s, and he was the first photographer to use the 20 x 25 cm Polaroid format, which opened the way for new experiments in the use of a highly expressive and intense light. Roversi has ventured beyond the limits set by the genre of fashion photography: he always seeks purity in his black-and-white images and is highly interested in portraits, nudes and still lifes. He is particularly sensitive to light and colour, creating delicate images that are supreme expressions of grace and fragile beauty. He works with a large format and long exposure, which allows him to exploit natural light as it pours through the window of his Paris studio. The models invited to pose in front of his Polaroid camera are transformed into angels, into phantasmal figures who float in a timeless and hypnotic universe. Roversi constantly fights against the construction of their professional image. 'These are portraits of encounters,' he says. 'In the nude, masks fall away. They can no longer play a role. There is no more defence, only the relationship between fashion photographer and model ... all the little clichés, smiles, gestures, poses, hand movements, they all disappear. What remains is their gaze, their body, their sexuality. They are self-conscious and a little *à la garçon*. This leaves a moment of emptiness. And for me, this emptiness becomes a moment of richness.' Suspended between their materialization and the possibility of their sudden disappearance, Roversi's figures are full of life at the same moment at which they seem about to vanish either into the darkness or the light. 'Above all, photography is the representation of the unknown, of the unreal. For me, the photograph is a dream.'

Natalia, Paris, 2003

© *Paolo Roversi*

PAOLO ROVERSI was born in Ravenna in 1947. His interest in photography was ignited when he was seventeen during a trip to Spain, and at twenty he began working as a reporter for a photo agency. In 1970 he opened his first studio in Ravenna, where he focused on still lifes and portraits. In 1973 he moved to Paris and, on meeting Laurence Sackman, developed an interest in fashion photography, later becoming Sackman's assistant. Though Roversi's first works were far from the world of fashion, he soon found his path. He currently lives and works in Paris. He regularly collaborates with numerous publications, and works on advertising campaigns for renowned stylists.

STÉPHANE SEDNAOUI

The water slips glossily over the surfaces, changing and distorting every-thing. In this image the artist confounds expectations, establishing new and insoluble enigmas for the spectator. Stéphane Sednaoui's magical and surreal photography is a continuous game of distorting mirrors, of surfaces that appear to be real but are fictitious illusions that we would do well to doubt. Sednaoui began his career with William Klein, but soon sought out his own highly individual artistic path, which includes pop and underground elements. His characteristic style is to subvert conventions. He pushes fashion photography into uncharted territory, blending classi-cal journalistic reportage with private photography, and always presenting his spectator-readers with a forest of meanings in which to lose ourselves. Sednaoui's photographs are often like a record being played backwards, sending out unrecognizable phrases for which the terrified listener tries to find a meaning. His creations are both exciting and bewildering, and, when we are confronted with their dynamic and continuous shifts in meaning, it is difficult to believe our own eyes. Sednaoui's website has greeted visitors with an old clip of Charlie Chaplin in one of his later and more controversial roles – Monsieur Verdoux, a typical example of a respectable and apparently straightforward reality, which we learn to doubt. At the end of the film we might go back and view it again, to see the little hints scattered here and there in a completely different light – the inflections of Chaplin's melliflu-ous tones, his exaggerated behaviour which at first sight seems so blameless. Sednaoui uses *Monsieur Verdoux* as a warning to all his followers who are enthralled by the world of images: be wary of what is called reality and, for once, try not to believe what your poor, confused and overwhelmed eyes tell you.

Anthroposexomorphic 2

© *2000 Stéphane Sednaoui*

FASHION

STÉPHANE SEDNAOUI was born in Paris and now lives in New York. His career began with the great photographer William Klein, but he soon started to develop his own original and spectacular graphic style which explores the different areas of photography – fashion, advertising and reportage. Sednaoui is immersed in pop culture and in the course of his career he has directed videos for some of the most famous musicians in modern music, including Björk, Madonna, Massive Attack and the Red Hot Chili Peppers. The Contemporary Art Museum of Shanghai showed his work in two exhibitions, 'Remote/Control' and 'Animamix' in 2007, and the Galerie 208 in Paris showed 'Anthroposexomorphic' and 'Acqua Natasa' in 2008.

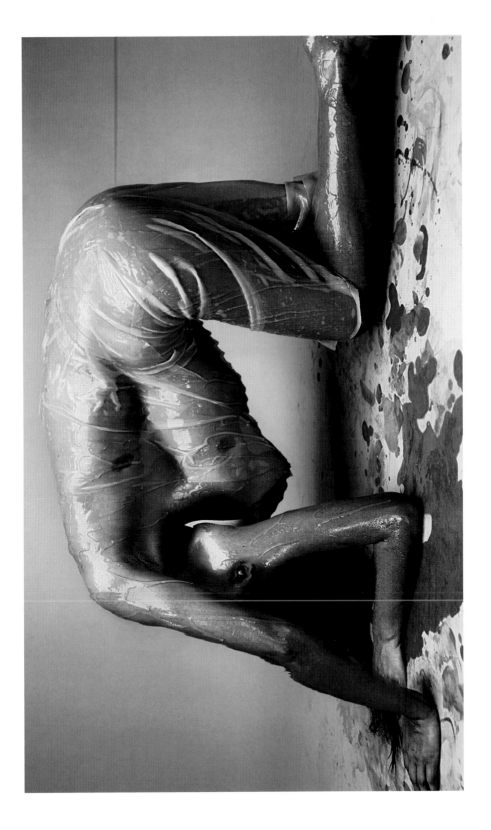

MARIO SORRENTI

Her body is almost two-dimensional, her gaze is magnetic, and her appeal is mysterious. Here is the new goddess of fashion. The 1980s were a celebration of hedonism and rampant materialism, of wealth and luxurious smiles. The bodies on magazine covers had to be glowing, sculpted and exuding good health; models were a kind of beautiful Valkyrie. In the second half of the 1990s, faces and sizes both changed – brand names were victorious but style became minimalist, grungy and apparently sloppy. In America the term 'heroin chic' was coined, and the most successful models were emaciated and pale with rings round their eyes. Kate Moss was a key figure: she was the highest paid, the most imitated and the most controversial. It was this campaign for Calvin Klein's perfume, Obsession, that launched her into the world of supermodels. It was a double anointing, for the model and for the photographer. Mario Sorrenti is one of the most successful fashion photographers today, but he was just twenty-one years old then and in a relationship with a nineteen-year-old model. He photographed her: his images were an album for her and a portfolio for him to present to the world. He had used a camera since the age of ten and had grown up with art: his parents worked in the fashion world and he moved with perfect self-confidence in that environment. He showed his images to Calvin Klein just at the moment when Klein was looking for a face and a photographer for his new Obsession campaign. Klein said: 'It was perfect for Obsession – his real obsession with her. You can see the love he has for this girl. I said let's give him a camera and let him shoot his feelings for her.' She was Kate Moss. They chose the location and the two of them left, he and she, both little more than adolescents, the photographer and his model. Thus, a supermodel and a style were born, a new icon of beauty in one of the most memorable advertising campaigns of recent times. For Mario Sorrenti, too, it was the start of a long and brilliant career.

Kate Moss, Calvin Klein's Obsession Campaign, 1993 (IMG Worldwide)

© Mario Sorrenti/ Art Partner www.artpartner.com

MARIO SORRENTI was born in Naples in 1971. At the age of ten, he moved to New York with his family. His parents were artists and, while Sorrenti was still an adolescent, he started to document his life with a camera. At twenty-one, he began a long collaboration with Calvin Klein. He has worked for major international fashion magazines and with Missoni, Ungaro, Jil Sander, Atsuro Tayama, Yves Saint Laurent and Shiseido. He has also directed various TV commercials for fashion houses and created images for numerous albums. In 2001 he published the book *The Machine*, a work dedicated to his younger brother, who died in 1997. Sorrenti's works have been shown in exhibitions all over the world. He now lives and works in New York.

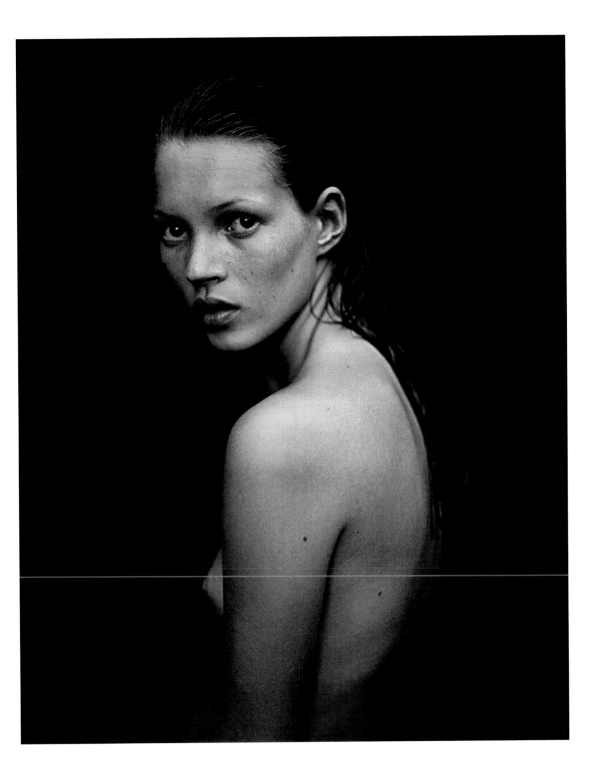

DENNIS STOCK

In 1951, at the age of just twenty-three, Dennis Stock won a competition for young photographers held by *Life* magazine. The legendary Robert Capa quickly recognized Stock's talent and invited him to join Magnum. The agency was growing and by that stage it had a large membership, and Capa, its president and a great cinema enthusiast, was eager to strike up stimulating and rewarding relationships with directors, set makers and film companies. And this was the role that he foresaw for the young Stock: he was to be the photographer in Hollywood during its boom years of the 1950s, Magnum's correspondent to the stars of the silver screen. Stock got to know James Dean here, became his friend, and presented the world with celebrated images of the actor – the most famous being his melancholy and solitary walk in rain-drenched Times Square – which contributed to the creation of the myth of a tormented and fragile rebel. And it was also in New York, in 1954, that he photographed a young actress, Audrey Hepburn, in a moment of calm on the set of Billy Wilder's film *Sabrina*. The filming lasted for nine weeks, at the end of which the cast presented their leading lady with a silver box inscribed: 'To Audrey Hepburn, with sincere affection and great admiration of the whole cast.' The elfin actress conquered everyone; she had even won an Oscar for her first film role in *Roman Holiday*. Wilder called her 'a joy to direct', and to enhance her innate elegance he engaged Givenchy, at that time the most exclusive designer in the Paris fashion world, as the film's costume designer. *Sabrina* received an Oscar for the best costumes, and permanently established Audrey Hepburn in the firmament of Hollywood stars. Dennis Stock's image of her was seen around the world, a further revelation of the innate grace and sophisticated charm of a great actress who was an icon not only of style, but also of engagement and intelligence.

Audrey Hepburn in Sabrina, *directed by Billy Wilder, New York, 1954*

© *Dennis Stock/ Magnum Photos*

FASHION

DENNIS STOCK was born in New York in 1928 and started to pursue photography after the Second World War. He was an assistant to Gjon Mili, and in 1951 his photo story on immigrants arriving into Manhattan by boat won first prize in *Life*'s Young Photographers contest. He joined Magnum and began a long career in Hollywood. Over the years he photographed prominent jazz musicians, and documented American music festivals and the lifestyles of alternative communities. During the 1970s and 1980s he worked on colour photographs emphasizing the beauty of nature. In later years he returned to his urban origins, exploring the modern architecture of large cities. His works are to be found in all the major international museums. He died in January 2010.

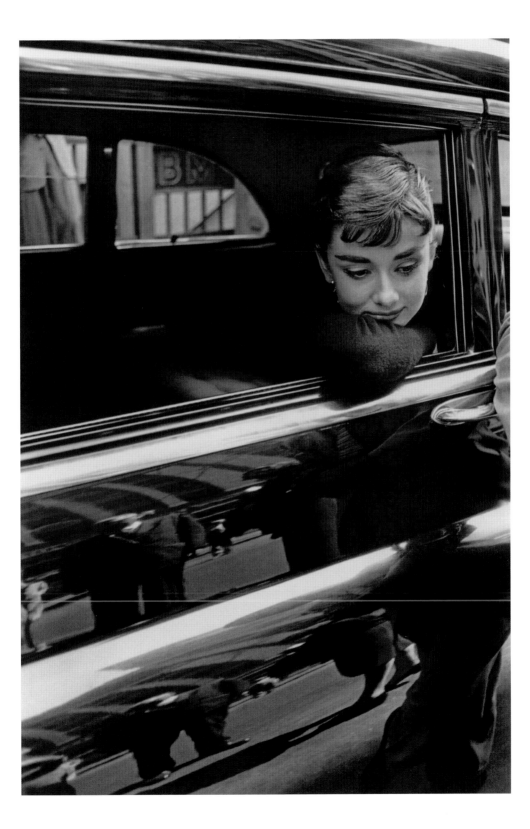

OLIVIERO TOSCANI

'I'm not really a publicist. I only wanted to show how through advertising it is possible to do something different, and I succeeded in doing it.' He is not a publicist, but nor is he just a photographer; in one way or another, Oliviero Toscani is a genius of communication. He has been acclaimed and criticized, censored and praised by newspapers, television and businesses; he is both hated and adored. He has made a style out of provocation, disturbing his interlocutor, twisting responses, shattering the inertia of the daily consumption of images. In 1982, when he began to create advertising material for Benetton, he subverted every stereotype, and in a few short years the label had become one of the best known in the world. Toscani used gigantic photographs, did not include breathtaking models, and progressively made the product being advertised disappear. He was advertising values. He put his finger on the raw nerve of our times. There were no adverts with beautiful smiling families, but instead a baby still attached to the umbilical cord, a priest and a nun kissing, a man dying of AIDS, images of the Bosnian War and the Albanian exodus on giant posters in cities and on the pages of newspapers. He went so far as to show the faces of twenty-eight men on Death Row in the United States, a choice that provoked storms of protest and a definitive rupture with the clothing company. The objective of all advertising is the sale of a particular product, but Toscani maintains that it is also a powerful form of communication that speaks to society as a whole. The kissing priest and nun evoked the notion of overcoming sexual and religious taboos. A prohibition was being violated; opposing identities could live together; barriers could be broken down. The only commentary on the image was the company's logo. And yet it is still advertising. It raises the question, how does the desire for profit transform denunciation into speculation? Popular wisdom would reply that it is better to be talked about than not.

Priest and nun, 1991

© *Oliviero Toscani*

FASHION

BORN IN 1942 in Milan, Toscani studied photography and graphic design in Zurich. He is the creative force behind some of the most famous magazines and brand names in the world, creating images and advertising campaigns, and has worked as a fashion photographer for major magazines. From 1982 to 2000, he created the brand image and strategy of communication for Benetton. In 1990 he devised *Colors* magazine and in 1993 founded Fabrica, a communication research centre, later followed by another, La Sterpaia. Since September 2006 he has been engaged in the artistic direction of the interactive TV channel MusicBox.

MAX VADUKUL

Max Vadukul is all about rhythm, music, animation and continual invention. A visit to his website (www.maxvadukul.com) – which is recommended to those who think that fashion photography is tedious, bombastic and repetitive – becomes a veritable journey through forms of art and communication that are blended together in a unique and rich way. Vadukul is overflowing with a creativity that makes itself felt in his incredibly dynamic photographs, his elegant designs, his preference for 1970s-style optical art forms, his insistence on the circle as a recurring and dynamic device, and in the music that he creates and plays, for example, with his Max Vadukul Trio. It may be here, in his music, that it is also possible to get to know and appreciate his photography. It is as though music, with its exhilarating movement, can give meaning to everything else. Vadukul is especially fond of drums and their recurrent pounding rhythms are not just part of his jam sessions, which are themselves an echo of the 1970s, but also of his fashion photographs, which are simultaneously retro-styled and ahead of their time. It is a heartbeat that underlies the images, the still pictures on a single roll of film as long as Vadukul's own life and as varied as a journey around the world. If 'everyone is photographable', as he says on his website, then only he has been granted the ability to feel that beat. With his sinuous rhythms he conducts us, through fashion photography, incomparable icons of beauty and innovative reportage, creating new myths and, appropriately, new rhythms that resonate with all our hearts.

I Love Challenge, Italian Vogue, *2003*

© *Max Vadukul/ art-dept.com/ trunkimages.com*

MAX VADUKUL was born in Nairobi in 1961, but grew up in London. From an early age he concentrated on fashion, becoming Yohji Yamamoto's photographer in 1984. He works with the world's major magazines, including Italian *Vogue, L'Uomo Vogue* and *Vogue Hommes International*, and has created numerous covers for *Rolling Stone* magazine. He has carried out advertising campaigns for Armani, Comme des Garçons, Romeo Gigli, Max Mara and many others. He is also a staff photographer on the prestigious *New Yorker* magazine. He has published two books, *Max* (2000) and *Crazy Horse* (2001). He now lives and works in New York.

NOBUYOSHI ARAKI

Nobuyoshi Araki is the most controversial, provocative and sought-after Japanese photographer on the contemporary art scene. The inspiration behind his work is found in every facet and form of Eros – love, passion, desire, sexuality and loss. The favourite subjects of this erotic poet are the ethereal, seductive bodies of his models, women's faces, forms of figures embracing, Japanese skies, Tokyo nightlife, and colourful, sensual flowers. For Araki, photography 'is a furtive act of love-making, which mixes the sacred with the profane'. The picture revolves around a symbolic image of sexuality, intensely feminine both in the carnal and in the abstract. The flower, with its vibrant colour and sumptuous form, expresses and exalts pure, natural physicality. It is the embodiment of sublime, ephemeral beauty, and hints at unfathomable mysteries: the subtle boundaries that separate life from death, the sacred from the profane, pleasure from pain. In Araki's photographs the powerful symbolism of the flower, like the female body, is imbued with a sense of stillness and equilibrium, portraying Eros as a fundamental, universal life force.

Untitled, from the book Araki, *ed. Jérôme Sans, published by Taschen, 2002*

© Nobuyoshi Araki

NOBUYOSHI ARAKI was born in Tokyo in 1940, where he still lives and works. He is one of the most famous artists in Japan and is well known internationally. He has written numerous books, and his works have been exhibited in major galleries, including the Museum of Contemporary Art in Tokyo and the Kyoto Museum of Contemporary Art. In Europe his works have been exhibited at the Centre National de la Photographie in Paris, the Stedelijk Museum voor Actuele Kunst in Ghent, the Secession in Vienna, the Barbican Centre in London, the Centro per l'Arte Contemporanea Luigi Pecci in Prato, and the Galleria d'Arte Moderna in Modena.

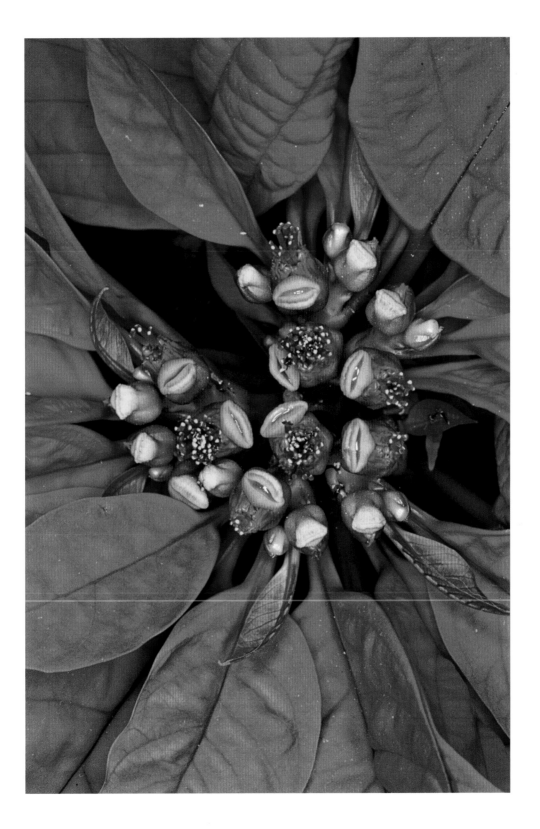

GIAN PAOLO BARBIERI

Ten starfish are the unusual protagonists of this sophisticated picture, in white and black, with amber tones. The balance of the composition is achieved by the repetition of shape, the pattern altering slightly with each repetition. The subjects of Gian Paolo Barbieri's photographs are taken directly from nature, carefully selected from the tropical latitudes of the Seychelles. Nature, in its luxuriant magnificence, is not reproduced authentically, but serves as the inspiration behind a series of exotic, dreamlike creations. The creativity of the photographer lies in his skills of selection and composition, in the interplay of pattern, form and colour, of memory and immediacy. Combined with nature's raw materials, this produces an image of timeless beauty. The photograph is not seeking to be a truthful representation. The precision of the composition, and the minute details observed at close range, are two of Barbieri's methods of pushing the boundaries of the visible, and creating an other-worldly perfection.

Starfish, Seychelles, 1999

© *Gian Paolo Barbieri*

GIAN PAOLO BARBIERI was born in Milan in 1938. After a period in Rome working in film, he moved to Paris, where he was assistant to Tom Kublin. In 1965 he started to work for Italian *Vogue*. In 1978 *Stern* magazine named him among the top fourteen fashion photographers, and in 1982 he published the book *Artificial*. In the course of his work he travelled to many exotic locations, which then became the subjects of important and innovative photographic projects, such as *Madagascar, Tahiti Tattoos, Equator* and *Innatural*. In 2007 a major retrospective devoted to his work opened at the Palazzo Reale in Milan.

ANTONIO BIASIUCCI

Antonio Biasiucci grew up not far from the slopes of Vesuvius, where the earth still shifts and bubbles. Time seems to stand still in the face of these primeval forces of nature, chthonian forces that can take the shape of a dinosaur's egg emerging from the boiling, tumescent mud. Biasiucci's style eliminates the extraneous and examines the detail: he looks for the universal in what he sees and leaves it open to different interpretations. As William Blake said, we should look at the whole as the sum of its parts. By using black and white, Biasiucci explores the contrasts of light and shade in a range of subjects, including inanimate objects, stuffed animals, archaeological finds from Pompeii, and the plaster casts of anthropomorphic figures. They are the relics of an abandoned civilization, fragments of a lost world, now illuminated and rescued from obscurity. It is as if things that no longer have a function, and have been thrown aside as useless, can be rendered beautiful and valuable once more through photography. Silence pervades the photographs, a silence as complete as that of the moment that precedes creation, and the moment that follows the end of life. Biasiucci explains: 'I was born with black and white, and my imagination is constructed out of black and white.' He is seeking to portray a different aspect of reality, one where organic and inorganic forms intermingle in a process of continual metamorphosis. His photographs act as an invitation to go further, to go beyond the divide. The light conquers an area of darkness, giving new life to what it touches.

Mud, The Solfatara, Pozzuoli, 1995

© *Antonio Biasiucci*

ANTONIO BIASIUCCI was born in Dragoni, Caserta, in 1961, and moved to Naples in 1981, where he began to study concepts of space on urban peripheries. In 1984 he began to work on a documentary of volcanic activity in Italy for the Osservatorio Vesuviano. In 1992 he won the European Kodak Panorama prize at Arles. His research has been rooted in topics pertaining to the culture of the south of Italy, and more recently he has begun to explore the primary elements of existence and personal memory. His book *Res: Lo stato delle cose* (2004) won the Kraszna-Krausz Photography Book Award and the Bastianelli Prize. The work *Ex voto* was exhibited as part of the 2007 FotoGrafia International Festival.

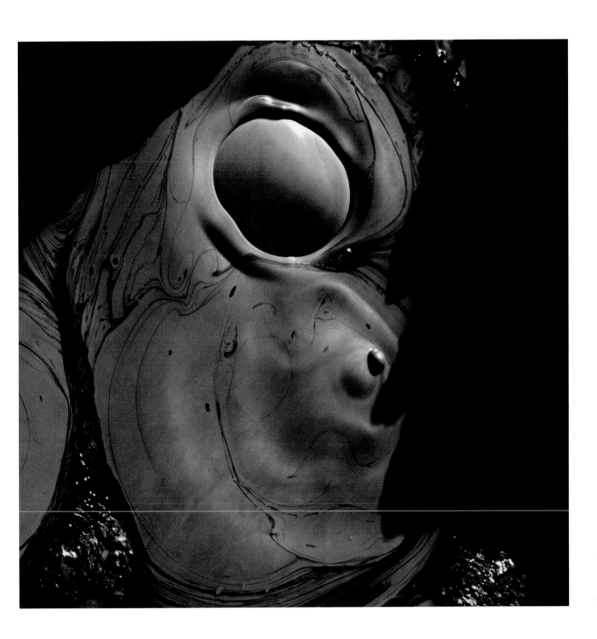

GIOVANNI GASTEL

Here Giovanni Gastel has taken four identical objects and photographed them one on top of the other to create a new form. It is typical of this Milanese artist, who has pushed the boundaries of traditional still-life photography and developed his own unique style. The image is articulate and elegant in its simplicity. The central silhouette, composed of the interplay of sinuous lines in a way that is reminiscent of a Miró painting, is about to be swallowed up by a giant Surrealist mouth, not dissimilar to the famous sofa modelled on Mae West's lips which was designed by Salvador Dalí in the 1930s. Hints of irony are combined with an extraordinary technical perfection in this photograph. Gastel used a large-format camera, a Deardorff, with a plate size of 20 x 25 cm, which allowed him to capture perfectly the intricacies of detail and colour. The purest touches of red are a crucial element of the whole composition, and an integral part of the seductive power of the photograph. The use of colour is innovative, striking an intriguing balance between artistic experimentation and effective advertising.

Woman, Milan, 1983

© Giovanni Gastel
www.giovannigastel.it

GIOVANNI GASTEL was born in Milan in 1955. Nephew of the director Luchino Visconti, he became passionate about photography at a young age, and by seventeen was working for Christie's and taking his first still-life photographs. A tireless experimenter, by the 1980s his sophisticated, distinctive style had made an impact on the fashion world. The 1997 Triennale in Milan mounted a retrospective exhibition devoted to his work entitled 'La fotografia velata'. Gastel teaches at several educational establishments, and divides his time between Paris and Milan.

ANDRÉ KERTÉSZ

When the legendary Leica came onto the European market in 1925, it seemed to have been made for André Kertész. He had been taking pictures on the streets of Budapest since 1912, carrying around with him medium- or large-format cameras with glass plates. His approach had been so modern that Henri Cartier-Bresson was later to remark that 'everything we did had already been done by Kertész'. Cartier-Bresson, who later excelled in the art of the decisive moment, was only four years old when Kertész was excelling in the art of the fleeting moment, of the unexpected detail, and of elliptical vision. He was creating his own modern form of lyrical realism. In 1925 he moved to Paris, to the heady atmosphere of avant-gardism. Some of his most famous photographs were taken at the celebrated Café du Monde, a meeting place for artists, dreamers and drifters. In 1928 he photographed a fork, or rather the idea of a fork – a fork that represented the idea of form, and the idea of light; light gliding perfectly over an object, which then transcends its usual, practical function and becomes a vehicle for more cerebral thoughts. Kertész was not trying to create an abstract, but to reveal the beauty hidden within objects. His composition is simple and minimalist, but objects do not melt away into lines, they remain objects. Kertész rests the fork against a plate, and zooms in with the lens until neither the fork nor the plate are visible in their entirety. The fork is still clearly a fork, but thanks to the formal composition, the play of light and shade on the surfaces, and the tonal richness of black against white, it has been imbued with an aesthetic dignity and grace. Life is composed of such fleeting glimpses of beauty, but one must learn to look at the world in wonder in order to be able to catch these moments of enchantment before they fade away.

BORN IN BUDAPEST, Hungary, in 1894, André Kertész bought his first camera in 1912 and began taking photographs of acquaintances and street scenes. In 1925 he emigrated to Paris, where he became involved in the avant-garde movement. He also worked as a freelance photographer for several magazines, including *VU*. In 1933 he shot the famous series 'Distortions'. In 1936 he and his wife moved to New York, where he worked for *Harper's Bazaar*, *Vogue* and *Look*, all the while pursuing his personal photography projects. In 1981 he published *From My Window*, a collection of photographs taken from the window of his apartment in New York. In 1984 he donated all his negatives and personal documents to the French state archives. He died in 1985.

NICK KNIGHT

In 1992 the visionary photographer Nick Knight visited the herbarium in the Natural History Museum, London, where he discovered a world that surprised and fascinated him. As he looked at the exhibits, the beauty of the plants revealed itself to him in unexpected ways. 'My attention was seized immediately. I realized I had discovered a real gem. What I found most fascinating was the way these plants did not resemble plants at all. They made me think of completely different things: some looked like feathers, but like neon feathers, designed by laser, exquisitely refined and enchantingly delicate.' Already famous for his creative graphic style, and for the 'visual sculptures' of his perfect compositions, Knight devoted the next few years to taking these extraordinary still-life photographs. Splashes of colour in unusual geometric shapes stand out against a stark white background, taking the observer by surprise, and challenging the conventional view of plants as objects of transient, ephemeral beauty. 'These plants did not seem to be dead; they seemed to emanate life. Transplanted from their normal, fragile context, they seemed to have acquired a new and bold vitality. They managed to escape their destiny.' The project, published as the book *Flora* in 2004, is representative of Knight's artistic style, always in search of new ways of seeing things, and new ways of photographing them. 'One of the things which makes me most happy is to find a new and different way of seeing a familiar object, something that would have seemed unimaginable until that moment. It is a wonderful sensation, liberating and optimistic.'

Flora, 1997

© *Nick Knight*

BORN IN ENGLAND in 1958, Nick Knight is one of the most influential photographers in the world. He is also the founder and director of SHOWstudio.com. In 1982, while still a student at Bournemouth and Poole College of Art and Design, he published his first book of photographs, *Skinheads*. The editor of *i-D* commissioned a series of one hundred portraits from him for the magazine's fifth anniversary issue. This work caught the attention of art director Marc Ascoli, who recruited Knight to produce a catalogue for the designer Yohji Yamamoto in 1986. Knight has been awarded numerous prizes since then for his editorial work and for his advertising and fashion projects. He has created several album covers for Björk, David Bowie and Massive Attack. His works have also been exhibited in many major museums.

LOUIE PSIHOYOS

It is a process that was happening millions of years ago and continues to happen today, but in different media. In Mesozoic times the medium was amber; here it is photographic emulsion, although even that is slowly becoming a thing of the past. Digital photography cannot possibly compare: its technique of capturing an image lacks real physical substance. The insects trapped in the resin were preserved intact down the ages, ending up in the Museum für Naturkunde (known as the Humboldt Museum) in Berlin. Since 1839 images of our faces, bodies, expressions and emotions have until recently been set in the silver compound used for daguerreo-types and film and, like the insects in amber, they have endured down the years. Louie Psihoyos has always been interested in palaeontology and has devoted a substantial part of his long and varied career to it. Commissioned by *National Geographic*, he travelled the world documenting dinosaur dis-coveries and researching these early inhabitants of the planet. Millions of years ago, at the opposite end of the size spectrum, insects appeared along-side these dinosaurs. This brings to mind *Jurassic Park*, the book by Michael Crichton, which explores the extraordinary idea of recovering dinosaur DNA by extracting the dinosaur blood sucked by the small predators of the time. The book, later made into a film by Steven Spielberg, illustrates the success of this experiment, and its inevitable disastrous consequences. But returning to the photograph by Psihoyos, here it is still possible to imagine these insects flying around in blue skies and sunshine. Suddenly the buzzing ceases: they have become stuck in amber. There is the faintest of sounds, then nothing. It is a prehistoric snapshot.

Insects in amber, Berlin, 1991

© *Louie Psihoyos/Corbis*

LOUIE PSIHOYOS was born in Dubuque in Iowa in 1957, the son of a Greek immigrant who fled the Communist occupation of the Peloponnese. At the age of fourteen Psihoyos discovered photography and won several Kodak photography contests. He graduated in photojournalism from the University of Missouri and moved to New York, where he lived for ten years, alongside Sandro Chia, Julian Schnabel and Arman, in an artists' building that was both home and studio. In 1980 he joined the staff of *National Geographic*, where he worked for seventeen years. In 1994 he published the volume *Hunting Dinosaurs*, a record of all the major palaeontological discoveries in the world. This was followed by *Hyperion* (2000), a book devoted to the first computer-controlled sailing yacht. Psihoyos lives in Boulder, Colorado.

STILL LIFE

WILLIAM HENRY FOX TALBOT

It was called a shadowgraph. The name hardly does it justice, but this is what William Henry Fox Talbot chose to call his invention. These shadowgraphs were a crucial stage in the revolutionary invention of photography. An object, in this case the minute perfection of a leaf, is interposed between the light source and a piece of paper soaked in a solution of salt and silver nitrate. It would then be exposed to the light, causing the unprotected sections to darken. Next came the process of fixing, again using a salt-based compound, and finally a negative would appear – a shadow of the 'negated' object. In 1839 the invention of photography was announced almost simultaneously by two different scientists in two different countries, Daguerre in Paris and Talbot in London. Talbot took the process further and in 1841 he was able to make the shadow of the leaf become real, or positive again, thanks to the development of the calotype, which takes its name from the Greek *kalos*, meaning 'beautiful', and *typos*, meaning image. The images became known as Talbotypes, in honour of their inventor. The negative acted as a matrix on the collodion plate, and when the image, unique in the case of the daguerreotype, came into contact with another sheet of paper, it turned positive and multiplied. This was the basis of the photographic process. Three years later Talbot published his first book illustrated entirely with photographs: *The Pencil of Nature* described his discoveries and included twenty-four calotypes. The author wrote: 'The plates in this book have been produced solely with the use of light, never with the artist's pencil. They are images made by the sun, and not etchings, as some are saying.' The subjects of Talbot's most famous prints include 'The Open Door', a flight of stairs, a mountain top, Westminster Abbey, a bust of Patroclus and a branch of leaves. They were the most beautiful prints ever to have been produced.

Leaves on a branch, c. 1838

© Royal Photographic Society Collection/NMem/ Science & Society Picture Library

WILLIAM HENRY FOX TALBOT was born in Melbury, Dorset, in 1800. He studied mathematics at Trinity College, Cambridge, and conducted research into light. In 1831 he joined the Royal Society. In the spring of 1834, at his home in Lacock Abbey, Wiltshire, he conducted his first experiments in the reproduction of images, and the negative images he produced were known as shadowgraphs. He presented his discoveries to the Royal Society on 25 January 1839, prompted by Daguerre's announcement from Paris a few days earlier. In 1844 he published *The Pencil of Nature*, which included twenty-four calotypes. He died at Lacock Abbey in 1877.

EDWARD WESTON

The story goes that it was Brett, his second son, who ate the pepper. Maybe out of disrespect to his father, or maybe just because the purpose in life of a vegetable is to end up under the knife. Either way, within a few minutes, nothing remained of that famous pepper whose image has been endlessly reproduced, except for a few small scraps on the plate. No matter, for the iconic photograph had already been taken. Edward Weston had chosen to light the pepper using a tin funnel, which gave a homogeneous distribution of light. The exposure lasted six long minutes, and the result was an image that was both realistic and simultaneously transcendent. In his diary entry on 10 March 1924 the photographer wrote: 'What is the best use of a camera? You only have to look at the masterpieces of a great sculptor or a great painter to know that a camera should be used for the recording of life, for rendering the very substance and quintessence of the thing itself, whether it be polished steel or palpitating flesh.' And later: 'To photograph a rock means that the image should be more than a rock. A meaning, not an interpretation.' A few years after writing those words, Weston produced the series of photographs of peppers, in which they have all transcended the banality of their ordinary existence to become objects of muscular beauty, resembling the backs of Titans, shimmering in dark velvety tones. The peppers were part of a whole catalogue of sculptural photographs of mushrooms, artichokes, cabbage leaves as beautiful as evening gowns, seashells and tree trunks. They were shot by setting the lens to an aperture of f/64, to secure maximum image sharpness for minute details and for large sculptural forms alike. By now Weston had moved some way from his initial enthusiasm for Pictorialism, which in culinary terms would have equated to serving his pepper smothered in a sea of sauce.

Pepper Number 30, 1930

Collection Centre for Creative Photography
© 1981 Arizona Board of Regents

EDWARD WESTON was born in 1886 in Highland Park, Illinois. At sixteen he was given his first camera and photographed his aunt's farm. He moved to California in 1906, and in 1908 enrolled in the Illinois College of Photography. He was inspired by Pictorialism. In 1909 he married Flora Chandler, with whom he had four children. In 1915 he started to keep a diary. In 1922 he photographed the ARMCO steel plant, with a new emphasis on abstract form and a sharper resolution of detail. In 1923 he moved to Mexico City, where he opened a studio with Tina Modotti. In 1926 he returned to California, where he took many of his most famous photographs. He moved to Carmel and shot the first of many photographs of the rocks at Point Lobos. In 1932 he founded Group f/64. In 1936 he produced a series of nudes, and that same year became the first photographer to receive a Guggenheim Fellowship. He began to experience the first symptoms of Parkinson's disease in 1946 and died in 1958.

STILL LIFE

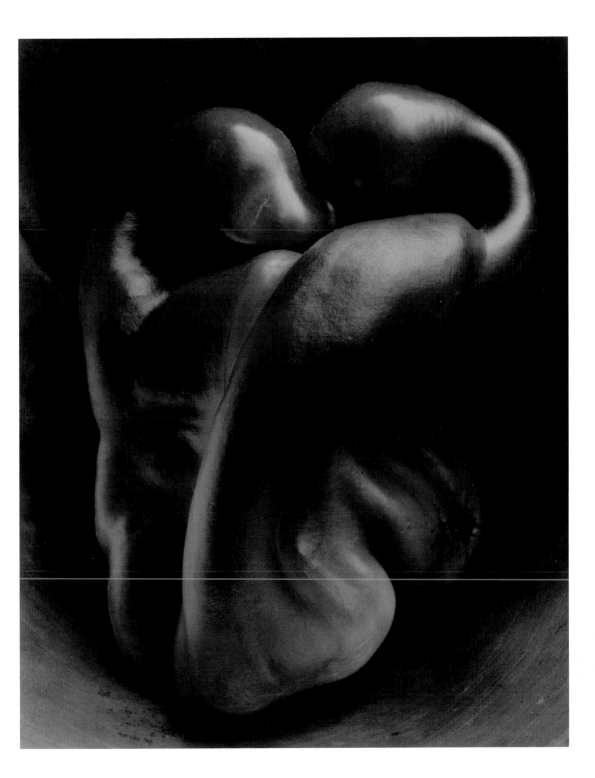

ANDREW ZUCKERMAN

Thousands of exploding droplets of liquid are caught mid-air in a fraction of a second, suspended in elegant motion. The cohesion of the milk is on the point of disintegrating, and the white is on the point of obliterating the black. The magic of the photograph lies in this frozen moment during the process. Technical advances in photography have overtaken the power of the naked eye, and expanded the horizons of perception. The young American photographer Andrew Zuckerman has succeeded in capturing the flight of a liquid by devising his own invention to cause an explosion, an experiment he carried out with milk, egg and water. 'I developed a particular technique to capture minuscule fragments of time, and produced a series of experimental photographs. I took pictures of various liquid substances inside a balloon, which was punctured by a pellet. Using a device which connected a light source to a microphone, the noise of the explosion would then activate the camera shutter.' As with his equally evocative photographs of animals, what interests Zuckerman most is the idea of the 'frozen moment', and its philosophical and aesthetic implications. Here, the photograph is reduced to its essential elements: black and white; the solidity of the background; and the ephemeral, transitory cloudburst of disintegrating liquid immortalized in a single moment of movement and transformation. 'By removing any sense of context, and capturing an infinitesimal second, not only can you freeze a moment in time, but you can also eliminate any sense of time itself.'

Milk Explosion

© Andrew Zuckerman
andrewzuckerman.com

ANDREW ZUCKERMAN lives in New York. He is a renowned photographer and director, and received the D&AD Yellow Pencil Award for Excellence in Photography in 2006. He is also the co-founder of Late Night & Weekends, a company that produces advertising, books and films. He directed and co-produced the film *High Falls*, which premiered at the Sundance Film Festival in 2007. He also produced the book *Creature* in 2007.

STILL LIFE

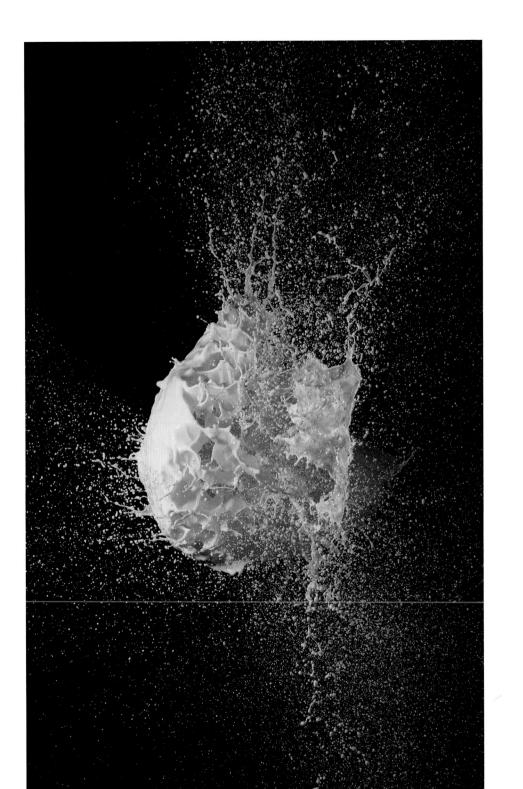

ALESSANDRO BIANCHI

The All Blacks are one of the greatest teams in the world, perhaps even the greatest. They are certainly one of the best-known, thanks to the impressive *haka*, a traditional Maori dance and war cry, which the players perform before every match. Their kit consists of black shorts, and a black shirt with a silver fern on the chest. They have travelled from New Zealand, on the other side of the world, and here they are in the middle of the Flaminio Stadium, arm in arm, preparing themselves and one another before the match with Italy. This is a team moment, and the identity of their opponents is, in a sense, unimportant. Rugby demands strength, speed, elegance and the killer instinct. It is truly a team sport, in which even the best player in the world must work with the others if he is to succeed. It is violent, too, involving the players in the tangle of the scrum and in brutal tackles, but all the players maintain the core values of the game, adhere to the rules and respect their opponents. As the old saying goes: 'Football is a gentleman's game played by hooligans, whereas rugby is a hooligan's game played by gentlemen.' This photograph, taken in the Flaminio Stadium on a November day in 2004 by the Reuters photographer Alessandro Bianchi, has an intriguing formal composition. There is no scrum, no racing athletes, none of the excitement of the sport: instead we have a green rectangle and a black ring on one side. This is a moment of silence. In a second the green will be invaded by the individual figures of that interlocked shape, running out to target the heart of enemy territory. The frenetic rhythm of the game will begin, and from its hiding place between the players' bulky bodies the oval ball will emerge, to be passed backwards in order to travel forwards. Back and forth – rugby is a strange game. This particular match ended in a score of 59–10 to the All Blacks. But then everyone knows that they are not just another team…

The All Blacks before the game against Italy at the Flaminio Stadium, Rome, 2004

© Alessandro Bianchi/ Reuters

SPORT

ALESSANDRO BIANCHI was born in Rome in 1967. He began working as a freelance photographer for newspapers and magazines in 1992. In 1995 he became a staff photographer at the Italian press agency Stampa, and covered many national and international sporting events. He has worked for Reuters since 1993.

DAVID BURNETT

Over the last forty years Afghanistan, the coup d'état in Chile, the Iranian Revolution, the famine in Ethiopia, the fall of the Berlin Wall, the US military intervention in Haiti and the devastation of Hurricane Katrina have all passed before David Burnett's camera. But he has not worked exclusively in war zones and on current affairs: at a certain point he encountered sport, which proved an explosive exchange. 'As someone who was not really a sports photographer, I had become more and more interested in trying to find new ways to capture the miracle of sport.' The evolution of technology has facilitated the craft but also occasionally hindered the vision: lenses became faster, film was finer grained, and the photographer could edge ever closer to 'that magic moment when the action, the tension, the feel and the body all come together' to show the viewer what is really happening. But Burnett observes: 'I realized that much of what bothered me about contemporary sports photography was that, in an attempt to bring the viewer ever closer, it often omitted the context of where and how the event was taking place.' The photographer was now faced with a choice between 35mm and the medium format, which results in a larger and finer negative and offers a wider frame with more detail, but also presents the challenge of having only one shot – one try and ultimately one image. Burnett would load his film, wait, watch and then shoot. And, clearly, the waiting is key. 'You know you have only one try. It takes discipline and patience to capture "The Moment". Sometimes you get it, most often you don't.' However, because the eye is forced to be cautious, pictures of real depth can be produced. Burnett discovered a way of seeing sport that was entirely new to him – stimulating and exciting. 'I hope this sense of excitement is something the viewer can share.'

Diver, Atlanta Olympics, 1996

© David Burnett/Contact Press Images/Grazia Neri

DAVID BURNETT was born in 1946 in Salt Lake City and began his career covering the Vietnam War in 1968 for *Life* magazine. Since then he has worked as a photojournalist in eighty countries. He contributed stories to *Time* magazine, and in 1976 co-founded the photo agency Contact Press Images with Robert Pledge. He received the Robert Capa Gold Medal in 1973, and won the World Press Photo of the Year award in 1979 and the Overseas Press Club's Olivier Rebbot Award in 1984. A veteran of the political scene in Washington, he has photographed every US president from John F. Kennedy to Barack Obama. He also covered all the Olympic Games between 1984 and 2004, and in 1996 published the collection *E-motion. Grace and Poetry: The Spirit of Sport.* He currently lives and works in Washington, DC.

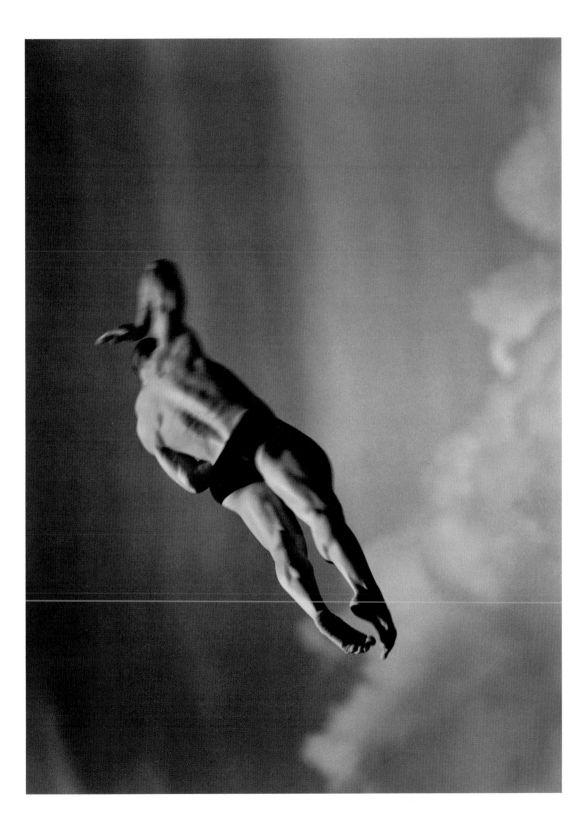

THOMAS HOEPKER

In 1966 Muhammad Ali became the World Heavyweight Champion. The year before, barely one minute into the fight, he had knocked Sonny Liston to the canvas with the famous – and lethal – 'phantom punch', which nobody captured on film. He was at the height of his fame and strength. Thomas Hoepker, fascinated by Ali's exuberance, followed him around the world for weeks, from London to Miami. He took this photograph in Chicago as Ali jumped the security rail of a bridge over the river. It is the picture of a champion: the arms are outstretched in a victory position, dominating the cityscape behind him. He has a sculptural physique, an expression of fire and strength on his face, and the wide-eyed cockiness of a man who has never lowered his gaze before anyone or anything. Hoepker takes on the role of a receptive recorder, while the fighter strikes a pose that reveals an extraordinary attitude to communication. Every aspect of this atypical, full-length portrait seems to illustrate and underline the claim Ali made after gaining the world title: 'I'm the greatest thing that ever lived. I'm so great I don't have a mark on my face. I shook up the world.'

Muhammad Ali, Chicago, 1966

© Thomas Hoepker/ Magnum Photos

SPORT

THOMAS HOEPKER was born in Munich in 1936. From 1960 onwards, after studying art history and archaeology, he worked as a photojournalist, and in 1964 he joined the editorial team at *Stern* magazine. In 1972 he became a cameraman and documentary film producer for German television. He moved to New York in 1976, where he worked as photo editor for the American edition of *GEO* magazine from 1978 to 1981. He returned to Germany and re-joined *Stern* in Hamburg from 1987 to 1989. In the latter year he became a member of Magnum. He bore witness to the 9/11 tragedy in 2001 with a number of colour images. The monograph *Photographien, 1955–2005*, a summary of fifty years' work, was published to accompany a touring exhibition, organized by the Munich Stadtmuseum.

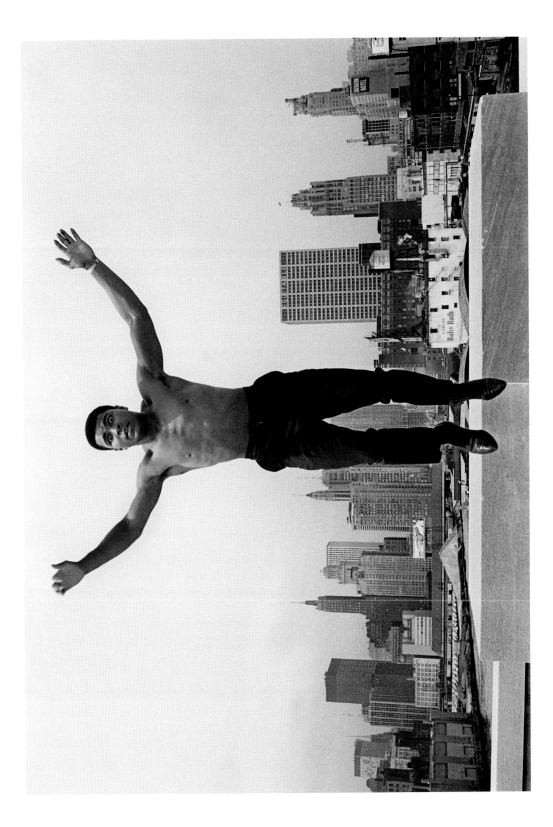

ANNIE LEIBOVITZ

Annie Leibovitz took this studio portrait in 1999 just after Lance Armstrong won the Tour de France. The American cyclist's victory was not only a sporting success but also a triumph over a life-threatening adversary. Only three years earlier cancer had blighted Armstrong's career and destroyed his training routine. But he conquered it, and his arms raised in a victory sign in the ultimate race became a supremely telling gesture. Leibovitz shot him in profile, pedalling in apparently incessant rain – perhaps a reference to the downpour that affected the 1993 World Road Race Championship in Oslo, which he won for the first time that year. The decision to depict the subject naked here stems from the desire not only to shock, but also to reveal the beauty of a victor's body, the harmony of the athletic pose, and the will and passion that triumph over pain and fatigue. It is a powerful portrait of a man who seems to personify strength and vitality. The great portraitist would never ask her subjects to undress merely for the sake of shocking her audience. Nudity provides a point of entry for her to understand the personality of her subject, and multiplies the interpretative layers in the image. Some of Leibovitz's pictures are particularly memorable, such as the strong, delicate image of a naked, pregnant Demi Moore for the *Vanity Fair* cover. More significant is the poetic photo of John Lennon, naked in the foetal position, holding Yoko Ono tenderly: it was taken on the morning of 8 December 1980, just a few hours before he was killed. That image, showing Lennon's consuming devotion to his wife, became a seminal cover for *Rolling Stone* magazine, and was nominated in 2005 as the best cover of the last forty years by the American Society of Magazine Editors.

Lance Armstrong,
New York, 1999

© Annie Leibovitz/
Contact Press Images/
Grazia Neri

BORN IN 1949 in Connecticut, Annie Leibovitz studied painting at the San Francisco Art Institute, and discovered her interest in photography during a trip to Japan. In 1970 she began working for *Rolling Stone* and two years later became the magazine's chief photographer, photographing singers, musicians, actors and athletes; she also shot the Rolling Stones' world tour in 1995. In 1983 she began working for *Vanity Fair*, and in 1989 she met the writer Susan Sontag, who remained her partner until she died in 2004. Leibovitz completed the book *Olympic Portraits* for the Organizing Committee of the Atlanta Olympics in 1996, and three years later, with Sontag, she published *Women*. Her *Annie Leibovitz: A Photographer's Life, 1990–2005* came out in 2006.

SPORT

460

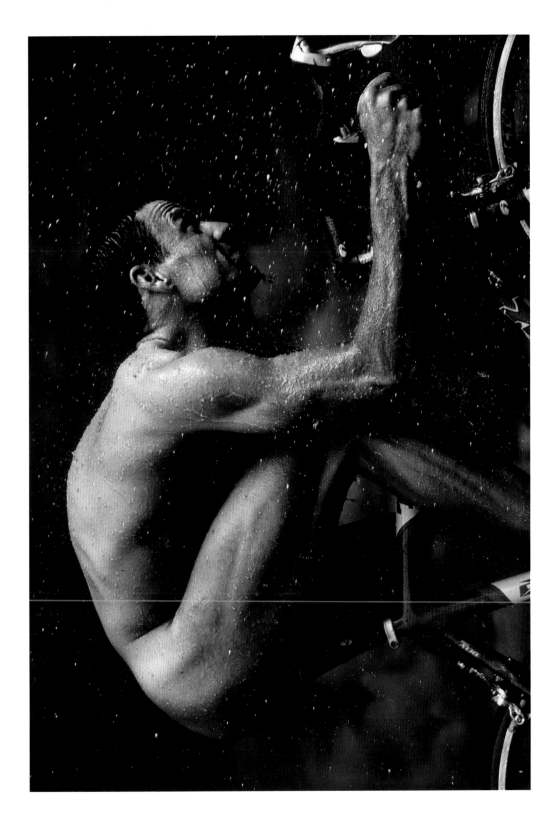

GIORGIO LOTTI

The road over the Stelvio Pass is hostile and cold as it winds upwards with never a moment's respite to catch your breath. Every turn is a challenge and on every bend the slope becomes steeper. The climate is against you, waging a battle against your muscles and your mind. At the Stelvio Pass the Giro d'Italia becomes an epic; it snows at the end of May and the road is often impassable. In 1965 the cycling world was electrified by a young champion, who immediately won people's hearts as he raced past like a bolt of lightning. His name was Felice Gimondi and though he was not yet twenty-three years old he was equipped with both the intelligence and the skill to win. In 1965 he came first in the Tour de France and third in the Giro d'Italia. As always, the cheering crowds lined the route, as the cyclists pressed onwards and upwards, their arms and legs aching with exhaustion. Among the many fans and journalists was the photographer Giorgio Lotti. Suddenly, metres of snow fell unexpectedly on the road ahead, Gimondi took off his tight protective goggles and Lotti, a master portraitist, shot a picture of rare intensity in sport photography. The cyclist's face shows all the signs of the chill and fatigue, but the intensity of his determination is undiminished. Lotti compresses the frame around his eyes, so that we see every detail of the skin over his cheekbones, chapped by the snow. The black-and-white medium showcases the face of an ancient warrior who will never give in.

Felice Gimondi at the Giro d'Italia, Stelvio Pass, 1965

© *Giorgio Lotti/Contrasto*

BORN IN MILAN in 1937, Giorgio Lotti began taking photographs in the 1960s, working for *L'Europeo*, *L'Illustrazione Italiana*, *Settimo Giorno* and *Paris Match*. In 1964 he joined the staff of the prestigious magazine *Epoca*, then after its closure in 1997 moved to *Panorama*, where he remained till the end of 2002. In 1974 he received the World Understanding Award by Columbia University for his photo stories on China, and in 1994 he received the prestigious literary award Città di Modena. In 1995 he was honoured with the Horus Sicof in Milan for his contribution to photography, and in the same year he participated in the Venice Biennale. His exhibitions have toured the world, and some of his photographs are in museum collections in London, Paris, Modena, Tokyo and Beijing.

PETER MARLOW

2001 saw Michael Schumacher claim his fourth world title and his second for Ferrari. The German driver won the championship with four races to go, and by the end of the season he had clocked up 123 points to the 58 of his nearest rival, David Coulthard. In that year Schumacher won nearly every Grand Prix, beat Nigel Mansell's record of 112 points for the season, and matched Frenchman Alain Prost's Formula One World Championship wins with Ferrari, for whom Prost had only managed second place. Schumacher was thirty-two, had no rivals, and was driving the fastest car on the grid. He was also within reach of Manuel Fangio's record of five Formula One Championship wins, which he equalled the following year. This image of the champion was created by one of the most independent visionaries of the Magnum group. Peter Marlow began as a photojournalist and war reporter, pursuing the ideal of communicating through his photography the suffering of mankind. If he could not change the world, he wanted at least to try and understand it. However, he returned from various conflicts believing that many photographers claimed to pursue this ideal as a smoke screen for competing with one another and pursuing fame at all costs. So he began to focus on personal projects and to showcase his own individual style, exploring not necessarily the things that were happening, but the everyday time between the events. That aim is clearly evident in this picture of a champion. Marlow does not portray the celebration, the tension, or the lifting of the trophy – there are none of the typical gestures or behaviours associated with the aura of a sporting legend. Here Schumacher is not a hero, but simply a man dressed in a driver's uniform, sitting alone at a modest table waiting for a meal.

Michael Schumacher, 2001

*© Peter Marlow/
Magnum Photos*

BORN IN ENGLAND in 1952, Peter Marlow graduated in psychology from Manchester University. From 1977 to 1980 he documented international events, such as the conflicts in Lebanon and Northern Ireland for the Sygma agency. In 1983 the Arts Council of Great Britain awarded him a grant to carry out the project 'London by Night', and in 1988, with funding from the Photographers' Gallery, he realized his project on the effects of the economic crisis on Liverpool. His book *Liverpool: Looking Out To Sea* was published in 1993. He joined Magnum in 1981 and became a full member in 1986, since when he has travelled and worked in Japan and the US. He recorded the last flights of Concorde, publishing his photographs in the book *Concorde: The Last Summer* (2006).

SPORT

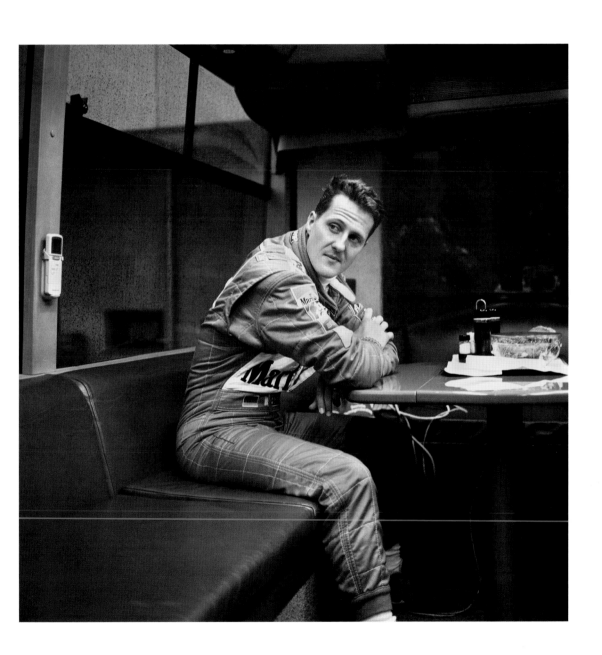

LUCY NICHOLSON

Lucy Nicholson went to her first basketball game – the National Basketball Association finals – in 2001, while she was working as a runner for the agency France Press in Los Angeles. It was love at first sight. She was mesmerized by the energy, speed and impact of the game, and has photographed every NBA final since then. During the games, only one photographer is allowed to set up a camera on the iron bars holding the backboard of the net, so the large agencies must take turns to occupy this privileged position. When it is Lucy Nicholson's turn, she installs a 400mm lens, which can be activated from a distance as soon as the athletes jump up to the net. In this photograph we are in San Antonio, Texas, where a game is being played in the NBA finals of the Western Conference, which is made up from teams from the western states. The Phoenix Suns are pitted against the home team, the San Antonio Spurs. Quentin Richardson, a forward from the away team, approaches the net and throws the ball from under the board. The camera hangs above him, and at that moment Lucy Nicholson pushes the button and the lens captures the second with perfect precision. The zoom shortens the perspective and, like a magnet, guides the eye from the athlete's arm to the ball hanging in the air. The perspective is compressed, as if sucked in by the same force of gravity that is pushing the ball down through the upper hoop of the basket and on towards the bottom rim, which perfectly frames the athlete's face. The trajectory ends there, where the player's eyes seem anxiously to return our stare.

Quentin Richardson during the NBA final, San Antonio, 2005

© *Lucy Nicholson/Reuters*

LUCY NICHOLSON was born in London in 1972 and has worked as a photographer in Mexico, Chile and Northern Ireland. She currently lives in Los Angeles and is a staff photographer at Reuters New Pictures, covering the most important calendar sporting events. Her photographs have received several awards, among them the MLB Baseball Hall of Fame, China International Press Photo in 2005, and Editor and Publisher's Photos of the Year in 2007. Her work has been published in magazines and newspapers such as *Time, Newsweek*, the *Washington Post*, the *New York Times, USA Today* and *Sports Illustrated*.

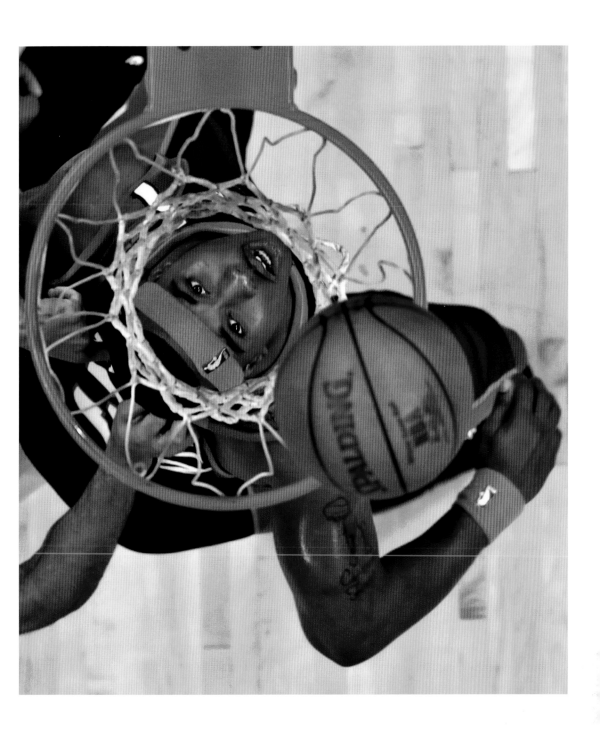

FINBARR O'REILLY

The challenge when reporting on Africa is to extricate the mind and eye from the confines of cliché. This continent, with its own soul, rich in vernacular culture and history, and full of contradictions, is very often reduced to a single country, marked by the associated motifs of poverty and hunger. The reality is in fact much more complex, and the photographer Finbarr O'Reilly has for years attempted to narrate to the West the varied stories of Africa. He began working in the continent with Reuters, at first as a correspondent writing articles. In 2005 he decided to devote himself to photography, in the conviction that it is a more direct and immediate means of communication, which makes a greater impact on public opinion. He has covered famine, disease, conflict and poverty with strong, intense pictures of shared emotion. He is the author of a moving image of famine: the tragedy encapsulated in a child's emaciated fingers delicately resting on the lips of his mother won the World Press Photo of the Year 2005. However, O'Reilly is not interested only in stories of suffering. He avoids representing Africans merely as victims, responding to the strength of character and dignity of his subjects, who live in some of the most difficult conditions on earth. His photos also, therefore, offer glimpses of the beauty of the landscape and its people, and capture the more positive and serene aspects of everyday life. This picture, taken on a hot June day in the capital of Senegal, resonates with energy and joie de vivre. The photographer shoots a young woman, seeking relief from the torrid tropical heat by bathing in a hotel swimming pool. The chopped frame, the composition of vivid colours and the beauty of a young and healthy body transmit an infectious sensation of fresh vitality.

A Senegalese woman cools off in a swimming pool, Dakar, 2007

© Finbarr O'Reilly/ Reuters

FINBARR O'REILLY was born in Swansea in 1971 and has both British and Canadian citizenship. He began his career as an arts correspondent for the Canadian newspaper *The Globe and Mail*, before moving to the *National Post*. From October 2001 he worked for Reuters as a freelance correspondent in Kinshasa, Democratic Republic of Congo. Since 2005 he has worked full time as a photographer, and he is currently chief photographer for Central and Western Africa, based in Dakar, Senegal.

SPORT

ERIK REFNER

'When I took it, I knew that it would make a good photograph,' said Erik Refner of his most famous picture – the corpse of an Afghan boy in Pakistan, swathed in a sheet, and surrounded by a group of hands that lovingly prepare for his burial. It is more than just another piece of reportage: it won the World Press Photo of the Year 2001, bringing it to worldwide attention. The knowledge of what it takes to make a powerful and meaningful photograph accompanies photographers in their work. Sometimes the event is the determining factor, at other times it is the intense significance of the situation. The photographer's ability to assess the intrinsic value and journalistic potential of what he sees in front of him, and his decisions about the subtle interplay of shapes and the alchemy of the light all contribute to a good photograph. While the eye may respond more emotionally in the face of human tragedy, it is no less well prepared when witnessing a sporting event, with all the mental and physical tension of the ultimate competitive situation. The supreme test in sport is the marathon, which often strains the athletes to the limit of physical endurance. Training alone will not make the difference between success and failure: breathing, maintaining the pace, and above all having the will to win, or at least to finish, the race are all crucial. Lit by a strong flash from the lights, against the backdrop of a dreary Scandinavian sky, the participants in the Copenhagen marathon reach the finishing line and pass wearily before Erik Refner's camera. As the runners are sprayed with water, there is a strong sense of sudden release, like the feeling when you let go a breath that you have held for a long time. The light illuminates the exhaustion on the faces, as the strained and taut expressions suddenly relax. For Refner, the Danish photographer celebrated for his images of social significance and his humanitarian reportage, this picture marked a new departure, and another triumph. Good photos do not always have to depict death and tragedy. This one won the World Press Photo 2007 in the category of Sports Features.

Finishing line,
Copenhagen Marathon,
2007

© *Erik Refner*

ERIK REFNER was born in Copenhagen in 1971. In the early 1990s he served as a sergeant in the Danish army, and, as a skilled athlete, was a member of the Danish national pentathlon team for a year. He then immersed himself in the world of photography, working first as an assistant to a fashion photographer. In 1998 he enrolled in the Danish School of Journalism, and in 2001 won the World Press Photo of the Year award. His images have been published in the leading international magazines and he has exhibited his work in touring group exhibitions throughout the world. Since 2006 he has been a member of Trunk Images.

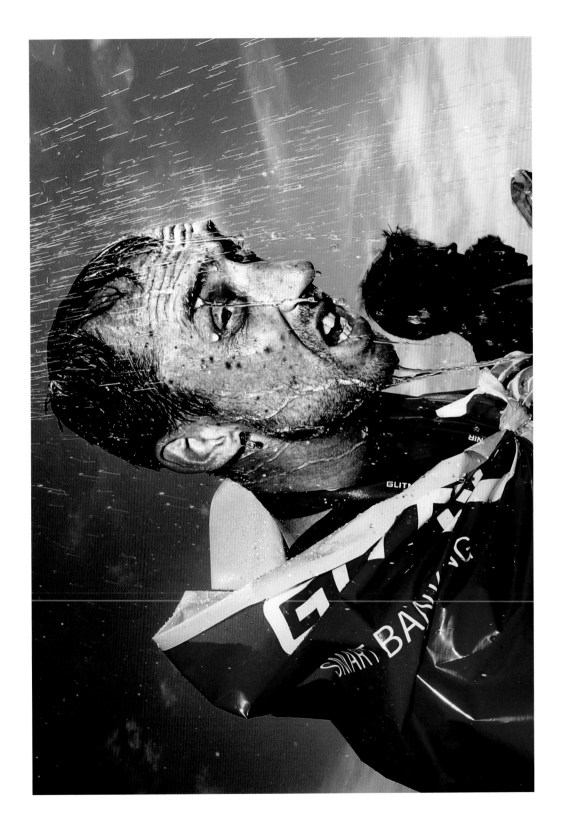

MAX ROSSI

This image is the visual equivalent of the perfect synthesis of two notes played together in a piece of music. All you need to create the play of harmony are two tones, two degrees of the scale. Max Rossi's picture, which won the World Press Photo 2007 in the Sports Action category, transmits just such an interplay of harmony, movement and balance. Here we have, as it were, the musical score for a piece of gymnastics, a challenge for the eye and a game of chance with time. The occasion is the Artistic Gymnastics World Championships in Aarhus, Denmark, in 2006. On the platform the highest achievers in every discipline are on display, and watching it all is a photojournalist from Reuters. Even this works like a musical composition – an ensemble of agency photographers playing at the quickest tempo, each of whom conceives a different image from all the others, unique and symbolic, so that together they synthesize a kind of polyphony. Once the competition begins, the huge arena comes to life, divided into separate areas for the various disciplines. It is like the scherzo of a symphony: on this side the floor exercise, on that the pommel horse, over there the parallel bars and opposite them the rings. The gymnasts arrange themselves in front of the photographer's lens, engrossed in their own activity. Before they start they have only one idea resonating through their minds: a 'what if', a hope, a dream of success, an aspiration that is perfectly achievable thanks to their amazing technique, provided they can count on an ounce of luck. Then the image materializes, real, plausible and possible. Two athletes, two skills, two moments: the virtuoso steadiness of a floor handstand and the acrobatics of the blurred figure as he swings through a routine on the rings. And then there is the maestro's touch, the gymnast's arm that forms a diagonal in the circle, seeming to seal in the magic of the moment. Musically it is a fortissimo and the ovation breaks out before the curtain falls.

Dorin Razvan Selariu on the rings and Niki Böschenstein in the floor event at the Gymnastics World Championships, Denmark, 2006

© Max Rossi/Reuters

MAX ROSSI was born in Rome in 1965. He began working as a freelance photographer for the national Italian press in 1990. From 1996 to 2002 he worked exclusively for *Famiglia Cristiana* magazine, covering major national and international stories. He joined Reuters in 2003 as a freelancer and two years later was made staff photographer. For Reuters he has covered – among other events – the Athens Olympics, the British Open Golf Championship, Formula One and Moto GP races, the Winter Olympics in Turin and the Italian football championship. He also followed Pope John Paul II and Pope Benedict XVI on many of their trips.

MASSIMO SIRAGUSA

Malaga, Andalusia, during the 2002 August Feria, the Plaza de Toros la Malagueta. A bullfighter leaps out in front of his victim, already wounded several times. The bullfight, so beloved of generations of artists and photographers, makes an appearance, with its ritual, its warm colours, the expectancy that always accompanies this ancient spectacle, and the fighter's speed of execution. The extreme blurring, used as an expressive device rather than an aesthetic tool, heightens the dynamism of the scene. The imprecision of the forms and outlines underscores the cruelty of the action but also discreetly disguises the details. The bullfighter's face is smudged into a grotesque and anguished grimace: the executioner, unrecognizable, is transformed like a figure in a Francis Bacon canvas. Death, the ultimate subject of the picture, is imminent, dangerously close for the wounded bull, now reduced to a dark mass, its limbs seemingly caught in a racing, convulsive movement by the film. The distortion underlines the approaching disintegration and, paradoxically, the tragic final act is played out in a feast of colour. The solid, powerful body is lost and annihilated in a whirlwind of dust, tension and sweat.

Bullfight, Malaga, 2002

© Massimo Siragusa/ Contrasto

MASSIMO SIRAGUSA was born in Catania, Sicily, in 1958. In 1987 he began working as a professional photographer, after having studied political science. In 1990 he moved to Milan and from that point began working for the photo agency Contrasto. In 1997 he won second prize in the Daily Life category of the World Press Photo with his photo story on faith and spirituality in Italy. The following year his work on the circus world was chosen by LEICA International for the Photokina Fair in Cologne, and in 1999 also won the World Press Photo in the Arts category. In 2001 he published *Cerchio magico* and in 2003 *Credi. Le feste religiose in Sicilia*; he also contributed to a collective book, *Solo in Italia*, in 2008. His work on amusement parks earned him second prize in the Arts category of the World Press Photo 2008, while his photographs of the Messina slums won him Third Prize in the Contemporary Issues category of World Press Photo 2009.

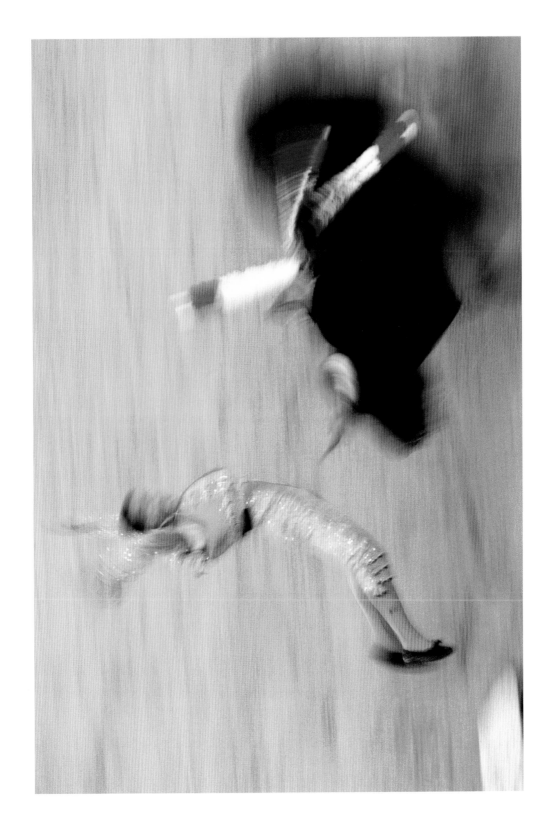

RÉMY STEINEGGER

What are those splashes of colour on the white background, that swarm of little insects with long delicate legs, which move frenetically forwards, filling the frame? In this image it is the photographer's position, his distant viewpoint, that makes the picture what it is. A ski marathon – especially when it involves over 12,000 skiers – is an event full of tension, joy and competitive spirit. This is the winter marathon at Engadin in Switzerland, a 42-kilometre (26-mile) course from Maloya to St Moritz, the whole length of which is traversed on skis. The competitors tackle it with relish, physical endurance and commitment. As the dense group of skiers set off to race across the frozen Lake Sils, for now, at least, indifferent to the surrounding landscape, they are watched from a distance by spectators like Rémy Steinegger. As Steinegger states on his website, he is self-taught and has converted his passion into a career. Based in the canton of Ticino, he has made photography and journalism his raison d'être. He has lived life intensely and is a talented all-rounder, as those who freelance over many years often have to be. Steinegger joined the renowned agency Reuters in 1992 as a member of their prestigious staff photography team; he specializes in sport and in creating the most daring photographs. However, the skill in this profession lies not only in being able to create extreme images, but also in knowing the exact moment at which to change tack and reverse the pace. You must leave the group – even your fellow photographers – behind in order to be able to watch what is happening from afar and offer a different perspective. The fresco-like orchestration of this image, in which the cluster of athletes struggling to cross the finishing line fills the frame and absorbs the viewer's attention, becomes a new medium for documenting the mountain and the actions of humankind.

Aerial view of skiers during the Engadin Ski Marathon, Lake Sils, 2001

© Rémy Steinegger/ Reuters

RÉMY STEINEGGER was born in Locarno, Switzerland, in 1957. He taught at an elementary school for three years, and in 1984 began working as a freelance photojournalist for a Swiss press agency. In 1992 he joined Reuters as their Swiss correspondent. He currently freelances for several newspapers and magazines, mostly in his native country.

SPORT

TOM STODDART

Since he was thirty, Tom Stoddart has been documenting for Western audiences events happening in the furthest corners of the globe. He has witnessed the worst humanitarian crises, which often go unnoticed, testifying to them in powerful pictures that strike the eye, trouble the mind and imprint themselves on public awareness. They range from the tragic famine in Sudan to the siege of Sarajevo, from the plight of refugees in Rwanda to ethnic cleansing in Kosovo, from the Mozambique flood to the conflict in Iraq, and, most recently the AIDS pandemic ravaging sub-Saharan Africa. In 1993 Stoddart visited sports schools in China, where potential Olympic champions are groomed for the future. In the 1950s Mao decided that sporting success could be a means of bestowing glory and prestige on the country, and since then China has invested considerable resources in intensive training for its athletes, starting in childhood. Stoddart's photos show very small children, some as young as four, subjected to a very demanding exercise schedule: their faces are contorted with pain and their bodies sometimes bear the marks of extreme physical exhaustion. But this photo also exemplifies the elegance, lightness and grace of a tiny body in movement, captured at a moment when the formal composition of the lines and light endow it with an almost ethereal appearance. Sport in China, as in many other parts of the world, can be an instrument of joy and a source of suffering, but also it offers the chance, and the hope, of a lifeline.

Young gymnast training at school, China, 1993

© 1993 Tom Stoddart

BORN IN ENGLAND in 1953, Tom Stoddart began freelancing for magazines and national newspapers in 1978 and worked for the *Sunday Times* during the 1980s. In 1982 he found himself in Beirut, where he returned years later to photograph the living conditions in the Palestinian Borj el Barajneh refugee camp. In 1991 he went to Sarajevo to document the war in Yugoslavia and was injured the following year in the fighting around the Bosnian parliament; after a year's recovery he went to Mississippi to report on the flooding. In 1997 he had exclusive access to Tony Blair's election campaign. Stoddart was a founding member of the Independent Photographers Group (IPG). He is also the recipient of several awards, among them the 1995 World Press Photo in the General News category and the Care International Award for Humanitarian Reportage in 1997.

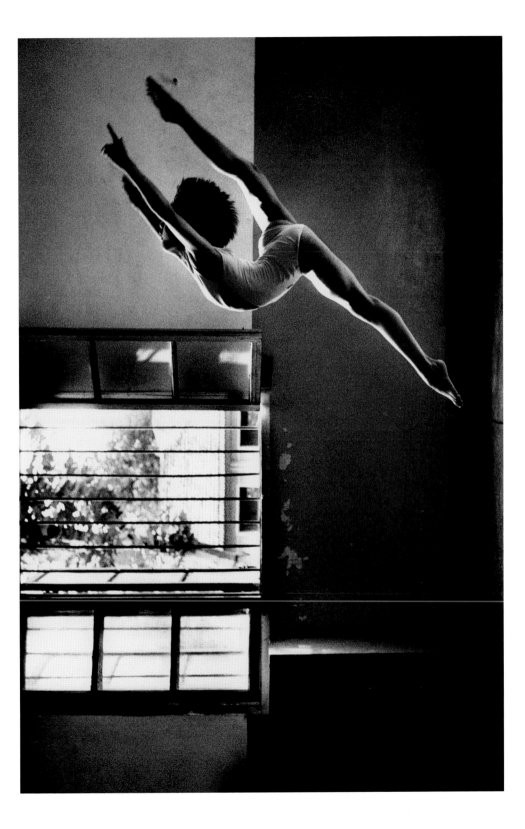

BRIAN WALSKI

The field is over 100 metres long, and – like all sports fields – the scene of running and collisions, exhaustion and ecstasy. Two teams of players, eleven against eleven, will compete for victory on the pitch. American football is a hard, physical, contact sport, involving perilous runs, tackles and falls on the muddy grass churned up by the players' boots. Sport is just a game but a very serious one, and never more so than in the United States, where college teams fight to secure the most athletically gifted students. This being so, the field is not just an area of grass for competitive sport, but a platform for personal growth and achievement. As a photographer at the *Boston Herald*, Brian Walski covered local news, and whenever one of the high school championships was held in the city he would follow the games. 'No victory without sweat,' as the saying goes, and perhaps on this particular day the boy portrayed in the image was on the winning side. He seems to have given his all on the field and, now that he has removed his helmet, his face perfectly portrays the exhaustion that follows intense athletic effort. The photographer's eye quickly captures the moment in expressive black and white – an amusing and slightly fantastical image (in low temperatures the sweat evaporates in a cloud from the player's shiny head). He almost resembles a worn-out comic-strip hero, returning from his latest adventure, eyes closed, his face sunk between his enormous shoulder pads.

A full head of steam,
Boston, 1997

© Brian Walski/
Boston Herald

BRIAN WALSKI was born in the United States in 1958. He studied journalism at Northern Illinois University. He started his photographic career in 1980 at the *Albuquerque Journal*, later working for the *Boston Herald*, where he remained for twelve years, and then, in 1988, moving to the *Los Angeles Times*. During his career he has covered local news, the Gulf War, famine in Africa, the troubles in Northern Ireland, the Kashmir conflict and crisis in the Balkans. He is the recipient of several prizes. In 2003 he was the subject of a scandal, when the *Los Angeles Times* discovered that he had manipulated some photos taken in Iraq for greater impact. He lost his licence over the incident and has since opened his own photo agency in Denver.

SPORT

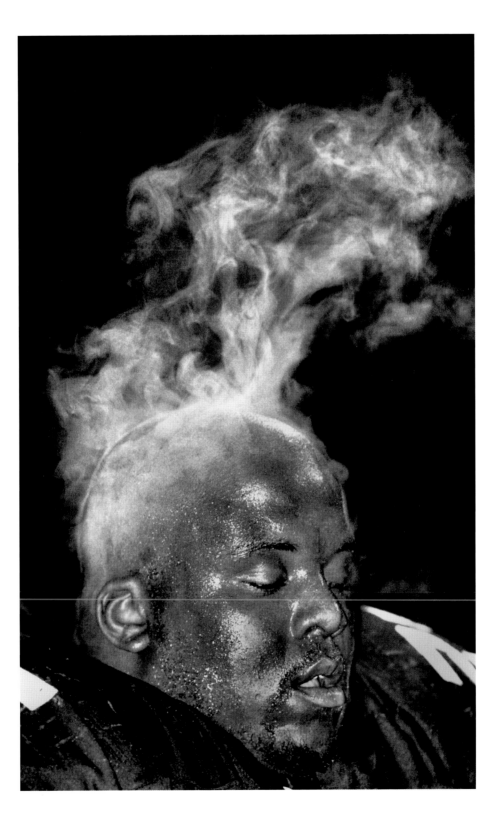

SAM ABELL

Two ponies are fixed in identical poses, one in front of the other, against a background of the hills of Somerset in the south-west of England. It was luck, the essential element of any snapshot, that placed them so precisely. The photographer had the complex task of capturing the very instant in which this coincidence occurred. The two animals look beyond the boundaries of the shot, outside their field and into the mist, or perhaps even beyond it. Sam Abell, a photographer for *National Geographic*, skilfully chose what to include and, more importantly, what to exclude from the scene. What was happening beyond the borders of the image? What had attracted the two ponies' attention? Perhaps it was the nearby herd from which they had wandered away; perhaps a gunshot. We cannot know, and this deliberate limiting of our gaze increases the mystery and fascination of an image that has a formal perfection that still provides space for our imagination. 'Learn to see, and be patient' is Sam Abell's motto, as it is for all documentary photographers who choose the natural world as their subject. He does not use a flash or a zoom lens, but prefers lenses with a short focal length and a wide angle of vision. Landscape is too important to be squashed into the foreground as the subject; he chooses to let the observer's eye wander, to lose itself in the image, rather than pinning it down with precise detailing. He says that he prefers early morning or late afternoon light and that his first action is to choose a background that interests him; then he waits, pausing until the light and the subject come together on that landscape and complete the image. 'Learn to see, and be patient', and nature will surprise you with its unexpected coincidences.

A pair of Exmoor ponies, Somerset, England, 1992

© Sam Abell/National Geographic Image Collection

SAM ABELL was born in Sylvania, Ohio, in 1945. He became interested in photography at a very young age, as his father who was a geography teacher also ran a local photographic club. He has worked for the National Geographic Society since 1970, carrying out work for articles and books all over the world. In 1990 Eastman Kodak collected some of his images in a retrospective monograph entitled *Stay This Moment: The Photographs of Sam Abell*; its publication was accompanied by an exhibition at the International Center of Photography in New York. In 2002 a new anthology, *Sam Abell: The Photographic Life*, was published, with a text by Leah Bendavid-Val. Abell has taught numerous workshops, and lives and works in Virginia.

ANSEL ADAMS

At the age of fourteen, Ansel Adams was confronted with the transcendent beauty of the Yosemite Valley and from then on, he said, his life was 'coloured and modulated by the great earth-gesture of the Sierra'. Few American photographers have had as wide a following as Adams, and no one knew better than he how to show his fellow countrymen the majesty of their own natural landscape. He was an enthusiastic mountaineer and the Sierra Nevada was his spiritual home. He had a rare gift – the capacity to transform geographic realities into emotional experiences. The sensation of a mystical presence in Adams's photographs comes not just from his choice of sublime moments and unexpected points of view, but also from his legendary technical talent, which allowed him to transform an ordinary scene into a precious and luminescent subject. To achieve the formal purity that he required, he developed over the course of many years a rigorous control technique, which he called his 'Zone System', that allowed him to visualize the tonalities of the image before taking the photograph. In this way he was able to use his camera with almost the same sophistication as a painter with paintbrushes and a palette. Between 1943 and 1944 Adams took hundreds of pictures at Manzanar, the location of an internment camp for Japanese-Americans during the Second World War. During one of these visits, he came to a place dominated by a vast expanse of rocks: 'there was a glorious storm going on in the mountains. I set up my camera on the rooftop platform of my car, and so I had a wonderful view over the rocks right to the base of the mountains.' The result is an evocative image in which black and white define a primordial landscape flooded with an eloquent light. Every Adams photograph is perfect; he paid attention to even the most microscopic detail in the belief that 'a great photograph is a full expression of what one feels about what is being photographed in the deepest sense, and is, thereby, a true expression of what one feels about life in its entirety'.

BORN IN SAN FRANCISCO in 1902, Ansel Adams was one of the most celebrated American photographers of the twentieth century. He left school in 1915 to study at home. He trained as a pianist, and at the age of fourteen he received a camera as a present while visiting Yosemite National Park. When he was seventeen, he joined the Sierra Club, an environmentalist group, of which he was a member for the rest of his life. He benefited from three study grants from the Guggenheim Foundation, and in 1966 was elected as a member of the American Academy of Arts and Sciences. In 1980 Jimmy Carter awarded him the Presidential Medal of Freedom, his country's highest civil honour. He died in 1984. In 1985, in recognition of his work and his commitment as an environmentalist, the US Board on Geographic Names named a mountain peak in Yosemite National Park after him.

Mount Williamson, the Sierra Nevada, from Manzanar, California, 1945

© *Ansel Adams/Publishing Rights Trust/Corbis*

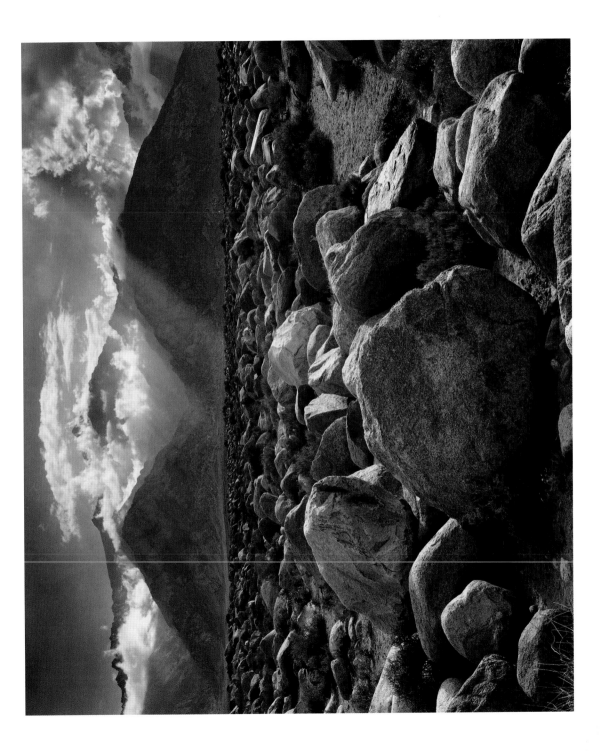

WILLIAM ALBERT ALLARD

The infinite gradations of colour and the quality of the light are the primary subjects of an image that William Albert Allard has created as if it were an invitation to contemplation. In order to take it, the photographer has had to slow down his pace, adopting the professional contortion of the photo-journalist, but he has still succeeded in capturing an event. Or rather, the petals falling from the apricot trees are the vestiges of an event in a static and centralized image. His perfectly composed examination of the landscape creates a backdrop for the sudden intrusion of an extraordinary event, sketching out the lines of that complex and fascinating discourse: the perpetual relationship between man and his environment. The beauty that Allard recreates with his camera, although it appears to be caused by the power of nature, is in reality the result of a lengthy negotiation with the inhabitants of the place in which the photographer found himself. The bond between these people and the river that flows past almost invisibly in the left of the shot has been and continues to be very close; it has been created by dangerous and violent events (catastrophic flooding is offset by huge reductions in the river's water levels and drastic changes to its course), and also by mutual exchanges and love, which bring the distant figures in this image to walk along its banks.

Parco del Valentino,
Turin, 2002

© *William Albert Allard/*
National Geographic
Image Collection

WILLIAM ALBERT ALLARD was born in Minneapolis in 1937 to a family of Swedish descent. He studied journalism at the University of Minnesota, and carried out a report for *National Geographic* on an Amish community in Pennsylvania in 1965, which led to the magazine hiring him immediately. Two years later, Allard left this job in order to practise exclusively as a freelancer. In 1982 he published *Vanishing Breed*, a collection of images taken in the American West; the book received a Leica Medal of Excellence and many other awards. In 1995 he issued a retrospective monograph. He re-joined the staff of *National Geographic* in 1996.

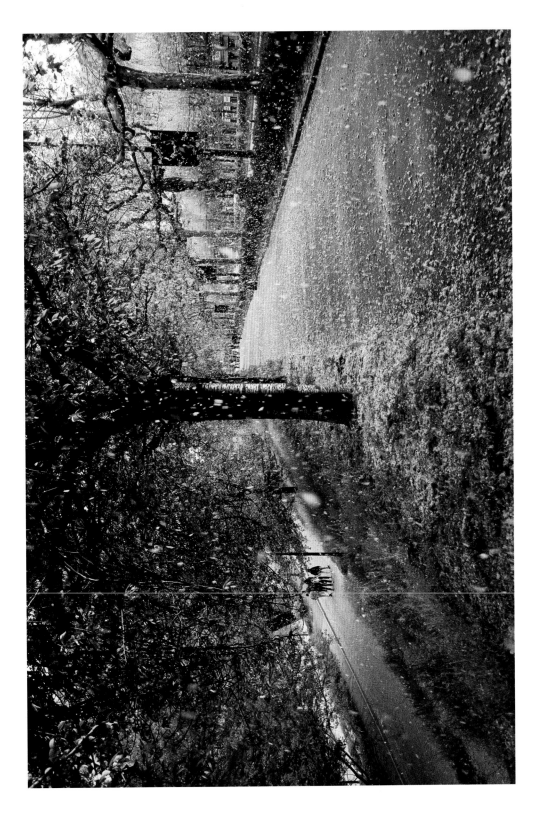

YANN ARTHUS-BERTRAND

In 1995, under the patronage of UNESCO's Ecological Science Department, the French photojournalist Yann Arthus-Bertrand began an ambitious investigation into the planet's ecosystem by creating a database of images of the earth seen from above. He embarked on a long journey of exploration across the world, flying in helicopters for 3,000 hours and visiting 76 countries. The result was a collection of 214 extraordinary aerial photographs, published in *The Earth from the Air*, which very quickly became a global bestseller, and was translated into twenty languages. The images taken from the sky are so carefully framed that many of them resemble abstract compositions, with patches of colour, contrasting shapes and lines and astonishingly dynamic effects. His challenge was not simply to tell the story of the overwhelming beauty of the earth, but to reflect on the planet's evolution, showing its fragility and revealing the impact of man and the scars from the wounds that unregulated industrialization inflicts on the space in which we all live. In this scenario the view from above does not create distance; on the contrary, it is a way of bearing witness, a participation that creates a sense of belonging. The mangrove swamps of Everglades National Park, on the southern tip of Florida, extend to the point where the fresh water of Lake Okeechobee and the saline waters of the Gulf of Mexico converge. The Everglades region has already been severely reduced because of drainage works and the construction of dams, which were begun in 1880 to create space for agriculture and urban development. Many animal species find refuge in the 6,000 square kilometres of the national park, in particular 40 species of mammals, including the manatee, now almost extinct, and 347 species of birds. The biological importance of the site is universally recognized: it has been a biosphere reserve since 1976, a UNESCO World Heritage Site since 1979, and a Wetland of International Importance since 1987. Despite this recognition, in 1993 the Everglades was added to the UNESCO list of World Heritage Sites in Danger. Human population is increasing, and industrial, urban and agricultural pollution is destroying this extraordinary place. An ambitious project is underway to re-establish the ecosystem and avoid an ecological and economic disaster, providing potable water for the region and preventing sea water from penetrating into land that has already been overexploited.

BORN IN 1946, Yann Arthus-Bertrand exhibited a great passion for nature from his earliest years. At the age of thirty he moved to Kenya with his wife, Anna, to study the behaviour of lions in the Masai Mara reservation. When he returned to France, he specialized in nature, adventure and sport photography, and worked for leading publications. In 1994 he conceived the idea of *The Earth from the Air* project and obtained UNESCO patronage for it a year later. The work, first published in 1997, became a worldwide bestseller and has been shown as a travelling exhibition in many major cities.

Mangroves in Everglades National Park, Florida, USA (25°27' N, 80°53' W)

© Yann Arthus-Bertrand

MARTIN DOHRN

For many years, night in the animal world remained a mysterious realm, inaccessible to photography. Long periods of patient waiting, and exhausting hours spent hiding, can never overcome the brutal glare of a flash bulb: until recently the only effective way to break through the nocturnal barrier was to use infrared light, which is invisible to human and animal eyes. When the BBC commissioned the cameraman and photographer Martin Dohrn to film animals at night in the Masai Mara, his need for objectivity as a documentary maker spurred him into researching new solutions. 'Film is a suspension of disbelief. With night filming it is even more so, because you're adding light, even if it is infrared. So you are expecting people to believe it is dark when there is an obvious light source.' And so Dohrn, with the assistance of technicians and engineers, set about resolving this contradiction, combining existing technologies in an innovative way and producing particularly light-sensitive image intensifiers and lenses, which could magnify the luminosity of an image. As well as shooting film footage, he also took still photographs. The result is an astonishing series of images in which nature reveals itself while keeping its savage mystery intact. No artificial illumination brightens the darkness of these dangerous places where only starlight shines down on animals as they go about their nocturnal pursuits. The lion's yellow eyes blaze like flames in the darkness, as do the hyena's teeth, exposed in a sardonic snarl, while a herd of elephants approaches the camera placidly and slowly, as if they had come from a post-apocalyptic desert world: everything around them is dark, but the vault of the sky behind them is studded with stars, whose light ignites the white of their tusks.

A herd of African elephants at night, Masai Mara, Kenya

© Martin Dohrn/Nature Picture Library

MARTIN DOHRN is a reporter and photographer who has worked for the BBC Natural History Unit and National Geographic Television for twenty years. In 1994, he formed his own production company, Ammonite Ltd, and began to produce films. At the same time, he carried out photographic assignments for the BBC, *National Geographic* and the Discovery Channel. Over the years, he has won numerous prizes for his innovative films.

NATURE

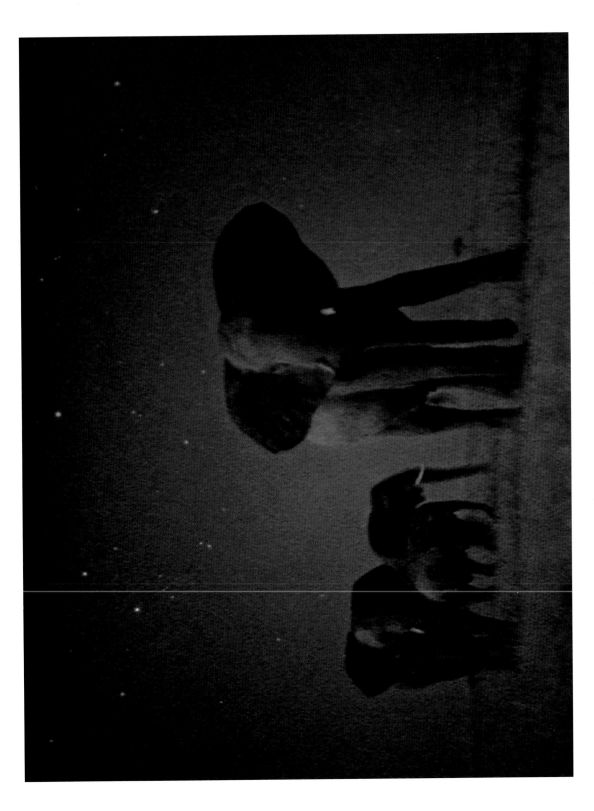

BERNHARD EDMAIER

Bernhard Edmaier sees the world as a scientist and an artist: both perspectives are reflected in his pictures as he studies the shapes and sublime beauty of structures of the earth's crust, with all their astonishing features and wide spectrum of colours. Edmaier is a geologist as well as a photographer, and he tries to transmit his knowledge of natural phenomena via his camera by showing geological processes that have evolved over eons of time – the different stages of erosion and the layers of the earth's stratification. Art and science merge in this way to create fascinating aerial images that look like abstract works of art. The artist has travelled through the most spectacular scenery on earth, to unspoiled places still intact in their primordial forms: from the ice of the Arctic to the waters of the Pacific Ocean; sandy deserts to icy wastelands; snow-covered Alps to lush green forests. His images capture the tonalities and shadings of the soil, rocks, sand, lava and ice from Europe to the Bahamas, Alaska, Australia and North America. In this photograph Edmaier presents us with a spectacular vision from the air of the largest hot spring in the USA. It has a temperature of 80°C (176°F) and is so rich in minerals that it shapes the surrounding land and produces a spectrum of particularly varied and intense colours. His intentions, however, go beyond the mere exhibition of beauty: 'I also want to arouse interest in the geological process, the process of transformation that has been going on for millions of years and is constantly reshaping our planet. The purpose of my project is to document unspoiled natural landscapes. By doing this I hope to broaden people's awareness that there are still large expanses of our planet that are worth protecting.'

Grand Prismatic Spring, Yellowstone National Park, Wyoming, USA, 1999

© Bernhard Edmaier/ Contrasto

BERNHARD EDMAIER was born in 1957 in Munich, Germany. He began his professional career as a civil engineer and geologist before becoming a professional photographer. In 1992 he founded the Geophot-Bilder der Erde photographic agency. He has always been interested in natural phenomena and has travelled to the least polluted places on earth. His work has received numerous prestigious awards over the years.

CRISTINA GARCÍA RODERO

What lies between heaven and earth? Are they truly opposites? Is there a frontier, a clear border? Cristina García Rodero has asked herself these questions for many years and has gone travelling in search of an answer. After a great deal of wandering and self-questioning, she brings us the results of her research: a testimony to special moments in which extremes come together and merge. These are moments with particular intensity, filled with significance; moments that reward the effort required to find and capture them. Rodero's journey began in rural Spain, her own country, as she discovered its rituals and traditions, its beliefs and superstitions, its religion and its paganism. It is a journey back in time, a struggle to recover the sense of a world that is vanishing. The perspective chosen by the photographer is unusual: her point of observation is that of a pilgrim who walks though the streets during public celebrations. Rodero has the eye of both an anthropologist and a documentary maker; her compositions are those of an artist, who uses black and white to depict the true Spain, a magical and mysterious place in which time sometimes stops and it is possible to discover a primal link between the earthly and the celestial; body and soul; nature and man; the religious and the pagan – a place where reality can create visions that seem to belong only to the realm of dreams and imagination. On the arid soil of Almeria it is possible to encounter a white horse at the very moment when it rolls in the dust with its hooves in the air on an abandoned western film-set. This is a surreal vision of old film studios in the driest place in all of Europe, where Sergio Leone shot his most famous films. All around everything is quiet: there are no people, not even a trace of a human presence, just a horse, with its muzzle and belly turned to the sky, which seems to have lost itself in a dreamy and joyful trance.

Old film studios, Almeria, Spain, 1991

© Cristina García Rodero/ Magnum Photos

BORN IN 1949 in Puertollano, Spain, Cristina García Rodero studied painting in Madrid before developing her passion for photography. She teaches photography at the University of Madrid and has carried out reportage pieces on public celebrations in Spain and other Mediterranean countries. This project culminated in the book *España oculta* (1989), which won the Book of the Year Award at the Arles Festival of Photography. She also won the prestigious W. Eugene Smith Award in the same year. She continued her photographic and ethnological research by focusing on voodoo rituals in Haiti: this work was exhibited for the first time at the Venice Biennale in 2001. She has been a member of the VU agency for fifteen years, and joined Magnum in 2005. She is currently working on a large monograph entitled *Entre el cielo y la tierra.*

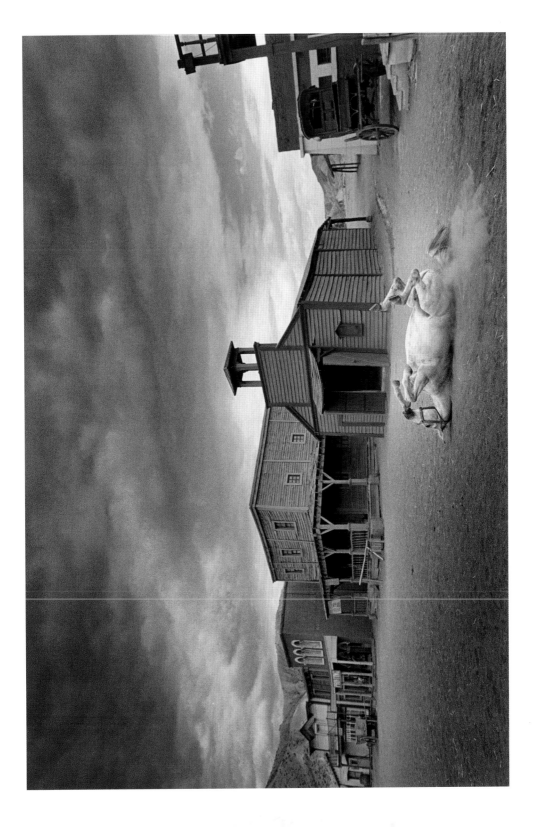

ANNIE GRIFFITHS BELT

On 13 January 1888 a group of thirty-three explorers and scientists met at Washington, DC's Cosmos Club in Lafayette Square. Their intention was to form a society to increase and diffuse geographic knowledge. Thus the National Geographic Society came into being and nine months later, as if it were its child, the *National Geographic* magazine was born. Ever since, the monthly magazine with its iconic yellow-bordered cover has been synonymous with exploration, travel and nature. All the great photographers have appeared in the pages of this landmark of publishing and science. Annie Griffiths Belt has earned her place here, too, and in 2008 she celebrated the thirtieth anniversary of her first report for the magazine. In the years since then, a flurry of activity has taken her to every corner of the globe, especially to places where nature is still unspoiled and exists according to its own laws, as in the Mississippi Delta in Louisiana, which she explored from the air while following the journey of a colony of white pelicans. As the river divides into myriad tiny streams where it meets the sea, here it bends into a curve that looks almost like the section of a motorway or stadium. The birds follow the current in an orderly fashion and it is as if our normal perspective – looking from the ground up into the air – has been substituted for theirs. Just for a moment we are the ones who move freely through the air with the acrobatic lightness of the helicopter, without any restrictions, queues or stress, while the pelicans, the lords of the sky, remain below. But even here, in the peacefulness of their river journey, in the elegant poise of their passage, the creatures still have something to teach us.

White pelicans in the Mississippi Delta, Louisiana, USA

© Annie Griffiths Belt/ National Geographic Image Collection

ANNIE GRIFFITHS BELT was born in Minneapolis. She earned a degree in photojournalism from the University of Minnesota in 1976. Two years later she began to work for *National Geographic*. Her assignments have ranged from Lawrence of Arabia to Baja, California, Israel and Sydney. She has participated in numerous editions of *A Day in the Life*, and has been awarded prizes by the National Press Photographers Association and the White House News Photographers Association. Together with Barbara Kingsolver, she created *Last Stand: America's Virgin Lands* (2002). Belt now lives in Great Falls, Virginia, with her husband, Don Belt, who is a senior editor of *National Geographic*, and her two children, Lily and Charlie. She dedicated an autobiographical work – *A Camera, Two Kids and a Camel* (2008) – to travelling with her family.

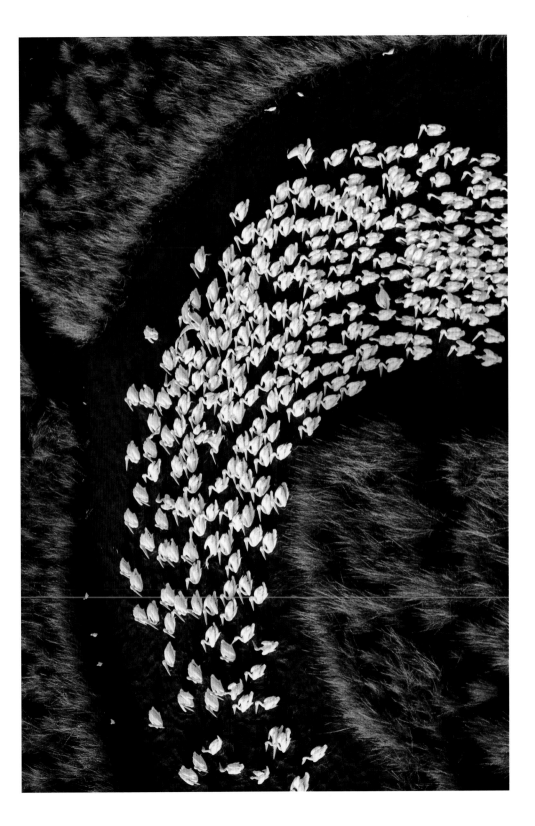

HANA JAKRLOVA

In the Meantime: Europe is the title of a collection of photographs that eventually became a book in which Hana Jakrlova depicted her Europe – a Europe that the Czech photographer discovered and intimately explored after the collapse of the Berlin Wall; a Europe composed of freedoms, of possible routes to follow into a territory which was, at long last, so vast and made up of different cultures and desires, a place where one could become confused and get lost. 'After the Wall fell, the word "home" ceased to have fixed and impassable borders for me [but, for the first time,] on my travels through the "new Europe", I experienced the vulnerability of anyone who had decided to live for a while in a strange town.' For Jakrlova, leaving became an opportunity to meet new neighbours, an exploration of unknown territory, an entry into the heart of darkness of Europe's own past, an escape route. Her camera allowed her to record the different emotions of a journey that took place in a suspended time, between one millennium and the next, while in the meantime the world continued to turn and change. Jakrlova knows very well that one has to travel lightly, be ready to confront anything – beauty as well as misery – and never lose the capacity to be surprised. It can happen, for example, as it does in this photograph, that the surprise comes in a sudden wild and powerful rush in Ireland's lush green countryside. It makes you catch your breath, this feeling of being free to go where you will, which merges with the fear of a journey made by unknown thousands and, perhaps, of the loss of a real destination to travel towards. 'My journey was a game, but also a battle with demons. [I was] drawn sometimes to beauty, sometimes to ugliness... I was myself, and at the same time anyone: like a Polish pilgrim in Santiago de Compostela, an English businessman in Prague or a Bosnian immigrant in Berlin, I, too, was both master of my destiny and an insignificant part of changing history.'

Europeans, Galway, 2000

© Hana Jakrlova/
Anzenberger

HANA JAKRLOVA was born in Brno, Czechoslovakia, in 1969. She graduated in architecture at Prague's polytechnic and subsequently studied photography at the Opava University, also in Prague. Since 1996 she has worked as a freelance photographer for publications such as *Reflex, Magazín LN, Koktejl, Mlady Svet*, the *International Herald Tribune, Focus* and the *New York Times*. She has carried out various assignments in Eastern Europe and Russia. Her photographs are included in the collections of the Bibliothèque Nationale de France, the Czech National Bank and the Galleria Facchinato in Bologna. She has been represented by the Regina Maria Anzenberger Agency since 2002.

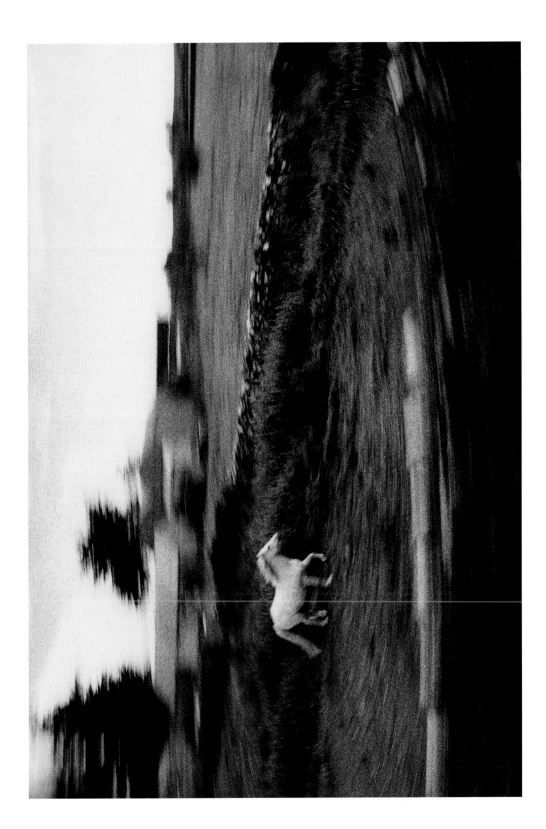

LI ZHENSHENG

They were hidden beneath his floorboards for more than twenty years: thirty thousand negatives, a treasury of truth and the certainty of a death sentence. 'Negative negatives' is how they were described by Robert Pledge, the representative of the Contact photographic agency who worked with Li Zhensheng for four years editing the book *Red-Color News Soldier*, now considered a classic of photojournalism. The collection brings to the fore the events, characters, enthusiasms, rages, humiliations and violence of the Chinese Cultural Revolution; the heroism coupled with ferocity; the hope of a new and brutal world; the destruction of every piece of ancient knowledge. This was 1966. Two years earlier Li, a photojournalist for the *Heilongjiang Daily* newspaper, was sent by the Socialist Education Movement to document life in the countryside as both a mission and a punishment, from which grew the first series of extraordinary images brought together in the chapter '"It is right to rebel" 1964–1966'. It is right to rebel against corruption and reactionaries, the landowners, as in Mao Zedong's own words. Li's photographs illustrate this: in a radiant dawn over farmland we see two young peasants, presented as both humble and heroic, setting off in search of manure to fertilize the fields. There are also the parades, the patriotic songs that even the children sing, the female soldiers, the posters with Mao's image and the heights of the cult of personality. But these pictures are paired with the images of public trials, pillory, placards with insults hung around people's necks and capital punishment. Li, with the red band of a Soldier of Information on his arm, took pictures and hid them away. And twenty years later, after one of the longest development processes in the history of photojournalism, he finally printed them.

Early dawn in the countryside in Heilongjiang Province, China, 1964

© *Li Zhensheng/Contact Press Images/Grazia Neri*

LI ZHENSHENG was born in 1940 in Dalian, in the province of Liaoning. Two events marked his childhood – the death of his mother and that of his brother who was a soldier in the Red Army. Li was late in enrolling at school, but soon achieved the highest marks. He studied cinema at Changchun Film School and became a photojournalist. In 1963 he started to work for the *Heilongjiang Daily* newspaper. He documented the Cultural Revolution in 1966, but eventually transgressed the rules of propaganda. He was denounced, and in 1969 was sent to a re-education camp for two years, while his most incriminating negatives remained hidden beneath the floorboards of his apartment. He started to work again in 1972, and in 1999, together with Robert Pledge, he began to sort through his 'prohibited' images. His book, *Red-Color News Soldier*, appeared in 2003.

FOSCO MARAINI

He used to refer to himself jokingly as 'Citluvit', a citizen of the Moon on an educational visit to Planet Earth. Fosco Maraini's life seems like a novel in which he plays all the characters: anthropologist, writer, orientalist, professor, mountaineer, photographer and, above all, traveller. A thousand men in one, he saw so much of the world that for him travelling was a continual lesson in 'diversity'. From his crumpled-up journal, which was also used to wipe his ski boots during a holiday in the Tre Cime di Lavaredo, we know that Giuseppe Tucci, the great Italian oriental scholar, was organizing an expedition to Tibet and was looking for a photographer. This was the moment when Maraini's life made an unexpected turn towards the East. Tibet was the sudden bolt of lightning, the vital spark that made him fall in love with Asia. It was 1937 and Maraini, as the photographer on the expedition, left for that remote land weighed down with photographic equipment and all the chemicals necessary for developing his rolls of film. Not long after this, he moved to Japan for several years and dedicated the rest of his life to studying oriental civilizations. 'The Struggle with Nothing' was one of his favourite photographs. It is New Year's Day morning in Tokyo, and members of the fire brigade are giving public demonstrations of balance and courage. The men ascend long fragile bamboo ladders held upright by their colleagues. The young fireman balancing so delicately has only the sky around him: he looks like a mythical warrior struggling with evil spirits or a strange divinity of the Japanese cosmogony. There is no enemy, or at least not one that can be seen. The struggle with nothing is an internal combat, a journey of self-discovery. Both the man's pose and the sense of purpose that guides his body are full of meaning: this is a moment that allows the spirit of the place, of a person and of a whole people to emerge.

'The Struggle with Nothing', acrobatic exercises for firemen, during New Year celebrations, Japan, 1963

Fosco Maraini/Courtesy Gabinetto Vieusseux © Archivi Alinari www.alinariarchives.it

FOSCO MARAINI was born in Florence in 1912 and from an early age made many journeys in Europe and throughout the world. As a twenty-two-year-old English teacher for cadets at the Naval Academy in Livorno, he embarked on the ship *Amerigo Vespucci* as it made a tour of ports in the eastern Mediterranean. In 1937 he followed the orientalist Giuseppe Tucci on an expedition to Tibet. He dedicated himself to ethnological research and to studying oriental cultures, making many journeys in Asia and living in Japan for several years. He turned the accounts of his journeys into books, which have been translated into many languages, and he also produced many photographic works. Maraini died in 2004, and by his express wish his collection of books on the Orient and the photographic library of his images are now preserved in the Gabinetto Scientifico Letterario G. P. Vieusseux in Florence.

NASA

'The image pursued by man for centuries was presented to our gaze, simultaneously containing all previous images and making them incomplete, as it did all written books, and all symbols, whether they were decoded or not. It was not just the image of the world in graffiti, frescoes, paintings, writings, photographs, books or films. It was simultaneously the image of the world and all the images of the world.' Thus wrote Luigi Ghirri after the publication in every newspaper of the photo taken from the Apollo 11 spacecraft on its return journey from the moon. 'One small step for a man, one giant leap for mankind,' said Neil Armstrong as he set foot on the lunar surface on the night of 20–21 July 1969, one of the most emotional and hopeful moments in the history of man. At that moment, Armstrong and Buzz Aldrin took photographs. They returned with images of the dusty surface of the moon, and of the earth immersed in a darkness that had neither beginning nor end. Three years later the crew of Apollo 17 took this picture, which was to become the most famous image of the earth from space. Photography was able to show what words could never explain – what it is to exist within the infinity of space and time. The astronauts saw the sun, the moon and our place in the universe with their own eyes, and recorded it all with a camera, thus becoming involuntary reporters, perhaps even photojournalists. This was a very particular photojournalism, able to offer possible answers to the questions that man had always asked himself, even before the mythological Icarus flew too close to the sun on his wings of wax. Photography became interlinked with the human need to understand. The image of the earth seen from the depths of space is more than simply a wonderful, beautiful novelty: it is, as Ghirri imagined, a majestic hieroglyph in which 'the space between the infinitely small and the infinitely large is filled with infinite complexity: that of nature, man and his life'.

The earth, photographed from Apollo 17, 7 December 1972

© Bettmann/Corbis

THE FIRST PHOTOGRAPH of the earth seen from deep space was taken in December 1968 by the crew of the Apollo 8 spacecraft. On that occasion, the astronauts took the astonishing photo of the terrestrial dawn: the earth seen from the moon. From then on, NASA, conscious of the importance of using images to document the great effort involved in the discovery of space, created an efficient photographic department and called on *National Geographic* and *Life* photographers to instruct the astronauts. It was only a year later that Neil Armstrong took the extraordinary photographs of the lunar surface that were published in magazines around the world. Over the years, a valuable archive of views from space has been collected.

SEBASTIÃO SALGADO

'The destiny of men and women is to create a new world, to reveal a new life, to remember that there exists a frontier for everything except dreams, which allow them to adapt, endure and believe. In history there are no solitary dreams.' These are the words of a dreamer called Sebastião Salgado, a photographer who, resisting the pressure simply to supply the fragmented testimonies that are so much part of modern photojournalism, has dedicated his life to creating much broader reflections of what happens in the world. Salgado's projects require a long holding of breath: he concentrates on them for years at a time, inspired by his moral conviction to undertake long journeys and managing, as few others have done, to bring together the threads of a discourse in which all his images finally converge into a single, epic vision of man. Salgado has always photographed people by showing their pain and celebrating their dignity. In the last few years, however, one theme has claimed his attention: the alarm call of a world in danger; a cry so constant that it has almost become an unheard background noise. When Salgado set out in 2003, he had a new dream in his head: 'I called this project *Genesis* because I want to return to the beginnings of our planet: to the air, water and fire that gave birth to life; to the animal species that have resisted domestication, to the remote tribes whose "primitive" way of life is still largely untouched; and to the surviving examples of the earliest forms in human settlement.' The photographer searches for facets of nature and of humanity that are still unspoiled, and for traces of their ancient and harmonious balance. These are photographs of singular power and delicacy, dominated by heavy skies in which the forces of light and darkness shape a vision nourished by a sense of wonder and an admiration for beauty. These are stirring photographs because they are created with a participatory and empathetic vision, capable of investing all its convictions in every picture, because 'you photograph with all your ideology'.

Iceberg between Paulet Island and the Shetland Islands, Antarctica, 2005

© *Sebastião Salgado/ Amazonas Images*

SEBASTIÃO RIBEIRO SALGADO, born in Brazil in 1944, is one of the greatest living social documentary photographers. After studying economics and sociology, he worked in London for the International Coffee Organization and began his career as a photographer in Paris in 1973. Among his works, the large series of photographs on manual labour at the dawn of the new millennium, which became the book *Workers* (1993), is particularly memorable, as is another series on the phenomenon of migrations throughout the world, *Migrations: Humanity in Transition* (2000). Many of his books and exhibitions have been conceived and created by his wife, Lélia Deluiz Wanick. In 1994 the couple founded the press agency Amazonas Images. Salgado is a special representative for UNICEF and an honorary member of the American Academy of Arts and Sciences.

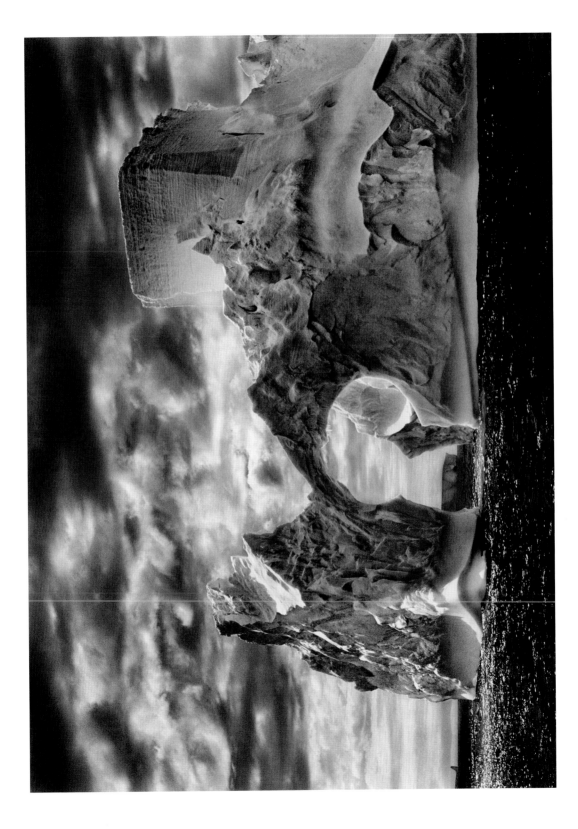

ANUP AND MANOJ SHAH

Certain photographs are surprising because of their naturalness: particular gestures seem to have been captured in such a spontaneous way that they astonish the viewer. These can be quite banal, but yet so authentic, so profound. This holds true for human subjects – but for animals, too? What seems to be ordinary and surprises us with its intense normality is still difficult to capture. The photographer who chooses nature as his field of observation, and who tries to present the rhythms of familial intimacy between animals in a free, wild state, has a difficult task. Committed to long waits and exhausting hours spent hiding, perhaps even for days at a time, the photographer must have both the talent and the capacity to shoot, and the ability to be at one with the surrounding atmosphere, to live in perfect accord with his photographic subject. The Shah brothers were born in Kenya to an Indian family. They were 'weaned' in the savannah, and, after completing their studies in England, decided together to return to where they had started, the place where they belonged: Africa. The observation of wild animals in their natural state became the area of specialization for the brothers, with their deep attachment to the landscape. If it is difficult for a photographer to take pictures without being observed, and to produce candid snaps – unexpected, fresh and spontaneous photographs – if he is disorientated by the environment, then it is far more difficult when the terrain that he moves through is not the streets of Paris, New York or London, but the immense open spaces of Africa. Herein lies the grandeur of this image, which miraculously manages to capture a moment of tenderness between an adult giraffe and its young. The sweet intimacy of the image, so serene and maternal, makes us feel like voyeurs, embarrassed at having disturbed this idyllic scene with our gaze, even if only for a second.

A giraffe and its young, Masai Mara, Kenya

© SHAH Anup/JACANA

ANUP AND MANOJ SHAH, sons of Indian parents, were born and brought up in Kenya. Anup graduated in economics from the London School of Economics and Manoj took a doctorate in topographical surveying at the University of London. The pair returned to Africa as soon as they were able, as they felt a great love for the landscape and its unspoiled natural beauty, and transformed their passion into highly successful photographic careers. Their work has won many prizes and has been published by various magazines, especially *National Geographic*.

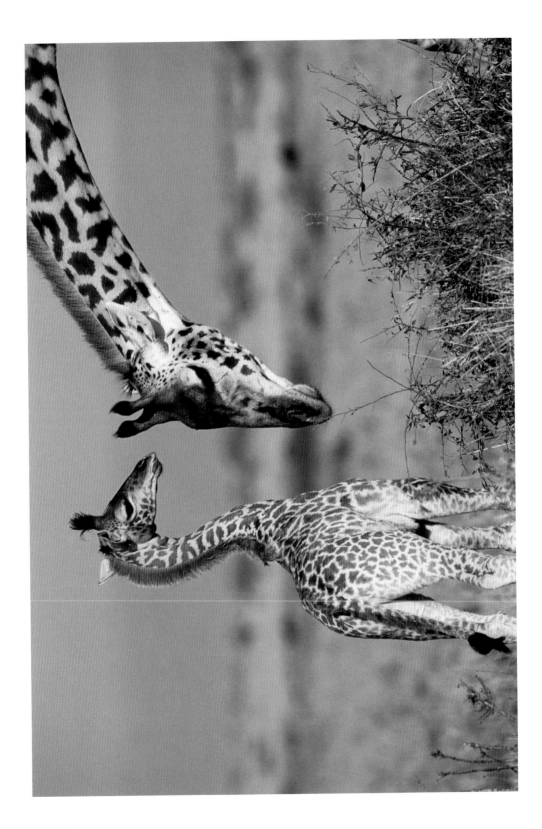

ANDREW ZUCKERMAN

The lion's yellow eyes fix on the observer with an expression of intense seriousness. His gaze is astonishing for its immobility, its concentrated attention and its enigmatic distance. The background is a pure, stark white, and the image is completely filled with the mystery of the lion's frozen expression. For five years Andrew Zuckerman has brought animals of very different species and dimensions – from a gigantic elephant to a tropical bee, a snake and even an alligator – into his studio and taken their portraits. He photographed them all against a completely white background. 'By distilling a frame down to its crucial elements, I can reject superfluous information that pulls my eye away from its essence.' The 'essence' that Zuckerman looks for is the personality of each animal, 'the underlying consciousness that all living beings share'. He uses a special technique of his own invention that allows him to fix minute fractions of time. Thus he is able to capture the most infinitesimal movement – a wing beat, a blink of the eyes – and freeze an instant in time, or rather eliminate the concept of time itself. He wanted his photographs to look like the stuffed-animal exhibits that intrigued him in natural history museums: stoic, frozen, and lost in strange and distant thoughts. The result is a series of photographs that bring the observer face-to-face with extraordinary creatures that show themselves in all their savage splendour and mysterious complexity.

African lion, 2006

© Andrew Zuckerman
andrewzuckerman.com

ANDREW ZUCKERMAN lives in New York. He is a renowned photographer and director, and received the D&AD Yellow Pencil Award for Excellence in Photography in 2006. He is also the co-founder of Late Night & Weekends, a company that produces advertising, books and films. He directed and co-produced the film *High Falls*, which premiered at the Sundance Film Festival in 2007. He also produced the book *Creature* in 2007.